WALTER GROPIUS
AND THE CREATION
OF THE BAUHAUS IN WEIMAR:
THE IDEALS AND
ARTISTIC THEORIES
OF ITS FOUNDING YEARS

UNIVERSITY OF ILLINOIS PRESS   Urbana   Chicago   London

# WALTER GROPIUS AND THE CREATION OF THE BAUHAUS IN WEIMAR: THE IDEALS AND ARTISTIC THEORIES OF ITS FOUNDING YEARS

MARCEL FRANCISCONO

To R. F.

# ACKNOWLEDGMENTS

This study was begun under my teacher, Robert Goldwater, to whom I should first like to express my appreciation and esteem. His methodological rigor and scrupulosity have continued to be an inspiration in an area of study where serious historical and critical appraisal is still too rare. The basic research was carried out in the Bauhaus-Archiv, Darmstadt, in 1963 with the aid of a Duveen Fellowship from the New York University Institute of Fine Arts; to the Institute and its director, Professor Craig Hugh Smyth, I am extremely grateful. I am grateful, too, to Professor George Collins who somehow was able to read this study in its form as a doctoral dissertation and to offer his valuable comments during an arduous time of upheaval at Columbia University.

Of the numerous people who were kind enough to answer my questions in person or by letter, I should like to mention in particular Miss Charlotte Weidler, Dr. Alfred H. Barr, Jr., Mr. Bernard Karpel, and Professor Bruno Zevi. As for the many friends, colleagues, and students—to say nothing of family—upon whom authors impose at one time or another in large or small ways in order to complete their work, it is customary in acknowledgments to thank them collectively. I cannot forgo, however, giving individual thanks to my friend Allan Greenberg for generously allowing me to use some of his transcriptions of documents

and for helping me on several occasions to obtain hard-to-get source material. Discussions on our subject of mutual interest, the Bauhaus, did much to clarify my thoughts on a number of issues.

I have saved three special debts of gratitude for last. Two of these are owed to Dr. Charles Kuhn, former Curator of the Busch-Reisinger Museum and Mr. Hans M. Wingler, director of the Bauhaus-Archiv, Darmstadt. Their kindness and full cooperation in granting me access to the facilities of their institutions did much to make the research for this book a pleasurable and memorable experience. I wish especially to thank Mr. Wingler, who for seven months in 1963 acted as a gracious host, permitting me complete freedom of the Bauhaus-Archiv. During that time and since, his willingness to enter into discussions and to answer my questions has gone far beyond any requirements of scholarly courtesy.

Finally, I should like to express my gratitude to Mrs. Ise Gropius. Her willingness to cooperate with scholars is well known. I am greatly indebted to her for her kindness in permitting me to study and quote from the letters in the Gropius archives in Lincoln.

# CONTENTS

# ILLUSTRATIONS

9. Otto Bartning. House for a Director of the Coal Industry, Zeipau in Schlesien, 1923–1925 (Langewiesche—Köster)

10. Walter Gropius, with Adolf Meyer. Factory Administration Building and Hall of Machines, Deutscher Werkbund Exhibition, Cologne, 1914 (Museum of Modern Art, New York)

11. Heinrich Reinhardt and Georg Sössenguth. Hamburg Railroad Station, 1903–1906 (Courtesy German Federal Railroad)

12. Joost Schmidt. Foyer door of Sommerfeld House, 1921–1922. Apprentice work (from *Staatliches Bauhaus Weimar 1919–1923.* Courtesy Mrs. Ise Gropius and Mrs. Sibyl Moholy–Nagy)

13. Joost Schmidt. Woodcarvings, staircase of Sommerfeld House, 1921–1922. Apprentice work (from *Staatliches Bauhaus Weimar 1919–1923.* Courtesy Mrs. Ise Gropius and Mrs. Sibyl Moholy-Nagy)

14. Joost Schmidt. Staircase relief, Sommerfeld House, 1921–1922. Apprentice work (from *Staatliches Bauhaus Weimar 1919–1923.* Courtesy Mrs. Ise Gropius and Mrs. Sibyl Moholy-Nagy)

15. Frank Lloyd Wright. Midway Gardens, Chicago, 1913–1914 (Chicago Architectural Photographing Co.)

16. Walter Würzbach, architect, and Rudolf Belling, sculptor. Dance casino in the Scala-Palast, Berlin, ca. 1920 (from *Wasmuths Monatshefte* 6. Verlag Ernst Wasmuth KG, Tübingen)

17. Bruno Taut. Clubroom of the Single Men's Residence, Schöneberg near Berlin, 1919–1920. Interior painting by Franz Mutzenbecher (from *Moderne Bauformen* 1922. Courtesy Julius Hoffmann Verlag, Stuttgart)

18. Student exercises from Franz Cizek's classes, Vienna, ca. 1920–1921. Expressions of specific emotions: sorrow (from L. W. Rochowanski, *Der Formwille der Zeit in der angewandten Kunst*)

19. Student exercises from Cizek's classes, Vienna, ca. 1920–1921. Expressions of specific sensations: light versus darkness (from Rochowanski)

20. Werner Graeff. Exercise for Itten's preliminary course, ca. 1919–1920. Coll. Bauhaus-Archiv, Darmstadt (Bauhaus-Archiv)

21. Max Peiffer-Watenphul. Exercise for Itten's preliminary course, ca. 1919–1920. Coll. Bauhaus-Archiv, Darmstadt (Bauhaus-Archiv)

22. Friedl Dicker. Exercise for Itten's preliminary course, ca. 1919–1920 (from *Staatliches Bauhaus Weimar 1919–1923.* Courtesy Mrs. Ise Gropius and Mrs. Sibyl Moholy-Nagy)

WALTER GROPIUS
AND THE CREATION
OF THE BAUHAUS IN WEIMAR:
THE IDEALS AND
ARTISTIC THEORIES
OF ITS FOUNDING YEARS

# ABBREVIATIONS

BD,SG   Bauhaus-Archiv, Darmstadt, Sammlung Gropius. While the Gropius papers have to some extent been systematized, as of 1969 they were uncatalogued.

FP   The papers of Lyonel Feininger, Houghton Library, Harvard University, Cambridge, Massachusetts.

GAL   The Gropius Archives, Lincoln, Massachusetts.

StAW   Staatsarchiv, Weimar. In 1966 reindexing of the Bauhaus collection was begun. The temporary numbers used here will remain on file along with the new.

# INTRODUCTION

The Bauhaus remains the justly most famous experiment in art education of the modern era. Founded by Walter Gropius in Weimar in 1919, it expired with the Weimar Republic; but its short life span belies the range and impact of its contributions to the culture of our century. During its brief existence it developed a viable contemporary style of design which has influenced virtually every branch of the applied arts. It created an art pedagogy still widely accepted; indeed, which has become a new academism. It drew to its faculty some of Europe's greatest artists of the time, who in the course of preparing their classes contributed significantly to twentieth-century pictorial theory. All this, and whatever else the Bauhaus sought to do, was the direct consequence of what must be regarded as the most radical and sustained effort yet made to realize the dream cherished since the industrial revolution not merely to bring visual art back into closer tie with everyday life, but to make it the very instrument of social and cultural regeneration.

These avowed ambitions of the Bauhaus are common knowledge, and they would not be worth reiterating if it were not for the fact that they are still generally misestimated. The beginning years of the Bauhaus, until about 1922, have become recognized today as in some ways distinctive. They have been labeled "romantic"

and "expressionistic" in attempts to indicate something of their atmosphere of trial and revolution, of their ties to the past and presumedly unrealistic hopes for the future. Plainly, they were the outcome of a rich and distinctive, if not easily definable, complex of artistic philosophies and ideals. Yet, it is only recently that the ideas that led to the founding of the Bauhaus have begun to receive their proper weight and emphasis; and even now, the precise character of the school at its inception—the background and generative force of these ideas, the first attempts to realize them in practice, and the relationship of the first phase of the Bauhaus to what followed—is still its least studied aspect, and the least understood.

In the first two decades of the century Germany offered perhaps the most varied body of modern artistic theory and practice to be found anywhere in Europe. If Paris was the acknowledged center of modern painting, Germany could boast a vital expressionist (to give it its conventional label) movement in the arts inspired by a European-wide range of sources. But at the same time Central Europe had also become the most fruitful soil anywhere for the development of a modern architecture and applied design based upon directness and sobriety of expression and the use of industrial materials, forms, and techniques.

This latter tendency was the heritage of a number of nineteenth-century rationalist doctrines of design; and embodied as it was in the influential and practically oriented Deutsche Werkbund, an organization founded in 1907 to include all those—artists and architects, businessmen, officials, educators and critics—actively concerned with raising the standards of design and public taste, it sometimes seems to us in many respects to be the very opposite of what we loosely think of as the subjectivity or exaggerated emotionalism of German painting and sculpture.

In a limited and general way it is realized today that the Bauhaus was the inheritor of both these in some ways opposed streams of thought. As a school and a working community of widely differing artists, the Bauhaus was in a real sense the only viable attempt· ever made to synthesize them or at least hold them in equilibrium. For this reason, it has a claim on our attention not only for what

it actually managed to accomplish but as the paradigm and cul-
mination of an entire era of German art.

It is from this perspective that the present study examines the
founding of the Bauhaus. Its basic concern is with the Bauhaus at
the period of its birth, with the initial synthesizing vision of the
school and its very first years of creative ferment before its goals
began to crystallize and to a certain extent become simplified. But
at its broadest, it necessarily aims, as well, to trace some of the
principal strands of German aesthetic theory and practice from
the beginning of the Werkbund through the November Revolu-
tion, and to clarify their interaction.

Most of the pages of this book deal with the ideas of its founder,
Walter Gropius, and of its first few members insofar as they
essentially confirmed or transformed Gropius's conception. No
objective study of the creation of the Bauhaus can do otherwise.
For although it goes without saying that the Bauhaus could not
have achieved its present historical stature without the modern
painters and sculptors who taught there, the visionary zeal that
gave it its life and momentum was Gropius's. Even after the school
had begun operation, when Gropius could not exert as much in-
fluence upon its artistic direction as he might have wished because
of his administrative and publicity duties, he remained its guiding
spirit, as every source testifies, constantly holding up his ideals
before the eyes of his collaborators as the goals toward which to
strive. It was Gropius who created the initial framework within
which the artists of the Bauhaus acted, and whatever was at-
tempted or achieved there before his resignation as director in
1928 was either in essential agreement with or in defiance of his
ardent vision.

It is of course true that Gropius would not have obtained and
in great part kept the loyalty and cooperation of the remarkable
array of artistic talents who accepted his call to the new school if
many of the principles he believed in had not also been strongly
shared by them. For while very few of Gropius's ideas were orig-
inal with him, it is also true that it required a man with Gropius's
singular combination of visionary fervor and practical ambition,
of administrative and artistic gifts, to bring the school into being

and to inspire other artists to come to his side. Perhaps no archi-
tect of his time was more capable of joining for practical results
the concerns of the architects of the Deutsche Werkbund with
the disparate ideals of the modern painters and poets which
World War I caused to come together.

Until recently our critical conception of the early Bauhaus and
of the ideas of its founder was, not surprisingly, dominated by the
goals, ideas, and achievements of the school as it developed in
1923, when in an exhibition of its work held in the summer of
that year it first came to the attention of the world at large. The
history of the school was first written by men who had shaped its
middle evolution, most tirelessly by Gropius himself, and by a
generation of architectural critics and historians, Sigfried Giedion
and Nikolaus Pevsner, for example, whose experience and knowl-
edge of the school developed only at the time of or after the 1923
exhibition. These men were champions of the new normative
architectural concepts of the mid- and later twenties, after many
of the visionary goals of the immediate post-World War I period
which produced the Bauhaus had been rejected.

The posthumous historiography of the school can properly be
said to have begun with the catalogue of the Bauhaus exhibition
held by the Museum of Modern Art in New York in 1938. Edited
by Herbert Bayer and Walter and Ise Gropius, the catalogue,
while admirably broad in its selection of works and writings from
the Gropius era of the Bauhaus, naturally made no pretense to
scholarly disinterest. Of the expressionist roots of the school and
its utopian, handicraft beginnings, scarcely any mention was
made. In his introduction to the catalogue, Alexander Dorner
could refer to and dismiss the first four years of the school's ex-
istence with the simple words: "The press, quite understandably,
sometimes confused the aims of the Bauhaus with the 'isms' seen
elsewhere, and debated the 'entry of Expressionism into the
Bauhaus.' Today . . . it is astonishing to realize that . . . [the
Bauhaus] ever had anything to do with Expressionism and Dada-
ism, but it must be remembered how very confused the world of
art was when the Bauhaus began."[1] The very format of the cata-

[1] Herbert Bayer, Walter Gropius, and Ise Gropius, eds., *Bauhaus 1919–1928*
(Boston, 1959), pp. 12–13.

logue revealed its editors' desires to present the Bauhaus in the light of its later evolution as an institution with an essentially rationalistic program concerned above all with creating models for industrial production and imparting an objective and systematic body of knowledge about the elements of design. Examples of free painting and sculpture by faculty and students were placed at the rear of the book; and the section on the workshops was begun not with the first shop to be established, but with the carpentry shop, one of the last, but the one that most nearly fulfilled the aim of the school to be a house of building and that still epitomizes the later achievements of the Bauhaus in its Weimar period.

Dorner's introduction, the omission of the first Bauhaus program (as distinguished from its manifesto page), the emphasis upon industrial designing, and the undiscussed presentation of student work made it easy to regard the dada- and expressionist-inspired student designs and the obviously handicraft objects as basically extraneous to the clear-sighted aims of the director of the Bauhaus, who was thus in effect presented as continuing to champion wholeheartedly the principles he had espoused early in his career just after leaving the architecture office of Peter Behrens.

As the first, and for many years the only reasonably detailed work on the Bauhaus, the Museum of Modern Art catalogue became the standard reference on the workings and development of the school, even though Alfred Barr in his preface to it had cautioned that it was "not complete, even within its field," and that "at some time a definitive work on the Bauhaus should be written."[2] The viewpoint of its editors was taken up particularly by critics and historians of architecture and applied design. The standard monograph on Gropius, by Sigfried Giedion, published in 1954, for example, makes no mention whatever of the early ideas and attitudes with which this present study is principally concerned.[3] Typical of most of the studies of Gropius's thought which have appeared since the closing of the Bauhaus, it takes up Gropius's conception of the school only as it began to crystallize in his essay "Idee und Aufbau" of 1923, implying by omission that

2 *Ibid.*, p. 7.
3 *Walter Gropius, Work and Teamwork* (New York, 1954).

the direction of Gropius's ideas had remained the same since be-
fore the war. As recently as 1962, in the fourth, enlarged edition
of *Space, Time, and Architecture,* Giedion was still dismissing
"expressionism" in the architecture of the postwar period with
the words: "Men who were later to do grimly serious work in
housing developments abandoned themselves to a romantic mysti-
cism, dreamed of fairy castles to stand on the peak of Monte
Rosa. Others built concrete towers as flaccid as jelly fish."[4] But
Giedion mentioned no names, and while recognizing that the
Bauhaus and Gropius himself shared something of this romantic
impulse, he briefly generalized the aims of the school by stating
that "from the very beginning it set itself to unite art and in-
dustrial life . . . ,"[5] a true remark, but misleading in implication.

The end of World War II, however, already saw the beginning
of a change in this picture. The publication in the nineteen
forties and fifties of recollections and eyewitness accounts of the
Bauhaus, among the first and most valuable those of Helmut von
Erffa, Bruno Adler, and above all Oskar Schlemmer,[6] afforded a
new, distinct view of the first years of the school. The exhibition
of Bauhaus painters held in Munich in the spring of 1950, the
first of its kind since the closing of the school, also contributed to
this changing view. The exhibition catalogue was little more than
a series of brief paragraph descriptions of the activities in the
Bauhaus of the artists who taught there, with a four-page preface
by Ludwig Grote which very cursorily and not without error sum-
marized some of the ideas behind the school and its history to the
time of its closing in 1933.[7] But just because the exhibition and
Grote's essay were directed toward the painters and their con-
tributions, they drew attention to the hitherto de-emphasized or
ignored role of the fine arts and of genius in the formation of the
school. Like the recollections of von Erffa and Adler, Grote's

---

[4] P. 482.

[5] Pp. 482–483. Perhaps the most glaring example of a nongenetic approach to
Gropius's ideas is the study of the architect by Giulio Carlo Argan (*Walter Gropius
e la Bauhaus,* [Turin], 1951), whose book presents for the most part an abstract
formulation of disparate aspects of Gropius's thought from various periods without
regard for their chronology and evolution.

[6] On these and the following, see bibliography.

[7] *Die Maler am Bauhaus* (Munich: Haus der Kunst, May–June 1950).

essay, brief as it was, placed an unaccustomed stress upon the ro-
mantic aspect of the early Bauhaus; he drew attention to the
visionary strain found in the Bauhaus manifesto, introducing his
essay with the manifesto's last lines, which urge the creation of
the crystalline symbol of a new faith. He was one of the first
postwar writers to refer to Gropius's use of glass in architecture
and to reintroduce in this connection the name of the poetic
fantasist, Paul Scheerbart, though he failed to point out Scheer-
bart's significance for the ideas of the time. Mention of Scheerbart
was still novel enough in the literature of art to lead to misspelling
his name in the printed text.[8]

Since then serious students of the period have generally come
to recognize the distinctive character of the first years of the
Bauhaus, but we have only begun to move beyond this mere
recognition.

Work in the history of expressionist architecture and archi-
tectural thought, especially by Kultermann, Lindahl, Banham,
Conrads, and now Borsi and König; the republication of hitherto
little-known or forgotten architectural manifestoes and programs
of the period; and above all the monumental collection by Wingler
of Bauhaus photographs and documents, many previously un-
published, have all helped to show that the beginnings of the
school and Gropius's thinking of the time were part of that in-
tensely visionary and utopian desire of the revolutionary post-
World War I period in Germany to make society over by means
of art. The recent, more or less explicitly Marxist studies of the
Bauhaus from eastern Germany and Europe, particularly those
of Lang and Schmidt, have rightly laid stress upon, even if they
do not explore, some of the ideological considerations behind the
creation of the school.

The most detailed examination to date of the social and politi-
cal ideals held by modern German architects during the Weimar
period is in a recent study not by an art historian, but by a cultural
historian. Barbara Miller Lane's *Architecture and Politics in
Germany, 1918–1945*, is the first published work by a modern
historian to consider Gropius's ideas and the creation of the Bau-

[8] *Ibid.*, p. 6.

haus fully within the framework of the November Revolution and to attempt to understand the continuity that exists between the first, revolution-inspired phase of Gropius's thought and what he came to hold after 1921. Lane's book, however, is concerned with the political uses of architecture in the Weimar and Nazi eras; and illuminating as it is on matters of ideology, it merely surveys Gropius's artistic ideas and has relatively little to say about the internal workings of the Bauhaus. The beginnings of the school and its ideas thus remain in greatest part unexplored.

Numerous questions concerning the peculiar form and direction taken by the Bauhaus have until now scarcely been examined. In his recent book on the painters of the Bauhaus, Eberhard Roters raises but does not adequately answer a question which lies at the heart of the Bauhaus and its achievements: why in a school dedicated to applied design and architecture was the faculty composed almost entirely of painters and sculptors? His answer, the usual one given, that Gropius wanted to achieve "a whole work [of architecture] with a life of its own, created by a corporate body of artists and craftsmen and manifestly the result of the interaction of their related activities," and that "for this, he needed the painters,"[9] is true as far as it goes, but it only leads to further questions. Why should Gropius's desire to integrate the artist with society have at first sought its goal in the combined, unified work of art, the *Einheitskunstwerk* announced in the Bauhaus manifesto of 1919, instead of the later solution of a unity of style among things achieved by a common method of approach and vocabulary of form? Should we simply take this goal in architecture for granted and assume it to have been the natural one for the time? To be sure, the heritage of the English Arts and Crafts Movement, which had sought under the inspiration of John Ruskin and William Morris to regain the presumed social and artistic virtues of handiwork, was a potent, acknowledged factor; and with it, the long-urgent desire to reunite the artist with society. May we assume, as has been done notably by Banham, that in this respect the early Bauhaus simply continues, and is a further expression of, the desire for the total work of art—the *Gesamtkunstwerk*—held

[9] Eberhard Roters, *Painters of the Bauhaus*, trans. Anna Rose Cooper (New York and Washington, 1969), pp. 6, 7.

by the followers of the Arts and Crafts Movement on the Continent in the period of the Art Nouveau?[10]

Such an assumption, which to my knowledge has been challenged until now only by Lane, conflicts with the undisputed and undisputable influence exerted by the Deutsche Werkbund upon the ideas of Gropius. The question that needs to be asked is how far the Arts and Crafts tradition and the industrial concerns of the Werkbund were and could be compatible in 1919. Again with the exception of Lane, the only answer we have been given is to regard the first years of the Bauhaus, and Gropius's frame of mind then, as a retreat due to the social upheavals of the time into a romantic handicraft past and thus in conflict with the Werkbund ideals that preceded it and the Bauhaus that came afterward. We have, if anything, swung to the other extreme of exaggerating the contrast between the early Bauhaus and its later phases and between this period of Gropius's thought and his earlier period.

Should we also take it as a matter of course that Gropius would accept modern artists of predominantly abstract, cubist tendency for the Bauhaus instead of more conservative figures? Certainly, he himself was among the most advanced architects of the period; but he had not shown himself equally advanced in his taste in painting and sculpture before the war, as his collaboration in the 1914 Deutsche Werkbund exhibition with the then already relatively conservative César Klein, Richard Scheibe, and Gerhard Marcks seems to show. Roters rightly observes that the artists finally chosen for Weimar by Gropius, alone or with the advice of the Bauhaus faculty, "without exception wrestled with the same creative problems as arise in architecture," and that the "problems with which they had grappled as painters on the two-dimensional plane could now be explored in other media."[11]

But why, in fact, should painters instead of craftsmen or designers have been asked to contribute to the creation of a modern style of applied design? Even assuming what Gropius always maintained, that only the modern artist was capable of revitalizing the applied arts at this time, should we accept such a decision unquestioningly as merely the brilliant inspiration of a perceptive avant-

[10] See Chapter 1.
[11] Roters, pp. 6, 7.

garde architect? There was certainly little precedence for this in the Deutsche Werkbund. What factors led Gropius to this decision? One has to go back to the period of the Art Nouveau to find a comparable situation in Germany of painters and sculptors turning to the applied arts and to building, and even then they had not remained fine artists but had become designers and craftsmen; something that with few exceptions did not happen among the artists hired for the Bauhaus in Weimar.

These are some of the questions concerning Gropius's intentions and the early conception and realization of the Bauhaus which this study will investigate. Its aim is to define for the first time with historical depth and comprehensiveness the nature of the Bauhaus at its founding and to set it within its context of that extraordinary conjunction of artistic ideals that took place during and just after World War I.

# THE IDEAS OF WALTER GROPIUS AT THE END OF WORLD WAR I: CHANGE AND CONTINUITY

1

## The Roles of Handicraft and Industry in Gropius's Postwar View of Art and Society

Anyone who reads Walter Gropius's first Bauhaus program and proclamation, dated April 1919, after his pre-World War I writings, or with the Bauhaus as it developed after 1922 in mind, cannot fail to be astonished at the striking differences in style and content. That the proclamation and program express an ideal that was fundamental to Gropius's thinking since the beginning of his career has been recognized by virtually everyone who has seriously concerned himself with Gropius and the Bauhaus: the desire for a universal style of design stemming from and expressive of an integral society and culture is a theme that can be found in Gropius's earliest writings.[1] Recently, it has also been recognized that the visionary aspects of the proclamation have their precedents in Gropius's strong early interest in the symbolic possibilities of

[1] The proclamation and program are reprinted in Hans M. Wingler, *Das Bauhaus, 1919–1933. Weimar, Dessau, Berlin* (Bramsche, 1962), pp. 39–41 (hereafter as Wingler, *Bauhaus*); English ed., *The Bauhaus: Weimar, Dessau, Berlin, Chicago*, trans. Wolfgang Jabs and Basil Gilbert (Cambridge, Mass., and London, 1968). For the sake of documentary accuracy, the German edition has been cited throughout.

13

architectural form.[2] Yet the curriculum of handicraft training en-visioned by the first Bauhaus program; its underlying ideal of a society of artist-craftsmen united, on the model of the medieval *Bauhütten*, about the symbol of the great cathedral—the *"Ein-heitskunstwerk"*—with its implication of return to the then fre-quently criticized Wagnerian *Gesamtkunstwerk*; the very use of the manifesto form itself and its pathetic, hortatory language, which have their antecedents not in architectural (to say nothing of pedagogical) circles, but among the painters and poets of the pre-World War I avant-garde—all these stand in startling contrast to Gropius's relatively sober if not always fully reasoned delibera-tions before the war on the role of the artist in a modern industrial society.[3] Indeed, we seem to read in the Bauhaus proclamation and first program the virtual denial of the "progressive" principles of the Deutsche Werkbund as Gropius had shared them before the war. This contrast between the Bauhaus program and the earlier writings of Gropius has led one scholar to exclaim in be-wilderment: "It is all very weird—. . . the Gropius of Fagus [start-ing] an Expressionist guild."[4]

The contrast appears all the more startling if we add to the Bauhaus program the articles and speeches written by Gropius during the same period for the post-revolutionary organization of radical artists, the Arbeitsrat für Kunst in Berlin, which he helped found and of which he became chairman early in 1919.[5] Among these, the most closely related in spirit and content to the Bauhaus proclamation is the short essay for the "Exhibition for Unknown Architects," a show of utopian and visionary architectural designs, held in Berlin at the Kabinett J. B. Neumann by the Arbeitsrat in April 1919. The essay, in fact, uses some of the same material as

[2] Göran Lindahl, "Von der Zukunftskathedrale bis zur Wohnmaschine. Deutsche Architektur und Architekturdebatte nach dem ersten Weltkriege," in *Idea and Form*, Figura: Uppsala Studies in the History of Art, N.S., vol. 1 (1959), pp. 230–232.

[3] See the commentary on the first complete publication of Gropius's 1910 mem-orandum on prefabricated housing in "Gropius at Twenty-six," *Architectural Re-view* 130 (July 1961): 49–51.

[4] Nikolaus Pevsner, "Gropius and van de Velde," *Architectural Review* 133 (March 1963): 167.

[5] See below, pp. 143–147 and Appendices D and E.

the Bauhaus proclamation. Here we find again the ringing, quasi-religious call to artists and craftsmen to build a new, spiritual society whose artistic goal will be "the creative conception of the cathedral of the future, which will once more encompass everything in *one* form—architecture *and* sculpture *and* painting."[6] Far beyond what is written in the Bauhaus proclamation, however, we also find in the essay an open appeal to the untrammeled artistic imagination "unhindered by technical difficulties" and a seemingly unmitigated scorn for the *Zweckmässigkeit*—the practicality—that had been one of the watchwords of the Werkbund before the war:

What is architecture? Surely the crystalline expression of man's noblest thoughts, of his ardor, his humanity, his faith, his religion! That is what it once was! But who of those living in our expediency-accursed time still understands its all-embracing and beatifying nature? . . . Things shaped by utility and need cannot still the longing for a world of beauty built completely anew, for the rebirth of that spiritual unity which rose to the miracle of the Gothic cathedral. . . .

But ideas die as soon as they are compromised. Therefore, a clear distinction between dream and reality, between longing for the stars and everyday work.[7]

The tendency which Gropius always had, but which appears especially strong in his writings of the immediate postwar period, to reduce relatively complex ideas to general statements of position or manifestolike pronouncements, contributes along with an exaggerated rhetoric to place the Bauhaus proclamation and this foreword to the "Exhibition for Unknown Architects" among the most extreme of the utopian documents to come out of German

[6] The essay was originally printed as a flyer along with essays by Bruno Taut and Adolf Behne. The three are reprinted in Ulrich Conrads, ed., *Programme und Manifeste zur Architektur des 20. Jahrhunderts* (Berlin, Frankfurt am Main, and Vienna, 1964), pp. 43–45; the first two also in Ulrich Conrads and Hans G. Sperlich, *Phantastische Architektur* (Stuttgart, 1960). English ed., *The Architecture of Fantasy: Utopian Building and Planning in Modern Times*, trans., ed., and expanded C. C. Collins and G. R. Collins (New York and Washington, 1962), pp. 137–138 (Ger. and Eng. eds.).

[7] Conrads and Sperlich, p. 137. I have changed the English translation slightly to bring it closer to what seems to me the meaning of the original.

artistic circles just after the war. This has had a two-fold conse-
quence for the understanding of Gropius's ideas. On the one hand,
it has led scholars and critics to overemphasize the differences be-
tween Gropius's prewar and postwar thought; on the other, it has
made it easy to dismiss the latter and to submerge it within the
general stream of postwar utopianism. In consequence, we seem
to end up with a picture of two quite different Gropiuses: the
prewar exponent of modern economic organization, mass pro-
duction, and sober machine design; and the later nostalgic yearner
after a medieval past of handicrafts—an eager contributor to that
hazy mass of visionary, utopian literature which had its chief cen-
ter in the Arbeitsrat für Kunst immediately after the war.

If we wish to determine to what extent this conception of Gro-
pius is true and to what extent it has been distorted or simplified,
we must try to understand the precise nature and genesis of Gro-
pius's postwar thought within the context of his career up to that
time and to distinguish it as far as possible from the parallel ideas
of his contemporaries. Only by so doing can we hope to make
comprehensible the complex motives that led to the creation of
the Bauhaus. As an idea, the Bauhaus was intimately bound up
with the personality of its founder, and many of its seemingly
opposing tendencies are to be found in him as well, both ultimately
reflecting oppositions that run through the artistic and social
thinking of the time.

Of all aspects of the first Bauhaus program, it is the almost ex-
clusive emphasis upon handicraft training that has given rise to
the greatest perplexity and has led recent criticism to see the early
Bauhaus as a misguided, utopian attempt to return to a preindus-
trial condition of craftwork. Certainly, this departure by Gropius
from his earlier dominant interest in the problems of designing
for mass production—a departure made all the more striking by
the fact that he had propounded his former convictions with the
same energy he now gave to the new—does indeed seem at first
glance a long step backward toward the medievalizing views of
John Ruskin and William Morris and their "standpoint of in-
spired craftsmanship."[8] There can no longer be any doubt, despite

[8] Reyner Banham, *Theory and Design in the First Machine Age* (London, 1960),
pp. 277–278.

his repeated assertions to the contrary,[9] that at the start Gropius intended the handicrafts to be ends in themselves, whatever else he may have had in mind with respect to designing for industry. The inclusion in the Bauhaus program of such traditional craft occupations as metal chasing,[10] enameling, and stucco and mosaic working is in itself sufficient proof. Contemporary accounts, moreover, amply testify to the strong crafts orientation of the early Bauhaus.

Yet is modern criticism correct in seeing this new emphasis on handicraft as a substantial rejection of Gropius's previous artistic principles? All available evidence indicates that the question of Gropius's postwar intentions is a far more complex one than a one-sided presentation of the case for or against handwork would make it appear to be, and that it is a serious oversimplification to see the first Bauhaus program as a radical denial of the Werkbund experience.

That collaboration with industry was unquestionably contemplated from the start as part of the Bauhaus's activities is indicated by the inclusion in the published program of "steady contact with the leaders of crafts (*Handwerks*) and industry in the land" as one of its articles, even though it must be admitted that this brief clause is not elaborated further and that reference to industry occurs nowhere else in the program.[11] However, the inclusion, brief and nonspecific as it is, takes on greater weight when we add to it the evidence of other documents of the same time. One of the most important expositions of Gropius's ideas during the early months of the Bauhaus is to be found in the re-

[9] See, e.g., his reply to Howard Dearstyne, "The Bauhaus Revisited," *Journal of Architectural Education* 17, no. 1: 13–16 (published as a supplement to the *Journal of the American Institute of Architects* 38, no. 4 [October 1962]); Gropius's reply in *JAIA* 39, no. 6 (June 1963): 120–121, with a counter-reply by Dearstyne.
[10] See also the letter of Nov. 5, 1919, from Gropius to Julius [Naum] Sluzsky [*sic*] in Vienna: "Es ist mir gelungen von einem Hofjuwelier in Weimar die notwendigen Gerätschaften zur Einrichtung einer Ziselier- und Goldschmiedewerkstatt zu erlangen. Das Bedürfnis nach Ziseliertechnik ist auch unter den Studierenden gross. Deshalb haben wir uns entschlossen diese Werkstatt nun unverzüglich einzurichten. Es wäre also die Möglichkeit geboten, dass Sie sich dieser Werkstatt angliedern" (BD,SG).
[11] The phrase is also cited by Gropius in his exchange with Dearstyne, "The Bauhaus Revisited," as evidence of his continued interest in machine design (Gropius letter of Sept. 1963, *JAIA*, p. 105).

markable speech given by Gropius in Leipzig in 1919—probably in the summer—and later published as "Baugeist oder Krämertum" in the October 15, 1919, issue of *Schuhwelt*, a trade periodical of the leather and shoe industry.[12] This speech, which has been ignored by every student of Gropius and the Bauhaus, doubtless because of its relative inaccessibility, deserves study at some length because in it Gropius turned once again to the question of art and industry which had occupied him before the war. It was one of a number of similar speeches delivered by him in the first years of the Bauhaus to acquaint lay, trade, and business groups in Saxony with his ideas and the Bauhaus. As such, its subject and understandably more matter-of-fact tone set it in striking contrast to the Bauhaus proclamation and Gropius's Arbeitsrat declarations. For this reason it affords us the rare opportunity to learn something of Gropius's position with respect to industrial designing and handicraft in the crucial period immediately after the war.

The speech comes as a considerable surprise. As was his habit, Gropius reused for it lines and sections of others of his speeches and essays. The parts dealing with industry have to a great extent been taken over with only minor changes from his essay, "Die Entwicklung moderner Industriebaukunst," which appeared in the *Jahrbuch des Deutschen Werkbundes* of 1913, and from his 1916 plan for an architecture department for the Weimar academy, the Hochschule für bildende Kunst (which itself reused portions of the 1913 article).[13] In essence, Gropius has cast these parts within the framework of his new ideal of a morally and spiritually regenerated society in which craftsmanship in all fields of work is to play a vital social and economic role. The conflicting points of

12 Cited by Gropius, *ibid.*, pp. 105–106. It was published again a few months later. Wingler, *Bauhaus*, gives it to *Der Qualitätsmarkt* 2, no. 1 (Leipzig, 1920). Gropius (Dearstyne, *loc. cit.*) cites an additional reprinting in *Messe und Qualität*, Jan. 10, 1920.

13 BD,SG; 8 pp. typescript, excerpted in major part in Wingler, *Bauhaus*, pp. 29–30. The speech also draws upon his 1914 Werkbund article, "Der stilbildende Wert industrieller Bauformen," in *Der Verkehr*, Jahrbuch des Deutschen Werkbundes 1914 (Jena). Doubtless Gropius's busy schedule partly explains the apparent carelessness of the results. But more than that, the hastiness of composition and above all the tone of vague utopian speculation reveal someone concerned not so much with producing a reasoned analysis as with proselytizing for a cause.

view among the old and new sections are amply apparent; yet sur-
prisingly, Gropius seems to have made little effort to reconcile
them. In numerous places old and new portions stand in awkward
juxtaposition, and at times in outright contradiction. The result
only serves to increase our difficulties in understanding Gropius's
thought: the conflicts that exist between the Bauhaus proclama-
tion and the Arbeitsrat writings on the one side and the prewar
writings on the other have not been eliminated; they have become
all the sharper by being carried over into the postwar period itself
and placed side by side within the same tract.

Thus, for example, despite the recognition given throughout
the speech to industry and industrial design, it is the oriental
bazaar which is held up as a moral ideal: "The craftsmen sit be-
fore the doors of their stalls and work. When a stranger asks about
the price of their wares, they answer in a sullen monotone; for
they are in love with their work and will not be disturbed. They
part unwillingly even from their finished work. For them, making
money—selling—is only a necessary evil."[14] Throughout, in fact,
Gropius supports his proposed measures by a double appeal to
the purse—the practical justification of his 1913 Werkbund arti-
cle—and to moral and spiritual principles. His procedure fre-
quently gives the curious impression that he is criticizing on moral
grounds the very economic interest he is appealing to elsewhere in
the speech, as when he approvingly quotes from the Chinese
statesman Ku Hung-Ming's criticism of the European com-
mercial spirit as the cause of the World War, and shortly there-
after without apology resorts to a traditional German politico-
economic argument—often used in the Werkbund—that "quality
work" is necessary in order to compete in foreign markets.[15] At one

[14] Gropius, "Baugeist oder Krämertum?" *Die Schuhwelt* (Pirmasens), no. 37
(October 15, 1919), p. 821. "Die Handwerker sitzen vor der Tür ihrer Verkaufs-
stellen und arbeiten. Fragt sie der Fremde nach dem Preis einer Ware so geben sie
nur mürrisch und eintönig Antwort, denn sie sind verliebt in ihre Arbeit, wollen
sich nicht in ihr stören lassen und trennen sich auch ungern von ihrem fertigen
Werk. Das Geldverdienen, der Verkauf ist für sie nur ein notwendiges Uebel."
[15] *Ibid.*, pp. 820–821. The latter argument is repeated verbatim in his speech of
about the same time before the crafts and business interests of Weimar (see be-
low, pp. 44–64). This particular appeal to national interest in seeking to raise
standards of design had been used in Europe since the eighteenth century (Nikolaus
Pevsner, *Academies of Art Past and Present*, Cambridge, 1940, pp. 152–153, 248,

point, Gropius takes over almost verbatim from his 1913 article, "Die Entwicklung moderner Industriebaukunst," the hardheaded approval of the discovery by "big business—and that is what decides—" that artistic quality "pays off in the long run."[16] Now, however, this practical argument is extended in its application and made subordinate to "spiritual" considerations by changing "big business" merely to "business," thus allowing for better assimilation within the handicraft context of the speech, and by eliminating the phrase between dashes and substituting its negation: "to be sure, the prospect of greater gain must never be the deciding factor in these questions, but inner necessity alone, the growing satisfaction in building," so that what "decides the issue" is now neatly reversed.[17] The most striking and revealing of these conflicts in the use of older material occurs with the sentence from the 1913 article: "Only the most brilliant ideas are good enough for multiplication by industry and worthy of benefiting not just the individual but the public as a whole."[18] To make the passage fit a framework that will include handicraft, it has been altered to read, with other minor changes: ". . . for multiplication (*Vervielfältigung*) through handiwork [*sic*] and industry. . . ."[19] If this sentence is now to have any meaning, it must imply a separation, at least on

---

282). For examples of its frequent use in Germany after the turn of the century and especially within the Deutsche Werkbund, see Joseph August Lux, *Das neue Kunstgewerbe in Deutschland* (Leipzig, 1908), p. 4; Hermann Muthesius, "Wo stehen wir? . . ." in *Die Durchgeistigung der deutschen Arbeit. Wege und Ziele in Zusammenhang von Industrie, Handwerk und Kunst,* Jahrbuch des Deutschen Werkbundes 1912 (Jena), p. 26 (quoted in Banham, *Theory and Design,* p. 77); Bruno Paul, "Erziehung der Künstler an staatlichen Schulen," *Deutsche Kunst und Dekoration* 23, no. 7 (December 1919): 193 (also cited by Pevsner, *Academies,* p. 282); Peter Jessen, "Der Werkbund und die Grossmächte der deutschen Arbeit" (Jahrbuch des Deutschen Werkbundes 1912), pp. 2–3.
[16] P. 18.
[17] Gropius, "Baugeist oder Krämertum?" p. 859. The entire passage reads: "Führende Betriebe haben bewiesen, dass es sich auf die Dauer bezahlt macht, wenn sie neben technischer Vollendung und Preiswürdigkeit auch für den künstlerischen Formwert ihrer Erzeugnisse besorgt sind und mit ihnen Geschmack ins Volk tragen. Freilich darf niemals die Aussicht auf höheren Erwerb in diesen Fragen den Ausschlag geben, sondern allein innere Notwendigkeit, die wachsende Baulust, nicht die Gewinnsucht."
[18] P. 18. On this passage see also below, pp. 73–74.
[19] Gropius, "Baugeist oder Krämertum?" p. 859.

a certain level of work, between the conceiving artist and the executing craftsman. And this amounts to Gropius's acceptance of conventional design practices; which, as we shall see, was entirely in accord with his views of the time, however much he wanted to have the creative artist himself learn a craft.

What are we to make of Gropius's views on the relation of art to industry from these curiously unresolved juxtapositions? Although it may be too extreme to say that he now came to regard big industry and modern industrial organization as merely necessary evils, from his speech it becomes apparent that for him they had now become at least a less fruitful soil for the renewal of art than they had once been. A clue to the respective place of industry and handicraft in Gropius's scheme of things is given by the altogether pleased observation in his Leipzig speech that "certain kinds of craftsmen have today already registered an increase in numbers since the time before the war. Culturally this must be regarded as a first hopeful step forward; for, the increase in craftsmanship means the spread of that joy in creation, that vital spirit of building without whose general extension a culture in a state of grace is unthinkable."[20] Or by his remark later that today's "need forces us to raise the quality of our products everywhere in the crafts and in industry, insofar as it still survives."[21] Whether this last phrase expresses a wish or was merely a recognition of the current state of German industry, the fact is that like many German artists at the time, Gropius became at least partially persuaded that modern large-scale industrial organization had itself been a major cause of the war and that the hope for the future of art lay in the revival of skilled hand labor.

Given the circumstances of the damage suffered by German industry, the consequent absence of important architectural com-

[20] *Ibid.*, p. 821. "Gewisse Handwerkerstände haben rein zahlenmässig gegenüber dem Friedensstand heute bereits Zunahme zu verzeichnen. Kulturell muss darin ein erster hoffnungsvoller Fortschritt gesehen werden; denn diese Zunahme an handwerklicher Arbeit bedeutet Vermehrung jener Gestaltungslust, jenes lebendigen Baugeistes ohne dessen allgemeine Ausbreitung eine Kultur im Stande der Gnade undenkbar ist."
[21] *Ibid.*, p. 858. "Die Not wird uns zwingen, allenthalben im Handwerk und in der Industrie—so weit sie am Leben bleibt—die Qualität zu heben."

missions, and what were seen as urgent problems of social and artistic renewal which demanded solution, Gropius's former ideal of a modern style of the applied arts based aesthetically upon modern technological order could not but seem less relevant. Indeed, it was even immoral. Gropius's Leipzig speech is filled with such sentiments as: "the dangerous worship of might and material which led us over the spiritual to the economic abyss," and: "Europe's most dangerous sickness, European arrogance."[22] Among Gropius's surviving notes is the significant admission that he had been deceived in founding his expectations for a rebirth of art on the industrial and technological structure of modern society —on the "style-creating value of industrial building forms," as he had titled his Werkbund essay of 1914. The only hope, as it seemed to him, was the return to a spiritually sounder order of existence which, he fervently told himself, was bound to come now that the movement toward "world trusts" had reached its apogee.[23] He could, therefore, find consolation for those "organizations grown to grotesque dimension" of the prewar era in statistics indicating an increase in certain crafts, even though such expectations were already proving to be against the tide of events.[24]

Yet for all the second thoughts in Gropius's postwar conception of society and the social uses of art, which reveal themselves so vividly in the contradictions of the Leipzig speech, the speech also shows that Gropius's idea of design education changed far

---

[22] *Ibid.*, p. 820. ". . . an Stelle des sinkenden Schönheits- und Zartgefühls stieg jene verhängnisvolle Verehrung von Macht und Materie empor, die uns über den geistigen zum wirtschaftlichen Abgrund führen musste. Denn auch die geistigen Dinge wurden materialisiert. Anhäufung von Wissen galt fälschlich als Bildung und echte Herzensbildung sank im Wert. Mit dem Wust an Wissen und Schulweisheit aber schwoll vor allem die gefährlichste Krankheit Europas der europäische Hochmut ins uferlose an."

[23] See Appendix A, pp. 252–253.

[24] Gropius, "Baugeist oder Krämertum?" p. 820. "Das Verantwortungsgefühl des Einzelnen und die vertiefende Liebe zu seinem Werk stumpfte mehr und mehr ab, die lebendige Persönlichkeit verlor sich im Labyrinth der toten ins Groteske wachsenden Organisationen. . . ." On the growth of cartels and other large-scale forms of industrial and labor organization during the Weimar Republic see Karl Dietrich Bracher, *Die Auflösung der Weimarer Republik*, 3d, enl. ed. (Villingen/Schwarzwald, 1960), ch. 8 and esp. pp. 213–214.

less than has commonly been supposed from the Bauhaus procla-
mation or the tracts of the Arbeitsrat für Kunst. Indeed, the con-
tradictions in themselves are clear indications of the difficulties
he experienced in seeking to reconcile his new-found values and
beliefs with his older views.

The Leipzig speech shows unequivocally that Gropius remained
convinced of the necessity, for good or ill, of including industry in
his plans for education. To be sure, in order once again for the
artist and worker to become "builders" as they had been in the
Middle Ages and to create the sought-after society of the future
with its artistic and spiritual unity, handiwork would again have
to assume a major role in the economy; but at the same time
Gropius was prepared to admit that "industry will remain indis-
pensable in the future as well, even if in a changed form. We shall
therefore have to deal decisively with the formative properties of
the machine."[25] Throughout the speech—indeed, in the new
sections as well as the old—references to industry occur alongside
those to *Handwerk*; and such old Werkbund themes as the one
just quoted continue to be reaffirmed. An injunction such as the
following, to cite one more example, departs in no way from the
prewar Werkbund program of "Durchgeistigung":[26] "Good work,
i.e., every bit of raw material that we possess . . . or import, must
be raised in value many times over by means of highly qualified
work of handicraft (*Handwerk*) or industry, and above all by the
inimitable originality of its form." This requirement leads Gropius
to three practical steps outlined by him as necessary to halt the
artistic and economic decline of the nation: "1. Winning back for
handicraft (*Handwerk*) and skilled industrial work the masses of
uneducated laborers and those small tradesmen and clerks of all
kinds who are without jobs because of the decline in trade. 2. In-
tensive work of education with manufacturers and the broad pub-
lic against shoddy and *ersatz* goods. Awakening a new feeling for

[25] Gropius, "Baugeist oder Krämertum?" p. 858. "Die Industrie wird auch in
Zukunft unentbehrlich bleiben, wenn auch in gewandelter Form. Wir müssen uns
also mit den formbildenden Eigenschaften der Maschine nachdrücklich auseinander
setzen."
[26] This was the title of the first Werkbund *Jahrbuch* (1912)—*Die Durchgeistigung
der deutschen Arbeit.*

work in the *Volk*. 3. Fundamental training of all formative artists
—architects, sculptors, painters—in handicraft (*Handwerk*)."[27]

For all of this, it is necessary to observe that the word *Handwerk*
does not have, and had even less in the time of the Bauhaus, the
restricted meaning that "handicraft" has in English. It denotes
the manual disciplines in general, and in the early part of the
century included the work of the skilled factory worker and in-
dustrial craftsman as well, especially in those small factories such
as make furniture, where artisan labor accounted, and still ac-
counts, for most of the product. Consequently, it also takes into
consideration division of labor, as "handicraft" does not. The dis-
tinction Gropius draws in his article is not between industry and
"handicraft," but rather between *big*, highly mechanized industry
on the one side, and craftsmen's shops and relatively small, artisan-
dominated industries on the other.[28]

Despite the wording of the third point of Gropius's program,
it is quite clear from his adumbration that under the rubric of
*Handwerk* Gropius also includes skilled industrial labor. The state
workshops he wishes to see established will "have as their aim,
above all, the creation of models (*Vorbilder*) which will succeed
by the special excellence of their workmanship and form in bring-
ing orders into the land from outside, to the benefit of all *Hand-
werk* and industry."[29] Nothing can give a clearer indication than

[27] Gropius, "Baugeist oder Krämertum?" pp. 820–821.

[28] This difference between *Handwerk* and "handicraft" was pointed out to English-
language readers by Horace Shipp in an article of 1927 entitled "New Beginnings
in German Craft-Work": ". . . *Handwerk* is a term opposed to the ordinary one
of industry in a purely legal and organization sense as being the product of small
factories instead of the great mass production ones." (Clipping, BD, SG. Un-
fortunately, the name of the periodical is not given, and I have been unable to
trace it.) Cf. Wilhelm Wagenfeld, "Das Staatliche Bauhaus—die Jahre in
Weimar," *Form. Zeitschrift für Gestaltung*, no. 37 (March 1967), p. 19: "In
looking back to that time, we must not judge by the technical capabilities of to-
day's industry. In 1920, factories were still largely hand operated (*manufakturelle
Betriebe*), and the machine was beginning to replace the work of the hand
(*Handarbeit*) only to a very limited degree. The fabrication of so-called mass wares
was primarily hand work (*Handarbeit*) organized through the division of labor
and mechanization." Now also Barbara Miller Lane, *Architecture and Politics in
Germany, 1918–1945* (Cambridge, Mass., 1968), pp. 51–52, on the meaning of
*Handwerk*.

[29] Gropius, "Baugeist oder Krämertum?" p. 860.

this, written during the earliest time of the Bauhaus, that, as is plainly indicated in one of the articles, in setting down the Bauhaus program Gropius did not intend to exclude designing for industry, large or small, even if his contention that such was his only aim cannot be entertained seriously.

Like the reform concepts of *Handwerk* education developed in the Werkbund before the war, the program Gropius seems to have had in mind was aimed at encompassing a broad spectrum of design from handicraft and the decorative arts—including painting and sculpture—to simple models of objects of everyday use intended for at least partial machine reproduction, as with utility furniture. Such seemingly disparate tasks could be reconciled on a common aesthetic ground largely because since the end of the last century the modern movement in Germany had increasingly tended to blur the older, nineteenth-century formal distinctions between the work and product of the hand and that of the machine, and to recognize no essential difference between the training required for each. This occurred in two ways: technically, by coming to look upon *Handwerk* (in the broad sense the word had assumed by 1919—as "making" in contradistinction to merely designing) as above all a matter of *Gestaltung*, of formal conception, in respect to which the distinctive values imparted by the touch of the craftsman's hand in execution were of secondary consequence; formally, by including machine-inspired form within the canon of art and by applying a standard of *Sachlichkeit*, that is, of sober, minimally ornamented design—itself partly inspired by the machine—to purely handicraft objects as well.

### The Relationship of Handicraft and Industrial Design in the Prewar Werkbund

What the new attitude toward designing meant can be clearly understood if we compare to it the nineteenth-century views of John Ruskin and William Morris, from whose ideas and work the modern movement on the Continent received a major impetus. For Ruskin, formal conception had been but one of three equally indispensable factors involved in the outcome of any work of art or handicraft. These were, to use his words, thought, technical

skill, and bodily industry.[30] The great value which Ruskin placed on the last caused him, as is well known, to exclude altogether the use in the crafts of any tool or machine that went beyond merely assisting, in Ruskin's words, "the muscular action of the human hand."[31] For Ruskin, hand labor had both an ethical and an artistic importance. It was valuable, first, in itself for its intrinsic moral worth for the individual and society; so that given two forms of the same "abstract beauty," one made by machine, the other by hand, the latter would contain greater value merely by virtue of the human labor expended upon it.[32] Of equal significance, however, was the fact that the numerous subtle variations and irregularities of surface and form that would inevitably arise from the touch of the hand in the course of execution were the principal means of revealing the all-important individual vitality and spirit of him who had made it. Thus it was that Ruskin could affirm that "to those who love architecture, the life and accent of the hand are everything."[33] The "disposition of masses" (as he contemptuously called it when it became the overriding concern of the architect) was not, indeed, something whose importance he overlooked; rather, he tended to take it for granted as common to all art, but just for that reason to hold it, in a certain sense, below the ornament and details which gave life and individual beauty to the surface and most clearly expressed the unique character of the maker. This was why in reply to criticism that he was more interested in the details than in the essentials of architecture, he could assert that "I do with a building as I do with a man, watch the eye and the lips: when they are bright and eloquent, the form of the body is of little consequence."[34]

William Morris always urged and practiced a simplicity and

30 John Ruskin, *The Works of John Ruskin*, ed., E. T. Cook and Alexander Wedderburn (London and New York, 1903–1912), vol. 9, p. 456 (*Stones of Venice I*).

31 *Ibid.*

32 *Ibid.*, vol. 8, pp. 81–82 (*Seven Lamps of Architecture*); cf. vol. 9, p. 453 (*Stones I*).

33 *Ibid.*, vol. 8, p. 214 (*Seven Lamps*).

34 *Ibid.*, vol. 12, pp. 86–89 (*Lectures on Architecture and Painting*). For a recent discussion of Ruskin's doctrine of imperfection seen as an aspect of a broader primitivism in his aesthetics, see Robert L. Herbert, ed., *The Art Criticism of John Ruskin* (Garden City, 1964), pp. xi-xii.

directness of form in art which in itself went far to anticipate, and to inspire strongly, the similar attitude of the modern movement. But for Morris, following Ruskin, there could likewise be no question of leaving execution to mechanical means; he directly equated art with pleasure achieved in work. One of the most succinct expressions of this sentiment occurs in a lecture of 1881, in which he divided the work of architecture, and all the crafts that pertain to it, into mechanical toil, intelligent work, and imaginative work. Even the slightest interest or pleasure taken in a menial task was sufficient to raise it from the level of the first and to infuse the results with the elements of art. Thus, he defined "intelligent work" as work "more or less mechanical as the case may be; but it can always be done better or worse: if it is to be well done, it claims attention from the workman, and he must leave on it signs of his individuality; there will be more or less of art in it, over which the workman has some control." In contrast, the purely mechanical stood condemned with the words: "Now as I am quite sure that no art, not even the feeblest, rudest, or least intelligent, can come of such work, so also I am sure that such work makes the workman less than a man."[35]

By the time the full tide of English ideas reached Germany toward the end of the eighteen nineties, the ethical and social considerations which had supported the attachment of Ruskin and Morris to hand labor had lost their dominant position. Partly because of the emergent interest among designers of the eighteen nineties in the potentialities of the machine and the forms of engineering for the applied arts, and partly because of the dominance of various aesthetic and philosophic doctrines that put primary emphasis upon the formal and symbolic conception of the work of art, the modern movement on the Continent tended from the start to place the factor of design above the effects— artistic and moral—of hand execution.

To be sure, belief in the aesthetic superiority of hand crafting long continued to be held even among the designers of the Deutsche Werkbund. The issue was, in fact, to figure prominently in the early Werkbund debates. In the very opening address to the

[35] William Morris, *The Collected Works* (London and New York, 1910–1915), vol. 22, pp. 143, 145 ("The Prospects of Architecture").

first annual congress of the Werkbund in July 1908, the architect
Theodor Fischer, the first chairman of the Werkbund, expressed
his uneasiness over the direction machine design was taking—its
abandonment of the traditional appearance of handiwork—with
the complaint:

I do not hesitate to admit that in working I have come to the follow-
ing conviction: some slight imperfection of form is necessary for
aesthetic enjoyment. . . .

But once we have overcome the superstition that exactitude in itself
is the essential goal of our work, there will still be enough room even
in machine work for small, but highly effective variations. . . .[36]

Yet for all of Fischer's conservative preference for the imperfec-
tions associated with traditional craftsmanship (the very appre-
ciation of these being itself an historical consequence of the rise
of the machine), it is significant that he does not attach any
moral value to them; they are regarded not as signs of the indi-
vidual who made them, but as purely aesthetic qualities which
can as well be reproduced by mechanical means.

Even such an early and leading champion of precision and
*Sachlichkeit*[37] in design as Fischer's notable contemporary, the
architect Hermann Muthesius, could still about 1900 write of
ornamentation in the reverent words of a Ruskin as "a kind of
consecration which is poured over the everyday, and the voice of
him who produced it is bound to speak out from it." In a beaten

[36] *Die Veredelung der gewerblichen Arbeit im Zusammenwirken von Kunst, In-
dustrie und Handwerk. Verhandlung des Deutschen Werkbundes zu München
am 11. und 12. Juli 1908* (Leipzig, n.d.), p. 14. Waentig's citation of this speech
in connection with his criticism of Ruskin's doctrine of imperfection is sympto-
matic of the period's awareness that this was already a dead issue (see Heinrich
Waentig, *Wirtschaft und Kunst*, Jena, 1909, p. 299, n.). Waentig's is still one
of the richest sources of information about the start of the modern movement
in Germany and Austria.

[37] The term *Sachlichkeit*, which Muthesius (who probably took it over from
Alfred Lichtwark) was chiefly responsible for popularizing, was, in Schmalenbach's
words, "about 1902 suddenly in everyone's mouth" (Fritz Schmalenbach, *Jugend-
stil. Ein Beitrag zu Theorie und Geschichte der Flächenkunst*, Würzburg, 1934, p.
75; also Nikolaus Pevsner, *Pioneers of Modern Design: From William Morris to
Walter Gropius*, rev. ed., Harmondsworth, Middlesex, 1960, p. 32). The word has
the connotations of restraint, sobriety, and objectivity in conformity with the
purpose of the object.

silver vessel, he continues, we feel the zeal and joy of the crafts-
man. The same ornament beaten by machine seems instead trivial
and can affect only the undeveloped sensibility. Like a memorized
protestation of love, it is not only flat, but immoral.[38]

This argument, taken directly from Ruskin, against using the
ornament proper to handicraft in machine design was to be re-
peated many times in the Werkbund with little change.[39] But for
Muthesius and many others who later came together to form the
Werkbund, its significance has changed vastly. It amounts to
nothing more than recognizing a legitimate area of distinction
between effects appropriate to handwork and those appropriate
to the machine. Muthesius's little homage to artisanship, unlike
Fischer's nostalgia, does not involve a dissatisfaction with ma-
chine production for being too exact; on the contrary, it is part of
his effort to establish a new, but equally legitimate aesthetic of
mechanized production within which the expressive values of the
artist's hand will, as a matter of course, have no place. In reply to
criticism, Muthesius never ceased to insist that strict adherence to
even the most utilitarian tasks and the most rigid mathematical
requirements did not and could not of itself exclude artistic tem-
perament; that some aesthetic choice, and with it artistic ex-
pressivity, was inevitable.[40]

The notion of a valid machine style plainly held broader impli-
cations for Muthesius and others in the Werkbund than merely
those of the means of production. Exactness, simplicity, and regu-
larity of form were seen not simply as functional requirements of
the machine, but expressive and even symbolic desiderata, in
themselves expressions of the power, economy, and efficiency of

[38] Hermann Muthesius, *Kultur und Kunst*, 2d ed. (Jena, 1909), p. 66; first pub-
lished 1904. The five essays in the collection are undated but according to the
foreword stem from the years about the turn of the century.
[39] E.g. by Peter Behrens (see Fritz Hoeber, *Peter Behrens*, Munich, 1913, pp.
103–104); Waentig, pp. 362–363; Karl Gross, "Das Ornament" in *Die Durch-
geistigung der deutschen Arbeit. Wege und Ziele in Zusammenhang von Industrie,
Handwerk und Kunst*, Jahrbuch des Deutschen Werkbundes 1912 (Jena), pp. 60–
64.
[40] Muthesius, *Kultur und Kunst*, pp. 51–56, 73–74; idem, *Kunstgewerbe und
Architektur* (Jena, 1907), pp. 12–16; idem, "Wo stehen wir?" esp. pp. 22–25;
idem, "Das Formproblem im Ingenieurbau," in *Die Kunst in Industrie und Handel*,
Jahrbuch des Deutschen Werkbundes 1913 (Jena), pp. 25–30.

modern social and economic organization; hence their value lay beyond the mode of execution. As support for this conception of a modern style, there were ready to hand a number of rationalist doctrines which in their origins antedate the rise of interest in a machine style but which became in the time before World War I primary justifications for it. By and large the unsystematic and, as it were, syncretistic nature of Werkbund ideas makes it of little value to attempt to draw fine distinctions among the artistic views held by Werkbund designers.[41] But in at least one notable instance, a rather interesting distinction was drawn, and by none other than Peter Behrens. Contrary to the usual historical accounts of the time, and in attempted refutation of them, Behrens traced the sources of the modern movement not to the Gothic-inspired English Arts and Crafts Movement or to the German Romantic movement which, he said, was allied with it, but to classical art, and specifically the nineteenth-century classicistic *Raumästhetik* stemming from the circle of Hans von Marées, Conrad Fiedler, and Adolf Hildebrand. The modern movement, Behrens says, is aiming at a new classical art, represented by artists whose attempt it is "once again to adapt to the conditions of modern times and to work in accord with the whole complex of modern conditions."[42] This in fact amounts to the explicit choice of classicism as the style most peculiarly suited to the needs of the modern age; for if it were not perfectly evident from his architecture that for Behrens this "new classical art" is to be an outgrowth of the neoclassical tradition, he more than implies it in his writings by bringing in the names of Hildebrand and von Marées and by seeing the principal means of achieving architectural expression precisely in that disposition of masses—in "proportionality and order" (*Gesetzmässigkeit*)—which in the previous century Rus-

[41] As Banham, *Theory and Design*, p. 69, has observed.

[42] Peter Behrens, in a discussion of the role of art in the economy which appeared in the Aug. 27, 1910, *Volkswirtschaftliche Blätter*; *idem*, in "Der moderne Garten," *Berliner Tageblatt*, June 10, 1911, no. 291, evening ed. (both summarized in Hoeber, *Peter Behrens*, p. 227, no. 19 and no. 20). The former was in direct reply to the historical expositions of Muthesius. Taking these statements as his point of departure, Hoeber emphatically makes Behrens an adherent of Hildebrand's aesthetic principles (pp. 40–41, 72). See also Hoeber's attempt (p. 219)—not altogether convincing—to contrast Behrens's "idealism" with Henry van de Velde's more "realistic" interest in structure and the particulars of material.

kin had depreciated. Behrens was even to speak later of "proportion, which is the alpha and omega of all artistic creation." In Behrens's view, as in that of almost all the major Werkbund designers, rich ornament was unacceptable on machine-made forms. Industrial design therefore had to depend for its effects on "a simplification that favors the clear proportional relationships (*Massverhältnisse*) of the individual parts."[43] But such an approach had validity for a modern style beyond being an expediency of machine production. As he stated it in an article in the *Jahrbuch des Deutschen Werkbundes* of 1914, Behrens saw the requirement of the modern age of speed in a classicistic architecture of the utmost regularity, with "surfaces as closed and smooth as possible" and all "necessary details" set in "a uniform row" (*gleichmässiges Reihen*).[44]

Behrens's views of design are important in this context because they illustrate at its most explicit a characteristic Werkbund tendency, in large part derived from classicistic aesthetics, to place order and abstract *Gestaltung* above matters ostensibly prompted by material and structure, and to give to both handicraft work and industrial design simple, precisely executed forms.[45] Behrens's

[43] From Behrens's articles of 1908, 1909, 1912. Excerpted in Hoeber, *Peter Behrens*, pp. 225, 226, 228.

[44] Peter Behrens, "Einfluss von Zeit- und Raumausnutzung auf moderne Formentwicklung," in *Der Verkehr*, Jahrbuch des Deutschen Werkbundes 1914 (Jena), p. 8. This was not the first time classicism had been upheld as the most suitable style for the modern age. Otto Wagner, writing in the 1890's, was even more explicit than Behrens on its relevance to the needs of the day: "The reason for this imputation [of my work] is to be sought in the frequent use of some characteristic motifs of the Empire period in my buildings and designs, such as the . . . horizontal band and the straight line. It is only necessary to refer to the importance of the straight line in our modern buildings. Our perfected construction, machines, tools, and structural methods all require it. . . ." (Otto Wagner, *Modern Architecture: A Guide for his Pupils in this Domain of Art*, trans. N. Clifford Ricker from the 2d German ed. of 1898, Boston, 1902, p. 10. This passage was omitted from the 3rd German ed. of 1902.)

[45] But cf. the prominent Dutch architect H. P. Berlage, who also preached the need for geometric order and logic in architecture. Berlage's rationalism derives in greatest part from the medievally inspired French and English doctrines of material and structural logic (H. P. Berlage, *Grundlagen und Entwicklung der Architektur*, Berlin, 1908, *passim*; *idem*, "Modern Architecture," *The Western Architect* 18, no. 3 [March 1912], esp. pp. 32–36; *idem*, "Foundations and Development of Architecture," pts. 1 and 2, *The Western Architect* 18, nos. 9, 10 [September, October 1912]). This emphasis in the Werkbund upon the conceptual

aesthetics shows itself directly in the reform program he developed for the Düsseldorf School of Applied Arts (*Kunstgewerbeschule*) after he became its director in 1903. The relevance of his program lies in the explicit attempt it made to mediate between the artistic demands of handicraft and those of industry by returning to what were considered to be the fundamental principles of form:

Today's school of applied arts has to meet both the demands of the handicrafts for aesthetic directives and the needs of industry for artistic impulses. The goal, but not always the way, of the two tasks is the same. The Düsseldorf school seeks a mediation by going back to the fundamental intellectual principles of all form-creating work, and allows the principles of form to take root rather in the artistically spontaneous, in the inner laws of perception, than directly in the mechanical aspects of the work. Within the limits of his talent, the pupil will be given the ability to master through his knowledge of the laws of art the manifold and not always fully defined requirements of technique and material.[46]

Behrens's reform program was not the only one at the time to attempt a mediation between craft and industry, but it is one of

---

went hand in hand with a clear awareness of the difference between technical and material quality on one side and formal quality on the other. The distinction was already emphatically made by the designer Rudolf Bosselt at the first Werkbund congress in 1908: "Entsprechend dem Entstehungsvorgang trennen wir für die Beurteilung des kunstgewerblichen Gegenstandes die Form von der Ausführung, und zwar kann uns die gute Ausführung, wenn wir sie noch so sehr bewundern, nicht mit dem Gegenstand aussöhnen, wenn uns seine Form 'missfällt,' umgekehrt die mangelhafte Ausführung nicht davon abhalten, einen Gegenstand sehr schön zu finden. . . . Die Form ist der eigentliche Wertträger des kunstgewerblichen Gegenstandes" (*Veredelung der gewerblichen Arbeit*, p. 110). Cf. also Richard Riemerschmid's similar remarks at the congress (*ibid.*, pp. 35–36) and the memorandum (1907) of the founding committee of the Werkbund headed by Theodor Fischer and the industrialist Peter Bruckmann in which is stated: "Während . . . andere Gebiete des gewerblichen Schaffens . . . von selbst eine Steigerung der Qualität erleben—man denke an die Maschinen-, Schiffsbau-, und elektrotechnische Industrie—verquicken sich im Kunstgewerbe mit der rein technischen Qualität künstlerische Werte . . ." (quoted in Waentig, p. 296). From this it is apparent that the "idea that aesthetics could be independent of material quality" was grasped by the Werkbund leadership from the start and was not first introduced to the Werkbund in 1911 by Muthesius as Banham states (Banham, *Theory and Design*, pp. 71–72). Undoubtedly, however, the fact that Muthesius had to "push" the distinction in 1911 does show that it had not penetrated deeply among the rank and file.

46 "Kunstschulen," *Kunst und Künstler* 5, no. 5 (February 1907): 207.

the clearest and most succinct early expressions of an approach which was to become typical of the reform proposals for art education developed in the Werkbund.[47]

It was above all from his teacher, Behrens, that Gropius derived his prewar aesthetic, with its classicistically oriented preference for the "precisely stamped form" symbolic of modern life, and the closed, smooth planes of the recent metal construction, which, he was pleased to note, was replacing the old lattice type.[48] In his youthful memorandum of 1910 to the industrialist Emil Rathenau on low-cost prefabricated housing for workers, Gropius went even farther than Behrens in his evaluation of machine production as against hand execution. He precisely reversed Ruskin's judgment: for Gropius the advantage of the former lies just in its assurance that the designer's intentions will be carried out to the last detail and not left to the mercies of incompetent or differently minded artisans.[49] When, at the end of 1915 or the beginning of

[47] That *Vermittelung* is not the only or even the preferable way of organizing education for craftsmen and industrial designers may readily be seen by comparing the current practice of many art schools to divide sharply the training of the one from the other, after a certain basic level, due to the complexity of industrial design. For additional evidence of the Werkbund aim in art training of mediation between handicraft and machine design see also Muthesius in *Veredelung der gewerblichen Arbeit*, pp. 42–43: "Hier zeigt sich, dass das Kunstgewerbe seine Prätension, sich von dem gewöhnlichen Gewerbe zu unterscheiden, aufgegeben hat, dass die [neue] Bewegung . . . das ganze menschliche gewerbliche Gestalten unter grosse architektonische Gesichtspunkte gebracht hat. . . . Während also die Kunstgewerbevereine Vereine für das Kunstgewerbe waren, ist der Werkbund ein Verein für die architektonische Gesamtidee, ein Verein . . . zur Überwindung des Kunstgewerbes." Cf. Fritz Schumacher, *Die Reform der kunsttechnischen Erziehung*, Deutscher Ausschuss für Erziehung und Unterricht, no. 3 (Leipzig, 1918), p. 26: "Ich möchte . . . betonen, dass mir dieser Handfertigkeitsunterricht nicht etwa als Vorstufe zu irgendeinem bestimmten späteren Beruf wichtig erscheint, . . . sondern nur diese Schulung einer klaren Vorstellungskraft, die sich bei allen praktischen Betätigungen geltend machen muss, ist der wirklich stichhaltige Zweck." Similar is Bruno Paul's conception of the "Einheitsschule," as he calls it, in which "Rohmaterial veredelt wird durch eine maschinelle oder handwerkliche Bearbeitung" (Paul, "Erziehung der Künstler," pp. 194–195).

[48] Walter Gropius, "Die Entwicklung moderner Industriebaukunst," in *Die Kunst in Industrie und Handel*, Jahrbuch des Deutschen Werkbundes 1913 (Jena), pp. 19–20 and *idem*, "Der stilbildende Wert industrieller Bauformen," in *Der Verkehr*, Jahrbuch des Deutschen Werkbundes 1914 (Jena), p. 31. On the classicistic aspects of Gropius's early buildings, see Banham, *Theory and Design*, pp. 79, 84–86.

[49] "Gropius at Twenty-six"; also in Wingler, *Bauhaus*, p. 26.

1916 while in military service, Gropius was first asked by the Saxon State Ministry in Weimar to submit his ideas about a proposed architecture department in the Weimar academy which would have the task of raising the artistic quality of the handicrafts in the area, his recommendations were conceived entirely with the furtherance of his aesthetic ideals in mind, to the extent that they actually went counter to part of the intention of the government. The teaching establishment for which Gropius was being considered as director had little in common with what was later to become the Bauhaus. What was wanted was essentially a resumption of the highly successful *Kunstgewerbliche Seminar* that Henry van de Velde had begun in Weimar in 1902. Van de Velde had been called to Weimar by the Grand Duke Wilhelm Ernst for the express purpose of raising the standards—and hence the earning power—of the languishing art industries of the Grand Duchy. His contract, signed in October 1902, required him, among other things, to report to and advise the government on "matters pertaining to the arts and crafts, architecture, decorative arts, and the like"; "to give practical counsel to craftsmen and manufacturers"; and "to provide, through the preparation of designs, models, and prototypes (*Musterzeichnungen, Modellen, Vorbildern*), . . . artistic suggestions which will take into account the nature and condition of the local art practice."[50] Thus, by the terms of his contract, van de Velde was to design for both handi-

[50] The contract is excerpted by Hans Curjel in his notes to Henry van de Velde, *Geschichte meines Lebens* (Munich, 1962), p. 487. On the *Kunstgewerbliche Seminar* see *ibid.*, pp. 209–213 and Karl Ernst Osthaus, *Henry van de Velde. Leben und Schaffen des Künstlers*, Die neue Baukunst, Monographienreihe, vol. 1 (Hagen i. W., 1920), pp. 28–29, 40–50. See also the untitled *Denkschrift* which van de Velde published in October, 1915, after his release from the Weimar *Kunstgewerbeschule* in order to account for and justify his activities in Weimar (BD,SG). Van de Velde's seminar was itself in the succession of attempts which had been made by various German states since the middle of the nineteenth century to raise the level of handicrafts by creating advisory bodies with the power to conduct brief "master courses" for the craftsmen of the area. The earliest of these was the *Zentralstelle für Gewerbe und Handel* in Württemberg, established in 1849. The Württemberg experiment was to serve as the basis for others of the same type, including a short-lived *Grossherzoglich Sächsische Zentralstelle für Kunstgewerbe* founded in Weimar in 1881. See J. Wilden, "Handwerk" in *Handwörterbuch der Staatswissenschaft*, 4th ed. (Jena, 1923). For the Weimar *Zentralstelle* see Curjel in van de Velde, *Geschichte*, p. 487.

craft and manufacture; and in conformity to his often-voiced con-
viction that design should be above all a matter of logical con-
ception, he—like other industrially oriented designers—made no
basic distinctions between the formal requirements of each. Van
de Velde, indeed, had been one of the first artists to hail the po-
tentialities of the machine for the revival of the applied arts, and
the distance of his views from those of the earlier nineteenth cen-
tury may be judged by the maxim he proudly announced in 1897
in *Pan:* "to avoid systematically everything in furniture that could
not be realized by big industry. My ideal would be the thousand-
fold multiplication of my creations."[51]

But Gropius's eight-page plan for Weimar went beyond any-
thing proposed by van de Velde for giving the machine its due.[52]
It is certainly not a well thought-through document; for despite
the strong interest of the government in the small crafts of Saxony,
Gropius makes scarcely any allowance for handicraft, and his
references are all to "trade and industry." Predictably, a report by
the Chamber of Handicraft (*Handwerkskammer für das Gross-
herzogtum Sachsen*) criticized this aspect of it, pointing out that
as conceived (there were to be theory and drawing classes but no
workshops, which Gropius excluded because they would involve
too great an expense, raise fears of competition among the local
craftsmen, and tend to foster a dangerous lack of practicality in
the pupils) the teaching establishment could offer little to handi-
craft apprentices and journeymen.[53] From his plan it is clear, how-
ever, that Gropius did not intend to exclude the small craftsman.
In a reply to the Chamber of Handicraft he admitted that he had
had primarily the larger industries in mind, but he also said he be-
lieved "that this type of training is very well suited to profit the
small crafts apprentice as well."[54] The threatening danger to art
from the injudicious use of the machine, Gropius states in his
plan, can be met only by the artist's familiarizing himself with

[51] Henry van de Velde, *Zum neuen Stil*, ed. Hans Curjel (Munich, 1955), p. 64
(from "Ein Kapitel über Entwurf und Bau moderner Möbel").
[52] BD, SG; in Wingler, *Bauhaus*, pp. 29–30.
[53] BD,SG; 4 pp. untitled typescript dated March 15, 1916, and signed "R.
Alander, Vorsitzender der Handwerkskammer für das Grossherzogtum Sachsen."
[54] BD, SG, undated, untitled handwritten draft.

"the most powerful means of modern *Formgestaltung,* with machines of every kind from simple tools to complicated special machines," and forcing them to his will. The clue to the position of handicraft in his plan is given by the phrase "from simple tools to complicated special machines": handiwork is subsumed entirely under industrial design and included within the creation of a style suitable for the age of the machine. The design to be imparted would be of a precise, simple, and impersonal variety amenable to all tools and methods of production. Gropius's preoccupation with a universal and distinctively modern style causes him to insert into the text of his plan long verbatim passages from his 1913 Werkbund article. Among them is one voicing his deep-seated conviction that "the new times demand their own expression (*Sinn*). Exactly stamped form devoid of all accident, clear contrasts, the ordering of members, the arrangement of like parts in series, and unity of form and color—these will become the aesthetic supports of the modern architect, corresponding to the energy and economy of our public life."[55]

In their original context and as reused in the plan, these words refer primarily to machine-produced forms; but we can have no doubt that Gropius meant them to apply to all branches of the applied arts. For, the most urgent task of the teacher, he concludes, must be to impress upon every student from the beginning "the conviction that only the ability to revalue and shape anew the changed or completely new living conditions of the time determines the achievement of an artist." And with this, Gropius introduces for the first time in his writings the image of the medieval *Bauhütten,* in which

numerous related artists—architects, sculptors, and craftsmen of all grades—came together, and out of a kindred spirit, inspired by reverence for the unity of a common idea which filled them and whose meaning they comprehended, humbly understood how to make their independent portions of work a part of the common tasks which fell to them. With the revival of that tested way of working, which will be adapted to fit our new world, the image of our modern expressions

[55] BD,SG, [p. 7]. Part of the passage quoted here is omitted in the Wingler excerpt.

of life will necessarily gain in unity, in order once again in the coming days to coalesce in a new style.[56]

In this passage we have already fully developed that dream, which was to dominate Gropius's thought after the war, of artists of every variety joining together to create a universal style of contemporary relevance. What cannot fail to strike us about the passage is precisely Gropius's introduction of the symbol of the medieval *Bauhütten*—what has been regarded as the paradigmatic symbol of Gropius's postwar, so-called backward-looking "expressionism" —within the context of an almost total absorption in the issues of industrial design and the creation of a modern style based on industry.[57]

Gropius's dream of new *Bauhütten*, as we know, was not to change; but its content and the means of achieving it were. After the war, the degree of emphasis given to industry and to *Handwerk* was reversed; whereas now the handicrafts were made entirely subordinate by Gropius's concern for industry, later, for a brief period, it was the machine which was to take second place.

---

[56] Wingler, *Bauhaus*, p. 30: "In ihrem Kreise könnte eine ähnlich glückliche Arbeitsgemeinschaft wiedererstehen, wie sie vorbildlich die mittelalterlichen 'Hütten' besassen, in denen sich zahlreiche artverwandte Werkkünstler—Architekten, Bildhauer und Handwerker aller Grade—zusammenfanden und aus einem gleichgearteten Geist heraus den ihnen zufallenden gemeinsamen Aufgaben ihr selbständiges Teilwerk bescheiden einzufügen verstanden aus Ehrfurcht vor der Einheit einer gemeinsamen Idee, die sie erfüllte und deren Sinn sie begriffen. Mit der Wiederbelebung jener erprobten Arbeitsweise, die sich der neuen Welt entsprechend anpassen wird, muss das Ausdrucksbild unserer modernen Lebensäusserungen an Einheitlichkeit gewinnen, um sich schliesslich wieder in kommenden Tagen zu einem neuen Stile zu verdichten."

[57] Nor was Gropius the only one to employ the evocative term *Bauhütten* in a modern context. Its most publicized use was in the *Bauhüttenbewegung* of the 1920's and '30's, which owed its principal impetus to the architect Martin Wagner. In 1919 Wagner proposed that the building industry be reorganized into what he called *Soziale Bauhütten*—building cooperatives or guilds run by the architects and workers. These, be it noted, were to recall the Middle Ages in organization only, and in no sense involved a rejection of modern means of production; on the contrary, Wagner urged their full employment. On the *Sozialen Bauhütten* see Lane, *Architecture and Politics in Germany*, p. 51 and the bibliography cited therein. See also Martin Wagner, "La Socialisation des entreprises de bâtiment," *Les Annales de la régie directe* 14 (November 1921–June 1922): 12–63 (trans. H. Buriot-Darsiles of Wagner's *Sozialisierung der Baubetriebe*, 1919).

That the Bauhaus does not seem to have begun designing for manufacture until about 1922 has a number of causes: first, its extremely restricted budget, which prevented an adequate expansion of shop work and training in the first years; second, the difficulties inherent in the Bauhaus organization of relating the *Formlehre*—taught for the most part by artists without craft experience—to the work of the shops, with the consequent difficulty of developing consistent attitudes of approaches to design among the students; third, and more basic, the priority given in time and effort to the more fundamental task as the Bauhaus saw it of first developing in the students a fresh, unhackneyed sense for form, and this required experimentation and even play; fourth, the difficulty in the charged artistic atmosphere of postwar Germany of inculcating in many of the early students the relatively self-subordinating artistic discipline required for collaboration with industry, or even convincing them that such collaboration was desirable in the first place.[58] The contemporary accounts of Oskar Schlemmer as well as the minutes of the Bauhaus faculty meetings testify to what Gropius was in the beginning of 1922 to call the "exaggerated romanticism" of many of the students and their lack of serious interest in shop work.[59] In this, however, they merely shared an attitude prevalent among the faculty itself, for whom painting and sculpture remained the highest expressions of art. And this is still another reason for the resistance in the early Bauhaus toward designing for manufacture.

Gropius's well-attested tolerance of different stylistic directions at the Bauhaus, even when regarded by him as misguided, combined with his almost total involvement at the start in administration and promotional duties, contributed to these last problems.[60] His influence in determining the nature of the design work produced at the Bauhaus was much less felt than might have been the case had he had a more dogmatic turn of mind or had circumstances allowed him a greater freedom of activity within the shops. We may, of course, well suppose that a different teaching staff, one, say, in which a Moholy-Nagy, a Lissitsky, and a van

[58] See also below, pp. 162, 174–175.
[59] Memorandum of February 3, 1922; in Wingler, *Bauhaus*, p. 63.
[60] See Chapters 5 and 6.

Doesburg (who, it has been claimed, was invited in 1919 to teach at the Bauhaus)[61] were there from the beginning—or else a faculty headed by a more narrowly practical architect concerned exclusively with the immediate problems of building created by the war—might have achieved different results at the start and even attracted a different kind of student. But to do so in the first case is to presuppose an ideological orientation on Gropius's part which in the period immediately after the war he did not possess and which in some respects was opposed to the ideals he and the Arbeitsrat für Kunst stood for. As for the second case, the practical needs of the postwar period could not take precedence for Gropius over a more far-reaching preoccupation with a new style or the ostensible spiritual requirements of a new age; and it seems safe to add that without these other, less hard-headed concerns which he put to the fore, he would not have gathered about him modern painters and sculptors, but architectural and industrial specialists—*Fachmänner*—and whatever else the new school might have been, it would not have received the radical impetus which from the start was to make it unique and a special object of veneration and attack.

### Conservatism in Gropius's Aesthetic Principles, 1919–1921

In the light of Gropius's continuing interest in industrial designing, it is important to recognize that in spite of his Arbeitsrat writings, which with their declamatory style reflect the mood of the moment and its yearning for a new imaginative, spiritual life, when it came to his own work of the time, he remained surprisingly within the limits of his prewar aesthetic. He continued to give substantial weight to the idea of *Sachlichkeit*, although, to be sure, no longer couched in that familiar and outworn catchword; and his admonition in his Leipzig speech to the designer not to see "an exaggerated contrast between handicraft and in-

---

[61] According to Nelly van Doesburg he was invited by Gropius. Gropius has denied this and stated that van Doesburg sought a position there. For the polemics on this issue see Bruno Zevi, *Poetica dell'architettura neoplastica* (Milan, 1953), pp. 13–14; Gropius's reply, *ibid.*, pp. 161–162; and Banham, *Theory and Design*, pp. 191–192.

dustry"[62] must be understood as an implied criticism of the position held by many craftsmen and artists at the time.

The absence of any known work from Gropius during the years 1918–1919 makes it impossible to establish with complete certainty how he might have realized his ideas at the very first moment of his involvement in the Arbeitsrat für Kunst. But we do have as evidence the significant commission, a scant one year later, of the Sommerfeld house, which has always been held up as the prime indication of Gropius's "expressionist" turn of mind during this period.[63] Although always dated in publications as 1921, the house was designed in large part in 1920 and its framework already erected by the middle of December of that year, as a recently published program for the roof-raising ceremony (*Richtfest*) held on the eighteenth of the month now proves.[64] The lithograph of the house front printed on the program shows its exterior, with due allowance for the expressionistic distortion of the roof perspective and lighting—which characteristically and significantly make it more peaked, crystalline, and "radiant" than it was—to be identical to that of the executed building except for the proportions and a few finishing details (Fig. 1).

Because materials were scarce, the house was built of teak planks which Adolf Sommerfeld, an industrialist in timber, had obtained from an old boat.[65] The special nature of the commission thus makes comparison with other Gropius works difficult, but this fact alone makes Gropius's solution all the more revealing of his intentions, since it offered him a special opportunity for un-

[62] Gropius, "Baugeist oder Krämertum?" p. 858.

[63] Gropius's purely sculptural *Monument to the Fallen* of 1921 in Weimar, usually cited along with the Sommerfeld house as one of his "expressionist" designs, must be omitted from consideration in this context; as a piece of "pure" art it could be treated with a freedom not permissible in a work of architecture.

[64] Published erroneously in Walther Scheidig, *Crafts of the Weimar Bauhaus 1919–1924: An Early Experiment in Industrial Design*, trans. Ruth Michaelis-Jena and Patrick Murray, F.S.A. (Scot) (New York, 1967), p. 46 as an example of expressionist graphic style at the Bauhaus. Dr. Scheidig has kindly informed me that, according to the late Prof. Gropius, the lithograph was in fact not designed at the Bauhaus but by a graphic artist commissioned by Adolf Sommerfeld. It has been eliminated from the French edition of his book.

[65] According to information from Mrs. Gropius. See also Gropius's letter in the July 1963 *Architectural Review* (reply to Pevsner, "Gropius and van de Velde"); and Wingler, *Bauhaus*, p. 216.

usual designs. Yet, what one can judge of the Sommerfeld house
from the photographs of the exterior and the view of the lobby
suggests little that could not readily have been accommodated by
Gropius's prewar conception of architecture (Figs. 2–6). Aside
from the lobby, whose vertical, sharply cut space and restless
herringbone paneling make it by far the most impressive and
original part of the house; or the few ornamental details of the
exterior, such as the carved, projecting beam-ends and the some-
what modish angularity of the windows and flared entrance, re-
flective of the "crystalline" forms preferred by German archi-
tects just after the war, there seems little in the conception of the
house that can be called expressionistic, however one may define
that word to include all that was intensely personal, subjective, or
in some way extreme or outside the architectural norms. What
most obviously relates it to the new currents of the time, the in-
spiration it receives from the "primitive" architecture of log
peasant houses, was itself prompted by the requirement of the
commission, and was thus in essential conformity with the Werk-
bund principle of searching for forms that would arise out of the
nature of the material and commission. In fact, despite the temp-
tation offered by the material, Gropius does not exploit or drama-
tize the picturesque and primitivistic possibilities inherent in the
solution.

This seems especially the case if we compare the house to the
numerous contemporaneous exercises in primitivism by such arch-
itects as Eibinck, Margarete Kropholler, de Klerk, and van der Mey
in Holland, and Hans Luckhardt, Bartning, Hoetger, and Rosen-
thal in Germany (Figs. 7–9).[66] It is particularly evident in the way
the pitch of the roof has been suppressed by the low dormers and
by the broad, horizontal eaves crowned in classical fashion by thin
railings. This is the feature most at variance with peasant proto-
types and even exaggerated in the houses of the above-mentioned
architects. The broadly projecting eaves are reminiscent of the
work of Frank Lloyd Wright, as are the horizontal proportions

[66] For these and other Dutch examples, see the issues of *Wendingen* for 1918. The
German examples not shown here are illustrated in Walter Müller-Wulckow,
*Deutsche Baukunst der Gegenwart. Wohnbauten und Siedlungen* (Königstein im
Taunus and Leipzig, 1928), pp. 21–25.

and the wide, low entrance, both of which recall the Wright-in-
spired facade of Gropius's 1914 Werkbund administration build-
ing (Fig. 10). The flat, thin, and rather dry handling of surfaces
and details, the strict symmetry of the facade, its compartmental-
ization into bays and proportional rectangles are all still basically
in the classicistic vein of Gropius's prewar work.

As for the decoration of the Sommerfeld house, it should not be
forgotten that even for a Werkbund architect, a commission for
a middle-class house still called at this time for a certain amount
of ornament beyond what was considered suitable for a purely
utilitarian structure such as a factory or workers' housing. It is thus
not strictly comparable to the kind of architecture Gropius had
designed before the war. It has, indeed, been recognized that the
Werkbund concept of *Sachlichkeit* did not imply the elimina-
tion of all ornament.[67] Certainly, Gropius's rather conservative
prewar designs of interiors and furnishings should not lead us to
expect without evidence to the contrary that he would at this time
have approached the designing of the home of a wealthy patron—
even if he had had complete liberty—in the same way he did his
factory buildings or his workers' houses of 1906 in Jankow. Noth-
ing, in fact, illustrates better Gropius's conservative adherence to
an ornamental hierarchy dependent upon the degree of a build-
ing's utility—a hierarchy followed by all the Werkbund architects
—than the factory building complex by Gropius and Meyer for the
1914 Werkbund exhibition in Cologne, with its clear-cut dis-
tinction of treatment between the unadorned *Maschinenhalle,*
which continues the nineteenth-century type of engineer-designed
iron and glass shed, and the artistically embellished entrances of
the more "representative" office block. The fact that the building
complex was an exhibition pavilion doubtless led Gropius to
heighten its impressiveness through the use of art, in comparison
with his earlier, more utilitarian Fagus factory; but its very nature
as a piece of ideal, demonstration architecture makes its schematic
division into factory and office, and the related differentiation of
treatment, all the more revealing as a display of aesthetic inten-
tion. The Gropius Werkbund building is, of course, far from the
common example of the nineteenth- and early twentieth-century

67 Banham, *Theory and Design,* pp. 91–93.

iron shed—the train shed, for instance—with an elaborate, fre-
quently twin-towered masonry façade; but in its use of art for the
less utilitarian part of the complex as a "front" for the factory
proper, the mode of thinking has not changed appreciably from
that of the nineteenth century (Fig. 11).

The Sommerfeld house was the first complete opportunity for
the Bauhaus to realize its aim of uniting the arts under architec-
ture, but in its conception of artistic union it scarcely goes beyond
Gropius's comparable efforts in his Werkbund building or in the
lobby interior he designed for the same exhibition.[68] Joost
Schmidt's reliefs for the house bear a superficial resemblance to
Wright's decorations for Midway Gardens in their use of key,
checkerboard, and mortice and tenon patterns (Figs. 13–15).
How much Schmidt may have known of Midway Gardens is diffi-
cult to say. A detail of one of the building's friezes was published,
along with H. P. Berlage's article on Wright, in *Wendingen* at
the end of 1921, and Schmidt's designs, which may be as late as
1922, may owe something to the Wright decorations.[69] But
Schmidt's reliefs, unlike Wright's, are not co-extensive with and
an integral part of the architecture. They are self-contained panel
compositions. Whereas Wright's ornament, in conformity with
its character as an all-over surface enrichment, is open and repeti-
tive in organization, even when it is confined to limited areas,
Schmidt's manifests its easel-like self-sufficiency by its unified
cubist structure.[70] The way in which the carved decoration of
the Sommerfeld house is restricted to a few separate fields—
apparently limited except for the staircase to their traditional
places about the entrance ways—or else discreetly confined to the
beam-ends, continues to show the fundamentally conservative

---

[68] Ill. in *Deutsche Form im Kriegsjahr. Die Ausstellung Köln 1914*, Jahrbuch
des Deutschen Werkbundes 1915 (Munich), p. 49.
[69] H. P. Berlage, "Frank Lloyd Wright," *Wendingen* 4, no. 11 (1921): 3–8. Cf.
also the photographs in the 1911 Wasmuth volume on Wright of the fountains
for the Larkin Building, which show his characteristic ornamental cutting (*Frank
Lloyd Wright, Ausgeführte Bauten*, intro. C. R. Ashbee, Berlin, 1911, p. 135).
[70] See Wright's statement, in his introduction to the 1910 Wasmuth volume of
his work, p. 16, on the integration of ornament with architecture (*Ausgeführte
Bauten und Entwürfe von Frank Lloyd Wright*, intro. Frank Lloyd Wright, 2
vols., [Berlin, 1910]).

orientation of Gropius's prewar interiors. Nothing, indeed, demonstrates more clearly than the Sommerfeld house the basic cautiousness in style and conception with which even in 1920 Gropius approached the *Einheitskunstwerk* promised in the Bauhaus program.[71] At no time, in fact, did the Bauhaus ever seek a rich, pervasive architectural ornamentation such as was striven for by Wright in Midway Gardens, much less for a fusion of form and ornament in the manner, say, of Würzbach and Belling's "improvised" Scala-Palast of about 1920 or Bruno Taut's neo-Jugendstil club room for his *Ledigenheim* in Schöneberg near Berlin of the same time, on which the painter Franz Mutzenbecher collaborated (Figs. 16–17).[72] The last and most successful Bauhaus attempt comparable to that of the Sommerfeld house to join free painting and sculpture to architecture was to be made in 1923 with the decoration of the Bauhaus building by Schlemmer and students for the summer Bauhaus exhibition. But by then the aesthetic premises behind the *Einheitskunstwerk* had changed, and the attempt was not made again.

A revealing glimpse of how Gropius saw his own design work at the very beginning of the Bauhaus is given by the incomplete and somewhat schematic draft of a speech held in Weimar before representatives of the Weimar crafts and industries in the spring of 1919.[73] Utilizing much of the material which was to be used again later in the Leipzig speech, it aimed at explaining something

71 An early sketch for the vestibule (ill. Wingler, *Bauhaus*, p. 217) shows a still more conventional decorative scheme than was finally chosen, with a heavy-framed doorway surmounted by a framed, corniced figural panel. One cannot overlook the possibility, however, that this design takes into account a painting owned by Sommerfeld. One may assume that the grouping of period furniture shown is merely a convention for indicating the scale and general effect of the completed vestibule, using the kind of furniture Sommerfeld might have had. The characterless pieces have nothing in common with the period-inspired furniture Gropius was designing before the war. It is evident from the sketch that at this point Marcel Breuer's Bauhaus furniture for the vestibule had not yet been designed.

72 Lindahl is thus misleading when he claims that the "gewonnene Synthese" of the Sommerfeld house "ähnelt in ihrer Zielrichtung den gleichzeitigen Arbeiten von u.a. Walter Würzbach" ("Von der Zukunftskathedrale," p. 261). The artists involved in these collaborations were all members of the Arbeitsrat für Kunst.

73 BD,SG. See Appendix B, pp. 257–261. Its contents identify it almost certainly as the speech cited by Gropius in his letter of reply to Dearstyne, "Bauhaus Revisited" (letter of Sept. 1963, p. 106).

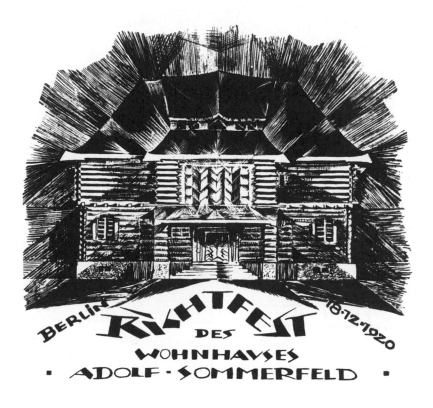

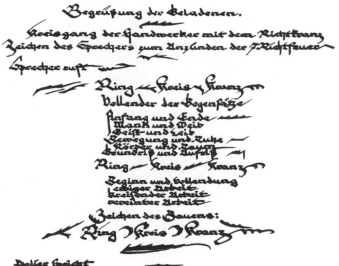

Fig. 1. Detail of the program for the *Richtfest* of Sommerfeld House.

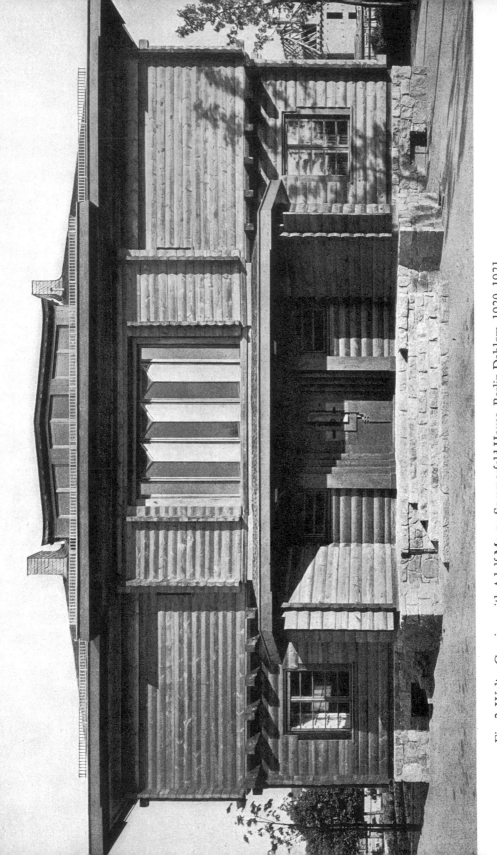

Fig. 2. Walter Gropius, with Adolf Meyer. Sommerfeld House, Berlin-Dahlem, 1920–1921.

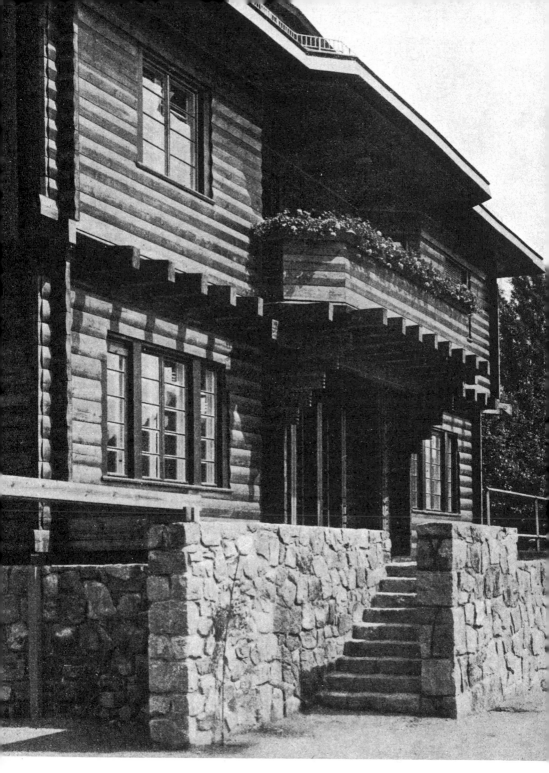

Fig. 3. Sommerfeld House. Garden facade.

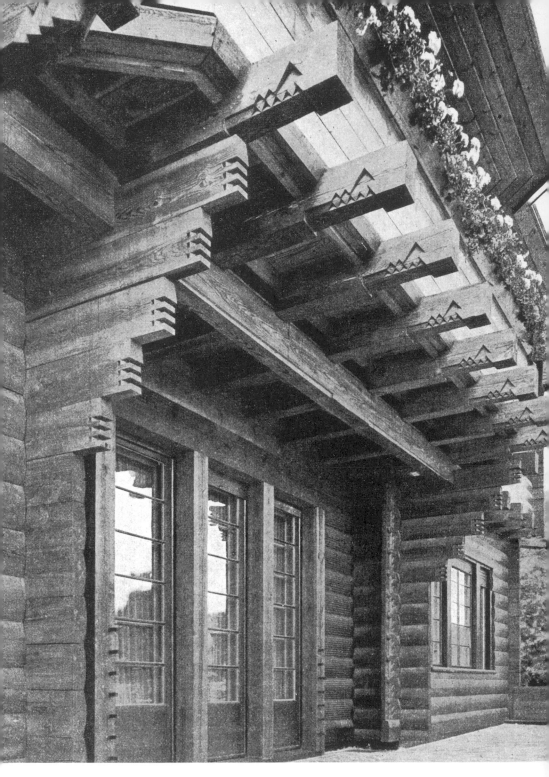

Fig. 4. Sommerfeld House. Entrance and balcony of garden facade.

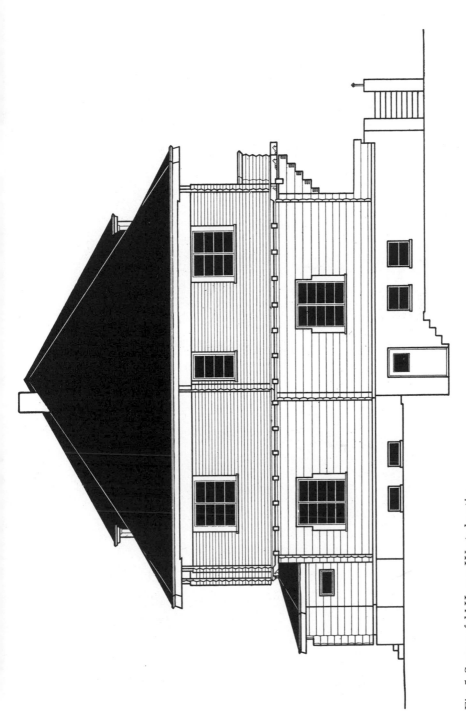

Fig. 5. Sommerfeld House. West elevation.

Fig. 6. Sommerfeld House. Foyer and staircase. Bauhaus furniture by Marcel Breuer.

Fig. 7. Hans Luckhardt. Design for a single-family housing project, ca. 1921.

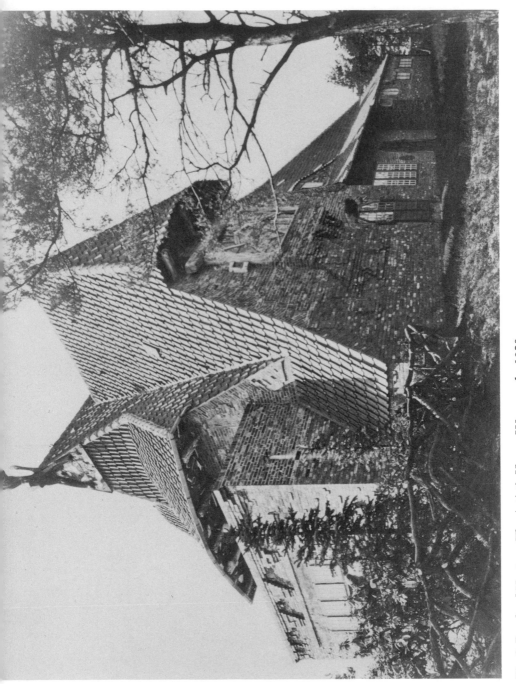

Fig. 8. Bernhard Hoetger. The Artist's House, Worpswede, 1920.

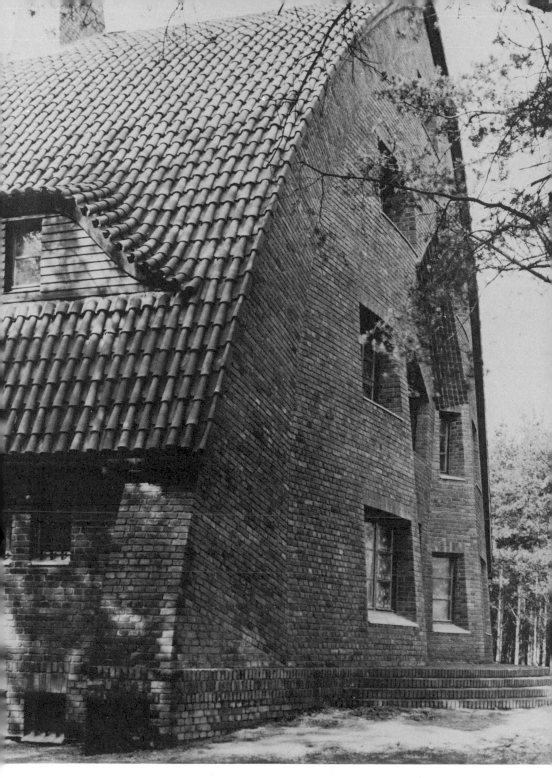

Fig. 9. Otto Bartning. House for a Director of Industry, Zeipau in Schlesien, 1923–1925.

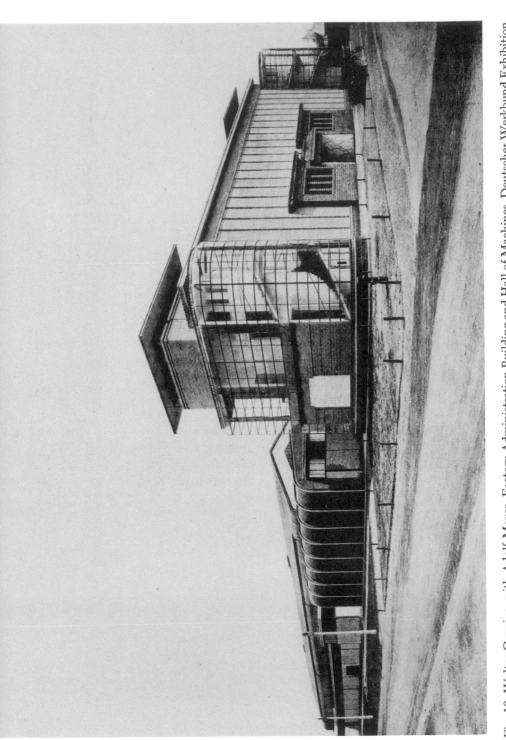

Fig. 10. Walter Gropius, with Adolf Meyer. Factory Administration Building and Hall of Machines, Deutscher Werkbund Exhibition, Cologne, 1914.

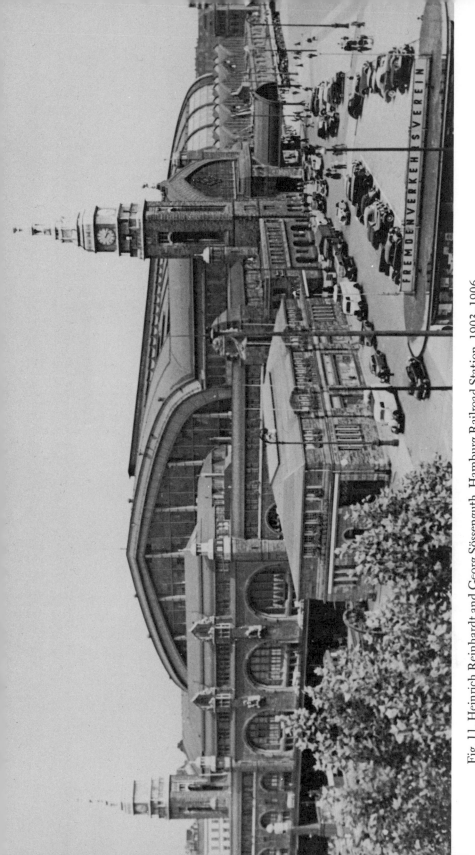

Fig. 11. Heinrich Reinhardt and Georg Sössenguth. Hamburg Railroad Station, 1903–1906.

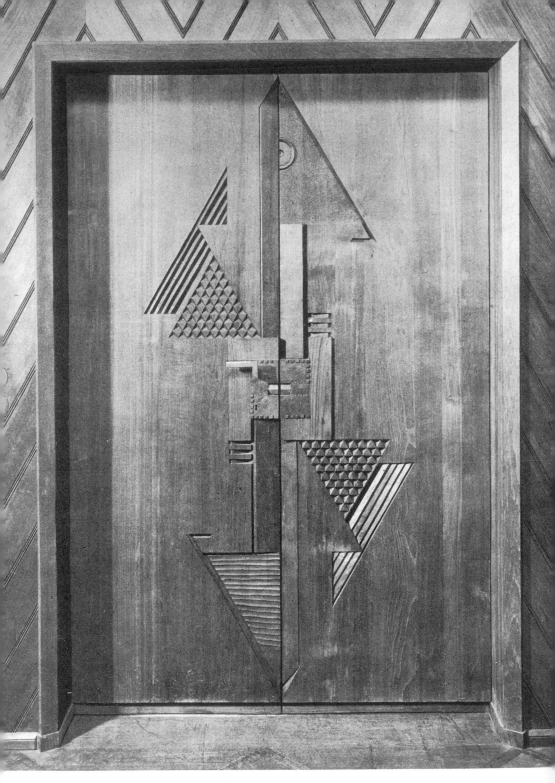

Fig. 12. Joost Schmidt. Foyer door of Sommerfeld House, 1921–1922. Apprentice work.

Fig. 13. Joost Schmidt. Carving for the staircase of Sommerfeld House, 1921–1922. Apprentice work.

Fig. 14. Joost Schmidt. Staircase relief, Sommerfeld House, 1921–1922. Apprentice work.

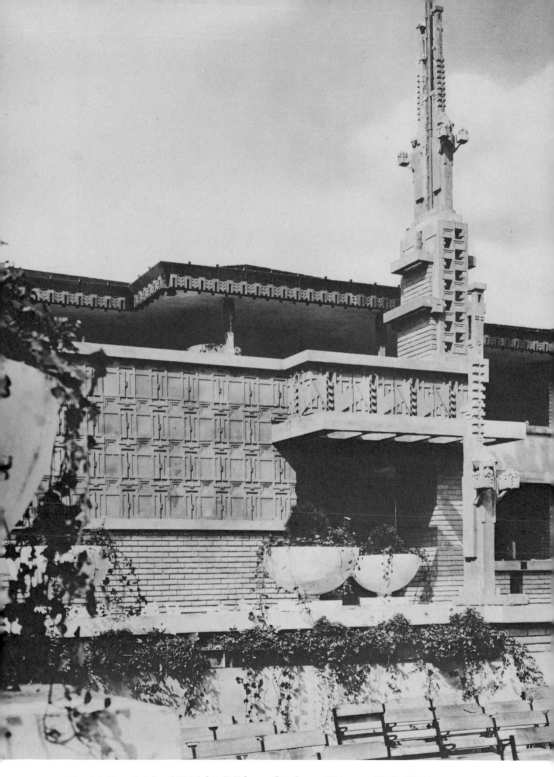

Fig. 15. Frank Lloyd Wright. Midway Gardens, Chicago, 1913–1914.

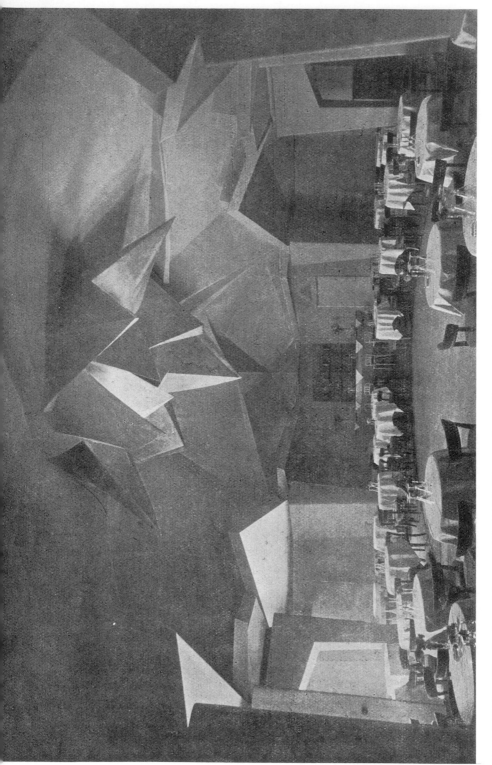

Fig. 16. Walter Würzbach, architect, and Rudolf Belling, sculptor. Dance casino in the Scala-Palast, Berlin, ca. 1920.

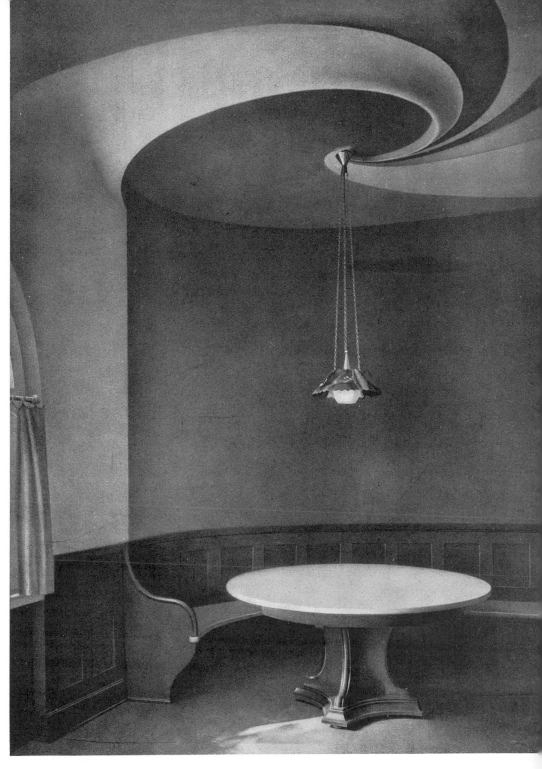

Fig. 17. Bruno Taut, architecture, and Franz Mutzenbecher, interior painting. Clubroom of the Single Men's Residence, Schöneberg, 1919–1920.

of the Bauhaus's objectives and Gropius's views to a skeptical audience which had come to the talk obviously fearing the worst. Some uneasiness toward the new school was certainly to be anticipated and in part had its roots in the traditional fear among the crafts groups and small industry of competition from state-operated workshops.[74] Quite other, however, were the doubts of Gropius's audience about the school's radical artistic direction. These led Gropius into an elaborate justification of his views (with, one imagines, not entirely persuasive results). His words here are significant not only because they reinforce the evidence of the Leipzig speech and Sommerfeld house of some basic continuities in his idea of designing and design training from his earliest period to his essay, "Idee und Aufbau" of 1923, but also for what they reveal of his views of the time on the relation of the fine arts to the handicrafts and industry.

In essence, Gropius reaffirms the necessity for rationality and simplicity in architecture and the applied arts in general, but his reasons for doing so now are new and surprising. The sentiments of the speech and its high-flown rhetoric—here in a scarcely translatable combination with conversational language—return us once again to the Bauhaus proclamation and the Arbeitsrat für Kunst writings and are not to be found in any of Gropius's prewar articles:

Now, you are probably wondering what such models [as the Bauhaus wants to create] will look like. Naturally, it is hardly possible to answer this question with words alone. . . . But I should at least like to clarify one point in this connection. A well-known Weimar master recently told me that a number of craftsmen have expressed agreement with my program but are at a loss to understand its title page. As a result, some of them now have, apparently, a very bizarre notion of what a house by Walter Gropius might look like. Gentlemen, I am convinced you would be surprised how reasonable and straight-forward the kind of house I design is. And this brings me to what I really want to say. For God's sake do not confuse everyday things of use with art. Art is holy. It occurs seldom, travels over the loneliest roads far in advance, and is born and can be understood only in a state of the highest ecstasy. Look at the tower of a gothic cathedral. Isn't it completely purpose-

---

[74] On this see Wilden, "Handwerk," pp. 139–140.

less? To be sure, it may carry a bell; but merely to serve as support for that it certainly does not need its thousands of stone figures, pinnacles, and rosettes. Such a tower was the expression of a spiritual movement, a religious sense of longing of an entire people. We no longer know this strong, common feeling, and until we do, the highest kind of art will be created and recognized only by a few isolated and scarcely understood men. We would do better, therefore, if we did not speak of art in connection with everyday things of use, which ought to be well, but simply and straightforwardly formed, but saved this word, until we once again have spiritual unity, for those few lofty works which, healed of all purpose, lead their existences free from the dominance of the commonplace and mere taste. Do not confuse, therefore, a free, abstract, and in this sense purposeless title page with a house or a piece of furniture. These things still look very different; for we still do not have a universal style, and the fine artist is far in advance of the things of daily life. So let us first begin our common work by making the hand-crafted or industrially produced object or portion of work simple and harmonious, taking tradition into consideration, of course, wherever it is still viable. For, enrichment and ornament can not come from below, but only from above.[75]

The new and dominant note here is the high and special place apart Gropius gives to art, and the striking rationale for simplicity that follows from it. The objects of handicraft and industry ought to be simple and matter-of-fact not because, as he had argued before the war, these traits best conform to and express the economic character and rational order of modern society, but because the utility of these objects makes them less than art—the word "art" should be restricted to the few "purposeless" creations of the vanguard—and because the lack of a universal style such as existed in earlier ages forbids the attempt to do more than design "simply and harmoniously." These two essentially negative arguments, which, it will be seen at once, are not necessarily related (indeed, they are incompatible, since the latter implies the desirability of art in things of everyday use), reveal separately and by their association the nature of Gropius's present concerns and the extent to which they represent a distinct reaction to his former Werkbund attitude.

In essence, Gropius now sees *Sachlichkeit* as merely transitional,

[75] Appendix B, pp. 259–260.

a confession, as it were, of the incapacity of modern man to achieve the true imaginativeness of art. What he wishes to see restored is the preeminence—the undisputable prerogative—of the untrammeled artistic imagination, "healed of purpose."[76] In contrast to his prewar willingness to accept the duties and restrictions imposed upon architecture by its practical ends because they offered a positive inspiration for the modern architect,[77] Gropius now seems to regard the practical side of architecture as an impediment, as the frictional coefficient, to use the expression of the art historian and theorist, Alois Riegl, whose formulation of *Kunstwollen* had become a ready support for the modern artists and architects who extolled the individual imagination in art.

We must be careful not to exaggerate the contrast between this elevation of the artistic above the utilitarian and the belief held by Gropius before the war in their desirable collaboration. His new attitude represents not a total rejection of his older convictions, but as we shall see more fully in the next chapter, an intensification of one significant aspect of them. It is doubtful whether more than a very few of the Werkbund designers even before the war shared the drastic opinion of an Adolf Loos that architecture and technical forms were best kept out of the hands of the trained artist.[78] Loos, to be sure, never ceased to insist that they were not art, but he praised the forms of technology as true expressions of the modern age. The Werkbund, on the contrary, had been founded on the proposition that, as Gropius emphatically put it in 1916, it is "the artist who is responsible for the creation and continuation of form in the world."[79] At best, the forms of the engineer or simple craftsman might produce a highly satisfying artistic form, but it would be largely unconscious—fortuitous, as it were. When it came to the designing of industrial architecture, the

---

[76] *Ibid.*, p. 260. These words are also used in his Leipzig speech (Gropius, "Baugeist oder Krämertum?" p. 894).

[77] Cf. esp. Gropius's earlier ideas in "Der stilbildende Wert industrieller Bauformen."

[78] E.g., Adolf Loos, *Sämtliche Schriften*, vol. 1, ed., Franz Glück (Vienna and Munich, 1962), p. 315 (from a *Sturm* lecture of 1910; see below, pp. 89–90): "So hätte also das Haus nichts mit Kunst zu tun und wäre die Architektur nicht unter die Künste einzureihen? Es ist so" (emphasis his).

[79] Proposal for the Weimar academy, in Wingler, *Bauhaus*, p. 29.

much admired achievements of the engineers might indeed have "style-building value," to quote the title of Gropius's 1914 Werkbund essay, but it was up to the "artistically trained" designer to "breathe a soul into the dead product of the machine."[80] Thus, Gropius was even before the war at pains to emphasize the difference between utility and technics on the one hand and the intrinsic values of art on the other. Even Muthesius, who indefatigably praised the beauty of utilitarian forms, could take the stand in the same years that "in the end, art is made by artists":[81] "The idea that it is enough for the engineer to make his structure, tool, or machine fulfill a purpose is an error; and still more in error is the remark often heard today that if they fulfill their purposes they are also beautiful."[82] There was already, in fact, as Banham has shown, a strong current of feeling in the Werkbund before the war that the stress on *Sachlichkeit* marked a necessary—even a welcome—phase in the battle against period styles, but that it was a transition, supportable only until a new, twentieth-century form of decoration could be developed.[83] Gropius, too, had shown something of this attitude when in 1914 he concluded that "a new development of form must take its point of departure from . . . works of industry and technology. . . . But only when the great good fortune of a new faith again falls to man's lot will art also attain to its highest goal once again and be able to create bright, decorative forms as a sign of inner refinement to add to the austere forms of the beginning."[84]

[80] Gropius, "Entwicklung moderner Industriebaukunst," pp. 18, 20.
[81] Muthesius, "Wo stehen wir?" p. 22.
[82] Muthesius, "Formproblem im Ingenieurbau," pp. 27–28.
[83] Banham, *Theory and Design*, pp. 92–93; cf. Gross, "Das Ornament," p. 61: ". . . so wurde zunächst alles Form, glatt und einfach; das war natürlich und richtig. . . . In diesem Stadium des Lernens von Grund auf stehen wir heute, und wir müssen uns bewusst sein, dass wir mit dem 'Schrei nach dem Ornament' vor einem bedeutungsvollen, aber auch sehr gefährlichen Abschnitt unserer Bewegung stehen."
[84] Gropius, "Der stilbildende Wert industrieller Bauformen," p. 32. "So muss von diesen Werken der Industrie und Technik eine neue Entwicklung der Form ihren Ausgangspunkt nehmen. . . . Aber erst wenn das grosse Glück eines neuen Glaubens den Menschen wieder zuteil werden sollte, wird auch die Kunst ihr höchstes Ziel wieder erfüllen und zu den herben Formen des Anfangs zum Zeichen der innerlichen Verfeinerung die heitere Schmuckform neu erfinden können"—a remark, incidentally, that already makes the characteristic connection

Yet for all of this, the early defenders of a machine-age style, including the founders of the Werkbund, had been at pains to de-emphasize the qualitative and aesthetic distinctions between the fine and applied arts, or between art and technical forms, and with them the special place apart that art supposedly had from the nonartistic forms of utilitarian objects. In the first burst of enthusiasm in the early years of the century for the works of the industrial age, utilitarian forms had not only been accepted but positively welcomed as the most fruitful source of inspiration for the creation of a modern style. We need not cite van de Velde's early, uncritical panegyrics to engineering (which in any case did not prevent him from continuing in the older Arts and Crafts tradition to regard industry as the antagonist of art which had to be overcome) as evidence;[85] more characteristic of the Werkbund and certainly more influential in promoting the ideal of *Sachlichkeit* was the measured approach of Muthesius.

Already about the turn of the century, Muthesius, following William Morris, had rejected the romantic concept of art as a unique realm of the imagination above and apart from everyday life and accomplishments: a "naive" but genuine kind of art had in fact remained with us, leading an underground existence unperceived until now because of our false assumption that art meant an overlay of stylistic decoration upon a practical core. Among these underground works of art, Muthesius included not only common tools, appliances, and engineering forms, but even such things as clothing.[86] The similarity of this attitude to Loos's contemporaneous expressions of delight in the unadorned modern garb and other "nonartistic" items of everyday use is apparent at once, even though Loos refused to bestow the name and dignity of art upon them. Here we find another application, like that of Loos, of that wholly optimistic estimation of the modern temper which so strikingly characterized much of the work and writings

---

between art and a religious revival which is to be found in his postwar thinking. This linking of the future of art to religion was also made by other architects at the time, most notably by H. P. Berlage (see also below, Chapter 3).

[85] E.g., van de Velde's speech of 1908 before the Werkbund, in van de Velde, *Zum neuen Stil*, pp. 206–210.

[86] Muthesius, *Kultur und Kunst*, pp. 45–46, 51.

of the generation of designers before World War I, and which
was to give the Werkbund its real impetus in the first four or five
years of its existence.

The mantle of art was spread by Muthesius, as it had been by
Morris, to include "everything we think and do." "Where in life,"
he asks, "does art begin and where does it leave off? . . . As soon as
one includes architecture [among the arts]—and who would pre-
sume to deny it entry?—there can no longer be any boundaries to
the concept of art; for this art serves primarily utilitarian ends by
its very nature."[87] The urge to give a pleasing form to whatever
we do is instinctive and realizes itself according to "definite laws"
inherent in the human psyche. This urge can no more be sup-
pressed or destroyed than any other innate human trait. It will
show itself intentionally or unintentionally whether we give free
reign to our fancy or restrict ourselves as narrowly as possible to
the practical requirements of the work.[88] For Muthesius, this
recognition of a universal human tendency to *Gestaltung*—he was
to repeat this exposition in almost the same words in his article for
the 1913 Werkbund *Jahrbuch*[89]—afforded a theoretical justifica-

---

[87] *Ibid.*, pp. 51–52, 54. It is true that in his speech before the Werkbund con-
gress of July 1914, Muthesius was seemingly to change his mind by his objection
that the word "art" was being used indiscriminately for too many things too in-
consequential, and that it would be better to use for these a lesser term such as
"good form," saving "art" for higher things (excerpted in Julius Posener, *Anfänge
des Funktionalismus. Von Arts and Crafts zum Deutschen Werkbund*, Berlin,
Frankfurt am Main, and Vienna, 1964, p. 200). But this remark, which is out of
character with everything Muthesius had said before, must be understood within
the context of the Werkbund debate as a polemical statement. The important
principle was not changed: to devote one's attention and talents to even the
humblest tasks, to achieve a *Durchgeistigung* of all manmade objects and
diminish whatever gulf existed between the fine and applied arts.
[88] Muthesius, *Kultur und Kunst*, pp. 40–42, 54–55.
[89] Posener, pp. 24–25, sees a transformation in Muthesius's ideas between ca. 1903
and ca. 1911 from a predominantly Lethabian emphasis on the relationship between
form and function to the formalistic view that beauty and use are not inherently
connected. Granting a shift in this direction, it seems not to have been as great
as Posener would make it. As evidence for the distinctiveness of Muthesius's later
views, he quotes the following passage from Muthesius's 1913 Werkbund essay,
"Das Formproblem im Ingenieurbau": "Es gibt nur ein menschliches Gestalten.
Genau dieselben Gestaltungstendenzen kehren wieder beim Kunsthandwerker,
beim Architekten, . . . beim Schneider, . . . bei der Mutter, die ihrer Kleinen ein
Kleid zurechtschneidert. . . . Die Tendenzen . . . sind unserer Gehirntätigkeit
immanent." Posener concludes: "Muthesius kehrt also der Grundlegung des

tion for two of his principal objectives. That the presence of art might be found as much in the *Sachform* as in the *Kunstform*, that is, in the structures and forms of common, utilitarian things which had historically least been touched by high art, offered the possibility of a genuine liberation from the styles of the past and the presumed excesses of a modern phenomenon such as the *Jugendstil*, against which he helped to lead the reaction. But this recognition came to support, in practical terms, what was uppermost in Muthesius's mind as one of the prime movers of the Werkbund and an official of the Prussian school system: the development of an artistic culture as broadly based as possible which, although necessarily guided at first by the trained artist, would ultimately not depend upon the personal inventions or idiosyncrasies of an artistic elite but manifest itself on all levels through a general feeling for good, simple forms and proportions and honest workmanship.

While wholly agreeing with the first, Gropius, along with many of the most important Werkbund designers, was apparently not prepared to accept, even before the war, the second implications of Muthesius's arguments, as the Werkbund debate of 1914 over *Typisierung* was to show.[90] Still, his conception of the formal requirements of industrial design followed that of Muthesius in many essential points: his words of the time amply testify to his belief in the advantages of indissolubly uniting art with technology, of drawing for inspiration directly upon industrial building and the work of the engineer, and above all of the necessity of submitting the artistic imagination to the economic requirements of the modern age as wholly positive factors in the creation of a modern aesthetic. (In this context, Gropius's Bauhaus slogan of 1923, "Art and technics, a new unity," not only had programmatic significance; it was to be the testimony of a personal reconversion.) As we have seen, as late as 1916, in his plan for the Weimar

---

Funktionalismus, die er im Jahre 1901 versucht hat, den Rücken und betont mit Entschiedenheit das Primat der Form 'in allem, was der Mensch sichtbar tut und treibt.' " But as the quotations from *Kultur und Kunst* amply show, Muthesius had from the very beginning insisted upon an innate sense of form revealing itself "in allem, was der Mensch . . . treibt."

[90] See Chapter 2.

*Hochschule für bildende Kunst,* Gropius was still repeating his words about the necessity of creating forms "corresponding to the energy and economy of modern life."

Sometime, therefore, between 1916 and the end of 1918, after he had returned from the war, his view of art and the place of art in society, although it shows definite connections to what he had believed before the war, nevertheless underwent a significant change. The source of his new attitude is not to be found primarily in the stated goals and principles—that is to say, in the main direction—of the Werkbund before the war, but in ideas and movements that had touched the Werkbund then only peripherally.[91] There is nothing in the published writings of any of the founders of the Werkbund before the war to compare with the tone of Gropius's essay for the Arbeitsrat für Kunst's "Exhibition for Unknown Architects" and its sentiment that "ideas die as soon as they are compromised; therefore, a clear distinction between dream and reality, between longing for the stars and everyday work."[92] Not even in the *Leitsätze,* the counter-theses, of van de Velde, who in the 1914 Werkbund debate defended with them the "ardent individualist" and the "free, spontaneous creator,"[93] will we find anything like the intensity with which Gropius now emphasized "feeling" (*Empfindung*) as the source of artistic inspiration,[94] and exalted art as "nothing other than the sensible embodiment of the transcendental"—a "crystallized longing for God"—and with it the stature of the architect to that of seer and leader.[95]

[91] See Chapter 3.
[92] In Conrads and Sperlich, *Architecture of Fantasy,* p. 137.
[93] Van de Velde, *Zum neuen Stil,* p. 213, Leitsatz no. 1.
[94] Gropius's statement of 1919, in *Ja! Stimmen des Arbeitsrates für Kunst in Berlin* (Berlin, November 1919), p. 32; also in Diether Schmidt, ed., *Manifeste Manifeste 1905–1933. Schriften deutscher Künstler des zwanzigsten Jahrhunderts,* vol. 1 (Dresden, [1964]), p. 213: "Durch Schmerz lernten wir von neuem empfinden. Empfindung . . . ist ja die Quelle der Eingebung, der Erfindung [sic], der schöpferischen Gestaltungskraft, kurz der Form- und Baulust im weitesten Sinne des Wortes."
[95] Appendix A, pp. 253–255; cf. also Gropius's words in Appendix B, p. 260; and Gropius, "Baukunst im freien Volksstaat," in *Deutscher Revolutions-Almanach für das Jahr 1919* (Hamburg and Berlin), p. 135: "Architekt das heisst: Führer der Kunst. Nur er selbst kann sich wieder zu diesem Führer der Kunst erheben, zu ihrem ersten Diener, dem übermenschlichen Wächter und Ordner ihres unge-

Whether one places greater importance for the Bauhaus upon what Gropius derived from his early Werkbund experience or upon what is new and distinctive in his thought of the immediate postwar period depends ultimately on whether one is thinking of the Bauhaus as it developed after 1921 or of its earliest years. If the change to a program based on the idea of functionalism and the primary training of the designer for industry proved to have been easier to effect than might be supposed from the language and content of the first Bauhaus program, it was in no small part due to such basic continuities of aim as are evinced by Gropius in his Leipzig and Weimar speeches and to his retention of the broad educative ideals of the Werkbund with their general requirement of simplicity in handicraft as well as in objects of machine production. But the postwar period set these aims in a new ideological framework, and it is this which we shall have to consider in greatest detail; for if the new, rhetorically couched sentiments and ideas of the Bauhaus proclamation and the Arbeitsrat writings seem to have had a relatively minor impact on Gropius's own practical work, they were to be of the most vital importance for the conception of the Bauhaus.

---

trennten Gesamtlebens. Der Architekt von gestern war nicht mehr der universale Schöpfermensch und mächtige Meister aller künstlerischen Disziplinen."

# GROPIUS AND THE 1914
# WERKBUND CONTROVERSY

2

Just as we find that Gropius's dominant prewar interest in *Sach-lichkeit* and designing for industry continued to play a part in his postwar art and thought, so the gulf between the two periods can be narrowed from the other side as well. Gropius's personal papers reveal a side of his activities that distinctly anticipates the direction he was to take during the war and complicates the picture usually drawn of his early Werkbund years.

The postwar change of direction cannot be fully understood outside the context of Gropius's involvement in the Werkbund debates over the nature and course of the organization. It is a fact that the new currents that were radically to shape German architectural thinking, Gropius's included, during and just after the war were prepared for by an already well-developed dissatisfaction within the Werkbund itself; and this dissatisfaction was also shared by Gropius.

Gropius's position among the Werkbund factions was a far more equivocal one than it has been thought to be until now. On the strength of the now well-recognized classicistic tendencies in his early architecture, the closeness of many of his views of the time to those of Muthesius, and undoubtedly also his better-known role after 1921 as spokesman for the developing rationalist current in architecture, it has become customary to regard the

prewar Gropius as a convinced supporter of the Muthesian concept of types or norms in architecture (*Typisierung*). Yet, on the basis of what may be learned about him in these years, this conclusion must at the very least be qualified. Lindahl has already shown that the central preoccupation in Gropius's Werkbund articles of 1913 and 1914 with the creation of an architectural style whose forms will express and symbolize the distinctive character of modern life is a significant anticipation of Gropius's postwar thinking.[1] Probably influenced most directly by the similar ideas of Peter Behrens, this concern by its dominant position in his thought already marks a small but significant shift of emphasis over the expositions of Muthesius, for whom interest in architectural content and expression was decidedly secondary to—or at least less developed than—the issue of a widely based work exhibiting, in the loose Werkbund term, formal and material "quality" (*Qualitätsarbeit*). There is another, related aspect of Gropius's thought, however, which, taken together with his strong interest in architectural symbolism, makes his deviation from Muthesius decidedly pronounced.

Although in his 1910 memorandum to the industrialist Emil Rathenau Gropius had, following the influential lead of Behrens and Muthesius, enthusiastically endorsed the artistic values of standardization,[2] since that time a second, mediating element had come to the fore in his thinking: repeated allusions to the spiritual side of architecture, to the artistic "Wille zur Form," and with this a stress on the necessity of having the strongest, most highly gifted artists do the work of industrial designing. Thus, in his essay for the 1913 *Jahrbuch des Deutschen Werkbundes*, "Die Entwicklung moderner Industriebaukunst," which includes a standard Werkbund attack upon the inartistic factory *Musterzeichner*,[3] Gropius insists that "the invention of new, expressive

[1] Göran Lindahl, "Von der Zukunftskathedrale bis zur Wohnmaschine. Deutsche Architektur und Architekturdebatte nach dem ersten Weltkriege," in *Idea and Form*, Figura: Uppsala Studies in the History of Art, N.S., vol. 1 (1959), pp. 230–232, 238.

[2] "Gropius at Twenty-six," *Architectural Review* 130 (July 1961); also in Wingler, *Bauhaus*, pp. 26–27.

[3] For Werkbund criticism of the factory *Musterzeichner* see, e.g., Karl Schmidt's 1908 address to the Werkbund in *Die Veredelung der gewerblichen Arbeit im*

forms requires a strong artistic . . . personality. Only the most brilliant (*genialsten*) ideas are good enough for multiplication by industry and worthy of benefiting not just the individual but the public as a whole."[4]

Now this side of Gropius, too, can be found in Behrens. In a speech delivered in Braunschweig in 1910 before the eighteenth annual congress of the Verband Deutscher Elektrotechniker, Behrens had concisely expressed the same sentiment: "Nothing great which has been created in life has ever resulted from conscientious professionalism; on the contrary, it has been due to the enterprise of great and powerful personalities."[5] Gropius, in his turn, was to insist upon this over and over again. His requirements, later in his article, for a modern industrial architecture generally reflect, as we have seen, the "objective" *Raumästhetik* of Behrens: "precisely stamped form devoid of all accident, clear contrasts, the ordering of members, the arrangement of like parts in series, and unity of form and color"—these we recall are the characteristics of the highly rationalist style needed in the present age. But he is with this even more insistent than before that "these are only guidelines. Only in the hands of a gifted architect will they coalesce to form an entity with artistic force," and "the more unrestrictedly the originality of the formal language can unfold, the more the building will possess publicity value for its firm and meet the advertising aims of its organizer."[6] In his later article for the 1914 Werkbund *Jahrbuch*, Gropius speaks throughout of the spiritual mission of the architect to create a new, valid image of his age and of the high degree of creative will and ability needed to achieve that image. To be sure, this image is to be one of unity and harmony, away from the "chaos of individualistic points of view";[7] and at one point, as most of the major Werkbund designers had done at one time or another, he even calls for

*Zusammenwirken von Kunst, Industrie und Handwerk. Verhandlung des Deutschen Werkbundes zu München am 11. und 12. Juli 1908* (Leipzig, n.d.), p. 100, and Hermann Muthesius, *Kultur und Kunst*, 2d ed. (Jena, 1909), p. 11.

[4] P. 18.

[5] Peter Behrens, "Kunst und Technik," published among other places in the *Elektrotechnische Zeitschrift* 31, no. 22 (June 1910): 552–555.

[6] Pp. 19–20.

[7] Gropius, "Der stilbildende Wert industrieller Bauformen," p. 29.

types: "These [new] structures of the present, whose function is to serve transportation, industry, and trade, will require definitive forms of expression—*Formentypen*—arising out of new technical and spatial requirements." But in context this seems to mean no more than generic new building types, such as the church or palace had been in earlier ages, and a strict conformity to the practical and aesthetic demands of exactness, regularity, and concision, not the adherence to certain forms or canons of proportion.[8] As before, the framework is one in which the appeal is to "artistic genius" and poetic inspiration. Once the modern architect has recognized that "the sharpest demands on material and the most concise use of space and time have become fundamental prerequisites" for him, "he will not only search out their meaning everywhere, but fill his forms with them in poetic exaggeration so that the basic idea of the whole is made apparent to every viewer"; and Gropius once again insists that "the correspondence of the *technical form* with the *artistic form* . . . signifies, to be sure, final perfection for every piece of architecture . . . , but only an enormous act of will is capable of bringing them into harmonious relationship."[9]

This seemingly unobjectionable point of view, while not different from that held by probably most of the major Werkbund designers, nevertheless strikes a significantly diverging note from that of Muthesius, who, as we have seen, had from the start sought to de-emphasize just this element of personal genius in the applied arts.[10] Nowhere in Muthesius's writings do we find any-

[8] *Ibid.*, p. 30. Cf. the similar references to "types" in an article of 1911 by the prominent Werkbund architect Hans Poelzig, whose observations on the symbolic values of "wirtschaftliche Nutzbauten" find echoes in Gropius's Werkbund articles: "Nur die ganz konsequente Ausbildung des Baues auf Grund seiner wirtschaftlichen und technischen Bedingungen wird die Grundlage für eine typische künstlerische Ausbildung geben. Die wirtschaftlichen Bauten aus den grossen Zeiten der Architektur sind typisch und wirken dadurch oft so überwältigend" (Hans Poelzig, "Der neuzeitliche Fabrikbau," *Der Industriebau* 2, no. 5 [May 15, 1911]: 104). See Appendix C, pp. 270–274, for what Endell, among others, believed to be the implications of Muthesius's idea of "types."
[9] *Ibid.*, pp. 30–31.
[10] E.g., in his address to the first Werkbund congress in 1908: "Ob . . . Erziehungsversuche nun . . . Künstler von grundlegender Bedeutung hervorbringen können, das ist eine andere Frage. Möglich, dass sie verneint werden muss. Es liegt aber ein grosser allgemeiner Bedarf vor an solchen Kräften, die eine künstlerische

thing comparable to the degree to which Gropius emphasizes the factors of expressivity and originality in architecture and to his consequent insistence upon the great will and artistic talent needed to achieve them in the design. In the basic principle itself of artistic leadership by the highly trained designer, the two men did not disagree. For, as we have already seen, Muthesius, too, had expressly recognized that the professional artist would have to initiate and guide the development of a modern style; and on his part, it is clear, Gropius believed in the strict submission of the architect's imagination to such supra-personal considerations as function, technics, and economy, drawing much of his inspiration for his architecture from "anonymous" utilitarian construction. Undoubtedly, in writing his articles Gropius also had the very practical intention of justifying the right of the trained artist to work in industry, a right still disputed by a significant number of businessmen at the time, as the polemical tone of these and other Werkbund articles on the matter show.

Nevertheless, if the principle itself was not at issue, the insistence in Gropius's essays upon artistic brilliance is closer to the view defended by Henry van de Velde in his counter-theses at the 1914 Werkbund congress in Cologne than it is to the position of Muthesius represented in his *Leitsätze* which touched off the controversy there. Gropius, in fact, has stated that he opposed Muthesius in the latter's dispute with van de Velde at the congress, during which the issue of individuality in design came dramatically to the fore.[11] The vehemence and extent of that opposition is revealed by Gropius's unpublished papers. They show that Werkbund politics were a large factor in the acrimony that developed around Muthesius, most of it directed against him personally, but the differences between Muthesius's conception of *Typisierung* as many understood it and the view exemplified by

---

Schulung haben um neben und unter diesen künstlerischen Wegweisern zu arbeiten. Dieser Stab künstlerischer Hilfskräfte ist nötig neben den Genies, die die künstlerische Richtung der Zeit bestimmen und ihrer Epoche den Stempel aufdrücken. Vielleicht würde man überhaupt am besten tun, das Wort 'Kunst' in der gewerblichen Erziehung ganz zu vermeiden und es durch 'Geschmack' zu ersetzen" (*Veredelung der gewerblichen Arbeit*, p. 148).

[11] Gropius's letter of July 1963 in *Architectural Review* (reply to Nikolaus Pevsner, "Gropius and van de Velde," *Architectural Review* 133, no. 793 [March 1963]).

Gropius's elevation of the "most brilliant ideas" were also at the center of the controversy.

The immediate cause of the conflict at Cologne was a set of ten propositions, or *Leitsätze*, which Muthesius had distributed to the delegates for consideration and debate a few days before his scheduled speech at the congress. These and his speech, which elaborated upon them, had unleashed a storm of protest among the artists and their supporters and had spurred van de Velde to read a set of counter-theses in defense of artistic freedom. To many present, Muthesius—especially in his *Leitsätze*—appeared to be attacking the very idea that the fine artist and the free artistic imagination should have a dominant and abiding role in the creation and development of industrial design.[12] In their place he seemed to be reoffering in highly provocative terms his favorite theme of an industrial design based broadly upon what he called *Typisierung*, that is, upon canons or fixed types of design which would allow even the semitrained, uncreative draftsman or builder to achieve a minimum level of design competence and uniformity.

While the conflict thus seems to have been fought partly on the basis of strictly practical considerations—in plainest terms, on the number and importance of the jobs for artists in industry— the nature of the artists' response to Muthesius's *Leitsätze* shows how jealously many of them guarded the prerogative of artistic freedom and personal expression, and how sensitive they were to

[12] Muthesius's *Leitsätze* have been reprinted in Julius Posener, *Anfänge des Funktionalismus. Von Arts and Crafts zum Deutschen Werkbund* (Berlin, Frankfurt am Main, and Vienna, 1964), pp. 205–207; Ulrich Conrads, ed., *Programme und Manifeste zur Architektur des 20. Jahrhunderts* (Berlin, Frankfurt am Main, and Vienna, 1964), pp. 25–26; and Henry van de Velde, *Geschichte meines Lebens* (Munich, 1962), pp. 364–365. Muthesius's position was, in fact, more polemically stated in his *Leitsätze*, which he distributed several days before his speech, than it was in the speech itself. This was recognized at the time by a number of the participants in the debate. See also the similar opinion in a report of the debate by Georg Jacob Wolf ("Der Deutsche Werkbund und die Deutsche Werkbund–Ausstellung in Köln," *Dekorative Kunst* 22 (17. Jhrg.), no. 12 [September 1914]: 534). The same observation is made again by Posener, p. 204, which reprints most of the debate at the Werkbund congress, including part of the speech (pp. 199–204). The full transcript of the Werkbund congress was published, including the debate (Hermann Muthesius, "Die Werkbund-Arbeit der Zukunft," in [Transactions of the] 7. *Jahresversammlung des Deutschen Werkbundes vom 2. bis 6. Juli 1914 in Köln*, Jena, 1914).

any presumed suggestion that it should be limited.[13] If it is true that, as Banham has put it, "van de Velde's polemic still left the question in the form 'Type or Individuality' and should be regarded as a spirited rearguard action by an outgoing type of designer,"[14] it is equally true that many of the important Werkbund designers saw the question his way and agreed essentially with his defense of creative freedom, including above all such a young, "advanced" architect as Bruno Taut.[15]

According to Gropius, he was "more against the person of Muthesius than the content of his thesis,"[16] and this seems confirmed by those of his papers which pertain to the dispute; for they give no hint of the extent to which he may have concurred with van de Velde's counter-theses or what he really thought about the principles involved. From all we know of his work and ideas of the time, it seems safe to say that he was little inclined to polarize the question into "individuality or type" as did van de Velde and others, and that he did not feel this particular issue with anything like the same intensity they did. In this respect, the silences in his letters and at the congress itself seem significant. We can probably conclude that like the designer August Endell, to whom he relinquished his speaking time in the debate,[17] Gropius was inclined to dismiss the whole matter of types as irrelevant to the task of the creative artist, and that like Behrens or another prominent designer, Richard Riemerschmid, both of whom, although leaning toward van de Velde, adopted mediating positions between the opposing views,[18] he recognized no inherent conflict between individuality and restraint on license, which, self-imposed, he believed necessary for the creation of a valid, consistent industrial style.

On the other hand, he undoubtedly rejected, like van de Velde, any suggestion that this consistency should be attained through

[13] Appendix C.
[14] Banham, *Theory and Design in the First Machine Age* (London, 1960), p. 78.
[15] See Chapter 3.
[16] Letter of July 1963 (Pevsner, "Gropius and van de Velde").
[17] Reported in the transcript of the debate (Muthesius, "Die Werkbund-Arbeit der Zukunft," p. 61).
[18] Cf. their remarks in the debate (Posener, *Anfänge des Funktionalismus*, pp. 208, 211–213). Also Appendix C, no. 4.

the routine implementation of commonly agreed upon formal conventions, or that anything less than considerable artistic gifts were required to achieve the desired goal. On the basis of his essays, we must assume that he, too, opposed on theoretical as well as practical grounds what was with justice widely understood to be Muthesius's intention to establish the broadest possible level of "good taste" in the applied arts—in large part for the practical reason of foreign trade competition—by the application of design norms or types.[19]

However strong Gropius's practical reasons for his stand might have been, it is entirely consistent with the point of view expressed in his articles—as well as, it may be said, with his awareness of personal achievement as one of the brightest younger talents in Germany—that in the attack on Muthesius he should throw himself in closely and wholeheartedly with some of the most distinctively personal designers and most confirmed champions of individual artistic liberty and self-expression in the Werkbund: besides van de Velde, these were, among the most prominent, August Endell, Hermann Obrist, Karl Ernst Osthaus (owner and director of the Folkwang Museum in Hagen and the patron of van de Velde, Behrens, and now also of the expressionist painters), Bernhard Pankok, and Hans Poelzig and Bruno Taut, both of whom were to become major figures in postwar expressionist architecture.[20]

The controversy at Cologne threatened for the moment to split the Werkbund. Gropius, as a leader of the younger generation, became, as his papers show, a principal advocate of secession, singling out these men among a number of others for specific mention as allies and potential members of a new organization. This secessionist frame of mind was to be carried through the war by Gropius and was a strongly predisposing factor in his later activity as a founding member and leader of the Arbeitsrat für Kunst. His involvement in the Arbeitsrat must in this respect be

[19] On this and the following pages see Appendix C.
[20] The ideas of Wright, whose Mason City, Iowa, bank, published in the first Wasmuth volume on Wright, influenced Gropius's office building for the Werkbund exhibition, must also have confirmed his belief in the values of individual genius.

seen as a fulfillment under the altered postwar conditions of his already existing desire to attach himself to a smaller, more exclusively artistic group which would have the creative vigor and effectiveness he and the others felt to be lacking in the Werkbund.[21]

What Gropius may have intended by such a course of secession is not clear; nothing indicates that he planned anything comparable to the later Arbeitsrat für Kunst, with its defiantly radical, wide-ranging, and visionary cultural program. It is more probable, from what little Gropius's papers tell us of his motives, that his immediate plans went little farther than to free the designers and architects from what they regarded as the extra-artistic political and propaganda policies of the Werkbund as it had been shaped under the leadership of Muthesius.[22] Unquestionably, however, the dominating presence of such artists as van de Velde, Endell, Pankok, Obrist, Poelzig, and Taut would inevitably have given the secession a more individualistic and radical direction, even if the war had not intervened to change the social and artistic conceptions of German artists.

Of the designers specifically named by Gropius in his appeal

[21] The prewar Werkbund organization and its activities were still a sensitive issue in 1919. One can find polemical allusions to them by Poelzig and Max Taut as well as by Gropius. Cf. Poelzig's speech before the Werkbund at the 1919 congress in Stuttgart: "Der Werkbund darf keine lose Vereinigung von Leuten sein, die durch opportunistische Erwägungen zusammengehalten werden . . ." (quoted in Hans Eckstein, ed., *50 Jahre Deutscher Werkbund*, Frankfurt am Main and Berlin, 1958, p. 35); and Max Taut's laconic ending to his reply in *Ja! Stimmen des Arbeitsrates für Kunst in Berlin* (Berlin, November 1919) concerning the return of artists to handicraft gilds and schools: "Ohne Werkbund" (reprinted in Diether Schmidt, ed., *Manifeste Manifeste 1905–1933. Schriften deutscher Künstler des zwanzigsten Jahrhunderts*, vol. 1, Dresden, [1964], p. 228). Gropius's remarks were made in his Leipzig speech and again in his speech at the first Bauhaus student exhibition (see below, pp. 142–143).

[22] On the Werkbund as an organ of publicity before the war see the statement of purpose in the Werkbund statutes at the rear of *Die Durchgeistigung der deutschen Arbeit. Wege und Ziele in Zusammenhang von Industrie, Handwerk und Kunst*, Jahrbuch des Deutschen Werkbundes 1912 (Jena). Cf. also Muthesius's address at the first Werkbund congress, 1908: "Aber Hand in Hand mit der Hebung der Produktion muss die Hebung der Qualitätsansprüche der Verbraucher gehen. Es entsteht daraus für den Deutschen Werkbund die nicht minder wichtige zweite Aufgabe der Propagierung des Qualitätsgedankens durch Wort und Schrift . . ." (in *Veredelung der gewerblichen Arbeit*, p. 46).

for secession, those whose dissatisfaction with or opposition to the prevailing direction of the Werkbund can most readily be documented were Obrist, Poelzig, and Bruno Taut. The leading spokesman for individualism at the congress, van de Velde himself, should probably not be placed in their company, despite his threat to secede if the executive board of the Werkbund did not take a stand in favor of artistic freedom.[23] He had, it is true—and in this he undoubtedly spoke for many in the Werkbund—never lost his mistrust of industry. As we know from his speech before the Werkbund in 1908, he was still at that time inclined to see the alliance of the artist and industry—the very foundation of the Werkbund—as an uneasy rapprochement between antagonistic interests, with virtue almost entirely on the side of the artist.[24] But he had never given evidence of opposition to the spirit and basic ideals of the Werkbund. On the contrary, his early, repeated, and even exaggerated homages to the work of the engineer; his belief in mechanization and the rationalization of design as prerequisites for the creation of a modern industrial art; his own extensive and undeniably fruitful collaboration with industry; and his indefatigable work of publicity for the modern movement had all combined to make him one of the mainstays of the Werkbund in spirit and deed. With Obrist, Poelzig, and Taut, however, differences with the Werkbund demonstrably went deep.

Hermann Obrist, whose numerous essays give us considerable information about his way of thinking in the first years of the century, had in almost all of his writings been concerned above all to defend the values of spontaneity, intuition, and personal invention as the paramount factors in art—so much so that J. A. Lux, in his early (1908) history of modern design in Germany, had begun his chapter on Obrist by calling him the Max Stirner of the applied arts.[25] And Obrist's views on this score seem to have become increasingly intransigent as the century went on. Thus, in the year the Werkbund was founded, 1907, within the frame-

[23] In a letter of July 15, 1914, to Gropius (BD,SG. See Appendix C, no. 8).
[24] Henry van de Velde, *Zum neuen Stil*, ed. Hans Curjel (Munich, 1955), pp. 206–210.
[25] Joseph August Lux, *Das neue Kunstgewerbe in Deutschland* (Leipzig, 1908), p. 149.

work of a questionnaire by the critic and editor of *Kunst und Künstler*, Karl Scheffler, on the reform of art education, he did more than voice the general conviction among modern artists that art *per se* could not be taught;[26] he attacked the notion of any systematic art education altogether, opening his reply with the provocation that "art thrives as long as it isn't taught." He insisted that only technique (*Ausführen-Können*) and a few things such as "sachliches" drawing and modeling were teachable, and that the art teacher could do no more than act as "fermenter" and "catalyst."[27] With this he implicitly disputed a significant body of opinion in and out of the Werkbund that, indeed, art could not be taught, but that a systematic training in certain fundamentals of design was both possible and necessary. But with it he also ignored his own similar optimistic assertions of earlier years that, beyond mere *Technik*, there were what he had called the "basic requirements of all the visual arts" (*Grundnotwendigkeiten aller bildenden Künste*), the "conditiones sine quibus non est ars" which could be imparted by teaching.[28] Now, instead, he demanded flatly, "away with 'orderly', 'systematic' instruction! Only thus will the way be free for art, for the creative."[29] Of course, how we interpret this depends upon how we understand his " 'orderly' " and " 'systematic'." Obrist had always maintained, and observed it in his own teaching, that art training could proceed only by self-discovery and through personal example and suggestion on the part of the teacher—through "opening the eyes" of the student. Presumably, the quotation marks placed around the words "orderly" and "systematic" meant that he was referring only to the "bad" sort of formula teaching associated with the academy, or to similar tendencies in certain of the new reform schemes. Nevertheless, if we compare this with the serious attention he had given

[26] Cf., e.g., the remark of Hans Schmidkunz of the same year that he disagreed with the "greatly predominant majority" on this question (Hans Schmidkunz, *Die Ausbildung des Künstlers*, Führer zur Kunst, vol. 7, Esslingen, 1907, p. 4).

[27] "Kunstschulen," *Kunst und Künstler* 5, no. 5 (February 1907): 208–209. "Kunst gedeiht, solange sie nicht gelehrt wird."

[28] Cf. Hermann Obrist, *Neue Möglichkeiten in der bildenden Kunst. Essays* (Leipzig, 1903), p. 64. With an earlier exception, these essays were written in the years 1899–1901.

[29] "Kunstschulen," p. 209.

earlier to the means by which the bases of art could in fact be taught, with the way he had seen the work of opening students' eyes as an orderly and disciplined pedagogical process, the difference in attitude—one is inclined to see it as a growing skepticism—is at once apparent.[30]

The fact that both men were fighting against revivalism and for the development of a viable modern style of art made it natural for Obrist to give his wholehearted support to Muthesius in 1907 when the latter came under attack from business interests opposed to the modern movement, the common goal of artistic renewal far outweighing among modern artists any divergencies of view they might have had.[31] But the essential differences between the two men eventually led to open disagreement. Obrist's characteristically ironic remarks at the 1914 Cologne congress were directed chiefly against the prevailing mediocrity of the exhibition, which he saw confirming his deepest convictions that the attempt to establish formal types as a means of achieving unity of style was premature in Europe and inimical to the creative growth of a true national art, which for him as for van de Velde was postulated on granting the widest latitude to individual creative effort—to "passion" and "rapture," as he put it—consonant with a respect for function and material. But Obrist also saw fit to add, *en passant* (the very offhandedness of the jibe indicating its self-evidence for him), that "the principles of the Werkbund are, to be sure, thoroughly contestable, but a few of them are undoubtedly excellent and worth taking to heart."[32] Moreover, a published ex-

[30] Cf. also Obrist, *Neue Möglichkeiten*, pp. 142–144.

[31] See Hermann Obrist, "Der 'Fall Muthesius' und die Künstler," *Dekorative Kunst* 16 (11. Jhrg.), no. 1 (October 1907): 42–44. For the speech of Muthesius's which led to the controversy, and its aftermath, see Hermann Muthesius, "Die Bedeutung des Kunstgewerbes. Eröffnungsrede zu den Vorlesungen über modernes Kunstgewerbe an der Handelshochschule in Berlin," *Dekorative Kunst* 15 (10. Jhrg.), no. 5 (February 1907): 177–192. Reprinted in Posener, *Anfänge des Funktionalismus*, pp. 176–186. Cf. also Heinrich Waentig, *Wirtschaft und Kunst* (Jena, 1909), pp. 285–286; and Nikolaus Pevsner, *Pioneers of Modern Design: From William Morris to Walter Gropius*, rev. ed. (Harmondsworth, Middlesex, 1960), p. 35.

[32] In Posener, p. 209. Cf. Obrist, *Neue Möglichkeiten*, p. 103: "[Die Konsequenz] ergibt sich . . . , dass es keinen einigen, einzigen Stil der Zukunft in der Architektur sollte geben können, sondern wie in der Musik . . . , mehrere, viele, ebensoviele, wie es ausgeprägte Persönlichkeiten geben wird, und dass das Wort Stil in der

cerpt from a letter of Erich Mendelsohn's of 1915 seems to indicate that Obrist had by then become deeply mistrustful of the machine's consequences for art and was inclined to divorce art from any consideration of utility, preferring to see it more than ever as a matter of *Kunstform* alone.[33]

We know much less about the prewar views of Hans Poelzig, whose duties at the Breslau academy kept him from following the Cologne dispute in person; his few published writings of the time show him to be wholly affirmative in his acceptance of the challenges offered the modern architect by the new industrial building tasks,[34] and give no hint of the position he was to take during

---

Zukunft jedenfalls auf geraume Zeit hinaus als durchgeführte persönliche Art wird definiert werden müssen" (from "Die Zukunft unserer Architektur," written in March 1900). To be sure, Obrist had, at the end of 1901, not altogether consistently urged that state workshops be established to develop convenient and practical "types," "die sogenannten Werkformen" of objects of common use which would form the "Substrat für die individuelle Variierung nach der Seite des künstlerischen Geschmackes hin" (*Neue Möglichkeiten*, p. 143. Obrist here retains the nineteenth-century distinction between *Werkform* and *Kunstform*, and the obvious question of how the former would affect the artistic element is not raised). But it is clear from his essay that this was to be only a means of purifying the applied arts and was not meant to supplant the more important contributions of the original artist of great imagination. "Type" for Obrist had never been a means, as it was for Muthesius or Behrens, of achieving homogeneity, which he did not desire: "Gewiss würden sich in vielen Fällen gemeinsame, stets wiederkehrende Grundformen an den Bauten vorfinden, und wie das einst im Mobiliar der Fall sein wird, so wird wohl auch in der Architektur das eintreten, dass man bei der . . . Verbreitung gewisser zweckmässiger Grundformen von einer . . . Volkskunst dereinst wird reden können. Allein das liegt noch und soll noch in weiter Ferne liegen. Vorerst aber hoffen wir von ganzem Herzen, dass die Städte, weit entfernt davon [sein werden], es sich zur Aufgabe zu machen, das ganze Ansehen der Strassen rein äusserlich einheitlich zu gestalten, indem sie einen Stil für mehr oder weniger alles kultivieren . . ." (*ibid.*, p. 115).

[33] Letter of April 4, 1915: "Eben schrieb ich an Obrist. Ich musste mich zwingen, nicht sarkastisch zu werden. . . . Alle künstleriche Arbeit hat schliesslich nur das Ziel, Zweckform und Kunstform zu absoluter Vereinigung zu bringen. Das heisst Stil. Die Notwendigkeit dieser Trennung ist nur Beweis für die Übergangszeit, in der wir uns befinden. Die Maschine als Ausgangspunkt der neuen Kultur trägt bereits das erfüllte Gesetz in sich. Zu ihm wird das Zeitalter der Mechanisierung jede Erscheinung zwingen, Sinne und Seele. Alles daneben erscheint mir als wertlos. Somit ist der Gegensatz zwischen 'Zweckgebilde' und dem Gebilde der Zwecklosigkeit mir fremd und gehört in die Zeit der gusseisernen griechischen oder sonstwie historischen Säulen" (Erich Mendelsohn, *Briefe eines Architekten*, ed. Oskar Beyer, Munich, 1961, p. 36).

[34] E.g., his "Der neuzeitliche Fabrikbau."

and after the war when he became the proponent of an extreme individualism in architecture, defiantly railing in terms similar to those of Gropius against the constrictions of function and use. However, a letter in reply to Gropius's proposal of secession reveals him to have been by 1914 thoroughly dissatisfied with the Werkbund. He wrote that not only had the organization been made into a "monster," it had been so, "indeed, from the start"; and he declared that, in consequence, it was "as good as certain" that he would step out.[35]

The most vehement of the three in his defense of individualism at the Werkbund congress was Bruno Taut, who embarrassed even his friends by the extremity with which he presented his view that real art of any sort can only come from the activity of the small, truly creative elite.[36] Taut called for the replacement of the present Werkbund committee structure by an "absolute dictator" who alone would be final judge in all matters of art. For this office he proposed either van de Velde or Poelzig.[37] Taut was at this time already an intimate of the *Sturm* circle in Berlin, and as we shall see, some of his remarks at the congress directly and vividly echoed sentiments of the pictorial and literary avant-garde, under whose influence his ideas were then being formed.

Taken together with the particular unmistakable direction we have seen in his writings, the discovery that Gropius counted himself a secessionist in the company of the individualists within the Werkbund makes it apparent that he, too, believed in the necessity of an artistic elite and helps to make far more comprehensible the changes that were to take place in his way of thinking by the end of the war and his union then with the painters and sculptors who came together to form the Arbeitsrat für Kunst. It also incidentally explains the otherwise puzzling fact which has scarcely been remarked upon, that it should have been Gropius whom van

[35] Appendix C, p. 263. In actual fact, he was in 1919 to be elected chairman of a "chastened" Werkbund to whose executive board Gropius and Taut were also to belong.

[36] See Osthaus's comments, Appendix C, p. 267.

[37] In Posener, pp. 214–215. Later in the debate Taut qualified himself by explaining that all he had meant by *Diktator* was that in any artistic undertaking the planning and directing must be done by an artist (Muthesius, "Die Werkbund-Arbeit der Zukunft," p. 82).

de Velde chose to recommend along with two designers of the *Jugendstil* generation, Endell and Obrist, as his successor at Weimar.[38] It was in recognition not only of his evident artistic and art-political talents, but more to the point, of his support at Cologne and his energetic endeavors in their common cause.

Such anticipations of Gropius's later activities with the Arbeitsrat on the one hand, and his connections on the other with men who were themselves very much aware of, and even in touch with, the avant-garde movements in the other arts, raise the still largely unanswered question of Gropius's own contacts in the years just before the war with modern—and particularly expressionist—painters and sculptors. A consideration of the question by Thomas Creighton within the broader context of Gropius's relation to the fine artists throughout his career has concluded in the absence of strong positive evidence that he was, in fact, acquainted closely with few fine artists at the time.[39]

Whether or not future evidence discloses that Gropius did have more intensive connections before the war with the radical movements in the sister arts than now seems to be the case—and the conclusion seems indeed to be that they were only peripheral[40]—it

[38] See van de Velde's letter to Gropius of April 11, 1915 (published in van de Velde's *Geschichte meines Lebens*, p. 501, and Wingler, *Bauhaus*, p. 27).

[39] "When one asks [Gropius] what artists he knew before the call to Weimar, he searches for names and remembers Gerhardt [*sic*] Marcks and Hinnert Schaper [*sic*], both of whom he took with him to the Bauhaus" (Thomas H. Creighton, "Walter Gropius and the Arts," in *Four Great Makers of Modern Architecture . . . : A verbatim record of a symposium held at the* [Columbia University] *School of Architecture from March to May 1961*, New York, 1963, p. 251). This statement is, however, misleading chronologically, if by "before the call to Weimar" we mean before Gropius's final acceptance and signing of the contract in April 1919. By then, of course, he was already in the Arbeitsrat für Kunst; friends with Feininger and César Klein, the *Geschäftsführer* of the Arbeitsrat; and acquainted personally, if not closely, with other fine artists in the group. Furthermore, if Gropius's recollection can be relied upon, his acquaintance with Scheper is without significance for the question, since the latter, only twenty-two in 1919, entered the Bauhaus as a student.

[40] There are few references to fine artists in Gropius's Werkbund papers (see Appendix C, letter to Osthaus of July 12, 1914, for the names of some artists, among others, sympathetic to Gropius's side in the Werkbund debate). Gropius had collaborated in the 1914 Werkbund exhibition with the sculptors Richard Scheibe and Gerhard Marcks, and the painters Carl Hofer, Erwin Hass, César Klein, Otto Penner, and Walter Bötticher (see *Deutsche Form im Kriegsjahr. Die Ausstellung Köln 1914*, Jahrbuch des Deutschen Werkbundes 1915 [Munich],

remains the case that the avant-garde had no appreciable influence upon his stated ideas and opinions. Although he shared the general goals of artistic renewal common to all modern artists, his writings of the time, unlike those of Taut, reflect very few of the distinguishing ideas and assumptions held by radical circles of painters and sculptors in Germany or elsewhere. In particular, they lack entirely the specific formulations and sentiments that, as we shall see, were to link Gropius's postwar statements to the thinking of the prewar expressionist circles of Munich and Berlin.[41]

In essence, the changes that were to appear in Gropius's thinking about art and its relation to society just after the war amount to his adoption of many of the ideas and convictions held in those

---

pp. 20, 34 and pls. 49, 139, and *Offizieller Katalog der Deutschen Werkbund-Aus-stellung, Cöln 1914, Mai bis Oktober,* Cologne and Berlin, 1914, pp. 317, 331). He also, presumably, had some acquaintanceship with the Viennese avant-garde through his friendship with Alma Mahler. They first met, according to her, in 1910 (Alma Mahler Werfel, *And the Bridge Is Love,* New York, 1958, pp. 49–51).

[41] Can we say the same, however, about this influence on his architecture of the time? His knowledge of Paul Scheerbart is a case in point. The use of glass in the Fagus factory certainly does not require us to see Scheerbart behind it. It can be accounted for on the basis of precedents as well as the widespread interest of the period in glass as a building material. It drew inspiration generally from utilitarian construction and most directly from Behrens's AEG turbine plant of 1909, from which Gropius derived the idea of hanging glass sheets forward of the piers from a crowning masonry surface set flush with the glass and of giving the glass a slight forward slope upward, which reversed Behrens's procedure in the AEG plant of setting a vertical glass screen against battered piers. The later Werkbund building is another matter, however. Lindahl expressly rejects any connection with the ideas of Taut and Scheerbart; but he also rightly finds the building "ebensowenig der blosse Ausdruck einer unkomplizierten Nützlichkeitsdoktrin. Auch bei Gropius [as with Taut and Scheerbart] handelt es sich um ein Programm, einen Utopismus mit entfernten und grossartigen Zielen" ("Zukunftskathedrale," p. 230). As developed by Lindahl, this is a just observation, even if the formulation overstates the case and is too suggestive of Gropius's postwar utopianism. Behne's early estimation of the building's "pionierhafte Phantastik," a quality too often overlooked in recent discussions, seems entirely apt (cf. Adolf Behne, "Die Kölner Werkbundausstellung," *Die Gegenwart,* no. 32 [1914], pp. 501–506). Its more expansive and freer use of glass, and especially its unprecedented glass staircase turrets which have no functional *raison d'être* do suggest a possible awareness of Scheerbart's ideas, even though the building does not generally share the poet's architectural aesthetic. Such an awareness could have come through Taut, who, as is well known, was close to Scheerbart and whose glass Werkbund pavilion was designed entirely under the inspiration of the writer (see Chapter 3).

circles. It is conceivable that he may have begun to come under their influence as early as 1914 as a result of his association with Bruno Taut during the Werkbund congress. Such a hypothesis might help, though it is hardly necessary, to explain his actions in the dispute with Muthesius. On the other hand, as we have already seen, his Weimar plan of early 1916 still shows no change over his earlier stated views; he had certainly not yet transferred his major interest from industrial designing to handicraft. The invocation in his plan of the medieval *Bauhütten* may already suggest the influence of Tautian ideas, since appeals to the Middle Ages are singularly lacking in at least published Werkbund discussions but were common enough among the expressionists and can be found in Taut's own writing. But this intimation aside, the really crucial changes in his outlook took place only after the beginning of 1916. In the transformed economic, political, and social climate of postwar Germany, ideas which before then had been most at home among the avant-garde painters, sculptors, and writers were to become relevant for many architects, especially among the younger generation. Under their impact, Gropius's dissatisfaction with the Werkbund and his hopes for a more effective organization of designers and architects were channeled in a new and radical direction.

# BRUNO TAUT, ADOLF BEHNE, AND
# THE MISSION OF THE AVANT-GARDE

3

### The Ideal of the "Cathedral of the Future"

In his excellent historical addendum to the republication of the Blaue Reiter Almanac, Klaus Lankheit justly remarks that the Bauhaus may be considered "the legitimate continuation of the 'Blaue Reiter' on a new historical plane"; for, he observes, besides the fact that Kandinsky, Klee, and Feininger had all been associated with the group, the Bauhaus manifesto "bears the same ... utopian character as the ideas of the 'Blaue Reiter' of a visionary advent and is comparable even in its diction with Franz Marc's essays." Moreover, he notes, both shared the idea of "a cultural synthesis encompassing all fields."[1] Lankheit's observation can be illustrated by comparing the manifesto's ringing conclusion, "let us ... create together the new building of the future, ... which will rise one day toward heaven from the hands of a million hand workers as the crystal symbol of a new, coming faith," with Franz Marc's very similar words from the Almanac on the mission of the new German painters: "Their thinking has a different goal: by their work to create *symbols* for their time which belong on the

[1] *Der Blaue Reiter. Herausgegeben von Wassily Kandinsky und Franz Marc*, ed. Klaus Lankheit (Munich, 1965), pp. 299–300.

altars of the coming spiritual religion and behind which the makers of technical things will disappear."[2]

Lankheit's presentation must, however, be modified in one important respect: the cultural synthesis of the Blaue Reiter, for reasons that are not hard to find, did not include architecture. For the most part, it was not from the Blaue Reiter directly that the Bauhaus proclamation drew its inspiration, but through the mediation of architects who had themselves been in close contact with radical painters and poets, and who had, before Gropius, assimilated and adapted theirs and similar ideas. Many of Gropius's postwar sentiments—their language and even many of the specific symbols used by him—are first to be found, already before the war, in the writings of architects as otherwise opposed as—surprisingly —Adolf Loos and Bruno Taut, both of whom were members of, or at least in close contact with, the circle of *Der Sturm.*

Loos is not usually thought of in an expressionist context, yet he was from the beginning the close friend of a number of artists and writers who regularly published in *Der Sturm,* among them Oskar Kokoschka and Else Lasker-Schüler. As early as 1910 he gave a lecture on architecture before the *Sturm*-sponsored Berlin Verein für Kunst.[3] In it, with customary irony, he excluded all of architecture except the funerary monument from the classification of art,[4] setting it as a useful enterprise against the self-sufficient work of art, which in contrast "is the private concern of the artist" and "needs to please no one." Loos's was not only an attack upon ornament from the side of an architect seeking a purified architecture; it was also a defense from the side of the fine artist of the

---

[2] ". . . erschaffen wir gemeinsam den neuen Bau der Zukunft, . . . der aus Millionen Händen der Handwerker einst gen Himmel steigen wird als kristallenes Sinnbild eines neuen kommenden Glaubens." "Ihr Denken hat ein anderes Ziel: Durch ihre Arbeit ihrer Zeit *Symbole* zu schaffen, die auf die Altäre der kommenden geistigen Religion gehören und hinter denen der technische Erzeuger verschwindet" (*ibid.,* p. 31; also quoted by Lankheit in his addendum, p. 287).

[3] The relevant portion was immediately afterward published in *Der Sturm* (Adolf Loos, "Über Architektur," no. 42, December 15, 1910). The entire speech is published in Adolf Loos, *Sämtliche Schriften,* vol. 1, ed. Franz Glück (Vienna and Munich, 1962), pp. 302–318.

[4] Loos, *Schriften,* p. 315: ". . . alles, was einem Zweck dient, ist aus dem Reiche der Kunst auszuschliessen."

special and inviolate position of art against the corrupting influence of the mundane. Loos, as one of the most ardent supporters of the new art, was impelled by the same fervor as the artists themselves to proclaim its high mission:

Art is revolutionary. . . . [It] shows mankind new roads and looks to the future. . . .

He who knows . . . that art exists in order to lead men ever farther, ever higher, to make them more god-like, will feel the confusion of material ends with art as a profanation of the highest. . . . The artist requires no majority behind him. His realm is the future.[5]

In this we find precisely the same sentiment toward art that was to be expressed by Gropius after the war, with the significant difference that Loos omits architecture from the exalted realm. If the tone of the speech is cooler and ironic (and no other architect, least of all a Werkbund architect, was to draw the line between the useful object and the work of art more sharply than Loos did here), the contrast it makes between the sacred mission of art as spiritual guide and the relatively humble role of everyday architecture is essentially the same as that made by Gropius. Loos's lecture first reached a wider public with its publication in French in 1912,[6] and later, in 1931, with his collected essays, *Trotzdem*. With its inclusion in the latter, the essay came to be seen as a part of Loos's prophecy of the new "functional" style of architecture. But seen within their original, *Sturm* context, Loos's remarks about the sacredness of art take on a different, and one is tempted to say expressionist, coloration.[7]

---

[5] *Ibid.*, pp. 314–316.

[6] In *Cahiers d'aujourd'hui*, no. 2 (December 1912), pp. 82–92 (not 1913 as stated in Loos, *Schriften*, p. 459n.).

[7] In fact, Adolf Behne, whose ideas are discussed in this chapter, actually cited Loos along with Taut in a *Sturm* article of 1915 as one of his two examples of true expressionist architects whose work does not depend upon external forms or concepts but develops "wholly from within" from the purpose of the work itself, and consequently evolves ever-new forms (Adolf Behne, "Expressionistische Architektur," *Der Sturm* 5, no. 19–20 [January 1915]: 135; reprinted from Behne's *Zur neuen Kunst*, published by *Der Sturm* in 1914, 2d ed. 1916). Behne in his article was in effect upholding *Sachlichkeit*, the importance of "the elementary, *sachlichen*, and therefore natural powers of life"; an indication, incidentally, of how broadly the concept expressionism was used at the time. For the early history and the meanings of the word "expressionism" in painting see Donald E. Gordon, "On the

Gropius was certainly acquainted with Loos's ideas on art by 1918, through either his Viennese or his *Sturm* connections. Given the direction of his thinking at the time, it is quite conceivable that such views on the sanctity and prophetic value of art coming from one of the earliest exponents of a modern style of architecture, one whose work showed a similar but even more rigorous concern for *Sachlichkeit* than his own, may have reinforced, along with the ideas of such an older Werkbund architect as Hans Poelzig, his own changing convictions. But it was Bruno Taut who, as Gropius's friend and close collaborator on the Arbeitsrat für Kunst, stands out as the single most important influence on Gropius's thinking after the war. The force of Taut's visionary beliefs and the ardor and zeal with which he propounded them as architect, writer, editor, spokesman, and organizer were such, in fact, that he was able to put his stamp upon a considerable body of postwar architectural thought in Germany. As a member of the Werkbund and at the same time one of the few architects in the *Sturm* circle, Taut was one of the major links before the war between the two groups. It was Taut who, more than any other architect, was responsible for giving the old belief that architecture was the leader and integrator of the arts the characteristic visionary stamp it received for the postwar generation by uniting it with the expressionist artists' broad ideal of the collective mission of the avant-garde to lead society to a new future.

Already at the beginning of 1914, Taut published an article in *Der Sturm* which, in calling for the erection of a great synthetic work of architecture, presented for the first time, and in words that are virtually those of the Bauhaus proclamation, what was to become after the war the pervasive symbol of the *Zukunftskathedrale:* "Let us build together a magnificent building! A building which will not be architecture alone, but in which everything—painting, sculpture, everything together—will create a great architecture, and in which architecture will once again merge with the

Origin of the Word 'Expressionism'," *Journal of the Warburg and Courtauld Institutes* 29 (1966): 368–385, and Victor H. Miesel, "The Term Expressionism in the Visual Arts (1911–1920)," in *The Uses of History*, ed. Hayden V. White (Detroit, 1968), pp. 135–151.

other arts. Architecture will here be frame and content all at once."[8] In the essay are stated many of the themes that were later to be reiterated with more or less elaboration in the circle of the Arbeitsrat für Kunst: that there was a need to get painting and sculpture out of their isolation and reunited under the aegis of architecture; that a relationship existed between architecture and abstract art by virtue of their common architectural thinking; that spiritual and artistic leadership was then held by contemporary painting; and that the ideal of architecture was the functionless building, "free," in Taut's words, "from utilitarian requirements." The first two ideas were the familiar property of all in the modern movement; but the last two represent a new and distinct departure from Werkbund philosophy.

It should be observed that what in the Bauhaus proclamation appears as a metaphor for the sought-after organic society is in Taut's essay meant literally as a building to be constructed, a tangible proof of architecture's ability and willingness to participate on fully equal terms in the present cultural revolution begun and led by the artists. "This building does not need to have a purely practical aim," Taut declares; "even architecture can free itself from utilitarian requirements."[9] It is to be a great temple-museum of the modern spirit, built to display as integral parts of the architectural fabric works of the leading modern artists. The enterprise, Taut adds, could be begun about a modern private collection. The antecedents of this idea are in part such a *Jugendstil* monument to the collaboration of the arts as the Darmstadt *Künstlerkolonie* and, more immediately for some of its aims, the concept of the *Volkshaus* as it had been promoted notably by Taut's teacher, Theodor Fischer.[10] More directly, the idea was

8 Bruno Taut, "Eine Notwendigkeit," *Der Sturm* 4, no. 196–197 (February 1914): 175: "Bauen wir zusammen an einem grossartigen Bauwerk! An einem Bauwerk, das nicht allein Architektur ist, in dem alles, Malerei, Plastik, alles zusammen eine grosse Architektur bildet, und in dem die Architektur wieder in den andern Künsten aufgeht. Die Architektur soll hier Rahmen und Inhalt, alles Zugleich sein."
9 *Ibid.* "Dieses Bauwerk braucht keinen rein praktischen Zweck zu haben. Auch die Architektur kann sich von utilitaristischen Forderungen loslösen."
10 For Fischer's conception of the *Volkshaus*, which had something of a reputation at the time, see his "Was ich bauen möchte," first published in *Der Kunstwart* in Oct. 1906 and republished there in the Jan. 1918 number. Fischer called for the erection of popular cultural centers consisting essentially of halls, "colored and

probably suggested by the examples of the Folkwang Museum in
Hagen, which Karl Ernst Osthaus—another major link between
the Werkbund designers and the expressionists—had had van de
Velde design for him in 1900 to house his extensive modern col-
lection,[11] and the projects for the Kröller house and collection in
the Hague which were being worked on in the years 1911–13 by
Behrens and Mies van der Rohe.[12] But the chief architectural
ideal, though not style, behind the conception of the building,
including Taut's plan for the exterior and interior piers to support
the "constructive (*aufbauenden*) sculptures of Archipenko," and
the curious postscript that it need not even be finished in one gen-
eration, is plainly the Gothic cathedral, which Taut upholds as
the great example of the unification of the arts, the embodiment
of a "resounding total rhythm."[13] This particular homage to the
Gothic had become more or less a commonplace by now, as was,
of course, the desirability in principle of the ideal it stood for of
collaboration among craftsmen and artist-designers. But Taut de-
livers it with a conviction that, if anything, recalls the spirit of the
nineteenth-century Gothic revival.[14] By so doing, he in effect by-

multiform," which would be open at all times and which would hold art ex-
hibitions, musical and theatrical performances, lectures, and festivals, all geared
to the times of the year and the rhythms of the seasons.
[11] Karl Ernst Osthaus, *Henry van de Velde. Leben und Schaffen des Künstlers*,
Die neue Baukunst. Monographienreihe, vol. 1 (Hagen i. W., 1920), pp. 21ff. The
sympathies between the ideas of Osthaus and Taut were to show themselves in
1919 and 1920 when Osthaus published several of Taut's volumes of architectural
fantasies and utopian tracts. These were: *Alpine Architektur* (1919), *Die Auflösung
der Städte*, and *Der Weltbaumeister* (both 1920). In 1920 Osthaus also published
an "ideal project" by Taut for the former's envisioned Folkwang school, conceived
by Taut as a complex of small linked, domed pavilions surrounding a towering
star-shaped glass "Haus der Andacht," a variation on his *Haus der Kunst* and
*Stadtkrone* (Karl Ernst Osthaus, "Die Folkwang-Schule, ein Entwurf von Bruno
Taut," *Genius* 2 [1920]: 199–205).
[12] Ellen Joosten, *The Kröller-Müller Museum* (New York, 1965), pp. 8–9. For
ills. of the Behrens and Mies projects see Fritz Hoeber, *Peter Behrens* (Munich,
1913), pp. 200–202, and Arthur Drexler, *Ludwig Mies van der Rohe* (New York,
1960), p. 12.
[13] Taut, "Eine Notwendigkeit," p. 175.
[14] Indeed, the conviction was such that this same year Taut answered in the neg-
ative—the only one to do so—to a question published by *Bauwelt* whether archi-
tects, like painters and sculptors, ought to sign their works (Adolf Behne, *Die
Wiederkehr der Kunst*, Leipzig, 1919, pp. 78–80. Taut's answer is there approv-
ingiy quoted in full).

passes the prevailing tendencies of the Werkbund and returns to an artistic ideal of the Art Nouveau or *Jugendstil* generation.

Insofar as the Werkbund was pursuing a course directed toward a technologically oriented *Sachlichkeit*, it inevitably tended to subordinate or de-emphasize the goal of artistic synthesis—the fusion of architecture and the fine arts—which had been striven for in the Art Nouveau period. The modest attempts at combining the arts in the Werkbund exhibition at Cologne later that year were to show plainly how fundamentally unsuited such a course was for the creation of the total work of art in the Art Nouveau sense or the grandiose way Taut envisions it here. Muthesius, like Loos, among the older generation, had been perfectly aware of this when he launched his campaign of *Sachlichkeit* against the Art Nouveau. It was precisely against the van de Velde type of total "artistic" interior that he had turned at the beginning of the century when, in the same terms as Loos, he complained apropos of the Darmstadt artists' colony that "it is just as much an artist's art as painting. Just as one buys pictures or sculptures, one buys . . . finished rooms. . . . These interiors cannot be that felt arrangement of our personal environment they ought to be. They are foreign intrusions to which the occupant has to adapt instead of their adapting to him."[15]

Taut was at this point, at least, not advocating a return to the Art Nouveau ideal of the indissoluble synthesis of decoration and architecture: his words in other contexts do not dispute the Werkbund aims of simplicity and straightforwardness; and, in fact, his designs for more or less utilitarian buildings which were meant to be executed—even his later ones with their subdued neo-Gothic details—like those of Gropius never departed significantly from the broad prewar Werkbund aesthetic.[16] Even his plan for

[15] Hermann Muthesius, *Kultur und Kunst*, 2d ed. (Jena, 1909), pp. 3–4; cf. Loos's satirical attack on the total artistic interior, "Vom armen reichen Mann," 1900; reprinted in *Der Sturm*, March 1910 (Loos, *Sämtliche Schriften*, pp. 201–207).
[16] Cf. Bruno Taut, "Zu den Arbeiten der Architekten Bruno Taut und Hoffmann," *Moderne Bauformen* 12, no. 3 (March 1913): 121–124, and Taut, *Frühlicht 1920–1922. Eine Folge für die Verwirklichung des neuen Baugedankens*, ed. Ulrich Conrads (Berlin, Frankfurt am Main, and Vienna, 1963), *passim*, for ills. Cf. also the designs in his *Die Stadtkrone* (Jena, 1919). It is a different matter with his architectural fantasies. These, like those of some of the other Arbeitsrat architects illustrated in *Frühlicht*, exploit a wide variety of organic and pictorial forms.

the "house of art"—by no means a utopian project in his mind—calls for the construction of a "simple architectural organism."[17] Yet, if we must recognize a decided split between his words and fantasy projects on the one hand and his practical designs on the other, we cannot overlook the radical import of his program as set forth in his *Sturm* article. In his glorification of the free, creative imagination, implicit in his conception of the house of art; in his call for the maximum possible richness and variety in architecture as a whole (even though only sporadically followed by him in his work), Taut puts himself squarely in the company of those former *Jugendstil* designers and individualists who were most at odds with the prevailing direction of the Werkbund. Indeed, with his conception of an ideal, symbolic building—an absolute work of art not expressing (as Gropius was seeking to do at the same time) the union of art and utility but rising above the practical world as the richly decorated, "purposeless" Gothic cathedral had towered above the modest, practical buildings of the medieval city (an image Taut was to use later)—[18] he goes beyond them. In this essay, whose very title, "Eine Notwendigkeit," recalls that mysterious collective "necessity" which Richard Wagner proclaimed as the driving force behind the great *Gesamtkunstwerk* of the future, Taut proposes for the first time a precise equivalent in the visual arts, though upon an altered aesthetic basis, of the Wagnerian ideal of the total work of art.

Only once before, and not unexpectedly in the Art Nouveau period, had an architect come close to adopting the symbol of the theatrical *Gesamtkunstwerk* for architecture. In his *Feste des Lebens und der Kunst. Eine Betrachtung des Theaters als höchsten Kultursymbols*, published in 1900 by a leading supporter of the neoromantic poets, Eugen Diederichs,[19] and dedicated to the Darmstadt *Künstlerkolonie* of which he was then a member, the young Peter Behrens had envisioned the creation of a mag-

17 Taut, "Eine Notwendigkeit," p. 175: "Es wird ein einfacher baulicher Organismus hingestellt, auf einem freien Gelände in der Nähe der Grossstadt. . . ."
18 E.g., in *Die Stadkrone*, pp. 52–53, and his "Für die neue Baukunst!" *Das Kunstblatt* 3, no. 1 (January 1919): 21–23.
19 On Diederichs, who also published the Werkbund *Jahrbücher*, and his involvement in neoromantic ideals see George L. Mosse, *The Crisis of German Ideology: Intellectual Origins of the Third Reich* (New York, 1964), pp. 52–63 and *passim*.

nificent theater which would constitute by its union of art and architecture with music and the theater a great cultural center and symbol.[20] But Behrens's vision still remained within the Wagnerian context of the theater and theatrical spectacle, the chief differences being in the greater role given to the visual arts and in the self-sufficiency of their collaboration; for Behrens rejected Wagner's naturalism, insisting, as Kandinsky notably was to do later among the painters of the expressionist generation, that each of the arts should retain its integrity.[21] Instead, Taut, who likewise rejected Wagner's concept of the mutual submission of the arts to a goal beyond or outside their supposed individual limitations, lifted his conception entirely out of the frame of the theater and gave it to architecture, which now was to serve in the same function as the symbol of and inspiration for a new, universal spirituality.[22]

Yet Taut's road, so to speak, from the Gothic cathedral and the Wagnerian *Gesamtkunstwerk* to his house of art is not a direct

[20] Summarized with quotations in Hoeber's catalogue of Behrens's writings (*Peter Behrens*, p. 223, no. 2). See also Behrens's "Die Lebensmesse von Richard Dehmel," which appeared with his designs for a theater, in *Die Rheinlande*, January 1901, Sonderheft der Darmstädter Künstlerkolonie (summarized in Hoeber, p. 223, no. 3).

[21] Cf. Kandinsky's "Über Bühnenkomposition," first published in the Blaue Reiter Almanac. It was both a tribute to and an attempt to reform Wagner's concept (*Blaue Reiter*, pp. 189–208).

[22] Collins has pointed out another, closer anticipation of the *Zukunftskathedrale*, though not, presumably, as a translation of Wagner, in the work and ideas of Antoní Gaudí. (See George Collins's note 55 to Ulrich Conrads and Hans G. Sperlich, *The Architecture of Fantasy: Utopian Building and Planning in Modern Times*, trans., ed., and expanded C. C. Collins and G. R. Collins, New York and Washington, 1962, pp. 160–161.) Gaudí's Sagrada Familia was, of course, conceived as a Roman Catholic cathedral; but with his conception of an architecture of almost wilful originality, which he saw within the context of the Catalonian Renaissance as the nucleus of a flourishing artisan industry, along the lines of the medieval *Bauhütten*, and which, using modern methods and materials, would combine all the arts in a radiant, complex symbolism of light, color, and form, Gaudí comes strikingly close to the architectural vision of his contemporary, Paul Scheerbart (see below, pp. 100–101), or of Taut as he was to develop it during the war years. In an interview of 1908, Gaudí called the Sagrada Familia not the last of the cathedrals but "the first of the new series!" (See E. Marquina, "La Sagrada Familia," *L'Art et les artistes* 6, no. 11 [February 1908]: 516–522; also George R. Collins, *Antonio Gaudí*, New York, 1960, pp. 8, 13–14, 25.) It is, of course, possible that Taut knew Gaudí's ideas at the time of his *Sturm* article or later, but his conception of the *Zukunftskathedrale* does not require Gaudí behind it.

one through the *Jugendstil* designers. It passes through at least two by-ways.

In part, it is clear, Taut's hopes for modern architecture have been encouraged and moulded by the example of the modern painters and sculptors,[23] whose achievements for him served to reinforce the lessons he had probably already learned from such architects and designers as van de Velde and Obrist, the latter of whom had more than anyone else of his generation proclaimed the future of architecture to lie in a breadth and richness of form corresponding to the individual differences among artists and patrons. It was modern art which, by turning, as Taut saw it, to "pure synthesis and abstraction," had taken the first step toward a rapprochement with architecture. For: "Everywhere one hears talk of constructing pictures. An architectural idea lies behind this expression . . . which must not be taken simply as a metaphor, but which corresponds to architectural thinking in the simple sense of the word. A secret architecture goes through all these works and holds them together; in the same way it happened in the Gothic period."[24] Taut's comparison throughout is with Gothic architecture; for him the goal of the modern architect must be to achieve that "resounding total rhythm" and "construction heightened to the point of passion" which he sees as the essence of the Gothic style. But Taut does not conceal his belief that architecture has something to learn from painting to achieve that goal. It is not a question of borrowing superficial forms, for "architecture is

23 It need scarcely be added that just these years before and during the time of World War I mark the high tide of interest by German painters in Gothic art as a formal and iconographic source of inspiration. On this see, e.g., Peter Selz, *German Expressionist Painting* (Berkeley and Los Angeles, 1957), pp. 16–19; and esp. Gustav Hartlaub, *Kunst und Religion. Ein Versuch über die Möglichkeit neuer religiöser Kunst* (Leipzig, 1919), for numerous ills. of contemporary German religious painting and sculpture. See also Gordon, "The Word 'Expressionism',", pp. 376–378, who discusses Paul Fechter's *Der Expressionismus* of 1914 as the first linking of expressionism with the German Gothic spirit.

24 Taut, "Eine Notwendigkeit," p. 174: "Die Plastik und die Malerei finden sich auf rein synthetischen und abstrakten Wegen und man spricht überall von dem Aufbauen der Bilder. Es liegt dieser Bezeichnung eine Architekturidee des Bildes zugrunde, eine Idee, die aber nicht bloss vergleichsweise zu nehmen ist, sondern einem Architekturgedanken im einfachen Sinne des Wortes entspricht. Es geht eine geheime Architektur durch alle diese Werke und hält sie alle zusammen. In ähnlichem Sinne, wie es zu den Zeiten der Gotik sich vollzogen hat."

already cubistic in its essence, and it would be perverse to use, for instance, nothing but angular forms." For that matter, "the paintings of a Léger unite both angular and soft forms." What painting can teach architecture, instead, is variety and freedom from convention, and specifically, freedom from the tyranny of one-point perspective, which Taut equates with facade architecture (*Kulissenschöpfungen*) and which, he says, was never characteristic of the great epochs.[25] It is Kandinsky whom Taut chooses as the example to emulate. The architect "must bring into his creative work all possible architectural forms, in the same way that they manifest themselves pictorially in the brilliant compositions of Kandinsky; and this because architecture has to take into account every possible prerequisite (artistic, constructive, social, and pecuniary) if it hopes to achieve something lasting in its creations."[26]

The choice of Kandinsky seems at first singularly inappropriate, considering the fluid, painterly nature of his abstractions. But Taut is taking cognizance of the variety, richness, and pioneering nature of Kandinsky's abstract forms; and he is above all giving recognition to a figure acknowledged by the avant-garde to be one of its foremost intellectual and artistic leaders and spokesmen, one of the prophets and builders of the new creative and cultural synthesis which was being prepared by modern artists in all fields. Apart from Kandinsky's paintings, the works of prophecy were, of course, *Über das Geistige in der Kunst* and the Kandinsky essays in the Blaue Reiter Almanac; but in addition to his prestige as an artist and theorist, Kandinsky gained his reputation as a champion of new thought in all fields of art by his activities as an organizer of artists' groups and his position as a steady liaison among various modern artistic and intellectual groups—including musicians, dancers, and theater people—in Central Europe and

---

[25] *Ibid.*, p. 175.
[26] *Ibid.* "[Der Architekt] muss ähnlich alle möglichen Bauformen in sein Schaffensgebiet hineinziehen, wie sie sich im malerischen Sinne in den geistvollen Kompositionen Kandinskys äussern, und zwar deshalb, weil die Architektur sich auf eine breite Basis aller möglichen Voraussetzungen (künstlerische, konstruktive, soziale und pekuniäre) stellen muss, um ihren Erscheinungen etwas Dauerndes geben zu können. . . ."

Russia.[27] A striking glimpse of the influence Kandinsky's ideas had on Taut is given by the latter's impassioned outburst in support of an artistic elite at the Werkbund congress in Cologne that summer. Taut's heated call for an artistic *Diktator* seems to leap across the war years to sound a strident and decidedly *unsachlichen* note within the bounds of Werkbund discourse: "Art represents a pyramid which widens below. Above, at the peak, stand the most able, the artists who have ideas. The broadening base means nothing more than a leveling of these ideas."[28] These words are an unmistakable echo from Kandinsky's *Über das Geistige in der Kunst* of the image of the spiritual triangle dragged upward by the small, creative elite at its peak.[29]

Taut's elitism at this time shows itself again clearly in his concluding words to "Eine Notwendigkeit" that in creating the house of art "every thought of social purposes is to be avoided. The whole project must be exclusive, just as great art always exists first in the artist alone. The public may afterward learn from it or wait until its teacher comes." This consciousness of being part of a small vanguard, with its refusal to compromise ideals in the slightest to outside requirements, was later to be modified somewhat under the pressure of events and undoubtedly, too, under the influence of close collaboration with Gropius and Adolf Behne.[30]

27 Artists as diverse in their fields and directions as Franz Marc, Hans Arp, Arnold Schönberg and Hugo Ball acknowledged him an inspiration and one of the first leaders of the arts. See, e.g., Schönberg's tribute in the Blaue Reiter Almanac (*Blaue Reiter*, pp. 74–75) and Ball's in his *Die Flucht aus der Zeit* (Lucerne, 1946), p. 10; also Lankheit's citation of Ball's interest in Kandinsky (in *Blaue Reiter*, p. 299). On Kandinsky as a "charismatic" figure see also Sixten Ringbom, "Art in 'the Epoch of the Great Spiritual': Occult Elements in the Early Theory of Abstract Painting," *Journal of the Warburg and Courtauld Institutes* 29 (1966): 388.

28 In Julius Posener, *Anfänge des Funktionalismus. Von Arts and Crafts zum Deutschen Werkbund* (Berlin, Frankfurt am Main, and Vienna, 1964), pp. 214–215: "Die Kunst stellt eine Pyramide dar, die nach unten in die Breite geht. Oben an der Spitze stehen die Tüchtigsten, stehen die Künstler, die Ideen haben. Die breiter werdende Basis bedeutet nichts weiter als eine Verflachung dieser Ideen."

29 Cf. [Wassily] Kandinsky, *Über das Geistige in der Kunst*, 2d ed. (Munich, 1912), pp. 11–12.

30 But only somewhat. In fact Taut seems always to have remained something of a solitary dreamer. Cf. Gropius's letter to Adolf Behne of Dec. 29, 1919: "Brunos Arbeitsgemeinschaft hat sich bis jetzt nicht erwärmen können, was Du auch aus

It was done by recognizing the desirability of effecting cultural change through social action and education, and in this form became embodied in the Arbeitsrat für Kunst. At this point, however, it still shared that sense of isolation of the founders of the Blaue Reiter which was reflected, for example, in the introduction to *Über das Geistige in der Kunst* or by Marc's conviction, later to be specifically criticized by Behne, that "in other times art was the yeast that leavened the dough of the world. Such times are far from us today. Until they are realized, the artist will have to hold himself far from official life."[31]

But if Taut was generally inspired by the example of the modern pictorial tendencies, his specific vision of a great new architecture took shape under the by now well-recognized influence of a figure who directly links the *Jugendstil* or neoromantic generation with the expressionists of *Der Sturm*. This was Taut's close friend, the Berlin poet and architectural fantasist Paul Scheerbart, whose first book had appeared in 1889 and who was a regular contributor to *Der Sturm* until his death in 1915.[32] Scheerbart's influence, which, freely acknowledged by him, was to pervade Taut's writings through the early twenties and, largely through him, the

anliegender Beantwortung eines Briefes an Luckhardt ersiehst. Ich erkenne, dass Bruno für keine Gemeinschaft passt. Sein Schicksal ist allein zu bleiben und er sollte das erkennen und die Konsequenzen ziehen" (StAW B'haus, temp. no. 399). I am grateful to Allan Greenberg for allowing me to use his transcription of the letter.

[31] Quoted in Adolf Behne, "Kunstwende?" *Sozialistische Monatshefte* 24 (October 15, 1918): 950.

[32] Scheerbart's influence on the development of glass architecture and on the designs and ideas of the Arbeitsrat group, and especially on Taut and Behne, has been well documented in recent years. See esp. Göran Lindahl, "Von der Zukunftskathedrale bis zur Wohnmaschine. Deutsche Architektur und Architekturdebatte nach dem ersten Weltkriege," in *Idea and Form*, Figura: Uppsala Studies in the History of Art, N. S., vol. 1 (1959), pp. 243–244; Reyner Banham, "The Glass Paradise," *Architectural Review* 125, no. 745 (February 1959): 87–89; Udo Kultermann, "Paul Scheerbart und die Architektur im 20. Jahrhundert," in *Handbuch des Bauwesens 1963* (Stuttgart, 1962), pp. 46–63; *idem, Der Schlüssel zur Architektur von heute* (Vienna and Düsseldorf, 1963), pp. 46–50, 211–212, 237–238 and *passim*; Conrads and Sperlich, *Architecture of Fantasy, passim*. For a description and evaluations of Scheerbart's life and work, see the introduction to Paul Scheerbart, *Paul Scheerbart. Eine Einführung in sein Werk und eine Auswahl*, intro. and ed. Carl Mumm (Wiesbaden, 1955), and the postscript by Else Harke to Scheerbart, *Dichterische Hauptwerke* (Stuttgart, 1962).

whole circle of the Arbeitsrat für Kunst, is to be seen only inferentially in "Eine Notwendigkeit"; but it is already fully apparent in Taut's glass pavilion for the 1914 Werkbund exhibition, whose vaguely Eastern glass cupola design was inspired by Scheerbart and which displayed mottoes devised by the poet expressly for it.[33]

Scheerbart's importance insofar as it pertains to this study is to be found in his vision of architecture as a free, richly imaginative—even fantastic—art capable through its sheer contemplative beauty and its transformation of the environment of effecting wholesale moral and spiritual changes in men. In particular, architecture had for him the power of bringing men to that condition of universal brotherhood with all things which was the central obsession of his writings. It was this dominant vision of unity, linked to a grandiose but not always fantastic conception of architecture, which in large part accounts for the great significance Scheerbart's work assumed for Taut and the circle of the Arbeitsrat für Kunst. Expressed by Scheerbart in extreme, mystical form, probably under the influence of Theosophy,[34] and for this reason doubtless rendered more attractive to the artists, his dream of unity was one more symptom—one of the most extreme—of that desire for wholeness—religious, artistic, and social—which all but universally influenced German art and literature of the period.[35] Affecting in art, on one level, the imagery and thinking of such artists as Marc and Kandinsky, and on a more mundane level the Werkbund goal of a coherent modern style, it was to lead socially to an attraction on the part of many artists for such radical solutions as Kropotkin's anarchism or, more generally, for that simple life of craftsmanship and art in close contact with the soil which

[33] The letters of Scheerbart to Taut relating to the glass pavilion and its mottoes were later published by Taut, Feb. 1920, in *Frühlicht* (reprinted in Taut, *Frühlicht*, pp. 18–23).
[34] Suggested by Banham, "Glass Paradise," p. 89. The influence of Theosophy is especially suggested by the astral imagery of some of Scheerbart's fantasies. Cf. esp. his *Lesabendio*.
[35] On these ideas in the literature of the period see Walter H. Sokel, *The Writer in Extremis: Expressionism in Twentieth-century German Literature* (New York, Toronto, and London, 1964).

we have already seen reflected in the postwar thinking of Gropius and which finds full expression in the writings of Taut or Adolf Behne.[36]

Taut was to develop and spread his ideas during and after the war in a number of books and articles. In the wartime climate and its aftermath, they received a new sense of urgency which at times reached an almost hysterical pitch. With a passionate longing for social and spiritual integrity strongly reflecting the comparable sentiments of Scheerbart, Taut reiterated ceaselessly the already long held assumption that a great new art could not arise again without a universal religion. Under the dominating influence of Scheerbart's thought, he increasingly came to see the essence of art and architecture as the expression of religious feeling, as aiming beyond the earthly toward some never defined, transcendent goal.[37] For this reason, he more than ever came to regard utilitarian building as an inherently inferior species, a necessary but distasteful chore. It was the architect who had to lead men back to their lost spiritual unity, who had "to remember his high, magnificent, priest-like, divine calling and seek to raise the treasure that lies in the depths of men's souls."[38] With these words Taut adopted for the architect what had been the symbolists' and before them the romantics' conception of the poet as a kind of priest. But because the architect did not yet recognize his lofty role, Taut again pointed to the other arts which were in their own ways striving for the unity it was architecture's rightful task to direct: "Where are the architects? Do they not hear the call? They, the true creators of an all-unifying art—where are they?" And

[36] The fullest statements of Taut's ideal of a decentralized communal society are to be found in his "Die Erde eine gute Wohnung," *Die Volkswohnung. Zeitschrift für Wohnungsbau und Siedlungswesen* 1, no. 4 (February 24, 1919): 45–48, written Christmas 1918, and his *Die Auflösung der Städte . . .* (Hagen i. W., 1920). See also Taut's reply in *Ja! Stimmen des Arbeitsrates für Kunst in Berlin* (Berlin, November 1919), reprinted in Diether Schmidt, ed., *Manifeste Manifeste 1905– 1933. Schriften deutscher Künstler des zwanzigsten Jahrhunderts*, vol. 1 (Dresden, [1964]), p. 226. In addition to Scheerbart, Taut frequently invoked in his writings the names of such opponents of centralization as Rousseau, Kropotkin, and Tolstoy. Kropotkin's *Fields, Factories and Workshops* went through three German editions: 1904, 1910, and 1921.

[37] See esp. his *Stadtkrone*, p. 51.

[38] *Ibid.*, p. 60.

he now cited the paintings of Marc and the cubists as those which above all showed the greatest striving toward unity, "a unity in pictorial construction and in the construction of a total art whose innermost essence is architecture."[39] It is not at all clear from this praise of cubism whether Taut is referring merely to its formal unity or whether he also has in mind a definite expressive or iconographic intention such as we know is present in the work of Marc. As we shall see, however, this distinction was not kept clear in the circle of the Arbeitsrat für Kunst, and cubism was made by Taut and others into a new kind of expressionism, appealed to for the mystical and universalist qualities the architects saw in it.

Taut's most elaborate program to appear after "Eine Notwendigkeit" was *Die Stadtkrone*, his treatise on city planning, published in 1919, in which his earlier conception of the "house of art" was developed into the vision of a towering "city crown," a Scheerbartian glass temple to the religion of the brotherhood of man, "socialism in the unpolitical, suprapolitical sense."[40] The symbolic values of the building were to be carried by the architecture itself, along with its sculpture and glass paintings, as the actual bearer of the religious experience. Here Taut presents the full-fledged *Zukunftskathedrale*, the literal embodiment of the "crystal symbol" figure of speech of the Bauhaus proclamation, the significant change over his earlier *Kunsthaus* being the explicit burden of social and religious meaning he now assigns to it.

The idea owes its most fundamental inspiration to Paul Scheerbart. It had first appeared in Taut's work in his folio of visionary architectural drawings, *Alpine Architektur*, published in 1919 after *Die Stadtkrone*, but conceived and drawn in 1917–1918, according to a note in the table of contents. There, in his presentation of the "Crystal House," a temple of devotion and contemplation, Taut made full acknowledgment of his debt by using a passage from Scheerbart's *Münchhausen und Clarissa* as a caption: "Nothing corresponding to our divine service exists here—they

[39] Taut, "Für die neue Baukunst!" p. 18. ". . . eine Einheit im Aufbauen des Bildes und im Aufbauen einer Gesamtkunst, einer Kunst, deren innerstes Wesen die Architektur ist."
[40] Taut, *Stadtkrone*, p. 59.

[i.e., the buildings in his mythical Australia] work entirely through their sublime architecture."[41] Scheerbart was again given frank and admiring credit for the idea in *Die Stadtkrone*. In a poetic essay contributed to Taut's book by Erich Baron, the inspiration behind the most remarkable aspect of the "city crown" was praised at length and included the same words:

Paul Scheerbart spoke of a religion of great silence. He knew "that before the magnificence of the universe we all have the need to kneel in ardent rapture." He dreamt of an entirely different kind of divine service than the one we know. His temples were to achieve their effect entirely through their sublime architecture and through a great still-ness which only now and then would be broken by refined orchestral and organ music.[42]

Unlike the fantastications of Taut's *Alpine Architektur* or his *Die Auflösung der Städte* of 1920, which were conceived (to quote part of his description of the latter in the title page) as "a parable or (although somewhat hasty) paraphrase of the 3rd millennium A.D.,"[43] Taut's *Stadtkrone* was a more serious project, intended, as he expressly states, for immediate consideration by architects and planners; consequently, it shows a rather sober arrangement of cubical masses.[44] Conceptually, however, Taut retains the Gothic cathedral as one of his models; but even more than that now, the

[41] Bruno Taut, *Alpine Architektur* (Hagen i. W., 1919), pl. 4.
[42] P. 103.
[43] The full title and description—all in script—read: *Die Auflösung der Städte oder Die Erde eine gute Wohnung oder auch: Der Weg zur Alpinen Architektur in 30 Zeichnungen. Es ist natürlich nur eine Utopie und eine kleine Unterhaltung,— wenn auch mit 'Beweisen' versehen im Litteratur[sic]-Anhang.—dem sehr geneigten Betrachter ein Gleichnis—oder eine ('doch etwas voreilige') Paraphrase auf das 3. Jahrtausend post Chr. nat. ('Aber es dürfte doch gut sein, sich auf alle Möglich-keiten der Wiedergeburt gefasst zu machen, wenn man noch nicht reif zum Eingehen ist.')* The captions and plates of *Alpine Architektur* and *Die Auflösung der Städte* have all been republished now in F. Borsi and G. K. König, *Architettura dell'espressionismo* (Genoa and Paris, 1967), pp. 256–272, 276–288.
[44] P. 81: "Sinn und Absicht dieser Arbeit ist es, nicht etwas zu geben, das in allen Einzelheiten feststeht, sondern vielmehr allgemein anzuregen und gerade auch dort fruchtbringend zu wirken, wo es sich nicht um ausgesprochen neue Städte, sondern um Erweiterungen und Umbildungen bestehender Zustände handelt." This, plus his cost analysis of the project and his discussion of recent antecedents and ways of implementing it (pp. 77–81), proves beyond doubt Taut's serious purpose in writing the book.

temples of India and Southeast Asia, which Taut raises to a higher position than the Gothic itself as the greatest achievaents of collaborative effort on a total work of art devoted to God. Involved in this supreme estimation of Eastern temple architecture is what Taut regards as its incommensurability. If he had earlier called for variety and richness of form as an expression of the individual artistic imagination, he now saw—again partly under the stimulus of Scheerbart's vision of entire peoples united in the construction of fantastically ornate, orientalizing architecture—[45]the proliferating detail of the Indian temple as the outcome of the collective effort of multitudes, creating joyously and anonymously under the sweeping inspiration of religious feeling: "The Indians have a saying that these buildings were built by gods; and we, too, can easily say it. For what has up to now appeared as something bizarre to eyes dimmed by Antiquity is beyond all concepts, principles, and theories so sublime and beautiful that no formula can encompass it. Life of the highest order and devoted creation in a state of ecstasy! In comparison, the radiance of the Gothic is limited."[46]

There is no doubt from everything he wrote and designed that Taut hoped for a future architecture with a scope and fantasy comparable to that of the Indian temple, one in which "all measurement, all copying is impossible."[47] But just as Gropius did, Taut insisted that until a new religion came into being and brought with it such a wealth of creation, the architect had no alternative but to build modestly and simply. Only in this way would he

---

45 Cf., e.g., Scheerbart's *Lesabendio* or *Münchhausen und Clarissa*.

46 Taut, "Für die neue Baukunst!" p. 24: "Der Volksmund in Indien sagt, diese Bauten haben Götter gebaut. Und auch wir können es ruhig sagen; denn was dem antikverschleierten Auge bisher bizarr erschien, das ist so über alle Begriffe, über alle Prinzipien und Theorien erhaben und schön, dass sich gar keine Formel damit decken kann. Höchstes Leben und hingegebenes Schaffen im Rausch! Die Verklärung des Gotikers ist beengt dagegen." For a contrast to Taut's elevation of Indian architecture to canonical status cf. Muthesius's reference in 1901 to it as "jene phantastischen, ornamentübersponnenen Bauwerke . . . , für die uns Europäern jedes Verständnis verschlossen bleibt" (Hermann Muthesius, "Kunst und Maschine," *Dekorative Kunst* 9 (5. Jhrg.), no. 4 [January 1902]: 143).

47 *Ibid.* "Vor der unbegreiflichen und unerschöpflichen Schönheit der indischen Bauwerke muss der . . . Fachmann . . . staunend wahrnehmen, dass jedes Messen, jedes Kopieren unmöglich ist. . . ."

show his true humility before the Highest. For Taut, a necessary corollary to the belief that imagination and its manifestation as ornament were expressions of religious feeling was the distinction that had to be made in treatment between the lavish *Kultusbau* and the modest unadorned work of everyday architecture.[48] It is not clear, given his predilection for an architecture of glass and steel, how he would have realized, within the handicraft-oriented society of communes he desired, this dream of a magnificent new architecture built by an entire people. His buildings would, presumably, have involved the large-scale use of hand labor—of both artists and craftsmen. Yet the aesthetic and technical consequences of this are never considered seriously by him. In a few places in his writings Taut criticizes the prevailing *Raumästhetik* or Berlage's concern with proportions as being too abstract and formalistic,[49] but aside from these and his general call for simplicity in utilitarian architecture, he gives few indications of a definite aesthetic to substantiate his vision of a future architecture comparable in richness to the Gothic cathedral or the Eastern temples.

Such an aesthetic was hinted at more strongly by the architectural critic and historian, Adolf Behne, the third founder, with Gropius and Taut, of the Arbeitsrat für Kunst.

### The Continuity of the Romantic Tradition in the Ideas of Behne and Taut

Behne and Gropius first met at the end of 1913 or the beginning of 1914, as is shown by the highly formal salutation and close ("Sehr geehrter Herr!" and "Hochachtungsvoll! Behne") of a letter by Behne dated January 15, 1914, requesting photographs from Gropius of his work.[50] By 1919, together with Taut, they had become close friends, addressing each other in letters in the familiar and—already at the beginning of that year—by their *noms de guerre* within the Arbeitsrat, "Mass" (Gropius) and "Ekart"

[48] *Ibid.*, pp. 20–24.
[49] *Ibid.*, p. 19.
[50] GAL, "Briefe, Arbeitsrat für Kunst, 1919/1921" file.

(Behne).[51] In any discussion of the ideas which were held in the postwar circle about Bruno Taut, Behne must, after Scheerbart, take third place. Along with Taut, he was a principal channel through which Scheerbart's visions were passed on to architects and an interested architectural public. Behne's ideas and convictions are at almost every point one with Taut's, as is the dithyrambic style of some of his writings of the war years and immediately thereafter. Not unexpectedly for a critic and historian, however, Behne set them in a more speculative and ideological framework, enlarging upon many of the themes only touched by Taut, though suggestively rather than in any systematic way.[52]

More than anyone else in the circle of the Arbeitsrat für Kunst who wrote in the years during and just after the war, Behne showed himself by his language, allusions, and choice of citations to be aware of the relation his thought had to the broad tradition of German romanticism. In his writings of these years is to be found repeated emphasis upon the infinite nature of art, the "divine will to form" (*göttliche Formungswille*) as the source of all beauty, and the necessity for artistic creation to conform to that will.[53] His lineage is revealed still more tellingly, perhaps, by his relative indifference to the question of form. *Die Wiederkehr der Kunst*, written in August 1918 partly in homage to the ideas of Scheerbart and Taut, and in its entirety as a hymn to the transcendent nature of art, opens with the ringing creed that "art is not a matter of form, but an attitude. . . . Art is the uncreated-created that requites us. Art is the touchstone that judges us. Art is the absolute!" And in place of those "wearers of spectacles, Winckelmann, Lessing, Goethe, Schiller, and Schinkel," who had decreed that architecture "could not be allowed to pull out all the stops,"

---

[51] *Ibid.* The first letter in Gropius's files (GAL) so addressed is a carbon of one of his to Behne dated March 6, 1919, revealing thereby that these pseudonyms were being used long before their use in the now familiar "utopian correspondence" initiated by Taut among his friends in November 1919. On the correspondence, see below, p. 126.

[52] According to Fr. Julia Behne, whose information was kindly conveyed to me by Allan Greenberg, Behne was a member of the majority Socialists. He was a regular reviewer and article writer for the *Sozialistische Monatshefte*, among other journals.

[53] Behne, *Wiederkehr der Kunst*, p. 25.

Behne offers "the true artists: from Heinrich von Kleist to Paul Scheerbart!"[54]

Like Taut, Behne at this time also attacked the classicistic *Raumästhetik* of the Werkbund; indeed, he went farther and attacked all of classical architecture, including that of Greece and Rome.[55] To it, he opposed an aesthetic of the wall as the sole carrier of artistic value in architecture. His, however, is not the Fiedlerian or Berlagian conception of the wall as the primary, not-to-be-violated artistic element of building, although both may be partly behind his idea.[56] Presented as it is within the context of praise for Gothic and Oriental architecture, it is closer to Goethe's well-known youthful praise of the walls of Strassburg cathedral as the tangible substance upon which the artistic genius of the builders was made sensible. "The carrier of life and experience in architecture," Behne states, "is the wall, and not space; for space cannot be grasped by the senses." And for support, Behne again leans upon Scheerbart, who "did not speak primarily of forms of space," but of "brick walls and still more, of glass walls."[57]

More insistently than Taut, Behne placed Oriental architecture above Gothic in the sheer wealth of its forms and in exercise of the imagination. It is clear from his articles on Russian medieval architecture that a decisive reason for his appreciation of the Eastern temple was, as it was with Taut, its freedom from what he condemns in all Western architecture, and even to a small degree in the Gothic: its constructed or tectonic character, by which he means the imposition of a controlling or dominant formal—that

---

[54] *Ibid.*, pp. 7, 74–75. "Kunst ist keine Formensache, sondern eine Gesinnung. . . . Kunst ist das Ungeschaffen-Geschaffene, das uns belohnt. Kunst ist der Prüfstein, der uns richtet. Kunst ist das Absolute!"

[55] *Ibid.*, p. 74 and *passim*.

[56] Earlier Behne had, in fact, propounded a view very similar to Berlage's (cf. his praise of Taut and Loos in his *Zur neuen Kunst*, excerpted as "Expressionistische Architektur" in *Der Sturm* 5, no. 19–20 [January 1915]: 135). The Amsterdam school may have been a partial influence on his later thinking. He was soon after the war to be in close contact with Dutch developments, which he reported regularly to his German readers (see below, p. 245).

[57] Adolf Behne, "Die Überwindung des Tektonischen in der russischen Baukunst," *Sozialistische Monatshefte* 24 (September 3, 1918): 836.

is to say, an essentially rationalistic—concept upon the individual parts and details of the building, so that they are to that degree robbed of their expressivity or imaginative quality.[58] The true architect, Behne says, using the familiar language of Kandinsky and *Einfühlung*, never prefers "some grandiose idea to what he has in front of his eyes and under his hands." Creating from "the law of inner spiritual necessity," he "identifies himself with every part, loses himself wholly in each section of wall, each cupola, each tower, and in so doing assures for his work the heightened fullness of life." In contrast, the tectonic architect identifies himself with the overall design, and thus his creative touch "can be found only in diluted form in the individual, perceivable part." In fact, Behne goes so far as to state that architecture is closer to the structure of E. T. A. Hoffmann's Rat Krespel in *Die Serapions-Brüder*, who built his house without plans of any sort, merely by starting to build the walls.[59] Such monuments as Borobudur or Chartres "are created not so much from a 'design' (*Entwurf*) as through the free cooperation of countless anonymous hands, through the cooperation of the people."[60]

[58] *Ibid.*, pp. 833–837, and *idem*, "Die russische Ästhetik," *Sozialistische Monatshefte* 24 (September 24, 1918): 894–896.

[59] Behne, "Überwindung des Tektonischen," p. 836. The Hoffmann story was, in fact, printed by Bruno Taut in the second issue of his *Frühlicht*, Feb. 1920.

[60] Behne, *Wiederkehr*, p. 76. Astonishingly, attempts at improvised collaboration between architects and artists were actually tried at the time in at least four instances, all of them involving members of the Arbeitsrat für Kunst: a shop on the corner of the Wilhelmstrasse and Unter den Linden designed and decorated by Otto Bartning and Oswald Herzog; some furniture for a *Gesellschaftszimmer* by the same artists; the Scala-Palast by Walter Würzbach, Alfred Gellhorn, Rudolf Belling, and Hans Brass; and the *Festsaal* and *Klubzimmer* in the restaurant for Taut's *Ledigenheim* in Schöneberg near Berlin, decorated by Bruno Taut, Paul Gösch, Franz Mutzenbecher, and a certain "Bildhauer Elster" (so identified by Taut, *Frühlicht*, p. 139; he does not appear on Arbeitsrat lists or in Vollmer). In the first three cases, according to Behne, who reported the artists as having undertaken it "um die theoretisch so oft vertretenen Möglichkeiten einer künstlerischen Arbeitsgemeinschaft praktisch zu erproben," the work was done without preliminary drawings. The furniture was executed directly from clay models, but the two buildings were built with the aid of craftsmen, without models, "directly and improvisatorily." Behne noted: "diese Art der Arbeit, die sich . . . dem Handwerklichen nähert, erwies sich . . . hier . . . als eine sehr glückliche, da sie auch den für die Durchführung der Arbeit herangezogenen Tischlern, Stukkateuren usw. eine

It is evident from all this—the ideal of a nation of artisans building together in spiritual unity, and especially the ensuing emphasis upon the manifestation of inspiration in the details and ornamentation of the building: upon an "organic" rather than a "planned" architecture—that Taut and, even more, Behne have returned in some respects to a position close to that of Ruskin and Morris. Theirs is not a simple continuation of the Arts and Crafts attitude, however; for, as we have seen, it represents a reaction against the dominant architectural thinking of the preceding generation. But neither is it a mere return to the Ruskinian point of view. If anything, Taut and Behne go beyond Ruskin and Morris in their scorn for the merely practical. There is scarcely anything before now in the history of the modern movement as it developed from Ruskin and Morris to compare to Behne's utter disdain for the "cabinets of Professor Schulze or Müller which are absolutely nothing but upright, perfectly accurate, dark, rectangular boxes," and to his heretical conclusion that "this cabinet is, of course, no better than the imitation Renaissance buffet it allegedly displaced; on the contrary, as bad as that was, this is even worse. For if the latter still had a counterfeit gleam of life, this one is totally dead!"[61] Similar is Taut's conclusion that "only where an excess of good living leads to a demand for luxury does it [architecture] seem to make its appearance in higher degree and to speak more strongly with its own voice. There it seems no longer

---

viel grössere innere Anteilnahme an der Arbeit abgewinnt." "Die Beteiligten glauben . . . die Erfahrung gemacht zu haben, dass die freie kameradschaftliche, direkte und improvisierende Arbeitsweise die Handwerker zu einer viel grössern Lust angeregt habe . . ." (Adolf Behne, "Berlin: Bauten," *Sozialistische Monatshefte* 27 [February 14, 1921]: 165–166). It is a rare indication that this Ruskinian argument was occasionally used by members of the Arbeitsrat. But Behne criticized the design of the Scala-Palast as not stemming from the structure and nature of the building. Taut described the work on the restaurant in Schöneberg as a "freie Improvisation . . . nach meinen Vorschlägen, . . . ein freies Musizieren in einer gleichen Tonart—im Gegensatz zu jedem puritanischen Stilgedanken" (Taut, *Frühlicht*, p. 139). Taut's intention was "dass die Künstler nur nach vorheriger Übereinkunft über das Allgemein-Räumliche ohne jede Vorarbeit im Atelier und demnach ohne Karton aus dem Raum selbst ihre Gestaltungen herleiten sollten." It is to be noted that throughout the account Taut's interest is entirely in the artistic *effects* of improvisation, and not in any putative moral value of the work itself.

61 Behne, *Wiederkehr*, p. 11.

so closely bound up with necessity, and hence for the first time to be really present as art."[62] The remark echoes the words of van de Velde's ninth counter-thesis delivered at the 1914 Werkbund congress that "quality is always created first for a very small circle of patrons and connoisseurs."[63] But van de Velde was there attacking the proposition that quality design could be achieved primarily out of a concern for economic policy; Taut's words, instead, are in their context intended even more than van de Velde's to point up the contrast between mere utility and the "purposelessness" of art. Thus, he defends, and even finds satisfaction in, a proposition that much of the modern movement since William Morris—and especially the Werkbund—had striven earnestly to challenge.

As with the *Jugendstil* generation, the focus of Taut's and Behne's ideas is in general shifted away from Ruskin's and Morris's central concern for the moral and ameliorative values of handiwork toward the aesthetic and symbolic, although the former consideration is still a factor for them. They place no particular emphasis upon the virtues of irregularity and imperfection, a doctrine concomitant in Ruskin to that of the morality of hand labor. This is true even for Behne, who otherwise gives so much importance to the sensuous, material aspect of architecture. Nor, by the same token, does either Taut or Behne have anything to say about the artistic effects of the machine upon the work of art. Most, if not all, of the members of the Arbeitsrat für Kunst were in agreement about the general evil of the present technological civilization and their desire for fewer, not more, machines. Behne, for one, went so far as to demand an outright choice: "Europeans, you cannot have both technology and art," and he insisted—logically—that Europe had to become "primitive again," that is, to "restrict . . . [itself] to the world of experi-

---

[62] Taut, *Stadtkrone*, p. 50.

[63] Reprinted in Ulrich Conrads, ed., *Programme und Manifeste zur Architektur des 20. Jahrhunderts* (Berlin, Frankfurt am Main, and Vienna, 1964), p. 27. Cf. also Obrist's remark just after the turn of the century: "Dass die Ausführung solcher Arbeiten zuerst nicht billing sein kann und Luxus sein wird, das erübrigt wohl von selbst. Es giebt aber keinen andern Weg zum Fortschritt" (Hermann Obrist, "Luxuskunst oder Volkskunst?" *Dekorative Kunst* 9 [5. Jhrg.], no. 3 [December 1901]: 99). That is, high-quality work must be costly at first, but it is ultimately to lead to a true *Volkskunst*.

ence" if it wished to free itself from the "slavery" of technology.[64]
And while Taut, to give another instance, did base his *Alpine
Architektur* and *Die Auflösung der Städte* upon a new era in tech-
nology, it was precisely a technology stripped of its power, of its
demands upon human joy, of its need for great economic and ma-
terial concentration. In Taut's utopia, men lead lives of simple,
individual pleasures much as they do in the "medieval," ma-
chineless utopia of William Morris's *News from Nowhere*. Tech-
nology in Taut, as in Scheerbart, is used almost entirely for play
and for symbolic, religious, or spiritual ends. Nowhere did Taut
ever sing the praises of the machine or technology; in none of his
utopian writings did he concern himself with even the most ele-
mentary economic, social, or material requirements necessary to
achieve the relatively few but astounding technical feats he as-
sumed in his future world.[65]

Despite all of this, however, the issue of the supposed aesthetic
superiority of handiwork over the machine, which had become a
relatively insignificant one since the founding of the Werkbund,

---

[64] Behne, *Wiederkehr*, pp. 111–112: "Wenn wir wieder primitiv werden, d.h.
wenn wir uns freiwillig auf die Welt des erlebens beschränken, ist die Erschütterung
der technischen Despotie die selbstverständliche Folge. . . . Europäer . . . : Du
kannst nicht Beides haben, die Technik und die Kunst. . . . Entweder du hast
die Einschienenbahn mit Kreiselstellung von London nacht Kapstadt und dazu
eine hohle Luxus- und Vergnügungskunst . . . oder du hast etwas was den Tempeln
zu Borobudor vergleichbar ist. . . ."
[65] The extent to which the machine would be allowed in the actual execution of
the work of architecture is, likewise, a problem not considered in the writings of
Taut and Behne, any more than it is by Gropius at this time. Clearly, their ideal of
the *Gesamtkunstwerk* necessarily limited severely, if it did not actually preclude, the
use of the machine in the "finishing" as opposed to the structural stages of building,
the former being left, as they were in the Sommerfeld house, for adornment by the
artists and craftsmen. We may assume that Taut and Behne accepted the use of
machinery for the purely technical tasks of construction, since they took for granted
the use of iron, glass, and concrete as building materials; yet the inevitable further
question of what consequences the use of machinery might have for the design
conception itself is never actually discussed by them. If this way of stating the
problem returns us to the nineteenth-century distinction between *Kernform* and
*Kunstform* (a distinction all modern architects of the period emphatically re-
jected in theory), it seems the inevitable outcome of trying to accommodate some
of the conflicts inherent in their vision of architecture. Indeed, the conflict be-
tween the intensive technological demands of steel and concrete as building ma-
terials for the great buildings envisioned by Taut and Behne and the return to a
smaller, simpler social structure remains in their writings an irreconcilable one.

was not raised again by Behne and Taut.[66] The main reason is not hard to find. They were interested above all in the importance for the work of art of the imaginative conception, and for them as for Gropius, this took precedence over any question of execution. Thus, in spite of his flat opposition of technology and art, his paean to the freedom of Oriental architecture, and his professed dislike of overall conceptualization, Behne could also praise Gropius as the only modern architect who demonstrated a "higher volition" (*höheres Wollen*), a reference perhaps to his ideas, but also, certainly, to his architecture.[67] What had attracted Behne to Gropius's work already before the war (and Behne's theories were broad enough to allow him to recognize and accept whatever was new and qualitatively distinctive in architecture) was above all its bold and extensive use of glass, its antimonumentality, and what Behne had perceptively called in his review of the 1914 Werkbund exhibition its "pionierhafte Phantastik."[68]

Taut and Behne, more than anyone else, carried over to architecture two dominant themes that had strongly marked German artistic thinking throughout the nineteenth century, from the romantics to the neoromantics at the end of the century, and that were then continued by many of the expressionist poets and artists: that the work of art should be the medium for the expression of a suprapersonal, transcendent content, and that it was the historical mission of the artist to lead mankind to the reattainment of social and spiritual harmony—to the organic society in which all human and spiritual oppositions would find their final reconciliation. We need merely recall Novalis's well-known millennial concept of the world mission of poetry to achieve a golden age in which the world and spirit will at last be united, and of poetry's original function "to reveal *within* the world that which is *beyond* it."[69] A similar conception of the sacred mission of art had like-

[66] The two other factors which along with the emphasis on formal design had figured in the similar indifference of Werkbund designers earlier—namely, the aim of designing specifically with the machine in mind and the related search for formal types—were, of course, not taken up by Taut and Behne.

[67] Behne, *Wiederkehr*, p. 22.

[68] See Chapter 2, n. 41.

[69] The literature on the romantic vision of the golden age, which the postwar German architectural dreams of an organic society fundamentally continue, is a vast

wise led Friedrich Schlegel to write: "It is time that all *artists* joined together as sworn brothers in eternal alliance" (*als Eidgenossen zu ewigem Bündnis*) to create a "community of the holy" (*Gemeinde der Heiligen*).[70] The basic continuity of this thinking through the neoromantics—in the Stefan George circle, for example—and prewar expressionists to the circle of the Arbeitsrat für Kunst which, along with the Bauhaus, Gropius was hyperbolically to conceive as a "secret conspiracy" of artists, becomes amply apparent.[71]

Within the context of these abiding ideals, the disputed figure of Richard Wagner and his conception of the *Gesamtkunstwerk* were not forgotten, least of all by Behne. Despite the general criticism that had been leveled at the Wagnerian idea of the "total work of art," Behne knowingly appealed to it in defending his ideal of architectural unity against possible objection. "It will be asked hesitantly," he admits in *Die Wiederkehr der Kunst*, "whether Richard Wagner's *Gesamtkunstwerk*, which we all thought had luckily been overcome at last, is now to be resurrected." But his answer is not a negative one, an attempt to help justify his architectural ideal by pointing to its departure from Wagner. On the contrary, he argues rather surprisingly that Wagner's ideal "was overcome only by virtue of the fact that we were not ready for it, that we did not heed its impulses, and not because of some insight higher than Wagner's into the essentials of art." Naturally, Behne adds that he recognizes the differences between

---

one. For a recent comprehensive study and extensive bibliography of the idea as it pertains to Novalis, who was of major importance in developing it for the nineteenth century, see Hans-Joachim Mähl, *Die Idee des goldenen Zeitalters im Werk des Novalis. Studien zur Wesensbestimmung der frühromantischen Utopie und zu ihren ideengeschichtlichen Voraussetzungen* (Heidelberg, 1965), esp. pp. 397ff.

[70] Quoted *ibid.*, p. 400, n. 4.

[71] On this last see Chapter 4. See also Sokel, *The Writer in Extremis, passim*, for a study of the ideal of unity among the literary expressionists; and Klaus Lankheit, "Die Frühromantik und die Grundlagen der 'gegenstandslosen Malerei,'" *Neue Heidelberger Jahrbücher*, Neue Folge (1951), pp. 55–90, for a number of suggestive parallels, which unfortunately remain only that in his treatment, between the words of the early romantics and those of Marc and Kandinsky. Cf. also Selz, *German Expressionist Painting*, pp. 19–21, and most recently Ringbom, "Art in 'the Epoch of the Great Spiritual,'" which in part treats the influence of Goethe and the romantics upon Rudolf Steiner and Kandinsky.

the modern view and Wagner's understanding of the nature of art; but these for him do not amount to a repudiation of Wagner so much as an extension of Wagner's ideal to include not merely the construction of "an occasional building supplied with wall paintings by a painter and portal sculptures by a sculptor," but "an inner transformation of all art," "a mutual drawing together" of the arts through common presuppositions and goals to achieve "an artistic cosmos from the artistic chaos of our day." And with this, Behne, like Taut, at once turns to cubism as the *Wegführer:* "We regard precisely this [creation of an artistic cosmos] as the true destiny of modern art, as the mission of cubism." For it is cubism more than any other artistic manifestation which by its forms and conceptions has come nearest to achieving a rapprochement with another art—namely, architecture.[72]

As is usual in the writings of the Arbeitsrat circle, which are more hortatory than explanatory, it is not easy to see precisely what this vaguely expressed conception of the union of the arts involves. It is certain, however, that Behne was not thinking of anything so exclusive as a narrow common language or vocabulary of forms, such as van Doesburg and De Stijl in Holland were envisioning, as the solution to the problem of artistic harmony, even though his words at first seem to imply it. Such a consideration would have gone directly against his concern for the freedom of the artistic faculty and would have meant the introduction into the creative process of that "external," imposed element of design he strongly objected to. The union of the arts as desired by Behne, and for that matter by Taut and Gropius, involved, rather, two separate notions which are not clearly distinguished in any of the writings of the Arbeitsrat circle: that of the actual physical union of the arts in the *Einheitskunstwerk;* but also the broader, more general—and for Behne the more important—notion, not primarily stylistic, of a common expressive and symbolic content capable of drawing together heterogeneous styles and different media. In *Die Wiederkehr der Kunst* Behne encompasses this common basis or spirit of the arts by the terms "cubist" and, rather inconsistently, "architectonic"; but by them he means little more

[72] Behne, *Wiederkehr*, pp. 39–40.

specific than a broad aim in each of the arts toward an abstract, constructive synthesis, whose "cosmic," supraindividual expression is opposed by him to the purely personal "psychograph" of the "mere lyricist," his term for the abstract artist who is only a naturalist of the inner life.[73]

For Behne, who here accepts entirely the metaphysical assumptions of German idealist thought, true art is the expression of the "World-Spirit." The words "architectonic" and "cubist" for him have nothing to do with what, as we have already noted, he elsewhere at precisely the same time calls confusingly the tectonic architect, that is, the architect who has an intellectual and, as it were, arbitrary conception of the whole. Rather, they describe that conformity by the artist to the eternal, immutable essence of all art, expressed by Behne in his distinction between the varying *Gestaltung* and the never-changing *Kunstform*. According to Behne, the true work of art, as contrasted to the "Machwerk," whose form is always characterized by "slackness," is determined "necessarily" by two "powers," between which it arises as between two poles. One is "Grace, which out of the infinite World-Spirit sends its ray into a man, the artist, and thereby releases the work of art." The other is "Fate, the cosmic World-Law, which from the other side, but stemming from the same World-Spirit, determines . . . the resulting work in every detail. . . ."[74] The true work of art, therefore, involves the close-to-perfect rapport between the artist and the spiritual basis of existence, which will then manifest itself inevitably in the essentiality of each form and

---

[73] *Ibid.*, pp. 16–25. The looseness of Behne's stylistic criteria may be judged from the painters he cites as architectonic: aside from the French cubists, he lists Marc, Chagall, Klee, and "above all," Feininger—all employing cubist structures (see also below, pp. 156–157). On the other hand, the Czech cubists Benes and Filla are called lyricists, since architectonic art is not a matter of "some sort of externality" (*ibid.*, p. 24). His list of "architectonic" architects is even broader and includes figures as different as Poelzig, van de Velde, Taut, Tessenow, and Gropius (*ibid.*, p. 22).

[74] *Ibid.*, pp. 32–34: "Das Kunstwerk steht zwischen zwei Gewalten, zwischen der Gnade, die aus dem unendlichen Weltgeist einen Strahl entsendet, der nun das Werk im Durchgehen durch einen Menschen, den Künstler, auslöst . . . und dem Schicksal, dem kosmischen Weltgesetz, das von der anderen Seite her, doch aus dem gleichen Weltgeist stammend, das entstehende Werk wie ein Magnet bis in alle Einzelheiten bestimmt als Kraft der Kristallisation."

the consequent harmony of all parts. From this it follows for Behne that "artistic form (*die Kunstform*), established prior to human existence, must forever be one and the same. What is different in the appearance of shapes (*Gestaltungen*) according to time and place does not lie in the perfection of the ideal, but in the inadequate means of reaching it. The ideal, the form, is unchangeable, and therefore art cannot 'develop,' it can only return."[75] It is clear that what Behne conceives here is not a concept of formal essences such as the French Purists were seeking in their art, but a far more undefinable abstract essential which is seen as underlying all real art, no matter what its style, and which is more or less approachable depending upon the spiritual depth and commitment of the particular era. It is very close to that undefined conception in Kandinsky's *Über das Geistige in der Kunst* of the "pure and eternal" objective element in art which is constant in all styles and for which all artists must strive. We may assume that Behne was influenced by Kandinsky's idea, but he focuses it expressly to include architecture and to make it more explicitly the bearer of a cosmic principle.[76]

This belief that all the arts should join in a common constructive goal, and even more, that all the arts at all times are at their core one and the same—a belief expressed by Gropius, too, in an article of 1919, "Baukunst im freien Volksstaat," as "ars una, species mille"[77]—helped to form the basis for the tendency in the Bauhaus to conceive design as the application of universal principles of form. The two aspects of the belief should, however, be kept in mind: it is usual to associate an interest in the physical union of the free arts—the *Einheitskunstwerk* of the first Bauhaus program—with the beginning of the school, and an emphasis upon the basic laws of *Gestaltung* primarily with the later Bauhaus, as it developed about 1922 after the coming of van Doesburg and De Stijl doctrines to Weimar. But as we shall see, the latter aspect was an important consideration from the very

[75] *Ibid.*, pp. 34–36.
[76] Cf. Kandinsky, *Über das Geistige*, pp. 65–71. See also Ringbom, "Art in 'the Epoch of the Great Spiritual,'" pp. 391–392, for the influence of Goethe upon this idea in Kandinsky.
[77] Published in the *Deutscher Revolutions-Almanach für das Jahr 1919* (Hamburg and Berlin, 1919), pp. 134–136.

start. Its source was on one side some fundamental Werkbund principles of formal simplicity and objectivity; but the broader ideal of a total formal and expressive affinity among the arts—which was also a Werkbund ideal—also played a role. The two may have led to different results in the view of many, Behne among them, but they were plainly not in conflict, as the acceptance of both in the early Bauhaus shows.

It was into this circle of thought that Gropius entered by 1918, and perhaps already as early as 1914 when he and Taut came together in their vigorous defense of van de Velde at the Werkbund congress. It led for a brief moment to his contributing to an impulse which is without parallel in architecture for the vehemence of its expression and the sheer scope and magnanimity of its social and artistic aspirations.

### The Relationship of Gropius's Ideas to Those of His Colleagues in the Arbeitsrat für Kunst

It has been exclaimed in astonishment that "a person like Gropius, grounded in the Werkbund and the office of Behrens, in touch with *Der Sturm* and its emphasis on Futurism, should be capable at this time of making no reference whatever to machinery, and should take his stand solely on the Morrisian standpoint of inspired craftsmanship."[78] But such a view not only fails to take into account sufficiently the extent to which Gropius's stand was in fact part of a new tendency in the architectural thinking of the time, it also mistakes seriously the ideological tenor of the *Sturm* circle, or for that matter, of German expressionism as a whole. Many expressionists did indeed look to a radically different future; but not, if one is to judge by expressionist criticism, poetry, and painting, with anything like the wholehearted enthusiasm of the futurists for technology and industrial civilization. Whatever "futurist" sentiment there may have been within the circle of *Der Sturm* was far outweighed by indifference or antagonism to the machine romanticism of the Italians. Marc, Macke, Campen-

[78] Reyner Banham, *Theory and Design in the First Machine Age* (London, 1960), pp. 277–278.

donk, and other leading German artists who exhibited at *Der Sturm* gallery adopted cubo-futurist styles but utterly rejected the technological imagery of the futurists. Even the lyrical, semi-abstract visions of airplanes and the Eiffel Tower painted by the influential French cubist, Robert Delaunay, have few counterparts, if any, in the work of his German admirers.[79] Two of the principal figures in the Blaue Reiter, Marc and Campendonk, used the style to express flight from the modern world and a primitivistic union of man and nature.[80] Marc's liking for the machine seems to have gone no farther than Ruskin's, if, indeed, it went even as far:

Is there a more lamentable spectacle than the captivation of our nation with the progress of science and technology? . . . On what do they base their conceit? The machine, for one. As if there were any machine that was not the shoddiest imitation of past human handiwork. A surrogate on which the spirit goes hungry. The railroad—the tritest plebeian invention; the airplane—can it in any way serve the spirit? . . . But there will come a time before long when our entire technology and science will seem endlessly boring. Men will abandon it completely—indeed, even forget it, because they will be dealing with spiritual goods.[81]

True enough, *Der Sturm*, as the principal showcase and champion of the avant-garde in Germany before the war, showed the futurists, defended them against critics, and published a number of their manifestoes and some of Marinetti's poems; but one looks in vain through the pages of *Der Sturm* for any echo of the manifestoes' technological sentiments. The contents of the periodical are entirely indicative of the general attitudes of the artists and writers who contributed to it. Aside from the manifestoes themselves, after 1911 not one article treating the relation of art and

[79] For the French cubists' interest in painting subjects from modern life see esp. Daniel Robbins, *Albert Gleizes 1881–1953: A Retrospective Exhibition* (catalogue), The Solomon Guggenheim Museum (New York, 1964), pp. 13–16 and *passim*.
[80] The best analysis of primitivism in the Blaue Reiter remains that of Robert Goldwater, *Primitivism in Modern Art*, rev. ed. (New York, 1966), pp. 125–142.
[81] Franz Marc, *Briefe, Aufzeichnungen und Aphorismen* (Berlin, 1920), vol. 1, p. 125.

the machine was published there until 1921.[82] The single exception altogether to this before 1921 was J. A. Lux's "Der Ingenieur," published in June 1911, an orthodox and by then commonplace praise of the forms of engineering by a critic of the older generation. It is a routine summarizing article, with nothing in it that would surprise an architectural audience, and obviously intended for the laymen who read *Der Sturm*. Until 1922, in fact, only a mere handful of articles was published on any aspect of architecture, whether on the subject of technology or otherwise. Again, aside from the manifestoes, six articles in all were printed in *Der Sturm* on futurism itself, five of them before the war. Only two, significantly, have anything at all to say about the machine-age side of futurist thought, and neither mention is positive.[83] Finally, it should be remembered that the maximum interest in futurism—at least as a style—was shown by German artists before the war, at the time when futurism was still a viable group movement and exhibiting as such. And this corresponds exactly with the period of Gropius's own strong interest within the context of the Werkbund in the relationship of art to the machine.

Gropius was not an intimate of the *Sturm* circle after his return from the war; nor, indeed, had he ever been one. By then the avant-garde had spread beyond the confines of a single center such as *Der Sturm*, and what remained of a *Sturm* circle properly so called, that is, a group of regular exhibitors in the gallery and contributors to the pages of the periodical, had lost the focal importance it had once had; the Arbeitsrat für Kunst along with

[82] In April 1921, Herwarth Walden was to write in *Der Sturm* that all *Gestaltung*, including machinery, is art provided its forms are adequate to its purposes, and that the artist who would design for the machine must himself become a technician or engineer. In the article Walden upholds the view that "art" as such must not be superimposed upon technological forms (Herwarth Walden, "Technik und Kunst," *Der Sturm* 12, no. 4: 68–70).

[83] Rudolf Kurtz, who merely refers to Marinetti as "vorgedrungen zur Schönheit der Eisenkonstruktion und keineswegs zurückschreckend vor dem Hymnus auf das Automobil" ("Futuristische Dichtungen," vol. 3, no. 136–137 [November 1912], p. 218), and Alfred Döblin, who exclaims polemically to Marinetti: "Sie meinen doch nicht etwa, es gäbe nur eine Wirklichkeit, und identifizieren die Welt Ihrer Automobile Aeroplane und Maschinengewehre mit der Welt? . . . Entsetzlich,—und doch scheint es fast wahr zu sein" ("Futuristische Worttechnik. Offener Brief an F. T. Marinetti," vol. 3, no. 150–151 [March 1913], p. 282).

the Novembergruppe now became one of the principal collecting points for various expressionist and abstract currents in Germany.[84]

An appreciation of futurist ideology was, therefore, to be had from few of the artists and writers who had been associated with the *Sturm*, and even fewer of the artists who were committed to the Arbeitsrat für Kunst.[85] Bruno Taut's cosmic glass and aerial fantasies would be all but inconceivable without a complex and highly evolved technological apparatus; yet as we have seen, Taut seems not to have been seriously disturbed by the obvious contradiction between such elaborate visionary projects and his desire, which had arisen already by 1918,[86] for a simpler, Kropotkinian or Tolstoian society of craftsmen and artists close to the soil. Despite occasional suggestions of futurist sentiment in Taut's writings, such as the remark that his ideal city will not need a large museum because "hopefully" there will be no interest in storing old or questionable things,[87] his "cosmic" visions remain almost wholly in the realm of the fantastic—grandiose symbols of the artistic will—inspired by and related to the fancies of Scheerbart; they have nothing to do stylistically or conceptually with the muscular and by and large realizable projects of the futurists.

Far from accepting the technological achievements of Europe with equanimity, there were probably very few in the Arbeitsrat für Kunst who did not at least for the moment stand with such popular philosophers as Spengler in seeing the West in decline. The excessive development of Western science and technology, and its economic dynamism, seemed to them to have been the first and ultimate causes of the war, and to face east had become for many the only means for the salvation of Europe. Thus, for in-

[84] On the decline of *Der Sturm* see also Selz, *German Expressionist Painting*, pp. 272–273.

[85] An exception among the painters who later came to the Arbeitsrat was Ludwig Meidner, who by his praise before the war of technology and the industrial excitement of the city as subjects for art, and his criticism of interest in the primitive, expressly allied himself with futurism (see Meidner's reply to a questionnaire that appeared in *Kunst und Künstler*, 1914; reprinted in Diether Schmidt, ed., *Manifeste Manifeste 1905–1933. Schriften deutscher Künstler des zwanzigsten Jahrhunderts*, vol. 1, Dresden, [1964], pp. 84–89).

[86] In his "Die Erde eine gute Wohnung" (see above, n. 36).

[87] Taut, *Stadtkrone*, p. 65.

stance, Lyonel Feininger, whose strict cubo-futurist style and interest in the townscape—even though not in its modern industrial aspects—place his work outside the nature primitivism of much German painting and closer to French and Italian art, and who, as Gropius's close friend, was with Gerhard Marcks one of the first artists to be given a position at the Bauhaus, also flirted at least for a time during and just after the war with the ideal represented by the Orient.[88] Beyond this, and far more significantly, however, the orientation of most of the German artists and architects to society was at heart an aesthetic one; and one of the worst failures of the West had been precisely its destruction of a living artistic tradition among the people as a whole—a tradition to them still apparent in the East—and its consequent inability to achieve a satisfying aesthetic order. It was the vision of a total aesthetic unity, and the underlying spiritual unity it represented, that in one form or another had inspired much of nineteenth-century artistic thought and that now, largely via painters and poets, returned stronger than ever to postwar German architecture. One of the ideals was still Gothic Europe, but now even more, the cultures of Asia as well.

Gropius's unpublished papers add nothing fundamentally new to our understanding of his ideas of the time, but they do serve to underscore the extent to which he concerned himself with the beliefs and convictions that have been described in this chapter. A number of notes and fragments for speeches and articles from this period have been preserved which set these forth with particular succinctness: his belief in the supramundane nature of art; his desire for a reunification of the arts which would result in a "mutual subordination, like a good theater ensemble"; his ideal of "small creative communities" in place of the present

---

[88] See the letter of June 21, 1917, from the poet Adolf Knoblauch to Feininger: "Andere Leute, die aus der Kriegsqual wer weiss wohin flüchten möchten, sehnen sich nach dem Orient, wo noch 'Urwälder rauschen.' Ihr Orient ist dicht bei Ihnen, lieber Feininger. Sie schwitzen bereits, unter ihm, derart, dass Sie ihn meiden mussten, um an der blauen oder weissen Havel Hafisische Seligkeit zu empfinden. Urwälder rauschten auch, aber die Stimmen der eigenen frohen Buben rauschen seliger und näher. Ueberhaupt wenn wir den Frieden nahe oder ganz da haben, brauchen wir den Orient nicht" (FP, bMS Ger 146 [1138]).

"Weltvertrustung";[89] and, finally, his belief in the necessity for art of a new religious spirit or, in the present absence of it, of the modern artists' need to band together as an intellectual and spiritual vanguard in small "Geistes-Cliques" which would serve as models for society as a whole.[90]

Yet, in realizing how essentially these aspects of Gropius's thought agree with the ideas of the other two leaders of the Arbeitsrat für Kunst, Bruno Taut and Adolf Behne, it is also necessary to recognize in what ways Gropius differed from them. We have already seen in the first chapter that Gropius did not wholly concur in their anti-industrial bias, even though he leaned in their direction.[91] This difference shows itself further in some significant departures in Gropius's way of thinking and personal style from the other Arbeitsrat leaders. He seems to have shared neither Taut's interest in utopian projects nor Behne's speculative and theoretical turn of mind to any appreciable extent. We know of nothing from his hand to compare with Taut's fantastic designs, or the extravagant sketches exhibited in the Arbeitsrat für Kunst's "Exhibition for Unknown Architects" or later published by Taut in his *Frühlicht*. Nor do we find in him to such a degree

---

[89] See also Gropius's reply to question no. 7 in *Ja! Stimmen des Arbeitsrates für Kunst* (in Schmidt, ed., *Manifeste*, p. 214).

[90] Appendix A. See also Chapter 4.

[91] Taking into account his prewar convictions, it is likewise difficult to believe that he subscribed as wholeheartedly to the utopian social ideals of many within the circle of the Arbeitsrat für Kunst; of Taut or Behne, or of Heinrich Tessenow, whose quasi-mystical paean to the small-city life of handicraft as the *via media* won for him at the time a certain prestige as an architect of social vision (cf. Heinrich Tessenow's *Handwerk und Kleinstadt*, Berlin, 1919, whose proposals are drawn largely from Kropotkin). Only Behne's sympathy with his social ideas can explain his otherwise puzzling appreciation of Tessenow (*Wiederkehr*, p. 22). Cf. Erich Mendelsohn's remarks of March 1918 to his wife: "Ich habe über den Tessenow-Abend . . . gelesen. Die meisten decken sich mit Deiner Kritik. Ich habe die zarten Federzeichnungen Tessenowscher Kleinhäuser immer nur als erfreulich im Sinne jeder natürlichen Einfachheit angesehen, ohne dass sie mir mehr als 'Fachliteratur' waren. Man kann diese innerlich menschlichen Fragen, die aus einem absoluten Ruhebedürfnis kommen, nicht als Zeitforderung im Sinn eines Lebensstils hinstellen. . . . Tessenows Wünsche begreifen nicht die entscheidenden Voraussetzungen. Trotz richtigen Instinktes bleibt er beim Traum und verwirft die Vernunft, die allein Wunder werden kann . . ." (*Briefe eines Architekten*, ed. Oskar Beyer, Munich, 1961, p. 44).

the primitivist sentiment that colored Taut's views in many areas of thought—that led him, for example, to urge in an Arbeitsrat questionnaire on the role of the revolutionary government in the arts that all verbal education should be abolished until the upper school grades.[92] There is almost nothing of this in Gropius's writings, and we may well doubt whether he ever felt himself in agreement with such views.

Gropius admired and greatly enjoyed the writings of Paul Scheerbart, recommending them warmly to uninitiated friends as "full of wisdom and beauty."[93] But there is likewise no very clear evidence that he came under the spell of the fantasist as completely as did Taut and Behne. On the contrary, from everything we have learned about him, it would be surprising if he had. Whatever may have been the stimulus of Scheerbart's ideas in, for example, the creation of the glass stair turret of Gropius's Werkbund factory building,[94] the overall style of Gropius's architecture, with its precise rectilinear forms and, especially, its use of clear glass in broad, plane surfaces, has little or nothing to do with Scheerbart's aesthetic of colored glass, tile, and ornamental detail. Gropius's use of glass comes more obviously and directly from Behrens and the Werkbund appreciation of engineering construction. The occasional Scheerbartian reflections in Gropius's writings—phrases such as "crystal symbol"—invariably occur only as simple metaphors and are never taken beyond the bounds of a generally declamatory and hyperbolic manifesto style. Such expressions of his as *Zukunftskathedrale, Einheitskunstwerk,* or "the great building" (*der grosse Bau*)[95] correspond, of course, to his very real desire to see the arts once again brought together physi-

[92] *Ja! Stimmen,* in Schmidt, ed., *Manifeste,* p. 226.

[93] Letter to Hermann Finsterlin, April 17, 1919: "Paul Scheerbarth [sic] müssen Sie unbedingt lesen; ich nenne Ihnen folgende Werke: Glasarchitektur . . . , Immer Mutig . . . , Münchhausen und Clarisse [sic] . . . , Lesabendia [sic] . . . , Graues Tuch und 10% Weiss . . . , Die grosse Revolution . . . , Cervantes . . . , in allen diesen Werken finden Sie viel Weisheit und Schönheit" (GAL, "Briefe, Arbeitsrat für Kunst, 1919/1921" file).

[94] See Chapter 2, n. 41.

[95] *Zukunftskathedrale* appears in his essay for the Arbeitsrat "Exhibition for Unknown Architects" (Conrads, ed., *Programme und Manifeste,* p. 43; Conrads and Sperlich, *Architecture of Fantasy,* p. 137); the other terms, in the Bauhaus proclamation and program (Wingler, *Bauhaus,* pp. 39–40).

cally in the service of architecture, in ways similar or comparable to their supposed unity in the Middle Ages; but nowhere do we find them actually developed or elaborated into visionary schemes in the manner of Taut.

We know from Gropius's speech of July 1919 to the Bauhaus students, from his stated intention in the first Bauhaus program to develop in the Bauhaus "extensive utopian building projects— *Volks- und Kultbauten*," and from other statements of his of the time that he, too, welcomed, and even took for granted, the creation of "houses of art" and *Stadtkronen* in Taut's sense. In a letter of April 14, 1919, to Wilhelm Brückmann accepting some of the engineer's fantastic drawings for the Arbeitsrat für Kunst's spring "Exhibition for Unknown Architects," he expressed his pleasure in what he called Brückmann's "utopian building projects" with the observation: "The ultimate goal [of architecture] is naturally the religious building (*der Kultbau*), which one day will have to return."[96] But he had neither the temperament nor the inclination to develop and promote such schemes without some concrete and practical end in view: an actual commission, an architectural display, or the pedagogical benefits to be derived from working on such a project in the classroom.[97]

In thus comparing the ideas of the three leaders of the Arbeitsrat für Kunst, it frequently seems as if Gropius had transformed commonly held utopian ideals into a chain of rhapsodic images that require being read primarily as a means of rhetorical overstatement. It is no mere idiosyncrasy or incapacity that led Gropius to use phrases and even entire portions of his essays over again in differing contexts. The convictions that lay behind them found their true outlets not in words or elaborate visionary proposals as they tended to do with Taut, but in programs of practical action: in pedagogy and administration, publicity work, and proposals directed at solving concrete and immediate problems of architecture and education.

Gropius thus appears in many respects as the most practical-minded and least utopian of the Arbeitsrat leaders, in spite of his declamatory style of writing. No doubt the fact that from the

[96] GAL, "Briefe, Arbeitsrat für Kunst, 1919/1921" file.
[97] See Chapter 4.

beginning of his activity in the Arbeitsrat für Kunst he was anticipating a pedagogical career and that in April 1919 he had already contracted to direct the school he named the Bauhaus and was therefore forced to deal with practical exigencies almost from the start, must have been a sobering check against any tendency toward merely utopian speculation on his part. It is now known that he contributed very little, if, indeed, anything at all, to the "utopian correspondence," the circular letters on the architecture of the future which Taut initiated within the circle of the Arbeitsrat für Kunst in November 1919; the very pseudonym Gropius used as one of the correspondents: *Mass*—measure, proportion— tells us something about his conception of himself within the group.[98] But Gropius's temperament, too—his already demonstrated inclination for the practical world of art politics and administration—afforded in itself a heavy counterweight to his visionary inclinations; as well as the fact that he had, after all, concerned himself forcefully with the tangible problem of creating a workable modern style for utilitarian architecture, with some substantial results to show for it. And as his Leipzig speech in particular indicates, he could not now entirely reject this most important aspect of his career, in spite of the feelings of disillusionment that at times beset him.

[98] For selections from the correspondence see *Die gläserne Kette. Visionäre Architekturen aus dem Kreis um Bruno Taut 1919–1920* (catalogue), Museum Leverkusen, Schloss Morsbroich und in der Akademic der Künste Berlin, [1963], and Conrads and Sperlich, *Architecture of Fantasy*, pp. 142–149. Nothing by Gropius appears in either collection. Cf. Taut's complaint in his circular letter of July 15, 1920: "Mass! [each correspondent had a pseudonym] Berxbach! [W. Brückmann] Tancred! [Hans Scharoun] Stellarius! [Jakobus Göttel] Warum schweigt Ihr? Wollt Ihr nicht auch mithelfen?" (*Gläserne Kette*, p. 53).

# THE FIRST BAUHAUS PROGRAM
# AND THE ARBEITSRAT FÜR KUNST

4

## Otto Bartning's Art Education Program as an
## Antecedent of the First Bauhaus Program

Of Gropius's unpublished papers, some of the most valuable concern his activities as a leader of the Arbeitsrat für Kunst. They give us only glimpses, and a more complete picture of his role in the organization will probably have to wait until a history of the Arbeitsrat is written. But they do indicate strongly what the fact that he was chairman of the Arbeitsrat implies but does not by itself prove: that he was the prime mover of the organization during the period of its greatest activity, from the first months of 1919 until the time in April or May when he took up his duties in Weimar.[1] Gropius's papers also give us more concrete evidence than we have had before of how closely the conception of the Bauhaus was tied in his mind to what he sought to accomplish with the Arbeitsrat für Kunst. For Gropius, the Arbeitsrat and the Bauhaus were two closely connected instruments for effecting the same ends; the latter an extension and fulfillment of plans which had come to crystallization in the former, and both for him the embodiment of the ideals and principles which, as we have seen,

[1] See Appendix D for a discussion of the chronology of the Arbeitsrat, which has been confused in the literature.

127

he took with all of their conflicting elements from the hitherto separate circles of the Deutsche Werkbund and expressionism.[2]

As far as it directly pertains to the Bauhaus, the single most relevant project undertaken within the Arbeitsrat was the preparation under its auspices of a plan for the general reformation of training in handicraft and the arts. It was drawn up at the end of 1918 by the architect Otto Bartning (who in 1924–25 was to take over directorship of the school of design in Weimar that succeeded the Bauhaus) with the "support" of a "special committee of the Arbeitsrat für Kunst to which Gropius, among others, belonged."[3] Gropius had made known his interest in serving on the Arbeitsrat's education committee and in consequence was sent a copy of the plan by its author. That Gropius scrutinized and carefully considered it is revealed by the existence among his papers of the fourteen-page typed copy with numerous written comments, emendations, and queries in his hand.[4]

[2] According to Lothar Lang, it was Behne who actually conceived the Arbeitsrat für Kunst (*Das Bauhaus 1919–1933. Idee und Wirklichkeit*, Studienreihe angewandte Kunst, Neuzeit 2, Berlin, 1965, p. 19).

[3] This is according to a note in the slightly amended summary of the program published in the *Mitteilungen des Deutschen Werkbundes*, September 1, 1919. Though published late, this summary is dated 1918, the time of its inception (Otto Bartning, "Vorschläge zu einem Lehrplan für Handwerker, Architekten und bildende Künstler," pp. 42–47).

[4] BD,SG. Gropius's initiative in studying the plan is shown by a letter to him from Bartning of Jan. 7, 1919: ". . . auf die Mitteilung des Herrn Taut, dass Sie geneigt sind, sich an der Arbeit unseres Unterricht-Ausschusses zu beteiligen, freue ich mich, Sie zur Sitzung am Donnerstag den 9.1.19 . . . einladen zu dürfen.

"In der Anlage übersende ich Ihnen ein Exemplar meines Entwurfes eines Unterrichtprogrammes, der der Diskussion zu Grunde liegt" (GAL, "Briefe, Arbeitsrat für Kunst, 1919/1921" file). Cf. the schematic table of school reorganization published by Bartning in his *Mitteilungen* article (Bartning, "Vorschläge") and the almost identical table, except for minor word changes, in Gropius's files (BD, SG). The latter exists in two forms: an undated draft in Gropius's hand and an undated mimeographed copy with some deletions and wording variations. The latter is titled "Anlage zu Punkt 1) des Fragebogens," and must have been intended—though not published—for Gropius's reply to question no. 1 (on the requirements for a reformed art education) of the eight-point questionnaire in *Ja! Stimmen des Arbeitsrates für Kunst in Berlin*, Berlin, November 1919 (in Diether Schmidt, ed., *Manifeste Manifeste 1905–1933. Schriften deutscher Künstler des zwanzigsten Jahrhunderts*, vol. 1, Dresden, [1964], pp. 211–212). A further, brief outline of the same plan, undated, in Gropius's hand also exists among his papers. The Bartning plan was announced at the end of Bruno Taut's *Ein Architektur-Programm*, Flugschriften des Arbeitsrates für Kunst, no. 1, in both the first print-

On the whole, the Bartning plan and the first Bauhaus program agree in outline: both are based upon a thoroughgoing course of workshop training for craftsmen, designers, architects, and artists alike; both would abolish the class and status title of professor and, in keeping with a handicraft system and with the Arbeitsrat ideal of a more egalitarian social structure, substitute those of apprentice, journeyman, and master; and both insist at the start upon an assumption fundamental to their conceptions—that art *per se* cannot be taught, but merely released and directed, as it were, through contact with a creative personality, and that only "knowledge," techniques, and handicraft skills are really transmittable. An occasional phrase of the Bauhaus program even recalls wording in the Bartning plan.[5]

Despite the foregoing, however, it would be a mistake to regard the latter as the principal source or inspiration for the former, as was done shortly afterward by Oskar Schlemmer and presumably others as well.[6] There were scarcely any of the numerous proposals for educational reform in Germany—even from conservatives— that did not by that time advocate the major recommendations found in the Bartning and Gropius plans: a combined training, at least on the primary levels, for all branches of the fine and applied arts, including architecture; the attainment of practical handicraft skills for even the would-be fine artist; and, for the

---

ing, dated Christmas 1918 and the second, dated spring 1919, as the forthcoming "zweite Flugschrift" of the Arbeitsrat; but was it actually published in that form? It does not appear in an up-to-date list of Arbeitsrat publications advertised at the rear of the Arbeitsrat's *Ruf zum Bauen*, which was published in 1920 and lists both out-of-print material (e.g., the 2d printing of Taut's *Flugschrift*) and work in preparation (R. P. Henning, *Ton*). Cf. also Gropius's remark in a speech of March 1919 before the Arbeitsrat about the "noch in der Schwebe befindliche Lehprogramm Bartnings" (Appendix D, p. 280).

5 Cf., e.g., Bartning: "[Die Kunst] liegt aber ausserhalb und oberhalb aller Methoden" (p. 1) with "Kunst entsteht oberhalb aller Methoden"; or "Solides handwerkliches Können aber ist ihre unerlässliche Grundlage" (p. 1) with ". . . deshalb wird als unerlässliche Grundlage für alles bildnerische Schaffen die gründliche handwerkliche Ausbildung aller Studierenden . . . gefordert."

6 Cf. Schlemmer's letter of Feb. 17, 1925, to Otto Meyer apropos of Bartning's succession to Gropius's post in Weimar: "In Weimar selbst wird der 'eigentliche' Vater des Bauhausgedankens berufen werden, Berliner Architekt, und er wird . . . umgekehrt anfangen: mit dem . . . Bauen . . ." (Oskar Schlemmer, *Briefe und Tagebücher*, ed. Tut Schlemmer, Munich, 1958, p. 169).

pupil with creative talents, the maximum freedom to develop his personal gifts as soundly, but as individually, as possible. It should be remembered in this connection that the entire remaining Weimar academy faculty had, at the end of the war, joined to urge the appointment of Gropius and the adoption of plans for a unified art school.[7] It was, after all, because of this all but universal desire for reform that Gropius's plans (even granting that their implications had not been fully grasped) could so readily have been accepted by Weimar, which had long had a reputation for artistic conservatism and cultural provincialism.[8] Even the preference for handicraft titles for pupils and teachers may be found in earlier plans by more conservative figures.[9] Gropius at the time was understandably at pains due to the political opposition in Weimar to legitimize the Bauhaus succession, and he freely acknowledged in a speech before the Thuringian *Landtag* the unoriginality of the Bauhaus idea as such, citing as precedents for, or parallels with the Bauhaus, in addition to the Bartning plan, eight other recent or contemporaneous reform proposals (or, in the case of Wilhelm von Debschitz's *Meisterlehrwerkstätten*, a reform already under way at the time of Gropius's speech, July 1920) by special school groups and highly prominent Werkbund designers and art educators of the older generation.[10]

[7] See the petition of Oct. 3, 1917, signed by Theodor Hagen, Walther Klemm, Richard Engelmann, and Fritz Mackensen urging adoption of an *Einheitsakademie* and esp. the letter of April 20, 1920, by Freiherr von Fritsch describing the "unanimous decision of the faculty of the *Hochschule*" to hire Gropius as director (Wingler, *Bauhaus*, pp. 31–32, 42).

[8] One theme runs through all contemporaneous newspaper accounts of the Bauhaus's political difficulties in Weimar: that Weimar was the wrong place to establish the school because it was too small, too provincial in attitude, and too attached to the old. The example may be cited of the storm provoked in Weimar in 1907 by Harry Graf Kessler's exhibition there of some Rodin drawings of nudes which brought down upon him the disapproval of the court (Karl Ernst Osthaus, *Henry van de Velde. Leben und Schaffen des Künstlers*, Die neue Baukunst, Monographienreihe 1, Hagen i. W., 1920, pp. 86–87).

[9] E.g., by Theodor Fischer, *Für die deutsche Baukunst*, Flugschriften des Münchener Bundes, no. 2 (Munich, October 1917), pp. 6–7.

[10] Gropius's speech before the Thuringian *Landtag* in Weimar, July 9, 1920; excerpted in Wingler, *Bauhaus*, pp. 52–53. The plans cited were those by Theodor Fischer, the *Deutsche Ausschuss für technisches Schulwesen*, Wilhelm von Debschitz, Otto Bartning (but here cited as a project for the Werkbund; cf. Bartning, "Vorschläge"), Fritz Schumacher, Rudolf Bosselt, Bruno Paul, Richard

The characteristic elevation by Bartning and Gropius of art (or "the deciding value in art, quality," as Bartning has it) to the level of inspiration, beyond all method, likewise had numerous antecedents in Werkbund thinking. To be sure, in the Bartning and Gropius programs this emphasis upon the unteachability of art is in large part the natural concomitant of their authors' strong belief in the personal and transcendent powers of art; but the conviction that the creative process is inherently not amenable to, and is even hampered by, a method was widespread in the Werkbund from the start and insisted upon, if not so vehemently, as part of a general polemic against the academy and the technical school. Few of the plans cited by Gropius in his 1920 speech actually consider the content of the teaching in the proposed new schools. It is typical of them and of Werkbund discussions of art education as a whole up to then that the serious question of how artistic sensibility might be developed and related to teachable skills is ignored either by expressly placing art beyond the proper competence of the school, or else by simply taking for granted the personal influence of the master on his pupil.[11]

Riemerschmid, and the *Reichsverband der Studierenden.* Of these, the following are included in article or pamphlet form among Gropius's papers at the Bauhaus-Archiv: Fischer, *Für die deutsche Baukunst* (1917); Bruno Paul, *Erziehung der Künstler an staatlichen Schulen* (pamphlet; n.d., but originally published as an article in 1917); Riemerschmid, *Künstlerische Erziehungsfragen* 1 and 2, Flugschriften des Münchener Bundes, nos. 1 and 5 (Munich 1917, 1919); von Debschitz, "Die Kunst ist Lehrbar!" (1920). In addition, Gropius's papers in Darmstadt include the essentially similar plan by Kurt Kluge, *Die Neugestaltung der Künstlererziehung gelegentlich der Eingabe der Leipziger Künstlerschaft an das Kultusministerium* (pamphlet, Leipzig, December 17, 1918); and Adolf Loos's "Richtlinien für ein Kunstamt," *Der Friede*, no. 62 (Vienna, 1919). The latter, in keeping with Loos's belief in the essential distinction between the fine and the applied arts, would preserve a separate training of painters, sculptors, and architects, but put them all in "Lehrwerkstätten" with an apprenticeship system and corresponding titles. Architects would have to learn a skilled trade as mason, carpenter, etc. before being admitted to a school of architecture. For a brief description of the Schumacher, Riemerschmid, Kluge, and, particularly, Paul plans, see also Nikolaus Pevsner, *Academies of Art Past and Present* (Cambridge, 1940), pp. 281–285. An excellent summary of the time of pre-Bauhaus attempts to reform art education is Fritz Hoeber, "Revolutionierung des Kunstunterrichts," *Die neue Rundschau* 30, no. 4 (April 1919): 487–497.

[11] A notable exception is the plan of Richard Riemerschmid, who although not regarding them as art, lists the basics of design as the real subject matter of the art

Aside from what the Bartning and Gropius programs have in common with other, similar plans, however, there is a more obvious reason why Bartning's cannot be regarded as the immediate source for either the Bauhaus program or the school as actually constituted: it does not provide a model for establishing an art school. The only section of the plan actually devoted to the "Kunstschule" proper speaks merely of "reform of the art school" with no further discussion. It is instead a description and outline of a program intended to cover all levels of schooling from the beginning onward. The actual craft and artistic training would take place at the higher levels under an apprenticeship system in what were at present the various extension, technical, and trade schools and schools of the applied arts (*Fortbildungsschulen, Fachschulen, Gewerbe- und Kunstgewerbeschulen*); in craftsmen's shops; the ateliers—both private and state supported—of artists and architects; and in public workshops to be established in various branches of the applied arts. But nothing is said about the nature and means of the education or training to be imparted except that the shops are to serve "principally to train apprentices." The control of design quality throughout the nation would for all fields reside in the hands of a chosen supervisory council (*Ehrenrat*) which would have the power to grant or withhold the right to train apprentices (*Lehrrecht*) to any artist, craftsman, or institution in the country.[12]

Whatever his sympathy might be with the notion of eventually abolishing the art school altogether, Gropius here as elsewhere was pragmatic; but after all, even if he had wished to, he could not reasonably have denied the art school its role when the final ap-

school: "Mit den Grundbegriffen künstlerischer Erkenntnis, mit den Fragen der Wiederholung, der Gegensätzlichkeit, des Gleichgewichtes von Formen und Farben, mit Flächenwirkungen und räumlichen Wirkungen, mit Verhältnissen und Massen und dann vor allem mit den Zusammenhängen zwischen Arbeitsvorgang und Form soll jeder veranlasst werden, von Anfang an sich auseinanderzusetzen, nicht verstandesmässig, wenn er dazu nicht neigt, sondern indem er sich handwerklich damit beschäftigt" (Riemerschmid, *Künstlerische Erziehungsfragen* 2, p. 5). Another exception is Fritz Schumacher, who discusses at length the importance of doing instead of merely drawing; but he says nothing about how *Gestaltung* is to be taught in the shops (*Die Reform der kunsttechnischen Erziehung*, Deutscher Ausschuss für Erziehung und Unterricht, no. 3, Leipzig, 1918).
12 Pp. 2, 3, 13, 14.

proval of his own appointment to one was imminent. The burden of Gropius's written comments on Bartning's draft of the plan is precisely its absence of any real consideration for the function of the art school and the nature of art training. Thus, for instance, Bartning's recommendation that craft training will also require some amount of "regular" (*schulmässiger*) instruction in accurate drawing, art history, and writing and arithmetic is questioned with "where? in which schools?" or again, his unelaborated references to the "school of architecture" (*Bauschule*) and "the school of architecture . . . is to be derived from the existing building trades school" (*Baugewerbeschule*) are queried with a question mark and "how then? too brief! more particulars!" respectively. Similarly, Bartning's deliberate avoidance of the problem of the criteria required to judge artistic quality in the workshops or ateliers, as revealed by one of his rare statements touching the issue: "No test or method of admission will ever be capable of separating art from non-art. . . . Only time can decide this . . . ," receives the question by Gropius, "where is the distinction?"[13]

There are some other points of difference as well between the Bartning plan and the Bauhaus program. The latter takes slight but explicit account of industry; Bartning makes no mention of it whatever. He does state at the beginning that "*handiwork* is . . . the ground in which the speculative skills as well as the free arts are rooted. . . . Instruction in handiwork, therefore, is the most natural elementary school of technics. . . ."[14] But unlike Gropius, he seemed disposed to keep art and handicraft as separate from

[13] Pp. 2, 9. Bartning would eliminate the concept of art as a criterion even in judging the trial piece for attaining to master's rank in the crafts: "Wenn diese Probezeit oder Probe sich auf vorstehenden Lehrplan beschränkt und konzentriert unter Ausschaltung der Begriffe 'Kunst' und 'Vielwissen,' so könnte eine solche Meisterprobe dazu führen, dass allmählich die völlig Unberufenen vom Bauen die Hände weglassen müssen, ohne dass, bei hinreichend freier Handhabung der Probe, der fähige Liebhaber für die Baukunst verloren ginge, sofern er sich nur die unerlässliche Grundlage des Werkmässigen geschaffen hat" (p. 9). We may also note that at the very end of the typescript Gropius has added the cautious words: "der Abbau des alten Systems kann nur allmählich erfolgen." Bartning was to amend his program when summarized later in the *Mitteilungen* to give the art school a more prominent place alongside the *Werkstatt* and the atelier.
[14] P. 1. ". . . Handwerk ist . . . der Boden, in dem die spekulativen Techniken wie die freien Künste wurzeln. . . . Die Lehre des Handwerks ist drum die natürlichste Elementarschule der Technik. . . ."

industrial work as possible; for in an article of October 1919, published in the organ of the SPD, *Vorwärts*, he declared that "architecture has the duty to protect handiwork from mechanization and industrialization, otherwise the basis for architecture and the fine arts will disappear."[15] When Bartning in his plan comes to his list of the handicrafts to be taught in the *Lehrwerkstätten*, he takes no account of industry or industrial designing. This leads Gropius to add the comments: "no pattern drawing" (*Musterzeichnen*) and "how are the factory *Musterzeichner* to be replaced?"—a concern, it must be clear by now, that does not indicate opposition to industrial designing as such, but to the old Werkbund bugbear, the semitrained hack draftsman working from formulas.[16]

The Bauhaus program is in this respect of according recognition to industry, however briefly stated, closer to the programs of the older established Werkbund figures cited by Gropius in his *Landtag* speech than it is to Bartning's. The line in the Bauhaus program about the need for steady contact with the leaders of handicraft and industry recalls, in fact, a similar clause from the highly detailed plan by Richard Riemerschmid which Gropius called in his speech "extraordinarily similar to the Bauhaus program":[17] "Steady relations with suitable and well-run workshops, factories, and building firms must make such an opportunity [for the school to acquaint itself with the life of commerce] always easily available."[18] Indeed, these earlier plans even provide precedents for what was to be one of the most distinctive features of the Bauhaus in Weimar: the double tutelage under *Form-* and *Werkmeistern*. The use of a craftsman along with a trained artist to help run the workshops is recommended by both Riemerschmid and the designer Bruno Paul as the obvious way of assisting pupils

---

15 Otto Bartning, "Bau-Kunst, -Verwaltung und -Unterricht." *Vorwärts. Berliner Volksblatt. Zentralorgan der sozialdemokratischen Partei Deutschlands.* October 5, 1919. "... die Baukunst [hat] die Aufgabe, das Handwerk vor Technisierung und Industrialisierung zu bewahren, sonst schwindet der Boden für Baukunst und bildende Künste...."

16 P. 2.

17 Wingler, *Bauhaus*, p. 41.

18 Riemerschmid, *Künstlerische Erziehungsfragen* 2, p. 7. "Ständige Verbindung mit geeigneten und gut geführten Werkstätten, Fabriken, Bauunternehmungen muss solche Gelegenheit immer leicht erreichbar machen."

with basic techniques while relieving the artist-teacher of these chores so that he may devote himself more fully to the creative side of the work.[19] This Bauhaus division of labor is not mentioned in the first program (it was codified only in the statutes of January 1921), but it was intended from the start.[20] Gropius's attitude toward it was, however, somewhat different. For Riemerschmid and Paul, this division is a matter of course, and it obviously reflects their own limitations as self-taught designers in the field of the building crafts. Gropius, on the contrary, could not but regard it on ideological grounds as an undesirable expediency, necessary only because of the unavailability of teachers combining high artistic with handicraft skills.[21]

What is unquestionably the major departure made by the Bauhaus program from the Bartning plan or, for that matter, from all the other similar plans that had been developed by prominent Werkbund figures, is the explicit place it gives to creative and even to "extensive utopian" designing in the work of the students.[22] The reasons for it are the same as those which led Gropius to question Bartning's lack of consideration for the function of the art school. There was, in the first place, the very obvious fact that whether or not one wishes to call what the Bauhaus sought to impart to its pupils "art," the school, after all, had assimilated the functions of an art academy as well as those of a school of arts and crafts, and its primary aim was not to train common craftsmen, whose education it was Bartning's intention also to consider, but to produce creative designers and artists— including at the beginning, it must be emphasized, "fine" artists, even if within the framework of architecture. The deeper and more fundamental reason, however, was Gropius's long-held desire for a vigorous artistic renaissance in all the arts—including

[19] *Ibid.*, p. 6; Paul, *Erziehung der Künstler*, p. 18.
[20] See the 1921 statutes, slightly abridged, in Wingler, *Bauhaus*, p. 54.
[21] "Die Absicht des Bauhauses sei es gewesen, die Lernenden von zwei Seiten zu befruchten, einmal von künstlerischer, zum andern von handwerklicher Seite. Da Persönlichkeiten, die beides in hohem Masse besitzen, heute nicht existieren, sei man zu der Regelung geschritten, wie sie im Bauhaus bisher üblich sei, jedem Lernenden zwei Meister zu geben, einen technischen und einen künstlerischen" (minutes of the Bauhaus *Meisterratssitzung* of Sept. 20, 1920, p. 5, BD,SG).
[22] In Wingler, *Bauhaus*, p. 40: "Gemeinsame Planung umfangreicher utopischer Bauentwürfe—Volks- und Kultbauten—mit weitgestecktem Ziel."

the applied arts—that would be both a spur to and a symbol of a new, richly cultured social order. All of the other programs we have been considering expressly keep to the minimum the amount of creative or imaginative designing the pupil would be allowed to do. The projects to be given him, particularly in architecture, would be restricted to only the simplest, most modest constructions. Even Bartning, who certainly shared Gropius's desire to see the symbolic *Zukunftskathedrale* realized in whatever form, was too concerned about the twin dangers of dilettantism and lack of inventiveness—the old presumed failings of the *Musterzeichner* and the academic architect—to permit even the journeyman architect (*Baugeselle*) anything more in his ideal plan than "*simple building tasks* (e.g., small homes)" (emphasis his).[23]

Gropius, too, believed it preferable in general to keep to such a sound and cautious approach. But in the uncertain transitional period in which he believed himself to be, he could not forego the opportunity, now that his hoped-for directorship of a school had become a reality on his own terms, to enlist the school in the fulfillment of his aspirations—to force, as it were, the new art and the new age—by engaging all in it in the "common planning of extensive utopian building projects." These would be the nuclei about which, as about the medieval cathedral, the small creative community of craftsmen, pupils, and modern artists would crystallize and largely for the sake of which the school had come into being.[24] The corollary to this projected utopian planning in the Bauhaus is the strong emphasis found in the program upon creativity, even with the proviso that art itself cannot be taught. Thus, the goal of the school is stated to be "to bring together all of

23 "Entwurf und Durcharbeitung von *einfachen* Bauaufgaben (z.B. Kleinwohnhaus) bis in die letzte Einzelheit. Es soll durchaus keine vorzeitige Fertigkeit oder Routine grossen Aufgaben gegenüber gelernt werden, zu deren Bewältigung erst der Mann allmählich heranreift" (p. 8).

24 For a sociological study of the Bauhaus as a utopian community, though written from an excessively simplified and abstract point of view, see Herbert Hübner, *Die soziale Utopie des Bauhauses. Ein Beitrag zur Wissenssoziologie in der bildenden Kunst* (Ph.D. diss., Westfälische Wilhelms-Universität zu Münster, Darmstadt, 1963). For a recent, sounder, and more comprehensive socio-historical study of the Bauhaus as an ideal social community and of the political ideology of its members, see now Allan Greenberg, "Artists and the Weimar Republic: Dada and the Bauhaus, 1917–1925" (Ph.D. diss., University of Illinois, 1967).

artistic creation into one whole," and the teaching aim of the workshop, to develop "organic creation" (*organisches Gestalten*).[25] Such language has no equivalent whatever in the Bartning plan and virtually none in the others mentioned by Gropius in his *Landtag* speech.

There are a number of obvious reasons why the projected visionary architectural works were never undertaken at the Bauhaus (at least not to such an extent that much, if anything, has survived): the very quick realization that they—and the ideal of the organic society they symbolized—could have little practical issue in the present world, the incompatibility of the *Einheitskunstwerk* with the stylistic direction of modern architecture as a whole, and not least, the sheer lack of means and of pupil and faculty interest in or sufficient capability for the work in the beginning when such an ideal was still viable enough to be undertaken.[26] We cannot know, indeed, to what extent Gropius actually thought of involving the Bauhaus in these projects when he was drafting the first Bauhaus program. Presumably, they were to be undertaken only as the culmination of patient labors on far more humble tasks first, and then only under the strict control of Gropius himself, with a few gifted and advanced students allowed to participate on a carefully supervised basis.

We will recall that from the very start of the school's activities, Gropius was emphasizing in his speeches to the community at large not this visionary side of the Bauhaus's creative work, but its practical tasks and the necessity on the part of all craftsmen for simple beginnings, for keeping at the start to "things of everyday use . . . well, but simply and straightforwardly formed" and leaving "art" to the few gifted individuals until such time as a new religious spirit should once again instill a feeling for creation in all of the people.[27] The words were meant as admonition to the ordinary craftsman in his audience; but we may assume that they also applied to the students of the Bauhaus, at least at the earlier stages of their work: although the designing of simple, practical

25 "Das Bauhaus erstrebt die Sammlung alles künstlerischen Schaffens zur Einheit . . ." (Bauhaus program, in Wingler, *Bauhaus*, p. 40).
26 See below, pp. 140–141, 174–175, 215–216.
27 See above, pp. 62–63. For Gropius's speech see Appendix B.

objects would be an important part of Bauhaus work—a first, necessary step toward a new art—it could plainly not be, from all we have learned, the highest goal of Bauhaus achievement as Gropius saw it in the beginning.

It is not much of an exaggeration to say that the school was messianic in intention. It was animated by that far-reaching artistic vista of the nineteenth century—of the romantics, of Ruskin and Morris, of the Art Nouveau generation—and in the twentieth century of the expressionists, in which art was to be the harbinger and expression of a new culture and a new religious spirit. In Gropius's eyes the Bauhaus was to be one of the places in which the artistic leaders of the new generation, those "few, isolated, scarcely understood men," would be reared who had the task of helping to effect the change.[28] Within the curriculum, the planning of utopian buildings (to use again the words of the Bauhaus program) would be an important means to this end, one of the principal ways by which the mature pupil would be able to raise his craft training to the high and affecting level of true art. On such projects, teachers and pupils alike would acquire the necessary artistic and social experience in collaboration, and in so doing become a potent example for the ultimate transformation of society as a whole. It need scarcely be added that herein lies the basic reason why Gropius chose to hire artists of advanced tendencies—and therefore only fine artists—as *Formmeister* for the Bauhaus, instead of men who had made their marks in the applied arts as had been true of every previous attempt to teach modern applied design.

### Gropius's Plans for the Bauhaus and for the Arbeitsrat für Kunst

Although the declamatory language of the opening manifesto of the Bauhaus program made it unmistakably clear to the public that the new school was impelled by the same ardent spirit proclaiming itself in the program of the Arbeitsrat für Kunst and other radical artists' groups of the time, the reference to utopian planning is the single substantive indication in the program itself of the radical intentions that were to make the Bauhaus differ

[28] Appendix B, p. 260.

from all previous schools and, it is safe to say, from all of the schools envisioned by the older generation of designers whose plans served Gropius in outline as guides. Most of our evidence for the role Gropius planned for the Bauhaus comes from elsewhere.

In a letter to his wife of June 27, 1919, just at the close of the first semester, Lyonel Feininger reported that "what Gropius is blamed for most by the students, and not altogether unjustly, is that he said he would always intercede for the 'most extreme art,' as it is a sign of the times."[29] We may well wonder what "most extreme" could mean for Gropius, when we consider that the by then relatively conservative Gerhard Marcks was one of his first two choices for the Bauhaus. Nevertheless, if we qualify the report to mean the championing of all more or less advanced art, it is perfectly consonant with what we know about Gropius's ideas and what is implicit in the reference of the Bauhaus program to utopian designing: that only the modern artistic tendencies had relevancy for the present and hoped-for future because of the symbolic and affective power of their forms and because of the affinities that modern abstraction had with architecture.

A vivid glimpse of how Gropius envisioned the Bauhaus at the start is given by his address to the students in late June or the beginning of July on the occasion of the first year's-end exhibition of student work.[30] In his critique of the exhibition, Gropius expressly tries to discourage what, to judge from his description and the illustrations of student work in the student journal, *Austausch*, was the lingering of a conservative, naturalistic expressionism and to encourage what he terms the "new construction (*neue Aufbau*) in painting" with its "relationship to building," by which he means the general tendency of the time toward geometric construction of whatever degree, a definition that presumably included the figural work of Marcks. Gropius's criticism also con-

---

[29] In Wingler, *Bauhaus*, p. 43.

[30] The text of the speech, in the Weimar Staatsarchiv, is published in part in Wingler, *Bauhaus*, pp. 45–46, and now in its entirety in Schmidt, ed., *Manifeste*, pp. 235–239. An incomplete type-draft also exists in the Gropius collection in Darmstadt. The exhibition began in the latter part of June and ran at least through the beginning of July. See the Feininger letters of June 22 and 27 in Wingler, *Bauhaus*, p. 43.

tains a revealing objection leveled at the "finish" of the show: "First of all, the appearance: many beautiful frames, impressive display, finished pictures. For *whom*, actually? I had particularly requested that *sketches of projects and ideas* also be submitted. Not a *single* painter or sculptor has submitted ideas for compositions, which in fact should form the *core* of such an institution as ours. Who today is capable of painting a completely executed, finished picture?"[31] This may seem a curious objection to make in a school ostensibly seeking to inculcate and develop a spirit of craftsmanship and "learning by doing." What more valuable training, after all, than to insist from the start, as all plans for the reform of art education were doing, upon the conscientious, craftsmanly execution of all phases of an artistic task? Certainly Gropius had not suddenly changed his mind about the inadequacies of mere pencil work, especially for the would-be architect and the designer of three-dimensional forms. We will find him more than once not very long after this criticizing the shortcomings of the "usual design work" from the hands of the "pencil strategists" and reiterating his familiar stand that the architect must undergo a practical crafts training in order to acquaint himself with materials and processes.[32]

This conviction, indeed, sheds light on the often-asked question why no regular architecture department existed at the Bauhaus during its time in Weimar, despite the occasional wishful use of the term *Architekturabteilung* in the minutes of Bauhaus faculty meetings to refer to whatever architectural instruction was given in connection with the school. Except for a few technical courses,

[31] Schmidt, ed., *Manifeste*, pp. 235–236. "Meine Herrschaften, zunächst das Äussere: Viele schöne Rahmen, prachtvolle Aufmachung, fertige Bilder, für *wen* eigentlich? Ich hatte besonders aufgefordert, auch *Entwurfs- und Ideenskizzen* einzureichen. Nicht *ein* Maler oder Bildhauer hat Kompositionsideen gebracht, die ja eigentlich den *Kern* einer solchen Anstalt bilden sollen. Wer kann heute ein fertig gebautes, durchgeführtes Bild malen?" The emphasis is supplied in the Bauhaus-Archiv draft of the speech.
[32] Gropius's notes of Dec. 9, 1921, for a Bauhaus speech, in Wingler, *Bauhaus*, p. 61: "Aus der Erkenntnis heraus, dass die bisher übliche Entwurfsarbeit beim Bau im weitesten Sinne des Worts falsch ist und die produktive Arbeit . . . in die Hände von Bleistiftstrategen gelegt wurde, wurde die Forderung aufgestellt, jedem schöpferisch Arbeitenden das handwerkliche Fundament zu geben."

architecture in the Weimar period was taught to selected students largely in Gropius's own office, whose activities were to an extent coordinated with the work of the shops. Architecture for Gropius demanded work with actual building materials and structures, and in the absence of a long-sought experimental building plot for the Bauhaus, whose creation was prevented by lack of money, only an architect's office could provide the necessary practical experience for a qualified journeyman. Thus, the certainly inexpensive alternative of designing on paper and in plaster alone was rejected. For Gropius, architecture was from the start the culmination of more humble tasks in the various crafts. Hence, despite the references in the first Bauhaus program and afterward to architecture as the main goal of Bauhaus teaching, in the absence of adequate funds and a sufficiently trained body of craftsmen, the other workshops had to receive priority.

Gropius's impatience with the finish of student work, therefore, represented no second thoughts on his part. His criticism specifically concerns painting and is entirely consistent with his determination to bring that art within the framework of architecture: it was not finished canvases that were relevant, but whatever designs the painters could contribute toward a future collaboration with architecture. Even more significant, however, in prompting Gropius's objection to finished paintings was a general consideration we have sought to bring into relief with respect to Taut and Behne in particular but shared by all modernists in Germany at the time: that the means for attaining to the desired future lay in the visionary, affecting powers of the artist's imagination, which is to say, in his ideas—his *Entwürfe*—and consequently, that this took ultimate precedence over any notions of *Qualitätsarbeit*, in the old Werkbund sense of good craftsmanship and respect for materials.

We find a supporting, and striking, indication of the priority Gropius gave (indeed, had always given) to conception over all material and technical considerations, if it came to a conflict, in a memorandum written for the Arbeitsrat für Kunst on the subject of architectural exhibits. In it, Gropius describes how "sections of architectural structures in full scale" might "be brought

before the eye either in genuine materials or a suitable imitation."[33] It is scarcely necessary to observe that this is a considerable departure from the nineteenth-century Arts and Crafts viewpoint and even that of the early Werkbund, for both of which honesty of work and materials (though in the Werkbund at least, not more important than conception) was a crucial consideration. From his memorandum we can now recognize that Gropius was of the same mind in this matter as (to name one pertinent example) Erich Mendelsohn, whose Einstein Tower, planned for reinforced concrete but executed in brick and stucco because of a shortage of materials, represents the most famous triumph of the time of conception over its supposed material basis.

With the usual remarks about the collapse of old Western values and the urgent need for new beginnings, Gropius in his speech to the Bauhaus students goes on to speak of his conception of the Bauhaus as one of "small, secret, self-contained bunds, lodges, *Hütten*, and conspiracies," whose mission it is "to keep watch over and give artistic form to a secret, to a kernel of faith." Such groups "will come into being until the day when there once again takes shape out of the individual groups a great general sustaining spiritual-religious idea, which will at last find its crystalline expression in a great *Gesamtkunstwerk*. And this great communal work of art, this cathedral of the future, will then shine with the fullness of its light into the tiniest things of everyday life."[34]

We are once again in the familiar atmosphere of Taut's ideas and the Arbeitsrat für Kunst. The words "secret conspiracies" share, perhaps, something of a fashionable revolutionary hyperbole, but the idea they voice is wholly in earnest. Behind them lies in part the memory of the prewar Werkbund and the dissatisfaction Gropius had come to feel with its methods and achievements.

---

[33] Appendix E.

[34] Schmidt, ed., *Manifeste*, pp. 237–238. "Keine grossen geistigen Organisationen, sondern kleine geheime in sich abgeschlossene Bünde, Logen, Hütten, Verschwörungen, die ein Geheimnis, einen Glaubenskern hüten und künstlerisch gestalten wollen, werden entstehen, bis sich aus den einzelnen Gruppen wieder eine allgemeine grosse, tragende, geistig-religiöse Idee verdichtet, die in einem grossen Gesamtkunstwerk schliesslich ihren kristallischen Ausdruck finden muss. Und dieses grosse Kunstwerk der Gesamtheit, diese Kathedrale der Zukunft, wird dann mit seiner Lichtfülle bis in die kleinsten Dinge des täglichen Lebens hineinstrahlen."

Against the ideal of artistic and spiritual community projected to the students of the Bauhaus, Gropius sets the earlier organizational pretensions of the architects: "Before the war we put the cart before the horse and sought to carry art to the general public backwards, through organization. We designed artistic ashtrays and beer mugs and sought by that means to rise gradually to the level of great architecture. Everything through cool organization. That was a boundless presumption on which we foundered; and now it will be the other way around."[35] And Gropius then calls for the small, dedicated, and compact artistic communities which, grappling with the problems of architecture on its most exalted plane, are to be the nuclei of the coming spiritual and artistic regeneration.

These are precisely the terms in which Gropius also viewed the Arbeitsrat für Kunst. In February 1919 Gropius was made chairman of the executive committee of the organization. In a speech delivered to the Arbeitsrat on the occasion of, or just after, taking office, he used the same words he was to use in his speech to the Bauhaus students:

... I believe we can be thankful that our tight purse has prevented us from advancing on a wide front. We have the advantage today, as a result, that a secret mystery still hangs over the Arbeitsrat, and that the public expects everything or nothing from us. I regard our association as a conspiracy; we are a small minority. If we want to accomplish something strong, we must uphold our program in every respect and permit no compromise. ... Better to accomplish *nothing* practical at first; for any attempt to wangle our way through means the beginning of the end.[36]

Doubtless, we can read in these remarks something of a justification for the lack of opportunity to do actual work; but their true significance lies in what they reflect of Gropius's and the Arbeits-

[35] *Ibid.*, p. 237. "Vor dem Krieg haben wir das Pferd beim Schwanz aufgezäumt und wollten die Kunst durch Organisation von rückwärts in die Allgemeinheit tragen. Wir bildeten Aschbecher und Bierseidel künstlerisch aus und wollten uns so allmählich bis zum grossen Bau emporsteigern. Alles durch kühle Organisation. Das war eine masslose Überhebung, an der wir Schiffbruch litten und nun wirds umgekehrt werden."
[36] Appendix D, p. 279. Although untitled and undated, the notes for this speech in the Bauhaus-Archiv are clearly identified and dated by their content.

rat's desire to give to art and architecture a profound social role. Behind them is again the example of the prewar Werkbund. They show that Gropius saw a conclave of artists guarding its "Mysterium" as a more valid alternative for the times than the type of broad, practically oriented association of multifarious interests represented by the Werkbund. Only slowly did we come to realize what we wanted, Gropius observes in his speech. "Between two fundamentally different objectives, which from the start were dangerously confused with each other: whether we should engage in art *politics* on a large scale or help bring a radical artistic creed to victory through the union of a small minority," we have only gradually come to decide in favor of the latter. So important did Gropius regard this difference in the aim of his organization that in correspondence with Arbeitsrat members and supporters he insisted upon it over and over again.[37]

As with the Bauhaus, one of the principal artistic manifestations of this radical artistic creed was to be the creation of utopian buildings such as *Volkshäuser*. There is no need to elaborate on the by now well-known fact that such projects were central to Arbeitsrat plans. One of the chief demands made by the Arbeitsrat to the government was the granting of a tract of land where full-scale experiments in large building projects requiring the cooperation of all the arts could be carried out and serve as a permanent exhibition. The demand was apparently Taut's idea, first put forward in his Arbeitsrat pamphlet, *Ein Architektur-Programm*, published Christmas 1918.[38] It was simultaneously made the first of the six demands to the government published in the Arbeitsrat announcement of purpose at the end of the year.[39] Gropius enthusiastically supported Taut's plan, elaborating it with little

[37] GAL, "Briefe, Arbeitsrat für Kunst, 1919/1921" file.
[38] With a second printing in the spring of 1919. Reprinted in Ulrich Conrads and Hans G. Sperlich, *The Architecture of Fantasy: Utopian Building and Planning in Modern Times*, trans., ed., and expanded C. C. Collins and G. R. Collins (New York and Washington, 1962), pp. 135–136, and Ulrich Conrads, ed., *Programme und Manifeste zur Architektur des 20. Jahrhunderts* (Berlin, Frankfurt am Main, and Vienna, 1964), pp. 38–40.
[39] E.g., as "Ein neues künstlerisches Programm," *Die Bauwelt. Zeitschrift für das gesamte Bauwesen* 9, no. 52 (December 26, 1918): 5; also published in the spring as a pamphlet; reprinted in Ulrich Conrads, ed., *Programme und Manifeste*, pp. 38–40. On the dates of these announcements see Appendix D.

change in the above-mentioned memorandum for the Arbeitsrat, in which he described the establishment of such *Probierplätze* and their value for displaying architectural prototypes, cultural symbols, and educational exhibits for the general public. In a spring announcement of reorganization, the Arbeitsrat, under Gropius's leadership, endorsed the plan still more strongly than before, repeating with greater urgency than ever that "the collaboration of [Arbeitsrat] artists on the basis of a comprehensive utopian building project" was "an important task for the immediate future."[40]

The same goal of bringing a radical artistic creed to victory also accounts for the fantastic character of the Arbeitsrat's "Exhibition for Unknown Architects," held at the Kabinett J. B. Neumann in Berlin in April 1919. The exhibition, which was selected by Gropius along with Max Taut and Otto Salvisberg,[41] had a different purpose in view than the display of workable projects, utopian or otherwise. Like the designs demanded by Gropius of his students, the drawings in the exhibition were shown primarily for their value as ideas, for their radical and even fantastic qualities of imagination. It is for this reason that a number of painters and sculptors as well as architects were exhibited.[42] The main purpose of the exhibition was expressed by Gropius in his introduction to it when he wrote of the "longing for a world of beauty built completely anew" and of the "construction of a fervent, daring, and far advanced architectural concept";[43] or as

[40] Published among other places in *Der Cicerone*, April 1919 ("Der Arbeitsrat für Kunst in Berlin," p. 230).

[41] The show was already planned and work for it solicited in January. See Adolf Behne, "Kurze Chronik," *Sozialistische Monatshefte* 25, no. 2–3 (February 10, 1919): 136, and idem, "Unbekannte Architekten," *Sozialistische Monatshefte* 25, no. 10 (April 28, 1919): 422–423.

[42] Among the nonarchitects shown were: Jefim Golyscheff, César Klein, Erwin Hass, Johannes Molzahn, Arnold Topp, Oswald Herzog, Gerhard Marcks, Hermann Obrist, Hermann Finsterlin, Friedrich Kaldenbach, Wenzel Hablik, and [Oskar?] Treichel (Behne, "Unbekannte Architekten," and Kurt Gerstenberg, "Revolution in der Architektur," *Der Cicerone* 11, no. 9 [May 1919]: 255–257).

[43] Conrads and Sperlich, *Architecture of Fantasy*, p. 137. The exhibition was explained more prosaically in a review by Adolf Behne: "Es schien dem Arbeitsrat wichtig die Probe zu machen, ob wirklich die Zahl unserer guten Architekten so beschämend klein ist, wie es, an Bekanntem gemessen, den Anschein hat." As for why painters and sculptors were also invited to show: ". . . es ist für die als notwendig

he put it still more succinctly in a letter to the painter Jefim Golyscheff, acknowledging acceptance for the show of some of his drawings about which there had evidently been some doubts: "We finally . . . had to admit to ourselves that your works have to be included in the category of architecture. They are, after all, an ultimate expression of what we want: Utopia."[44]

Talk of secret radical conspiracies at work on utopian projects hardly seems compatible with the professed interest expressed in the Bauhaus program in "steady contact with the leaders of crafts and industry in the land." Yet, should we assume from this a simple split between the two aspects of Bauhaus design—on one side shopwork concerned with such things as "furniture and objects of use" (to quote the Bauhaus program) which presumably would require the cooperation of industry; on the other, utopian schemes planned in lofty isolation from practical economic life as mere seeds for the future? The answer is strongly indicated by Gropius in his Arbeitsrat memorandum, which shows that experimentation toward the *Zukunftskathedrale* was likewise to involve the cooperation of existing industry. The experimental sites called for by the Arbeitsrat would be supported not only by the state, but also by the various construction and materials industries concerned. Materials and services had to be obtained from someplace, needless to say, and Gropius recommended that if they were not given voluntarily, then the government should compel participation. But he certainly preferred it otherwise. His is not simply a demand for contributions, but a hope for the active sharing of an uncompromised ideal on the part of industry: the memorandum speaks of "artists in cooperative work among themselves and together with industry" trying out "new artistic effects and technical possibilities" on the experimental site. And Gropius adds

erkannte Zusammenarbeit natürlich sehr wichtig zu erkennen, wie weit schon in den anderen Künsten tektonische Kräfte am Werk sind" (Behne, "Unbekannte Architekten"). Behne was disappointed by most of the contributions of the non-architects, except for Obrist, Finsterlin, and "Fritz" (Friederich) Kaldenbach.

44 Carbon copy of letter of March 22, 1919: "Wir haben uns schliesslich doch zu dem Standpunkt bekannt, dass Ihre Arbeiten in das Gebiet der Architektur hineinzubeziehen sind. Sie sind ja ein letztes Ende von dem, was wir wollen: die Utopie" (GAL, "Briefe, Arbeitsrat für Kunst, 1919/1921" file).

that "numerous industries will have the opportunity on the experimental site of widening their experiments within their own fields of undertaking," for doing which they would obtain "honor and at the same time highly deserved advertising."[45]

Thus, despite the warning in Gropius's introduction to the "Exhibition for Unknown Architects" not to confuse everyday work with that "longing for the stars" presumably displayed by the exhibition, on a fundamental level of aim beyond the question of form or practicability, no meaningful distinctions among the different aspects of planning—from the most visionary and programmatic to the most utilitarian—were recognized either by the Arbeitsrat or the Bauhaus. All of their activities were guided by the same basic intention to transform every aspect of art from the ground.

The cogent and sympathetically critical discussion of the "Exhibition for Unknown Architects" by Theodor Heuss at the time is of interest here because of what was undoubtedly a characteristic misconception of the exhibition and of Arbeitsrat intentions. In a review of the show attempting to explain the reasons for both the earlier "functional" (*zweckmässige*) phase of modern designing and the current reaction toward stressing the imagination, Heuss observed that the error of the Arbeitsrat exhibition was in not linking the imaginative, as in all true architecture it must be linked, with the practical.[46] But while strictly speaking true of many of the architectural drawings from the Arbeitsrat für Kunst, this missed precisely the essential point of the show. Adolf Behne directed himself succinctly to the issue in his own review of the exhibition, in which he replied to an obviously familiar criticism of the Arbeitsrat with faint and somewhat rueful irony: "For the Arbeitsrat, a *Utopia* is nothing laughable. One may call *utopian*, Bruno Taut's architecture program . . . ; *utopian*, Otto Bartning's teaching program, now in preparation; *utopian*, the idea of constructing large-scale, forward-pointing architectural models by architects, sculptors, and painters working together in order to

[45] Appendix E.
[46] Theodor Heuss, "Phantasie und Baukunst," *Der Kunstwart* 32 (July 1919): 17–20.

overcome the fatal boundaries between the dangerously isolated arts."[47]

It is necessary to emphasize this compatibility which the Arbeitsrat anticipated between utopian planning and practical endeavor because taken simply by itself it is too easy to see Gropius's description of the Bauhaus as a "secret" community as equivalent to Johannes Itten's lasting conception of the school as a cloistered spiritual training ground on the order of the famous artistic Abbey of Beuron, which Itten had visited;[48] whereas, in fact, Gropius had indeed at first regarded the Bauhaus as a shelter, but only as a way of buying time in that chaotic period for the students' inner development as men and artists.[49] For him it was something far more comparable—he himself acknowledged it by using the word "conspiracy"—to a revolutionary political cell; which does not mean that this, or the rebuilding of society, was to be in any way connected with political parties or doctrines. Gropius was most vehement on that score, as a series of letters to Adolf Behne of January-February 1920 from Weimar makes strikingly evident. In them he denounced party politics in the strongest personal terms as a sullying and ultimately fatal involvement for the Bauhaus.[50]

To understand how such utopian thinking could be reconciled with the hope of immediate practical effect in the world of government and commerce, the peculiar intellectual climate of Germany just after the war must be recalled. It was a unique distinction of the postwar period to permit these two aspects of visionary planning and practical endeavor to join in the minds of artists as never before or since in the history of modern artistic movements. The often seemingly hazy boundaries in the social

[47] Behne, "Unbekannte Architekten," p. 422.

[48] According to Schlemmer, *Briefe*, pp. 116–117.

[49] See Schlemmer, *Briefe*, p. 105 (letter to Otto Meyer of Feb. 3, 1921): "[Gropius] wolle, sagt er, dass ein Künstler auch ein Charakter sei, und erst dies, nachher das andere. . . . So wünschte er sich eine zeitweilige Mauer um das Bauhaus und klösterlichen Abschluss."

[50] E.g., letter of Jan. 31, 1920: "Ich sehe jetzt mit voller Deutlichkeit: jede Partei ist Schmutz, sie erzeugt Hass und wieder Hass. Wir müssen die Parteien zerstören. Ich will hier eine unpolitische Gemeinschaft gründen" (StAW B'haus, temp. no. 399). I am indebted to Allan Greenberg for kindly letting me use his transcription of this letter.

and artistic objectives of German architects and artists between what was possible and what is now clearly seen to have been impossible cannot be attributed to any supposed artists' impracticality. They can only be accounted for by the millenarian belief of the time that a major social and spiritual change was imminent, and that a government and, indeed, an entire society might now arise—for some certainly more a dubious hope than a real expectation[51]—which could recognize and further that change. For the advanced artists, this recognition necessarily meant the acceptance by the state and the public of their claims to the creative leadership of the new age; and the ideals and proposals they espoused seemed no less or more utopian and capable of realization than the ideals of the November Revolution itself. Compromise could only result in forfeiture of that leadership; hence the secret conspiracies and tight-knit bunds of dedicated modern artists, as Gropius pictured them, working in relative isolation toward their ideals until the time when they would be able to assume their rightful places as recognized leaders of society.[52]

Those notable and characteristic groups of the time, the Arbeitsrat and the Novembergruppe, which had largely overlapping memberships, were direct embodiments of this conception of the modern artist's position and activity in a period of transition. Seemingly inspired by the example of the revolutionary *Soldaten-* and *Arbeiterräte*,[53] the equivalents in Germany of the

[51] See Hellmut Lehmann-Haupt's discussion of the strong mistrust of government exhibited by the Arbeitsrat für Kunst questionnaire and many of the answers published in *Ja! Stimmen* (*Art Under a Dictatorship*, New York, 1954, pp. 20–21). On the general subject of the architects' hope for a new society see now Barbara Miller Lane, *Architecture and Politics in Germany, 1918–1945* (Cambridge, Mass., 1968), Chapter 2 and *passim*.

[52] Cf. Behne's defense of the Arbeitsrat in his review of the "Exhibition for Unknown Architects": "Der Arbeitsrat ist keine Clique, noch ist es sein Ziel durch Kompromisseln mit den Behörden kleine, für den Tag berechnete *Reformen* durchzusetzen, sondern der Arbeitsrat will durch intensive künstlerisch-geistige Arbeit, nicht durch Reden und Debattieren, das Gute erzwingen" (Behne, "Unbekannte Architekten," p. 422).

[53] The title *Arbeiterrat für Kunst* actually appeared as a misprint on the title page of the Arbeitsrat's *Ruf zum Bauen* of 1920. This is the only time the Arbeitsrat was ever referred to as such in print, and there is no reason to think it was anything more than an—understandable?—typographical error (possibly by a politically hostile printer?).

Russian Soviets, they constituted an essentially new type of artistic organization; for they combined in a singular fashion the intellectual solidarity, visionary spirit, and far-reaching commitment to cultural renewal that were characteristic, we have seen, of expressionism, with an involvement in practical issues of art education and the relationship of art to the state such as had very largely been the concern of architects and architects' groups before the war. In this respect, they differ significantly from the earlier, more narrowly conceived twentieth-century artists' groups and secession movements, or the Werkbund. In their desire to unify the arts and in the breadth of the social renewal they sought, they resemble instead the contemporaneous Stijl group in Holland and, thanks to a similar revolutionary political situation, the constellation of modern artists formed in Russia just after the war, by neither of which, however, despite immediate contacts among the groups, were they essentially influenced.[54]

The meeting in Germany of architects with modern painters and sculptors after the war in such action groups involved a readjustment of views on both sides. If the advanced artistic and literary circles of Berlin, Munich, and Vienna had helped to give a new direction and spirit to the younger generation of architects who came into contact with them, the architects became in turn an important influence in directing the elitism of many artists

[54] The German groups were in touch almost immediately with Russian developments. See Adolf Behne, "Vorschlag einer brüderlichen Zusammenkunft der Künstler aller Länder," *Sozialistische Monatshefte* 25 (March 3, 1919): 155–157, who notes that a "Consortium of Russian artists," among them Kandinsky, has sent greetings to the Arbeitsrat along with a "bold and outstanding program of work." A copy of this "Aufruf der russischen Künstler" was sent to Gropius by the artist Ludwig Baehr already in January (carbon of a letter to Baehr of Jan. 27, 1919, thanking him for it. GAL, "Briefe, Arbeitsrat für Kunst, 1919/1921" file), and was published, among other places, in the Feb. numbers of *1919. Neue Blätter für Kunst und Dichtung* and *De Stijl*. A detailed "Kunstprogramm des Kommissariats für Volksaufklärung in Russland," similar in many respects to the programs of the Arbeitsrat and Novembergruppe, was also published in March in *Das Kunstblatt*. Considering, however, the substantial differences between the German programs and the Stijl manifesto, published Nov. 1918, as well as the fact that the ideological grounds were already well prepared in Germany before the war and that ready political models existed close at hand, the Dutch and Russian developments probably had little, if any, direct influence on the formation of the Arbeitsrat and Novembergruppe.

toward a more direct form of social concern. It was observed in the previous chapter that, with some exceptions, architecture lay outside the major interests before the war of the principal German and Austrian artists who were in the forefront of the new culture. The basic reason is not hard to see. As applied arts, necessarily involving compromise with practical, nonartistic ends, architecture and all that pertained to it could have little place in the defiantly nonmaterialistic philosophy of artists concerned above everything else with self-expression or the expression of a refined spiritual content. Indeed, as Selz has pointed out, some of the first of the German expressionist painters, the founders of *Die Brücke*, had actually reversed the remarkable trend of the eighteen nineties: having begun as students in architecture, they turned to painting.[55] It is, of course, true that many painters now welcomed the opportunity for wall painting; but this is still far from the situation of the eighteen nineties when artists had eagerly turned to architecture and the applied arts as a way of giving their work greater social relevance.

With the coming of the war, and afterward of the revolution, however, a substantial number of painters and sculptors returned, like the artists of the nineties, to collaboration with architects— even if for some it was hesitantly and only in response to the exigencies of the moment. The November Revolution offered the promise of long-awaited fulfillment to that broad spectrum of utopian and socialist sentiment shared by probably most of the modern artists of central and eastern Europe. Communities of artists throughout Germany rushed to issue proclamations of their desires to influence the still nebulous political forces in the work of reconstruction.[56] In this process it was natural that architects

[55] Peter Selz, *German Expressionist Painting* (Berkeley and Los Angeles, 1957), pp. 77–78.

[56] See Schmidt, ed., *Manifeste*, for manifestoes from artists' groups in Halle, Magdeburg, and Bielefeld. Lisabeth Stern writing in the *Sozialistische Monatshefte* reported on socialist artists' groups in Düsseldorf (*Das Aktivistenbund* and *Junge Rheinland*) and Berlin (besides the Novembergruppe and Arbeitsrat für Kunst, a group headed by Friederich Natherots and including Heinrich Vogeler and Käthe Kollwitz). See Stern, "Kurze Chronik," vol. 25 (March 24 and June 10, 1919), pp. 297, 587; and Stern, "Sozialismus und Kunst," vol. 25 (July 7, 1919), pp. 675–676. An Arbeitsrat business report dated June 17, 1919, by Adolf Behne, who was secretary of the organization, lists 14 groups of radical artists in Germany,

should provide much of the impetus, since from the first they had been involved in questions of public concern. Much of the inspiration or guidance for the almost identical programs of the Novembergruppe and the Arbeitsrat für Kunst came from architects and architectural theorists such as Behne, or from such figures as Scheerbart and (among painters) César Klein, the latter a founder of the Novembergruppe, a director of the Arbeitsrat, and a prewar collaborator with Gropius and others in the Werkbund—men, in other words, who themselves had been deeply concerned with architecture.

To say that the Bauhaus was intimately bound up with the goals and activities of the Arbeitsrat für Kunst is in one respect, therefore, to say little more than that, like the Arbeitsrat itself, it was the product of a multitude of widespread artistic and social impulses. It is for this reason less important to recognize the specific links that tied the Bauhaus to the Arbeitsrat für Kunst as an organization, pertinent as they are to the history of the school, than to understand the common thought that lay behind both.[57]

---

Austria, Switzerland, and Holland (De Stijl) with whom the Arbeitsrat was in contact (GAL, "Briefe, Arbeitsrat für Kunst, 1919/1921" file). For the names of two additional groups see also Lane, *Architecture and Politics in Germany*, p. 42.
[57] The words of Udo Kultermann, although written with a view to correcting what has since been recognized as the incorrect notion of a purely rationalistic Bauhaus, are nevertheless still pertinent in this context: "From the start it [the Bauhaus] was a complex combination of all the various tendencies which since the 19th century had been directed toward a renewal of all aesthetic phenomena. It may sometimes seem from the perspective of time that there were basic differences between the circle of Bruno Taut and Hans Poelzig on the one hand and the Bauhaus on the other. Still, their endeavors all sprang from the same roots and sought the renewal of aesthetic, social, and political conditions through the rebuilding and formal mastery of our environment" (*Wassili und Hans Luckhardt, Bauten und Entwürfe*, Tübingen, 1958, p. 8).

# THE INCEPTION OF THE BAUHAUS
# AND THE PLACE OF THE FINE ARTS
# IN ITS EARLY CURRICULUM

# 5

## Gropius's First Choices for the Bauhaus:
## Marcks and Feininger

When it came to filling the first two positions at the Bauhaus, one of them for a sculptor, Gropius did not choose on the basis of a particular style—although both his choices represent the tendency away from the freely rhythmical abstractions and semi-abstractions of the Blaue Reiter period toward a greater compactness and severity of form—but not surprisingly, on the basis of their shared ideals. He turned to two artists with whom he was already befriended: Gerhard Marcks, his former co-worker in the Werkbund, and Lyonel Feininger, whom he first came to know after the war.[1] Both were members of the Arbeitsrat, the only two

[1] The newness of Gropius's and Feininger's friendship at the beginning of 1919 is shown by the use in their correspondence of that time of *Sie* and of formal salutations and closes (GAL, "Briefe, Arbeitsrat für Kunst, 1919/1921" file; esp. Feininger's letter of March 13). According to Günter Aust, Gropius also sought Otto Freundlich for the Bauhaus but was opposed by the faculty. Cf. Behne's remark in a letter to Gropius of October 8, 1920: "Du kennst ja Freundlich und soviel ich weiss, schätzt Du ihn— wie ich ja auch ihn schätze" (addressed to "Mass" and signed "Ekart"; GAL, "Briefe, Arbeitsrat für Kunst, 1919/1921" file). See Aust also for Freundlich's similar ideas concerning art as an expression of all-encompassing cosmic forces and the mission of the artist to prepare for a new society (*Otto Freundlich 1878–1943*, Cologne, 1960, pp. 14–25).

at the Bauhaus besides Gropius and Gropius's architectural part-
ner, Adolf Meyer, to have joined; and both shared his views closely
on the nature of the school, the reunification of the arts, the artist's
mission in society, and the handicraft requirements of art edu-
cation. Both, moreover, had become members of the Werkbund,
Marcks already before the war.[2] The only two *Formmeister* aside
from Itten chosen personally by Gropius, they were for him, so to
speak, known quantities, and his faith in them was not misplaced.
Because of their attachment to the ideals of the Arbeitsrat, along
with which went their devotion to the idea of art as heightened
craftsmanship, Marcks and Feininger were to act as sobering bal-
ances to the tendency present in the early Bauhaus among stu-
dents, and exacerbated by the similar interest of Itten in placing
inner spiritual development above, and even in opposition to, the
actual work of the shops.[3] Feininger, at least, although remaining
on close terms with Gropius personally, was by 1923 to "rebel with
complete conviction against the slogan 'Art and technics, the [*sic*]
new unity'" which marked Gropius's final turning away from
handicraft as an end in itself toward a full commitment to design-
ing for the machine.[4] But until that change he was to be, along
with Marcks, for whom the 1922–23 change was probably not as
disturbing because of his prewar experience in designing for in-
dustry, one of the closest supporters of Gropius in the conflicts
that were to arise with Itten over the orientation of the Bauhaus.[5]

As a collaborator with Gropius in the Werkbund exhibition of
1914, Marcks was a logical, if cautious, choice for sculptor. Even
though it was already conservative by the vanguard standards of
the day, Marck's figural style with its compact silhouettes, archais-
tic stylizations, and cubistically simplified planes had something of
the geometric order and *Geschlossenheit* which Gropius regarded
as sure signs that painting and sculpture were once again drawing

---

[2] Feininger is listed in the *Mitteilungen des Deutschen Werkbundes*, 1919–1920
(no. 6) issue, p. 179, among new members accepted between June 15 and the end
of December 1919.

[3] See below, pp. 174–175, 215–216.

[4] Letter of August 1, 1923 to Julia Feininger, in Wingler, *Bauhaus*, p. 83.

[5] This is revealed in letters and memorandums from the Weimar period which
show them siding with Gropius (albeit cautiously) in seeing workshop training
as the heart of the Bauhaus. See Appendix F, pp. 285–287, 296–297.

near in spirit and form to architecture. Marcks had been brought as a teacher to the Berlin *Kunstgewerbeschule* by its director, Bruno Paul, in 1918 and had already had experience working for industry by designing porcelain sculpture for manufacture. With the recollection of the ceramic sculpture that Marcks had further done for Gropius's foyer interior and factory complex at the Werkbund exhibition, Gropius undoubtedly foresaw Marck's task at the Bauhaus as centering principally on the development of architectural ceramics, a workshop for which had been one of the first specifically requested by him in his restricted budget estimate for the Bauhaus in February 1919.[6] According to Marck's recent account, he "was called [to the Bauhaus] as an old friend of Walter Gropius . . . with only the requirement to unite handiwork as much as possible with art."[7] The request accorded completely with Marck's own views. In his reply to the questionnaire sent out to members by the Arbeitsrat and published with the responses in November 1919 as *Ja! Stimmen des Arbeitsrates für Kunst,* Marcks shows himself to have been a completely convinced exponent of total shop training for the art student, going farther than Gropius to insist that "evidence of handicraft ability alone justifies admission to an art school as apprentice," and that there should be in the art school "no experiments and theoretical exercises, but rather a maximum *participation in carrying out the works of the master"* (emphasis his).[8] And when at the end of 1921 he was asked to state his mind in the dispute between Gropius and Itten over the expansion of practical work at the Bauhaus, he replied in a memorandum to Gropius that "for me the Bauhaus is more workshop than school."[9]

Feininger, unlike Marcks, had no experience with monumental decoration. It was, along with his ideas, his cubist style and archi-

[6] See the budget estimate in Wingler, *Bauhaus,* p. 34.

[7] In *Bauhaus. Idee—Form—Zweck—Zeit* (catalogue), Göppinger Galerie, Frankfurt am Main, February 1–March 14, 1964, p. 27.

[8] In Diether Schmidt, ed., *Manifeste Manifeste 1905–1933. Schriften deutscher Künstler des zwanzigsten Jahrhunderts,* vol. 1 (Dresden, [1964]), p. 216.

[9] Appendix F, p. 286. This memorandum is also interesting for its indication of how deeply Marcks continued to believe in the idea of the Bauhaus as a seminal creative community which in time would give rise to similar small communities all over the country.

tectural subject matter that attracted Gropius as being in the spirit of the new architecture. It is something of an exaggeration to say as has been said, that "Gropius understood the creation of space in architecture in the same way that Feininger understood the creation of space in his pictures."[10] It is, however, entirely justified to recognize that for Gropius architecture had its source in the same mysterious spiritual realm he found embodied in Feininger's paintings.

We do not have Gropius's own words on what he thought of Feininger's work, but it is not too much to assume that he saw it with eyes little different from those of Bruno Taut or Adolf Behne who, as we have already seen, conceived of cubism as a cosmic, immaterial architecture and the expression of a desire for transcendent unity. Behne in particular was most explicit regarding the meaning cubism had for him.[11] The leading movement in modern art, it was impelled by "a secret striving toward an ultimate unity" whose source, in his words, was a "feeling of world love that sounds ceaselessly out of . . . [its] finest works."[12] The effects of unity in painting demonstrably involved for some cubist painters—Juan Gris or Léger, for instance—the use of mathematical proportion or the expression of geometric archetypes.[13] But as these words of his make apparent, it was not this rationalistic side of cubism with its roots in classicism that interested Behne. On the contrary, he explicitly opposed it to classicism, a judgment that, if it is based upon style at all, plainly has more to do with German paintings derived from cubism than with French

[10] Hans Hess, *Lyonel Feininger* (New York, 1961), p. 88, who quotes from Gropius's 1923 essay, "Idee und Aufbau des staatlichen Bauhauses": ". . . der Mensch erfindet durch seine Intuition, durch seine metaphysische Kraft, die er aus dem All saugt, den stofflosen Raum des Scheins und der inneren Schauung, der Visionen und Einfälle; er fühlt die Zusammenhänge seiner Erscheinungsmittel, der Farben, Formen, Töne und verinnerlicht mit ihnen Gesetze, Masse, Zahlen. Aber dieser Raum der Schauung drängt zur Verwirklichung in der stofflichen Welt; mit Geist—und Handwerk wird der Stoff bezwungen. . . ."
[11] See above, pp. 115–117.
[12] Adolf Behne, *Die Wiederkehr der Kunst* (Leipzig, 1919), p. 24: ". . . einen geheimen Drang zu einer letzten Einheit. . . ." "Den Willen zur höheren Einheit offenbaren die Kubisten durch die Empfindung der Weltenliebe, die stets aus ihren schönsten Werken erklingt."
[13] On Gris and proportion see William A. Camfield, "Juan Gris and the Golden Section," *Art Bulletin* 47, no. 1 (March 1965): 128–134.

cubism. But as we observed in Chapter 3, for Behne the concept of cubism was far more than that of a style. He was emphatic in stating that it was not "a matter exclusively of painting," but a universal principle or essential of all creation. He placed it with the two highest expressions of the nonclassical spirit in European art, the gothic and the romantic; indeed, even going as far as to enlarge it to the status of a "high *Weltanschauung*" and to link it philosophically to Paul Scheerbart, whom he declared to be the very source of the modern movement in all of the arts.[14]

For Behne, in brief, cubism as a concept had two essential aspects; or, rather, it was really two interrelated concepts: it was a matter of content—that is, the high metaphysical content he saw depicted in the best of all the modern arts—and it was a universal formal principle. What related them, as we saw in Chapter 3, was the notion that, ultimately, both referred to a transcendental world-spirit: the first as the conscious expression of desired communion with that spirit; the second, when truly contained in art, as the manifestation of the communion achieved.[15]

It is for this reason not surprising to find that the artists who most completely realized Behne's ideal of painting in 1918 were Chagall, Marc, Klee, to whom he gave first place in Germany now that Marc was dead, and Feininger.[16] Behne, at whose home, according to Hans Hess, Gropius told Feininger that he was

14 Behne, *Wiederkehr*, pp. 25, 37–40, 64: "Gewiss ist es . . . sachlich zutreffend, dass die Malerei relativ früh von der [neuen] Bewegung ergriffen wurde. . . . Aber dieses . . . ändert nichts an der Tatsache, dass der Beginn der neuen Bewegung an ganz anderer Stelle erfolgte, nicht in der Malerei, sondern in der Dichtung, und zwar durch Paul Scheerbart" (p. 39).

15 Similar views of cubism were held by Ludwig Coellen, already in 1912 (*Die neue Malerei*, Munich), and by Paul Erich Küppers, director of the Kestner-Gesellschaft in Hanover. Küpper's *Der Kubismus. Ein künstlerisches Formproblem unserer Zeit* (Leipzig, 1920) is an all but indigestible paean to cubism as an ecstatic, mystical striving for the otherworldly. One finds in it virtually the entire repertoire of familiar themes of postwar German art criticism brought into relation with cubism: the longing for universal harmony, space as infinity, the analogy of abstract art with musical counterpoint, the crystalline symbol, and the spirit of the Gothic cathedral. Not unexpectedly, Küppers quotes copiously from such figures as Schleiermacher and Meister Eckhardt. On Küppers and the Kestner-Gesellschaft see now also Wieland Schmied, ed., *Wegbereiter zur modernen Kunst. 50 Jahre Kestner-Gesellschaft* (Hanover, 1966).

16 Behne, *Wiederkehr*, pp. 24, 44.

wanted for the Bauhaus,[17] first met the painter probably in September or early October 1918 through Feininger's friend in the *Sturm* circle, the poet Adolf Knoblauch; and it may well have been Behne who first introduced Feininger to Gropius and by whom he was brought into the Arbeitsrat a few months later.[18]

Nothing requires us to think that Gropius concurred in every respect with Behne's conception of cubism, especially with the notion that it was an anticlassical style. Considering his own work, he is not likely, for instance, to have opposed it to the classicistic aesthetic of precise, delimiting plans and geometric forms which he absorbed from Behrens and the Werkbund. Nevertheless, we may well doubt whether in 1919 Gropius shared the ideas of some French cubist theorists, or of the French Purists, for example, that cubism—least of all Feininger's cubism with its imagery of soaring cathedrals fragmented into planes of light—was at its base a classical and rationalist art of formal archetypes or mathematical proportions. Such a classicistic conception of cubism was represented in Germany at this time notably by the art dealer and critic, D.-H. Kahnweiler, in an article of 1919 on André Derain in *Das Kunstblatt* and in his *Der Weg zum Kubismus*, first published in 1920; and it was to become increasingly prominent in Germany after 1920 under the influence of Purism and of Dutch aesthetics. On the basis of the sentiments expressed in his proclamations of the time, however, it is most probable that what Gropius admired in Feininger's work, even more than its formal precision and

[17] Hans Hess, *Feininger*, p. 87.
[18] The meeting of Feininger and Behne is documented by three letters from Knoblauch to Feininger. The first, dated July 8, 1917, brings Behne to Feininger's attention with the following amused words: "Beängstigend geradezu ist der Behne: der Scheerbart, Taut und Ellora in einem Brei mischt und dabei Zille u. Prof Frey (?glaube ich!) verherrlicht. Eine sonderbare kunshistorische [sic] Existenz, dieser Behne!" (FP, bMS, Ger 146 [1141]). The second, of Aug. 8, 1918, reports that "mit . . . [Behne] habe ich mir erlaubt, über Sie Rücksprache zu nehmen, und ich glaube kein Unrecht gegen Sie zu begehen, wenn ich Sie bitte, seinen Besuch bei Ihnen . . . anzunehmen. Er wird Sie Anfang September in Ihrem Heim aufsuchen. . . . Er ist ein treuer, loyaler Mann . . ." (FP, bMS, Ger 146 [1169]). The third, dated September 17, 1918, states: "An Behne habe ich nun geschrieben, und er wird Sie vermutlich nächstens besuchen. Zeigen Sie ihm, soviel Sie dahaben, es wird sich für Sie lohnen. Er ist [ein] sehr starker Ideologe. Sie werden in manchem Gedanken sympathisieren" (FP, bMS, Ger 146 [1172]).

clarity, were just those effects of mystical unity of space and matter in which substance was dematerialized, and that creation of a crystalline, soaring image of architecture which in Feininger's woodcut for the Bauhaus manifesto so exactly caught, in fact, the spirit of the *Zukunftskathedrale* called for by Gropius.[19]

### The First Bauhaus Program in Practice

The reality to which Gropius, Marcks, and Feininger had to accommodate their closely matching conceptions of the Bauhaus was far from auspicious.[20] The former *Kunstgewerbeschule*, which comprised one half of the new institution, had been completely dissolved during the war. Its faculty had been dismissed, its equipment sold, and the building used as a military infirmary.[21] The first circumstance was advantageous, for it meant that the problem of what to do with an undesired teaching staff would not arise. The second, however, presented a major difficulty. The workshops, intended to be the backbone of the new school, had to be constructed almost from the ground. A few of those eventually established—excluding the printmaking shop which was already in operation as part of the academy—were at least able to begin in the fall of 1919 at the start of the second semester. These were the wall painting (still referred to in mid-1920 as decorative

[19] Cf. Blake's remark that "the showdown [in the Bauhaus] came in 1923 when Itten left to be replaced by Moholy-Nagy and Albers. These two, together with Breuer, and, of course, Walter Gropius himself, represented a more rational tendency which was akin in spirit to the heritage of cubism" (Peter Blake, *Marcel Breuer: Architect and Designer* [catalogue], The Museum of Modern Art, New York, 1949, p. 13). But as we see, this heritage in Germany was two-fold, and it seems likely that before 1922 it was not the rationalist side of cubism but its visionary, poetic side that attracted Gropius most strongly.

[20] The most detailed factual account of Gropius's accession to the directorship of the Bauhaus and the opening of the school is Walther Scheidig, *Crafts of the Weimar Bauhaus 1919–1924: An Early Experiment in Industrial Design*, trans. Ruth Michaelis-Jena and Patrick Murray, F.S.A. (Scot) (New York, 1967). Unfortunately, although he makes use of unpublished documents in the Weimar Staatsarchiv, the usefulness of his work is impaired by the absence of source citations.

[21] Wingler, *Bauhaus*, p. 27; cf. Gropius's description of conditions at the former *Kunstgewerbeschule* in his July 1920 budget request before the Thuringian *Landtag* (*ibid.*, p. 53).

painting) [22] and weaving shops, and the only workshop not origi-
nally planned in the program, the bookbindery, the establishment
of which was afforded by the practice in Weimar of Otto Dorfner,
one of the best-known bookbinders in Germany. The bindery, in
fact, was not an integral part of the Bauhaus. Its equipment re-
mained the personal possession of Dorfner, who was given space
in the Bauhaus, and after his amicable parting from the school as
*Werkstattleiter* in 1922, the workshop was dissolved. [23]

The severely restricted budget, however, drastically limited the
operation of most of the workshops during the first two years, and
some of them remained without basic equipment as late as 1921. [24]
The other workshops came only later. The first of these to open
was the metal shop, which began operation at the end of 1919. [25]

[22] A "Dekorationsmalereikursus" is mentioned in the minutes of the *Meisterratssit-
zung* of Oct. 5, 1919, as having been established (BD,SG). It is still so labeled in
the minutes of May 14, 1920 (StAW, B'haus, temp. no. 184 [p. 4]). Not all the
minutes of the Weimar Bauhaus faculty meetings have survived. The biggest
gaps in the early years occur at the end of 1920 and in the first half of 1921.

[23] Contracts with Helene Börner and Otto Dorfner to head the weaving shop and
bookbindery, respectively, were concluded by Oct. 5, 1919 (minutes of *Mei-
sterratssitzung*, Oct. 5, 1919, BD,SG). Frl. Börner, who had previously led the
weaving class at the *Kunstgewerbeschule*, brought some looms with her, so that
work could begin fairly soon (Gropius's budget request of July 1920 to the *Landtag*,
in Wingler, *Bauhaus*, p. 53; see also p. 308). On the bookbindery, see Gropius's
speech, *ibid.*, p. 53. Dorfner's departure was announced during a collective meeting
of the masters and *Werkstättenleiter* on April 7, 1922 (minutes, BD,SG). Some
sculpture certainly also continued to be done in the fall of 1919 under Richard
Engelmann, who continued with the Bauhaus from the former academy. In his
speech of June or July 1919 to the students, Gropius announced that "im Herbst
. . . zunächst für die Bildhauer ein praktischer Betrieb fertig eingerichtet sein
[wird]" (Schmidt, ed., *Manifeste*, p. 238). The first mention of sculpture shops in
the surviving minutes of the faculty meetings occurs on May 14, 1920, when it is
stated that other *Handwerkmeister* for the *Steinbildhauerei*, *Gipsgiesserei*, and
*Holzbildhauerei* are sought to replace the unsatisfactory Karl Kull in the first two
and Hans Kämpfe in the last (StAW, B'haus, temp. no. 184, [pp. 3–4]).

[24] E.g., Oskar Schlemmer, *Briefe und Tagebücher*, ed. Tut Schlemmer (Munich,
1958), pp. 93–94: "Es ist ja unglaublich, dass zum Beispiel die Werkstät-
teneinrichtungen, die vor dem Krieg in bester Art vorhanden waren, während des
Krieges verkauft wurden, so dass jetzt kaum eine Hobelbank da ist; und das in einem
Institut 'auf handwerklicher Grundlage.' An Bauen, selbst utopischst [*sic*], kann
kaum gedacht werden" (letter of Aug. 7, 1920 to Otto Meyer). In April 1921, e.g.,
the carpentry shop was still without a badly needed planing machine (minutes of
April 6, 1921, StAW, B'haus, temp. no. 184, [p. 3]).

[25] Gropius's letter of Nov. 5, 1919, to Naum Slutzky (see Chapter 1, n. 10).

At about the same time, the Bauhaus contracted with outside potters to permit the use of their facilities for throwing and firing. The ceramic shops in Dornburg were opened only a year later, in October 1920 at the start of the fall semester.[26] At that time, too, the stained glass workshop, one of the first to be projected,[27] was opened and the printmaking shop enlarged.[28] The last to be established was the urgently sought carpentry workshop, which would come closest of them all to fulfilling the name of the school as a house of building. It was not to begin operating until the very end of 1920 or the beginning of 1921.[29]

Whereas the *Kunstgewerbeschule* was received empty and without staff, the other half of the new school, the former academy, the *Hochschule für bildende Kunst,* was all too occupied. Of the teaching posts existing in the former schools and hence allotted by the budget to the Bauhaus, four were still filled by old *Hochschule* staff.[30] Or, rather, the situation should be put positively: the vacancies that had occurred in both schools during the war were plainly an additional inducement to Gropius to accept directorship of them, since it meant that he would be able to fill them with the artists he favored. Nevertheless, the mixture of modern and conservative academic faculty was bound to cause irreconcilable conflicts, even with the best of wills. Otto Fröhlich

[26] On the pottery shop see the basic article by Annegrete Janda, "Bauhauskeramik," *Kunstmuseen der Deutschen Demokratischen Republik. Mitteilungen und Berichte* 1 (1959): 83–114.

[27] E.g., in Gropius's budget estimate of Feb. 1919 (in Wingler, *Bauhaus,* p. 34).

[28] Wingler, *Bauhaus,* p. 34.

[29] The shop was still entirely to be set up on Nov. 9, 1920. The first indication in the minutes that it may already have been in operation occurs in those of Feb. 7, 1921, in which it is reported that *Tischlermeister* Pietschmann is to be replaced by Josef Zachmann, "da . . . [Gropius] sich nicht die Kenntnisse zutraue, die er für den Posten des Werkstattleiters der Tischlerei für notwendig erachte" (StAW, B'haus, temp. no. 184, [p. 2]; BD,SG, [pp. 4–5]).

[30] According to Scheidig, at one point, at least, nine places were allotted to the Bauhaus, of which five were from the defunct *Kunstgewerbeschule.* In support of this he notes that on May 22, 1919, after filling seven posts, Gropius "stated that two further chairs had not been filled" (*Crafts of the Bauhaus,* pp. 14–15). However, Gropius's Feb. 1919 budget estimate for the Bauhaus (Wingler, *Bauhaus,* p. 34) lists only eight positions for masters, observing in a letter to the government of March 3, 1919, that four positions in the *Hochschule* were open (BD,SG, copy of letter to Herrn Bundesbevollmächtigten Paulsen).

and Max Thedy left first. Walther Klemm and Richard Engelmann did attempt earnestly, though without success, to cooperate with the new staff despite the vast differences in their artistic outlooks, and they were in fact not to leave until the very end of 1920 when, with Thedy, they joined a newly reestablished academy, reconstituted by the government under pressure of the opposition in its former building alongside the Bauhaus.[31] It was only with the arrival of Kandinsky in the summer of 1922 that the eight teaching positions the Bauhaus was to retain in Weimar were at last filled with new staff members.

These practical difficulties must be borne in mind in any attempt to evaluate the course of the new school in its first years of existence. They serve in large part, though not entirely, to explain the paucity of concrete results prior to 1922, a paucity which is attested by the documents and by the accounts of the time of Bauhaus members, as well as by the fact that few things by students besides free art and *Vorkurs* exercises have come to light that can with reasonable certainty be dated before 1922. The absence of opportunity for unrestricted shopwork at the beginning was, perhaps, not altogether calamitous; for it quickly became apparent to all that, in any case, too many of the earliest students were either not interested in or incapable of designing adequately in the shops; and Gropius, along with, at least, Itten, came to the conclusion that a greater emphasis on theory would be required before any generally satisfactory level of student achievement could be expected.[32] This decision was in a very short time to move the Bauhaus a considerable distance from the original conception set down in the first program that art education ought to be for the most part a matter of shopwork, technical knowledge, and personal contact with an artist. But even at the start circumstances

[31] Fröhlich left at the end of 1919 after a dispute with the Bauhaus. He was still present at the *Meisterratssitzung* of Dec. 27, 1919, but by Jan. 15, 1920, no longer attended meetings. Thedy still attended the *Sitzung* of May 14, 1920, but was no longer present at that of June 15. On Klemm and Engelmann see Wingler, *Bauhaus*, pp. 212–213. They no longer appear in the minutes of Dec. 6, 1920. On the reestablishment of the art academy see Barbara Miller Lane, *Architecture and Politics in Germany, 1918–1945* (Cambridge, Mass., 1968), pp. 73–75.

[32] E.g., minutes of the *Meisterratssitzung* of Sept. 20, 1920 and of a joint meeting of faculty and students of Oct. 13, 1920 (BD,SG; StAW, B'haus, temp. no. 184).

forced the Bauhaus to be other than what its program had promised; in brief, they forced it to emphasize picture-making and theory.

The lack of shopwork and the retention of old staff meant that the Bauhaus had to start with essentially only the academic half of its program in operation. Except for some technical instruction in architecture and in constructive and projective drawing, taught in the fall of 1919 by, respectively, Paul Klopfer, director of the Weimar School of Building Trades (*Baugewerkenschule*), and a *Baumeister* Schumann, the curriculum seems to have been little different outwardly from that of a conventional academy.[33] Life classes continued to be taught, as, indeed, they were taught throughout the Weimar period.[34] Moreover, at the start of the first fall semester, lectures in art history to be given by Wilhelm Köhler, then director of the Weimar Museum, were planned; the painter Paul Dobe was invited to give a series of weekly lectures on "Nature as the Source of Art, with Particular Emphasis on Plants"; and a proposal by Richard Engelmann to introduce anatomy lessons from cadavers at the University of Jena received the approval of Gropius, who promised to make application to the university.[35]

If these last courses, especially, seem anachronistic within our usual picture of the Bauhaus, we must bear in mind that although circumstances restricted the Bauhaus at first to the drawing board,

[33] Minutes of the *Meisterratssitzung* of Oct. 5, 1919 (BD,SG). Klopfer, who was also a regular contributor to architectural journals, was to become a staunch defender of the Bauhaus in its later difficulties.

[34] The matter of life classes in the Bauhaus serves as an occasion to warn against the extremely unreliable anecdotes of Lothar Schreyer, who at thirty-five years' distance quotes long conversations supposed to have taken place at the Bauhaus. References to life classes in the minutes of Nov. 13, 1919 (StAW, B'haus, temp. no. 184, [p. 2]) and later should be compared with the preposterous scene in Schreyer supposedly witnessed by him (and hence only from the fall of 1921 onward), according to which no life classes had yet been held at the Bauhaus, and in which each of the masters struggles in turn against teaching them (*Erinnerungen an Sturm und Bauhaus*, Munich, 1956, pp. 218–221). Cf. also Schlemmer's letter of May 16, 1921, to Tut Schlemmer in which he writes of his eagerness to teach life drawing (*Briefe*, p. 112).

[35] Minutes of Oct. 5, 1919 (BD,SG). It would be interesting to learn to what extent, if at all, Dobe's lectures continued the Art Nouveau and turn-of-the-century interest in plant stylization.

easel, and lecture hall, it was not mere practical necessity that directed the choice of courses to be taught. Life drawing and nature study—including, rather surprisingly, the full array of academic pictorial subject genres: figure, animal, and plant drawing and painting; landscape painting; and still life—were listed in the first program.[36] We may remind ourselves, for that matter, that skill in depicting natural forms is still today required by most art schools for the visual training of the artist; and as its program made clear, the Bauhaus did aim at the training of painters, sculptors, and printmakers, in addition to craftsmen and industrial designers. The former would have the important duty of bringing their arts into union with architecture in the form of wall painting, mosaics, enamel work, stained glass, reliefs, and free-standing sculpture. Nothing in German art at the time—either in Gropius's own past work, or in the achievements of the Werkbund—forbade the use of figural art or figural ornament in conjunction with architecture as did the contemporaneous De Stijl in Holland. Quite to the contrary. The "important" architectural tasks of the fine arts, mural painting and decorative sculpture—that is, excepting the in part traditional, purely decorative paneling of walls and the ornamentation of borders, moldings, and the like—were all still being done in Germany until about 1920–1921 in figural styles of varying degrees of stylization or distortion.

The theory and practice of nonobjective art in Germany in the first two decades of the century had developed for the most part outside the province and without the interest of architecture.[37]

[36] In Wingler, *Bauhaus*, p. 41.

[37] The vexed question of whether some of the stylized decoration of the Art Nouveau is "proto-abstract" and to what extent it prepared the way for the abstraction of the second decade of the new century need not be considered here. It can, however, be asserted that although theoretical and stylistic connections between the art of the two periods were of significance, there is little mural composition or sculptural decoration of any sizeable scale in Germany from the time of the Art Nouveau which was not in major part based on stylized forms of nature. This holds true, e.g., for one of the most celebrated of "abstract" *Jugendstil* sculptural decorations, Endell's relief for the facade of his Atelier Elvira. Josef Hartwig, who executed Endell's design and later through Endell's recommendation became *Werkstattleiter* of the wood carving shop at the Bauhaus, has described the natural forms from which Endell drew his inspiration (Hartwig, *Leben und Meinungen des Bildhauers Josef Hartwig*, Frankfurt am Main, 1955, pp. 13–14).

Since shortly after the turn of the century, German architects had become relatively conservative in their choices of artistic partners, as a glance at architectural publications and exhibitions of before the war—including the 1914 Werkbund exhibition at Cologne— will show at once. It was Bruno Taut who, in his "Eine Notwendigkeit" of that same year, first publicly signaled a new interest among younger architects in joining their work to that of the most advanced men in the sister arts.[38] And in so doing he did not, it goes without saying, exclude the figurative from architectural decoration. Not until about 1920 do we find the first actual examples in Germany of architecture in which modern, nonfigurative styles play an important decorative role; and one of the earliest of these was, in fact, the Sommerfeld house with Joost Schmidt's abstract relief carvings.

Yet even after we have recognized the reasons for the relatively conservative start of the Bauhaus, there still remains to account for the discrepancy between Gropius's professed desire to foster the modern tendencies in art and his seeming ratification of the whole gamut of academic genre in the Bauhaus program; and perhaps even more, for the retention of easel painting not only in the first program, but still in the statutes formulated in late 1920 and ratified in January 1921.

Most of the answer to the first lies in the prospectus nature of the first program, which was published as a flyer. In other words, it was an advertisement, and as such naturally sought to present the unavoidable reality of the situation—in this case, the existence of an already functioning academy with faculty, students, and a conservative program of work in progress—in as full and appealing a light as possible. This, after all, is just what was done with the defunct *Kunstgewerbeschule* component of the new school: the program lists a full range of handicraft offerings, despite the fact that there were scarcely any shop facilities at the beginning.

To this, however, can be added the consideration that, as we have already observed, the idealistic or so-called utopian aspects of Gropius's plans for the Bauhaus did not exclude his taking account of present realities. Gropius's relative toleration for different artistic directions certainly made it easier for him than for

[38] See Chapter 3.

someone more dogmatic to acquiesce temporarily to conservative art practices and public taste. These were still responsible for almost all of the private and public commissions in which a decorative artist would be involved; and whatever Gropius's concern for change might be, one of the major stated objectives of all the programs for the reform of art education, including Gropius's —the abolition of a *Kunstproletariat*—necessarily had to be given importance in the difficult postwar period. There could be no purpose in eliminating from a leaflet intended to attract students and sympathetic interest to the new school any details of training which might plainly help provide jobs for the journeymen and master painters who completed their Bauhaus work. When, about a year later, the Bauhaus statutes were drawn up, a more realistic expression could be given to the actual practices there; and the inclusive and noncommittal term "nature study"[39] was substituted in the statutes for the list of genres.

The same reason may in part explain the inclusion in the first Bauhaus program of "easel paintings" (*Tafelbilder*) as one of the products of Bauhaus training; but its retention in the later statutes (as "Tafelbildmalerei"), and, indeed, the generally ambiguous place of free painting and sculpture within the Bauhaus curriculum, require other explanations.

From everything Gropius had to say at the time against salon painting and the unintegrated *Kunstproletariat* who worked for an uncertain commercial market, it must easily seem as if he accepted easel painting at the Bauhaus only on sufferance. In his very first address to the Bauhaus students, for example, he delivered an emphatic warning that "I will fight vigorously against an exclusive occupation with pretty little salon pictures as a way of passing the time."[40] The operative word here, we may assume, is "exclusive" (*alleinige*); presumably, engagement with the free arts outside and in addition to the regular workshop activities would be acceptable and perhaps even encouraged. Yet because of such remarks as this, the impression was understandably received by at least some of the artists on the faculty and by students that the free arts would find little welcome in Gropius's scheme of things.

39 In Wingler, *Bauhaus*, p. 54.
40 Appendix A, p. 250.

It was to be expected that the elderly, extremely conservative Max Thedy would for one take Gropius's plans and statements to mean the death of free painting at the Bauhaus. Criticism of salon art coupled with a school program based entirely on the workshop could only mean that Gropius wished to abolish free art altogether. And so he wrote in a long, bitter letter of recrimination to Gropius:

If, as an architect, you can have scarcely any concept of the technical difficulties which have to be overcome to make artistic expression possible, then a walk through the galleries ought to convince you that one dare not describe creations by Titian, Rubens, Velasquez, and Rembrandt as salon art just because they were created apart from building; and that painting is an end in itself. . . . I could regard your program as conducive to art if you were to give young painters the opportunity to learn, without coercion, only those handicrafts which are related to art, such as decorative painting and gilding.[41]

But Feininger, too, was not quite certain where Gropius stood with respect to free art. In one of his first letters from Weimar, written three days after his arrival, he reported that "I don't know whether Gropius really has any contact with a deeper, spiritual art in our meaning of the word. Sometimes I almost think his efforts are directed entirely toward the subjugation of art in the service of architecture, and that he understands only the purely fantastic and decorative side of it."[42]

The same impression seems to have been received by the students. In a faculty meeting of December 18, 1919, which was prin-

[41] Letter of Jan. 9, 1920 (BD,SG). "Wenn Sie als Architekt kaum einen Begriff haben können von den technischen Schwierigkeiten welche zur künstlerischen Ausdrucksmöglichkeit in der Ölmalerei zu überwinden sind, so müsste Sie ein Gang durch die Galerien überzeugen, dass man Schöpfungen von Tizian, Rubens, Velasquez und Rembrandt nicht als Salonkunst bezeichnen darf, weil sie unabhängig vom Bau geschaffen wurden und dass die Malerei Zweck an sich ist. . . . Ich könnte Ihr Programm für kunstfördernd halten, wenn Sie den jungen Malern ohne Zwang Gelegenheit geben würden, nur mit der Kunst verwandte Handwerke wie Dekorationsmalerei und Vergolderei zu erlernen."
[42] Letter of May 22, 1919 to Julia Feininger (FP, MS, Ger 146 [1445], vol. 2. The typed excerpt accessible to students at the Houghton Library is undated but is given as such in a translation of the letter by Julia Feininger in the Busch-Reisinger Museum.) Feininger first arrived in Weimar on May 19, as two letters of that date to his wife indicate.

cipally concerned with an apparent right-wing attack upon the Bauhaus by a pupil who had attended the former *Hochschule*,[43] Richard Engelmann reported the complaint by a student that the real issue in student dissatisfaction was not political, "but the question of 'easel painting'; and conceivably still more students will withdraw."[44] Here we must, of course, consider the possibility that the students concerned had also come from the *Hochschule* and like Thedy were likely to find the Bauhaus opposed to what they had done before. But was their complaint based altogether on misunderstanding? Whatever the answer, it is a fact that fears among the students and some of the old faculty were persistent enough to cause the masters on more than one occasion to attempt to allay them. In the same meeting of December 18, "the *Meisterrat* unanimously decided upon the following announcement: . . . we stand on the Bauhaus program and wish to point out once again that nature study and pure painting (easel painting) will be cultivated in every way at the Bauhaus"; and one month later, all of the masters were prompted in a memorandum to remind Gropius of a portion of conversation which had ensued at the December 18 meeting: "In the minutes of 12/18/19. Note by Prof. Thedy: 'Concerning the question of easel pictures, I observed that I had the feeling my school and easel painting were being pushed to the wall. Whereupon Feininger and Itten responded that, indeed, they themselves also paint easel pictures and are completely determined to foster them.' "[45]

Clearly, we see from this passage that even if fears had been well grounded, whatever attempts might have been made to restrict or discourage the practice of the free arts in the Bauhaus would have been vigorously resisted by the painters and sculptors on the faculty, just as, in fact, Itten was to resist the increasing

[43] On the Gross affair see Lane, *Architecture and Politics in Germany*, pp. 72–73, and Wingler, *Bauhaus*, pp. 49–52.

[44] StAW, B'haus, temp. no. 184, [p. 3].

[45] Memorandum of Jan. 13, 1920, signed by Engelmann, Marcks, Itten, Feininger, Klemm, Thedy (BD,SG). The relevant part reads: "In Protokoll von 18.12.19. Bemerkung von Prof. Thedy: 'Zur Frage Tafelbild bemerkte ich, dass ich das Gefühl habe meine Schule und das Tafelbild würden an die Wand gedrückt. Worauf Feininger und Itten erwiderten, dass sie doch selber auch Tafelbilder malten und durchaus gewillt sind das Tafelbild zu pflegen.' " That is, Thedy had inserted the record of this conversation by hand into the minutes of Dec. 18 (StAW).

emphasis Gropius sought to give to the workshops. But the fact is that even though there were no classes in free painting as such in the Bauhaus (except what could be learned in the decorative painting shop, from the individual masters, and, of course, from the theory classes), students continued to paint. If the free arts were not given a specific place in the curriculum, neither were they excluded. On the contrary, throughout the school's existence, the occasional pupil who showed himself especially gifted in them but had little interest in or talent for work in one of the shops was treated no less considerately in his specialty than the rest, receiving scholarships, studio space, and even special dispensation from shopwork. The last provision was first set down in a notice to the students of December 14, 1920, which announced the necessity of petition for anyone wishing to by-pass required work for reason of special attainments,[46] and it was finally made a part of the rules by being inserted into the revised statutes of July 1922 in a more explicit form: "For specially gifted students a special place can be made which will free them temporarily from shopwork."[47]

With this clause, the Bauhaus in effect went some distance toward adopting the idea of the *Meisteratelier* which had been advocated in all earlier proposals for the reform of art education, though without, needless to say, its thereby assuming traditional hierarchical distinctions among the courses of study. In the Dessau period under Hannes Meyer, in fact, the Bauhaus was once again to devote classes to the free arts, an indication of the widened separation in the program there between the fine and applied arts—something that in the Weimar years the Bauhaus had striven to avoid.[48]

From all of this—the official but exceptional place accorded to free painting and sculpture within the curriculum, coupled with

[46] *Anschlag* no. 84 (BD,SG). The relevant part reads: "Wer auf Grund seiner bereits erlangten Fertigkeiten glaubt, eine besondere Stellung im Bauhaus einnehmen zu dürfen, möge einen schriftlichen Antrag mit ausreichender Begründung (Werkstatt, Werkzeichnen und Formunterricht ist getrennt zu behandeln) unter Beifügung von Arbeiten zum 1 Januar dem Meisterrat des Bauhauses einreichen. Der Meisterrat wird dazu Stellung nehmen."
[47] *Staatliches Bauhaus in Weimar. Lehrordnung*, p. 5 (BD,SG).
[48] Wingler, *Bauhaus*, pp. 152, 475.

the impatience of Gropius with salon art and the negative impressions received even by Feininger of his attitude toward painting—it would seem that, in fact, Gropius was decidedly of two minds about the role and position of the free arts within the Bauhaus. On July 11, 1922, while recognizing a need felt by all that some means would have to be found to separate those students who were creatively gifted from those with merely technical skill, he at the same time "warned against endangering the foundation of the Bauhaus, which requires from every single pupil the complete mastery of a craft, by the creation of special places for individuals that would release them from handiwork"—and this just after the revised statutes had been drawn up granting this special place.[49] Yet exactly five months afterward, Gropius himself recommended to the *Meisterrat* that it grant the petition of Ise Bienert, who asked to be allowed to remain at the Bauhaus without having to belong to a particular workshop because she was not suited for shopwork. After her drawings were passed around for inspection, the recommendation was accepted.[50]

Given his general view of the relationship of art to society, Gropius understandably wished to limit the practice of the free arts within the scope of a school ostensibly devoted to building and all that pertained to it. But at the same time he plainly did not wish to rule them out of the curriculum even if he had been able to go against the wishes of the other form masters. For, as we have seen, Gropius recognized that the dominant and pioneer ing impetus in preparing the way for the sought-after universal style of the new age was coming from painters and sculptors. In a school dedicated to ushering in this age by—as everyone in the Bauhaus saw it—furthering the deepest creative urges of the time, there had to be room not only for the fine artist as teacher, but for the fecundating powers of free creation on the part of the students as well.

Granted, then, the initial decision to retain the free arts within the Bauhaus in one capacity or another, two considerations soon

[49] Minutes of July 11, 1922, [p. 2] (BD,SG). It may be noted that in a draft of the statute article quoted above, the word "occasionally" had been omitted (*Lehrordnung* draft, p. 5, appended to minutes of June 26, 1922, StAW, B'haus, temp. no. 184).

[50] Minutes of Dec. 11, 1922, [p. 4] (BD,SG).

entered to assure for them a central and permanent place. The first was the purely practical need for an extensive theoretical instruction to counter the designing inadequacies among the students. The other was the goal, which after 1920, under the influence of French, Dutch, and Russian ideas, became increasingly compelling in Bauhaus thinking, of developing an objective grammar of design capable of obviating the twin dangers of dependence upon past styles on the one hand and merely personal taste on the other. The result of both was the inauguration of three separate theory courses: the so-called preliminary course or Vorkurs created by Itten, extended by Muche who assisted him, and developed later and transformed by Albers and Moholy-Nagy; and those of Klee and Kandinsky. In considerable part because of them, the fine arts came to assume as central a relevance to the goals of the Bauhaus, though in a different way and for different reasons, as they had ever had within the traditional academy. It was not merely that one of the purposes of the theory courses was to develop an understanding of formal and expressive fundamentals which could do service equally for the fine or the applied arts; but more, that the teachings of Klee and Kandinsky, and part of Itten's course, were not preparation for shopwork but ends in themselves, concerned with, and strictly applicable to picture making alone.[51]

If any one general development can be said to have been of greatest significance in the Bauhaus during its early years it is this almost immediate—and one is tempted to say in hindsight, inevitable—attempt to develop and impart a systematic education in form and expression by means of an objective language

---

[51] Which does not mean, of course, that students could not and did not sometimes apply them to shop products as well, either as extensions of the methods taught or in more literal ways. One of the most charming and amusing examples of literal application is the cradle by Peter Keler from the latter part of 1922 or the beginning of 1923 (discussed and illustrated by Scheidig, *Crafts of the Bauhaus*, pp. 30, 124), which is constructed entirely of rectangular, triangular, and circular parts painted respectively red, yellow, and blue according to Kandinsky's doctrines. (For this aspect of Kandinsky's Bauhaus teachings, see his essays "Die Grundelemente der Form" and "Farbkurs und Seminar," in *Staatliches Bauhaus Weimar 1919–1923*, Weimar and Munich, [1923], pp. 26–28; reprinted in Wingler, *Bauhaus*, pp. 88–89, and Wassily Kandinsky, *Essays über Kunst und Künstler*, ed. Max Bill, Bern, 1955, pp. 71–72, 74–77.)

which, while not yet art, was nonetheless far more than merely technical knowledge. To be sure, Gropius himself, along with especially Marcks, Feininger, Schlemmer, and later the Bauhaus-trained *Jungmeister* Albers and Breuer, always regarded the *Form-lehre* as ancillary to the work of the shops. It would certainly be a great distortion to maintain that the heart of the Bauhaus's final achievement was not its contribution to applied design, whether in the strict sense or more broadly by its largely successful efforts to bring the trained artist into all fields of the applied arts and especially industrial designing. Nevertheless, any accurate characterization of the Bauhaus must also recognize that before 1923, its major achievement was the development of a modern artistic theory and pedagogy, and that the courses which most vividly stamped it before then were the theory courses of Itten, Klee, and Kandinsky.

In the final chapters we shall examine the Itten course and touch briefly upon the change of thought that led from the so-called expressionist phase of the Bauhaus commonly identified with Itten's reign there to the later, more pronounced objectivity and rationalism. Here we may anticipate, however, by observing that this change corresponds to the abandonment of the ideal of the *Einheitskunstwerk* envisioned in the first program. For, as that ideal gradually faded, its concomitant "medieval" (or, if one will, "expressionist") ideal of a relationship of the fine and applied arts based upon their physical union, and upon a strongly held *Weltanschauung* that would assure the harmonious relationship of individual styles, also lost its strength. Its place was taken in respect to form by a more exclusively stylistic concept of unity resulting from the willing submission of the personality to a restricted number of precise forms and to systematic procedures and functional methods of approach capable of being applied to all aspects of art.

# JOHANNES ITTEN, THE BAUHAUS PRELIMINARY COURSE, AND THE BASES OF DESIGN

## The Nature of the Preliminary Course and Itten's Philosophy of Education

In almost every respect—in force of personality, his influence on the course of the Bauhaus, the extent of his responsibilities—the dominant figure in the Bauhaus until 1922 was unquestionably Johannes Itten. For this reason no study of the ideas that went into the creation of the school can leave Itten and the preliminary course he developed out of account, if only because he offered the most serious challenge of the early years to Gropius's ideas, and represented by his convictions and attitudes some striking contrasts to what the Bauhaus was later to become.

The choice of someone to institute a trial course of instruction which would prepare new students for the regular work of the Bauhaus fell inevitably upon Itten, who of all the masters not only had extensive teaching experience but was a trained pedagogue, having begun his training and career as a teacher of elementary and secondary school before deciding, at the age of twenty-five, to devote himself entirely to painting. Itten and Gropius were brought together in Austria in the spring of 1919,[1]

---

[1] Johannes Itten, "The Foundation Course at the Bauhaus," in *Education of Vision*, ed. Gyorgy Kepes (New York, 1965), p. 104. Not in the summer, as stated

according to Itten's account, by Alma Mahler Gropius, who had become convinced of the value of Itten's ideas, and who with characteristic vigor had apparently done her best to convince Gropius of their importance for the Bauhaus.[2] It was thus not from the architectural reformers or *Kunstgewerbler* that the Bauhaus received its most creative and influential pedagogical idea, but from a fine artist and professional teacher outside Gropius's circle of the Arbeitsrat für Kunst.

As is evident from the contents of the first Bauhaus program, nothing like a foundation course or trial semester was at first planned by Gropius,[3] since he had wished at all costs to avoid any teaching that would smack of system, routine, or formula. The decision to raise admission standards by admitting students definitively only after a trial semester was first made at the start of the fall semester 1919;[4] but an "obligatory preliminary course of instruction" to be given by Itten to all entering students during the trial period was not instituted until the fall of the following year. Before then, Itten, like all the other masters, had taught his classes on an elective basis. At the same time, in the fall of 1920, the newly arrived Georg Muche was entrusted with a supplementary course in basic design (*Formunterricht*) which was to be compulsory for students already enrolled in the shops.[5]

The probably reluctant decision to expand the theoretical instruction and make it compulsory was made necessary, as we have observed, first of all by the lack of adequate preparation and dis-

---

earlier by him in his *Design and Form: The Basic Course at the Bauhaus*, trans. John Maass (New York, 1964), since we know from a letter of Feininger to his wife postmarked June 2, 1919, that Itten had just then arrived in Weimar to decide finally whether to join the Bauhaus (FP, MS Ger 146 [1445], vol. 2. The typed extract is dated only as June, but the postmark date is given in the translated extract by Julia Feininger in the Busch-Reisinger Museum).

[2] See Itten's slightly malicious account of the meeting in his "Foundation Course," p. 104.

[3] As already observed by Wingler, *Bauhaus*, p. 38.

[4] Minutes of the *Meisterratssitzung* of Oct. 5, 1919 (BD,SG).

[5] Minutes of Sept. 20, 1920 (BD,SG and StAW, B'haus, temp. no. 184) and Oct. 13, 1920 (StAW B'haus temp. no. 184). In the latter, which was a joint faculty-student meeting to explain the new regulations, Itten observed that "vor einem Jahre sein [i.e., Itten's] Unterricht . . . jedem geöffnet war . . ." (p. 3[b]).

cipline on the part of the students.[6] Their attitudes reflected those prevalent in the creative community in Germany as a whole. Every account of the first years of the Bauhaus testifies to the high idealism among the students no less than among the new faculty—to the spirit of expectancy and hope that embraced the former pupils of the *Hochschule* as well as those attracted from outside by the Bauhaus proclamation. This had its good and bad sides. The charged atmosphere served to create a readiness for experimentation and radical innovation that accorded with Bauhaus intentions. But it also tended to militate against the routine work habits necessary to the mastery of a craft or art, and to produce instead a spirit of restlessness which too often seems to have spent itself in idle speculation and theorizing instead of work.

Gropius had been most insistent from the start on the need to combat what in his speech at the first Bauhaus student exhibition he termed the "most dreadful fragmentation" (*ungeheuerste Zerrissenheit*) displayed by the work as a whole, which was for him "an accurate reflection" of their "dreadfully chaotic time."[7] This broader chaos was for Gropius also reflected in the generally "chaotic" life of the Bauhaus. So he called it on October 13, 1920, when he announced before the combined student body and faculty that compulsory theory courses (which some students regarded as an infringement of their freedom and a denial of the founding spirit of the Bauhaus) would begin.[8] The most serious disorder was an organizational difficulty which had made itself felt from the start: the uncertain relationship between the theory classes—that is to say, the basic design and fine art instruction—of the form masters and the actual work and instruction in the shops. Inherent in the use of double masters for theory

[6] A repeated complaint in the faculty meetings. See also Schlemmer's remark in his letter to Otto Meyer of Dec. 21, 1920: "Auch soll bei den Schülern wenig Lust zum sachlichen Handwerk sein," and again in a letter of March 2, 1921, to an unknown recipient: "Was—von den Schülern—positiv gearbeitet wird, an Kunst oder Handwerk ist gering. Fast erschreckend gering" (Oskar Schlemmer, *Briefe und Tagebücher*, ed. Tut Schlemmer, Munich, 1958, pp. 103, 108).

[7] In Diether Schmidt, ed., *Manifeste Manifeste 1905–1933. Schriften deutscher Künstler des zwanzigsten Jahrhunderts*, vol. 1 (Dresden, [1964]), p. 235.

[8] Minutes, StAW, B'haus, temp. no. 184, p. 2[a].

and shop, the problem was never entirely resolved during the Weimar period of the Bauhaus, despite the numerous attempts made to do so.[9] This was a second practical reason for making Itten's course compulsory. It would at least insure that all students began work in the shops with the same theoretical grounding, which could then be applied to all later work.

At the same time that the compulsory theory courses were initiated, it was decided, in order to make the contact between the preliminary course (or *Vorkurs*) and the shops still closer, to give Itten artistic direction for the fall semester of all the shops with the exception of the weaving and printing shops and the ceramics shop at Dornburg, these being the responsibility of Muche, Walther Klemm, and Marcks respectively. Before then, none of the workshops had been under the direction of a specific form master; and although the *Meisterrat* made certain that students would be able to work with other masters if they desired, the new regulations, combined with Itten's control of the *Vorkurs*, effectively gave Itten by far the greatest responsibility for the artistic direction of the Bauhaus.[10]

It was soon recognized that the burden of this arrangement was too inequitable, and with the arrival of Schlemmer and Klee at the beginning of 1921 Gropius proposed to divide the shops in the following manner: Dornburg would remain with Marcks, the stone carving shop would be given to Schlemmer, the wood carving and weaving shops to Muche, the bookbindery to Klee, the

---

[9] The problem of bringing the form courses and the shopwork, the *Formmeister* and *Werkstättenleiter*, together was taken up all through 1920 and was to remain unsatisfied. At the start of 1920 Gropius proposed a specific form master for each shop, but he was opposed by Itten who at that time preferred the existing free relationship between shops and theory classes (minutes of Feb. 2, 1920 [p. 5], StAW, B'haus, temp. no. 184). The issue was raised again at the end of the spring semester by Gropius, who now merely urged closer cooperation in the Bauhaus (minutes of June 15, 1920 [p. 2], StAW, B'haus, temp. no. 184). Even after the solution of the fall described in the text, the problem continued to exist. It was discussed again on March 17 and April 6, 1921 (StAW, B'haus, temp. no. 184). At the latter time Gropius proposed for the *Vorkurs* a change of teachers each semester; but since Itten not surprisingly rejected the idea, a satisfactory solution was once again postponed.

[10] Minutes of Oct. 26, 1920 (BD,SG). The plan was unanimously approved by the heads of the shops.

printmaking shop (now that Klemm had left for the reestablished academy) to Feininger, the newly created carpentry shop to Gropius, and the metal, stained glass, and wall painting shops to Itten.[11] This would still have left Itten with more shops than anyone else. The solution, however, was not accepted. As correspondence from the end of 1921 and the beginning of 1922 between Itten and Gropius reveals, Itten retained control of the stone and woodcarving shops and, in addition, had a large, and perhaps even major, say in the work of the carpentry shop, despite its official assignment to Gropius.[12] This evidence lends support to the often-voiced assertion that Gropius was too busy with administrative affairs and his own architectural practice to give sufficient artistic guidance during the first years. This is not, of course, to imply anything about the possible influence of Gropius's design ideas and work upon the students, however difficult it is to determine for this early period. It goes without saying that the amount of instruction imparted is not necessarily commensurate with the degree of influence exerted, just as a teacher may well influence classes not his own. Besides, from the large degree of responsibility entrusted to him, it is obvious that Gropius began by agreeing with much of what Itten was trying to do; and as we shall see, there was a surprising amount of agreement among the masters on broad principles of design. But it is also true that Itten was not merely a surrogate for Gropius in the carpentry shop. As with everything he did at the Bauhaus, Itten brought to the shop very decided ideas of his own about the kind of training the pupils should receive, and these came to be strongly opposed by Gropius. It seems accurate, therefore, to say that until the end of 1921 when growing differences between Gropius and Itten became irreconcilable, the carpentry shop was at least as much the creation of Itten as it was of Gropius.

Although the contents of the *Vorkurs* are by now familiar, having been described many times by Itten himself and by former pupils, it is perhaps useful to summarize them here, especially since in his later accounts Itten was not always concerned to dis-

[11] Memorandum of March 15, 1921, p. 3 (StAW, B'haus, temp. no. 184).
[12] Appendix F, pp. 290–294.

tinguish between the contents and methods of his Bauhaus course and those of his later teaching.[13]

The *Vorkurs* presented to the pupils over its six-month's duration a loose series of improvisatory and constructive exercises that began with two-dimensional problems and ended with arrangements and three-dimensional compositions of various materials.[14] At least some of the classes began with a series of warming-up exercises intended, according to Itten, to prepare the student for work by bringing him to the proper state of mental and physical concentration and coordination.[15] These included various breathing and relaxation exercises and the rapid drawing of simple rhythmical strokes, spirals, circles, and the like as a means of "training the machine for emotional functioning," as Klee reported somewhat amusedly on his arrival in Weimar in January

[13] Itten's only contemporaneous descriptions of his ideas and pedagogy as he held and practiced them in Weimar are to be found in his *Analysen alter Meister*, published in 1921 by Bruno Adler's Utopia Press in Weimar, and his explanatory brochure of April–May 1922 for an exhibition of Bauhaus *Vorkurs* work (in Wingler, *Bauhaus*, p. 64). Later pedagogical writings of Itten not included in the bibliography of the revised and English eds. of Wingler's *Bauhaus* are: "Erziehung durch bildnerisches Tun," in *Handbuch der Kunst- und Werkerziehung*, vol. 1, *Allgemeine Grundlagen der Kunstpädagogik*, 2d ed. (Berlin, 1953), pp. 440–442; "Der Vorkurs," *Form*, no. 6 (1959), pp. 12–17; and "The Foundation Course at the Bauhaus," in *Education of Vision*, ed. Gyorgy Kepes (New York, 1965), pp. 104–121. The title of Itten's basic course book (*Design and Form: The Basic Course at the Bauhaus*) is misleading, since it is a summation of his teaching philosophy throughout his career and is for the most part illustrated with student exercises from later years. Some of these, as for example, the drawings of pure geometric solids from the late '20's (pp. 120–123), are of design problems not presented by Itten in Weimar: they are inspired by Kandinsky and by elementarist concepts that developed only in the mid-'20's and are comparable to the sculpture compositions with cylinders, cones, and spheres set by Joost Schmidt at the Bauhaus in Dessau (cf. ills. in Wingler, *Bauhaus*, pp. 396–397, and Herbert Bayer, Walter Gropius, and Ise Gropius, eds., *Bauhaus 1919–1928*, Boston, 1959, pp. 160–161). Itten's "Foundation Course at the Bauhaus" is still more misleading. Essentially a rewriting of his book, it does not identify the post-Bauhaus exercises as such and should therefore not be used without reference to Itten's other works.

[14] The principal sources of ills. of *Vorkurs* work are: *Staatliches Bauhaus Weimar 1919-1923* (Weimar and Munich, [1923]); Bayer, Gropius, and Gropius; Wingler, *Bauhaus*; Itten, *Design and Form*; and now *50 Years Bauhaus: German Exhibition Sponsored by the Federal Republic of Germany, Organized by the Württembergischer Kunstverein, Prepared in Connection with the Bauhaus-Archiv, Darmstadt*, Illinois Institute of Technology, August 25–September 26, 1969.

[15] Itten, *Design and Form*, pp. 11–12.

1921 after observing an Itten class.[16] The semester's work included the making of exact, detailed drawings from the human figure and of various materials and textures in order to heighten perception, gain precision in rendering ideas, and develop greater understanding of the properties of different materials.

These exercises in exact seeing and rendition were intended to constitute a first stage in the training of the senses and the hand. They were complemented by others which, in contrast, aimed at the effective communication of inner experiences. Emotion-laden subjects such as war or a storm were required to be interpreted on paper freely and rapidly, occasionally several times over, with the broad media of chalk and charcoal. In contrast to the first, these assignments laid stress on spontaneity and improvisation.[17]

The third major component of the *Vorkurs* instruction was directed to the analytic and constructive side of the artist's training. It comprised a number of different exercises: the structural and rhythmical analysis of old masters; color analysis; and elementary two-dimensional compositions with basic forms or concerned with simple linear relationships, contrasts of light-dark, large-small, and the like. Related to all of these, finally, were various rhythm studies, both abstract and of the human figure in motion.[18]

The two-dimensional work of the course culminated toward the end of the semester in the three-dimensional design problems intended to join directly with the work of the shops. With these, the lessons learned from the two-dimensional studies would be brought to bear upon real materials of various sorts arranged and composed as collages and sculptural compositions.

The purposes of the *Vorkurs* were summarized by Itten in a printed statement explaining the *Vorkurs* designs exhibited at the

[16] Letter of Jan. 16, 1921. The letter is excerpted *ibid.* and printed in facsimile in *Paul Klee, Alexej Jawlensky* (catalogue), Städtisches Museum Gemäldegalerie, Wiesbaden, 1962. Paul Klee, *The Thinking Eye: The Notebooks of Paul Klee*, ed. Jürg Spiller, trans. Ralph Manheim (New York and London, 1961), pp. 29–32, prints a slightly, unacknowledgedly expurgated version in which Itten's name is replaced by "the master," making the letter more waspish than it was intended to be.
[17] Klee, *Thinking Eye*, pp. 29–32; Alfred Arndt's description of the course in *Bauhaus. Idee—Form—Zweck—Zeit* (catalogue), Göppinger Galerie, Frankfurt am Main, February 1–March 14, 1964, pp. 38–43.
[18] See esp. ills. in Wingler, *Bauhaus*, p. 259, and Itten, *Design and Form*, pp. 136–138.

Bauhaus in the spring of 1922. They were, in brief: to free the student's creative powers, in part by disencumbering him of that prior learning which would inhibit or prejudice his own solution to an artistic problem, and to develop the student's artistic abilities by a three-fold training of the mind, senses, and emotions.[19]

Phrased thus succinctly and, as it were, neutrally, leaving aside for the moment whatever doubtful features Itten's ideas and procedures may have had in detail, this statement of the purposes of art education seems, from the perspective of a time when it has been widely accepted, self-evident and supremely simple and integral in conception. Such, however, was far from being the case at the time. Its sources are complex and multifarious, and although most of the ideas that went into making the *Vorkurs* were separately "in the air," it is Itten's originality and lasting contribution to art pedagogy to have been the first to put them together in an effective manner and apply them to the teaching of art.

Perhaps the most original aspect of Itten's pedagogy—the foundation upon which the *Vorkurs* was built, and as far as the Bauhaus was concerned its most problematic aspect—did not come primarily from orthodox sources of professional art education but rather from the liberal Rousseau-Pestalozzi-Froebel-Montessori reform tradition of child education, which had as a basic tenet that education is essentially the bringing out and developing of inherent gifts through a guided process of free and even playful activity and self-learning.[20] This tenet lies behind

[19] In Wingler, *Bauhaus*, p. 64; trans. in Bayer, Gropius, and Gropius, p. 34. This statement is the most detailed description of the purpose of the course to come from the time of the Weimar Bauhaus.

[20] The connection between Bauhaus instruction and the Froebel-Montessori tradition has been made before—e.g., by Maldonado and by Logan—but without support—and now by Stelzer (Tomás Maldonado, "New Developments in Industry and the Training of the Designer," *Ulm*, no. 2 [October 1958], pp. 25–40; Frederick Logan, "Kindergarten and Bauhaus," *College Art Journal* 10, no. 1 [Fall 1950]: 36–43; Otto Stelzer, "The Preliminary Course in Weimar and Dessau," in *50 Years Bauhaus*, p. 35). Logan's suggestion that Froebel's "gifts" influenced the Bauhaus is made with general reference to the later Bauhaus interest in elementary geometric forms, in "sensory education" and learning by doing, and in not "coddling abnormal student 'sensitivities'" but instead giving them a "factual, even scientific grasp of the media of the arts" (p. 42). Logan's is thus still the incomplete view of the Bauhaus as it was known in the United States after the Bauhaus exhibition of

much of the *Vorkurs*. It is behind the practice of allowing the students themselves to help judge classwork;[21] and it is, above all, behind Itten's famous intention to "liberate the student's creative powers" and to retrain him from the beginning by means which initially include by-passing the intellect in order to reach what is conceived to be his natural, unlearned creative center.[22] Among these means were those exercises which most distinctively marked the preliminary course of Itten from the later courses of Moholy-Nagy and Albers. They include, in particular, the various improvisatory exercises in self-expression—scarcely more at times, it seems, than reflex acts—conceived as a way of giving direct voice to the unreflective creative urges of the student; and the compositional play with a great variety of materials, the results of which were to be free, ideally, of any prior conception, theory, or style of art.[23]

Much of the basic philosophy behind these reform principles of child education was by the beginning of the century already familiar, even in detail, to those modern artists and designers who were concerned with the problems of teaching art: the ideal of suiting education to the abilities and temperament of the pupil, of first searching out the young student's natural talents through an informal master-pupil relationship, the doctrine that true education requires "doing" rather than mere learning—all these, and especially the last, were as much the direct heritage of Ruskin and the English Arts and Crafts Movement as they were of more narrowly pedagogical traditions. They had in part reached Germany on that broad wave of interest in things English pertaining to the arts which had been generated in the eighteen nineties.[24]

---

1938 and the Chicago Bauhaus, and has no mention of Itten. The closest he comes to touching on the early *Vorkurs* is with the simple observation that "this new academy of the Bauhaus suggests an expanded course of experience for children."

21 Arndt, in *Bauhaus. Idee*, p. 40.

22 Leaflet to 1922 Bauhaus *Vorkurs* exhibition, in Wingler, *Bauhaus*, p. 64.

23 The materials studies were in part probably inspired directly or indirectly by the education theories of Maria Montessori which stressed above all the importance of sensory training. Cf., e.g., her *The Montessori Method*, intro. J. McV. Hunt (New York, 1964), esp. pp. 167ff.

24 A useful survey of Ruskin's theories of education is Hilda Boettcher Hagstotz, *The Educational Theories of John Ruskin* (Lincoln, Neb., 1942), esp. pp. 90–97,

But before Itten's time, detailed methods for effecting this phi-
losophy had been developed as a rule by professional educators
and teachers of children, and the most intensive teaching experi-
ments consonant with it had been made predominantly in the
lower grades of schooling and not on the professional level of
art training.

The gathering interest in Germany in the reform of art educa-
tion ( *Kunsterziehungsbewegung*) first culminated in September
1901 with a conference on art education held in Dresden which
was attended by a number of future leaders of the Deutsche
Werkbund, among them Hermann Obrist. At the conference,
R. Ross, a Hamburg teacher and disciple of the director of the
Hamburg Kunsthalle and pioneering reformer in art education,
Alfred Lichtwark, not only described the bases of children's aes-
thetic awareness in words that could with little change serve to
describe as well some of Itten's fundamental assumptions in cre-
ating the *Vorkurs*, but as Itten was to do, he related the develop-
ment of artistic imagination in the young to the processes of
empathy, the theory of which then dominated aesthetics. "The
essential conditions for the enjoyment of art," Ross began, "are
already present in the soul of the small child"; play was the earli-
est source of art education, and the aim of that education in
childhood, therefore, was above all not to damage the child's
natural development by a too early maturity. The earliest kind
of play, according to Ross, was imitative, and it was by this means
that the child first developed the ability to create aesthetic illu-
sion. Under this type of play Ross included both "the psycho-
logical processes of what is usually called 'empathy'—the lend-
ing of one's personality—" and the creation of artistic symbols
leading to reality.[25]

Granting that Ross's is still a view of art as imitation, it is not
hard to see how such a description of the artistic proclivities of

118–146. On the English teaching workshops (esp. Lethaby's London Central
School of Arts and Crafts, founded in 1896) and German interest in them, see
Nikolaus Pevsner, "Post-War Tendencies in German Art Schools," *Journal of the
Royal Society of Arts* 84 (1936): 248–250.

[25] The proceedings of the conference: *Kunsterziehung. Ergebnisse und Anregungen
des Kunsterziehungstages in Dresden am 28. und 29. September 1901* (Leipzig,
1902), pp. 66–67.

children could easily be extended to include a natural inclination on their part toward abstract forms and thereby to help justify— as the expressionist generation was to do—an urge toward abstract art, including the abstractions of children, as an innate tendency worth fostering. The step between seeing the symbolic activities of children as only a first stage of artistic imitation and seeing them as the workings of those equally innate powers of the imagination to produce expressive abstraction is a very small one. Ross did not take it, but he comes close to doing so; for, he continues, that which distinguishes the adult only in moments of artistic contemplation fills the entire life of the child up to a certain age: "He animates (*belebt und beseelt*) everything, he finds his own 'I' in everything"; and the more realistic a toy is, the less work the imagination has to do, and therefore the more dangerous the toy is for education.[26]

Such sentiments were voiced by many at the conference, and although the prevailing voice was for an art education for children that would pay strict attention to the exact perception of natural forms, the strong conviction was also present that no one was more creative than the child when left to himself, and that his natural inventive drives needed only a slight push in order to produce even better results.[27]

During the first decade of the century, this last conviction became increasingly prevalent in Germany; but with a few notable exceptions no conclusions seem to have been drawn from it as to the possibility of comparable teaching methods for the child and the professional art student. Thus, in July 1908 the noted art educator Georg Kerschensteiner delivered an address at the first congress of the Deutsche Werkbund in which he expressed his strong belief that art education in the Volksschule must not be prescriptive; must not, as he said was presently the case, "stuff the child with wisdom" but, rather, allow each child to "discover his own soul" and "bring out of . . . [him] what is concealed within." Kerschensteiner's context was general education, but he also extended his remarks to the schools of arts and crafts. Yet

---

[26] *Ibid.*, p. 68.
[27] These are essentially the words of C. Götze, another art educator from Hamburg (*ibid.*, p. 152).

characteristically, his words concerning them are restricted essentially to a simple and general "teach the whole man," a by then commonplace injunction not confined to the philosophy of child education, and when applied to professional art training not implying any specific approach based upon that philosophy.[28]

Kerschensteiner certainly did not attempt to suggest methods by which his advice might actually be effected in the schools of arts and crafts. He was one of the most progressive art educators of the period with respect to the degree of permissiveness with which he would have art taught in the lower schools. He even recounted an actual experience to illustrate the dangers of any external prescription whatever upon the child: for the pattern work based upon brush manipulation—that is, arising from the activity of the child himself—which he had recommended for some art classes, two teachers had taken it upon themselves to substitute a series of exercises based upon the stylization of natural forms. The results, he said, showed a marked decline in freshness and inspiration over what they had been earlier.[29]

Nevertheless, after recounting his anecdote, Kerschensteiner did not go so far as to suggest that art education on the professional level should or could be largely or wholly nonprescriptive, as in fact Itten's classes were to be. On the contrary, his writings make it clear that his remarks pertained only to beginning instruction. Permissiveness was necessary with very young children because they could not profit by artistic discipline. In an article published the same year as his Werkbund speech, he observed that "stylized studies from nature"—then still a principal concern of the *Kunstgewerbeschule*—can as a general rule succeed only when the child has reached ten years of age.[30] And a few years later, in his *Begriff der Arbeitsschule*, which was avowedly based upon, among others, Dewey and Montessori, he was insistent, as were

28 *Die Veredelung der gewerblichen Arbeit im Zusammenwirken von Kunst, Industrie und Handwerk. Verhandlung des Deutschen Werkbundes zu München am 11. und 12. Juli 1908* (Leipzig, n.d.), pp. 138–141.
29 *Ibid.*, pp. 139–140.
30 Georg Kerschensteiner, "Die Entwicklung der zeichnerischen Begabung," in *Deutsche Kunsterziehung* (Leipzig and Berlin, 1908), p. 18.

all reformers of crafts education, that although schools should start with play in kindergarten, they should very quickly begin to train for exact, skillful perception and manual work.[31]

By 1908, indeed, the emphasis in discussions of crafts education on any level, not to speak of the professional level, was overwhelmingly on the need for greater visual, conceptual, and manual discipline, not for a loosening of the reins of imagination. The progressive art educator Ludwig Pallat, a member of the Werkbund, thought it necessary that same year to apologize for the greater freedom of self-expression being granted young children in art classes and to reassure his readers that it was confined to the lower grades only, where it was indispensable, and that there was no danger of its leading to undesirable consequences through lack of sufficient discipline.[32]

In other words, the goals that the educators sought to achieve in public art education were not different from those wanted by most of the artists and designers concerned with professional training.

The meeting ground for the two groups after 1907 became, because of their common principles, the Deutsche Werkbund. But it is not surprising that their areas of professional competence and interest should remain for the most part separate. The professional educators did not generally possess the type of skill and knowledge necessary to enable them to offer detailed approaches and techniques for teaching art in the academy and the school of arts and crafts; and for their part, the artists and designers who taught on the level of the professional school were understandably concerned more with the specific task of training skilled, disciplined artists than with the theory and philosophy of general education and the question of the broader, humanistic ends of teaching. Nevertheless, already by the turn of the century, the new spirit in education had joined with the ideals of the modern movement in design to produce a universal demand for an art education and training at all levels of schooling that would be capable of developing to the utmost the artistic potential of lay-

---

[31] 1912. Translated into English in 1913 as *The Idea of the Industrial School*.
[32] Ludwig Pallat, "Zeichenunterricht," in *Deutsche Kunsterziehung*, p. 2.

man—even if only to make sound aesthetic judgments—and artist alike. In the closing speech of the first art education conference in 1901, Alfred Lichtwark voiced a fundamental conviction of his generation that art education had a central role in life: "The demand for an artistic education is no isolated phenomenon. From the first it was inseparably connected with the simultaneous—from about the mid '80's—more clearly formulated call for a moral renewal of our life. The two areas cannot be separated."[33] In Pevsner's words, art was to be "the center-piece of all education."[34]

Because of this universally pressing desire to reinstill the spirit of art into every aspect of life, it became a matter of course to regard art instruction at the professional level as a natural continuation of a process of schooling begun already with small children; and conversely, to regard the art education of children as a crucial means of creating the cultural ground upon which alone a vital and enduring artistic movement could be built. Thus, in his *Das neue Kunstgewerbe in Deutschland*, one of the earliest historical surveys of the modern movement in Germany, J. A. Lux in 1908 reviewed the reforms in all areas of art education in one chapter entitled "Ten Years of Art Instruction," bringing them together as a continuous spectrum from the public school to the art academy. Lux made no attempt to suggest that the specific methods of the one should be carried over to the other, but he assumed that a common spirit infused both. If the interest of the professional school was naturally focused upon disciplined results, the prevailing tendency was nevertheless to strive for an inner discipline within an atmosphere of greater outward freedom. The opening words of Lux's chapter are applied to all of art education: "To base instruction on the creative powers of the student; to give courage to his timid instinct for forming; growth and freedom—these are the common foundation of the reform"; and he wholeheartedly approves of the initiatory tendency in public education in England "and especially in America, the land of school democracy," to make "the pupil . . . the main thing,

33 Alfred Lichtwark, *Eine Auswahl seiner Schriften* (Berlin, 1917), vol. 1, pp. 3–4.
34 Nikolaus Pevsner, *Academies of Art Past and Present* (Cambridge, 1940), p. 266.

not the teacher. The teacher is only the hand that guides cautiously from a distance."[35]

The ground was thus well prepared by the beginning of the century for the radical freedom of expression which Itten was to introduce in his teaching; and if, for the reason already indicated, it did not prevail earlier in the art school, at least two notable figures before Itten did teach in schools of arts and crafts with a degree of permissiveness which approached that of the most advanced art classes for children.

Hermann Obrist had already made a distinctive reputation as a teacher at the beginning of the new century because of the unusual freedom of expression he allowed his sculpture classes in Wilhelm von Debschitz's school of applied arts in Munich. In articles written about 1900, Obrist seriously directed himself to the issue of mass art education, advocating in one of them that all art students should have a one-year elementary course (*Elementarunterricht*) in which they would be allowed to "swarm" (*ausschwärmen*) without appreciable direction, the only requirement being the completion of one problem—no matter how modest—each day. The instructor would be no more than an inspirer, a suggester, whose task it would be to sharpen and deepen the pupil's ability to see (*das Schauen*). Only after a year of this nonspecialized experimentation would those students who remained be required to undertake a "far more earnest life" as part of a working and striving community of artists.[36] Obrist evidently conducted his classes according to his beliefs. Lux was to single him out by describing his actual teaching in the same words Itten was to use to justify his own classroom procedures: "The spiritual makeup [of each student] is different and requires freedom rather than coercion in order for his pre-existing talent to unfold. The pupil determines the method; it springs from his individual inclination, which cannot unfold easily and freely under the pressure of a rigid system. So it was under Obrist."[37]

---

[35] Joseph August Lux, *Das neue Kunstgewerbe in Deutschland* (Leipzig, 1908), p. 191.

[36] Hermann Obrist, "Ein künstlerischer Kunstunterricht," written in 1900, in his *Neue Möglichkeiten in der bildenden Kunst. Essays* (Leipzig, 1903), pp. 73–79.

[37] Lux, *Das neue Kunstgewerbe*, p. 194.

Perhaps the most direct antecedent of this aspect of Itten's course, however, was the art classes given by Franz Cizek in Vienna before and during the years in which Itten had his own art school there. Unlike Itten, Cizek was not trained professionally as a schoolteacher; but already by the second decade of the century he had gained an international reputation for the success of his art classes for children.

Cizek was one of the first to base his teaching on the precept of allowing complete freedom to the child to create what he will. Already in his first classes for children in 1897 he followed the principle that the teacher must do no more than to stimulate originality and productivity in the child by encouragement. If some late recollections of his may be relied upon, he had already in the mid-eighties or early nineties, while still an art student, expressly measured the shortcomings of his academic training with the yardstick of the accomplishments of children. According to him, he directly compared the stultifying, "falsely constructed" training at the academies and its results with the natural creative processes and achievements of children.[38]

Criticism of the sterility of academic training was part of the widespread reaction of the eighties and nineties in Germany and Austria against rigidity and overintellectualization in all fields of education: even as classically oriented an artist and theorist as the sculptor Adolf Hildebrand had in the same years, in his *The Problem of Form*, published first in 1893, accused education in general of destroying imagination and "the life of the eye," which are "at their most vital" in childhood.[39] But Hildebrand remained a classicist. It is clear from the context of this statement that he was talking only about the need to sustain the creative vitality of childhood and was not stating anything about the aesthetic value of children's works. His concern was with the basic laws of art, which he recognized as finding their first, rudimentary ex-

[38] J. Ettel, "40 Jahre Wiener Jugendkunstklasse von Franz Cizek," *Die Österreichische Schule*, no. 8 (1937), p. 568.
[39] Adolf Hildebrand, *The Problem of Form in Painting and Sculpture*, trans. Max Meyer and Robert Morris Ogden (New York, 1907), pp. 121–122; quoted from Hartwig Fischel, "Die Frühjahrausstellung österreichischer Kunstgewerbe und der k.k. Kunstgewerbeschule im Österreichischen Museum," *Kunst und Kunsthandwerk* 15 (1912): 336.

pressions in childhood. But these laws for him were only a beginning step; they had to be applied as an exact language to the creation of a mature and sophisticated style.

For Cizek, instead, children's art had a positive aesthetic value, and was cherishable for its own qualities. Cizek was closely associated with the artists and architects of the Wiener Secession,[40] and his modern orientation enabled him to see from the start the symbolic modes of child art as valid and even vital expressions in their own right. He quickly came to recognize from his experience, while still a student, of watching children copy a naturalistic work of art, that there was an "opposition between what grows and flourishes naturally according to its own individual laws, and what is 'learned' and 'taught' in the academies."[41]

Cizek was eventually to apply some of the lessons he had learned from his work with children to his classes in ornamental drawing and composition. Little information is available about the way these classes were conducted before the war; but by 1920 many of the exercises being done in them were outwardly close to some being presented by Itten in the Bauhaus. Like some of the work of the Bauhaus *Vorkurs*, much of Cizek's course came to be based upon the use of expressionist, cubist, and futurist rhythms and conceptions, which under Cizek were developed into abstract and semiabstract decorations and stylized expressions of "specific emotions" and "specific sensations" (Figs. 18–19).[42] Cizek may already have guided his classes in this di-

[40] Wilhelm Viola, *Child Art and Franz Cizek* (Vienna and New York, 1936), p. 12.

[41] Ettel, "40 Jahre Jugendkunstklasse," p. 568. The words are Ettel's, based upon an interview with Cizek.

[42] From the ills. in L. W. Rochowanski, *Der Formwille der Zeit in der angewandten Kunst* (Vienna, 1922). Judging from the few dated examples shown, most of the reproduced works are from 1920–21. Besides the interpretive studies of emotions and sensations ("Ausdrücke bestimmter Gefühle und Empfindungen," pp. 12–15), Rochowanski reproduces, among others, "Studien der kubischen Existenz der Dinge" (pp. 24–25); ills. of "kubischer Raumgliederung" (pp. 26–27), and "ornamentaler Bewegungsrhythmen" (pp. 42–43). As is apparent, these exercises are roughly divided, as were Itten's, according to the emotive and the constructive. Like Itten's, too, there is a strong emphasis upon rhythmical movement as an expression of emotion. But as is also apparent from the categories and from the results, the Cizek exercises are far more literal in intention and invariably directed to the end of decoration, whatever their expressive basis. Cf. the review of 1921 in

rection during the war years, at the time Itten had his own school in Vienna. According to Rochowanski writing in 1922: "The force of the liberating effect [of Cizek's teaching] upon the pupil, who is allowed to grow according to his own powers without cold, obsolete prescriptions, is shown by the fact that Professor Cizek's section in 1912 already held a true dadaist, who made the same kind of things with which the dadaists of 1918–19 delighted us."[43] Whether or not this story can be taken at face value, it at least illustrates the reputation for extreme permissiveness and openness to all forms of self-expression that Cizek's teaching—even at the professional level—had acquired by the end of the war. It is highly likely that Itten was inspired or influenced by Cizek's pedagogy, certainly in its general approach, and perhaps even in specific methods.[44]

Itten and Cizek are linked by more comprehensive affinities than those of mere pedagogical background and techniques. It is no accident that the two artists, both gifted teachers, both coming to professional schools after first having taught children, should arrive at many similar insights and methods in their teaching. The essays on Cizek that appeared in the years just after the war show him to have shared the view of the time that abstract art was an expression of transcendent forces and of the social and spiritual unity desired by all.[45] Like Itten, he infused his teaching, at least in these years, with a vague but pervasive idealism which accorded well with the humane and libertarian doctrines of education he had derived from his experiences with children. Because he was, like Itten, in close contact with the modern movement—even though a generation older—and had matured and come to teach-

---

*Der Cicerone* of an exhibition of Cizek classwork: "Das Formale und das Hand-werkliche wird hier nicht aus der Erscheinung, sondern aus dem inneren Erlebnis entwickelt, abstrakte Gefühle und undefinierbare Empfindungen wie von Farben, Geräuschen usw. lernt der Schüler aus sich heraus gestalten" (H. G., "Eine staatliche Schule für Expressionismus in Wien," *Der Cicerone* 13, no. 15–16 [August 1921]: 452).

43 Rochowanski, *Formwille*, p. 96.
44 Wingler, *Bauhaus*, p. 14, asserts, in fact, that Itten's materials study was in-spired by Cizek. This is also stated now, but likewise without documentation, by Stelzer, *op. cit.*, in *50 Years Bauhaus.*
45 E.g., Rochowanski, *Formwille.*

ing within what was to be a major center of expressionism, he was, also like Itten, readily able to accommodate these doctrines to many of the tendencies and ideas current among modern artists of the time. Both men had the pedagogical insight to recognize that with the decline of naturalism and the interest of the modern artist in subjective expression and in conceptual modes comparable to those used by children, the same approach and some of the same methods that were successful with children could also be relevant to the education of art students. Both men, further, were able to relate their teaching principles to the prevalent aesthetic doctrine of empathy, which, as popularly understood, tended to lead in works of art to an emphasis upon rhythmical movements and kinetic forms as the means of expressing inner states and experiences.

For Itten, the process of freeing the student's natural abilities was equated with a process of developing his inborn psychological ability to "feel" himself empathically into the subject, form, or material before him, and to re-create the essence of his experience —which is to say, the essence of that subject, form, or material—as completely and vividly as possible in the work of art. The determination of success or failure (whether the work is "alive" or "dead") was the degree to which the student was able to transfer his experience to the viewer. The work of art thus functioned for Itten essentially as intermediary in an act of transference between artist and viewer, or more accurately put, between the original subject or concept, and the viewer.

This side of Itten's theories is to be found above all in his *Analysen alter Meister* of 1921, which, despite its title and ostensible purpose, namely, to present five diagrammatically analyzed old masters, is principally devoted to a presentation of Itten's theories of artistic expression. There, in pages of continuously varying type faces set decoratively in blocks and undulating lines whose assymmetry and rhythms themselves exemplify his thesis, Itten set down his conception of art as the realization of a "spiritually emotional vibratory power" (*geistig seelische Schwingungskraft*): "Everything vital reveals itself to man through movement. Everything vital reveals itself in forms. Thus all form is movement and all movement is manifest in form. Forms are receptacles of move-

ment and movements the essence of form."[46] This tautology by itself entails no particular style; however, the emphasis in the equation is upon the movement, and this does have consequences for art as Itten conceives it. Form, Itten continues, is the result of three "grades" of human movement: the physical, the emotional (*seelische*), and the spiritual or intellectual (*geistige*) which we empathically make in experiencing a thing, re-creating it as art, and reexperiencing it through the work of art. Itten attempts to clarify this by the example of a subject which is in itself, one may say, expressionistic: a thistle. "It is readily understandable," Itten observes, "that the drawn form of a thistle can be correct only when the movement of my hand, my eyes, my spirit corresponds exactly to the sharp, pointed, pricking, smarting form of the thistle."[47] It is not our purpose to consider here the semantic, psychological, or epistemological questions raised by Itten's simplified empathy theory. We wish merely to observe that it is the essential *rationale* for the high degree of emphasis Itten placed upon personal experience in his courses.

The theory of empathy found ready confirmation for Itten, as it doubtless did for other artists at the time, in Oriental doctrines of the mystical affinities existing between subject and object, spirit and matter. Itten's theories remind us, in particular, of Chinese theories of art that developed under the influence of Taoist beliefs. It is difficult to know how much Itten knew of Chinese art theory as such, since very little of it had been translated into the continental languages by 1920. But he was familiar, superficially at least, with Buddhist and Taoist philosophy, as his citations in the *Analysen* from Indian and Chinese sources prove. The introduction to his book makes reference to the Chinese tradition according to which men lived at first in perfect harmony with all creation and were thereby able to create perfect things instinctively without the use of rules or knowledge.[48]

---

46 Pp. 31, 33.

47 Pp. 41–45 and *passim*.

48 Pp. 11–27. The brief bibliography appended to *Analysen* includes the 1913 German translation of Fenellosa's *Epochs of Chinese and Japanese Art*, which contains excerpts from the treatise of Kuo Hsi; A. Grünwedel's *Mythologie des Buddismus in Tibet und der Mongolei*, 1900; and Otto Fischer's *Chinesische Landschaftsmalerei* of 1921, which von Erffa has already cited as one of the pos-

In conformity with the popular interest of the day in the Orient, Itten's Bauhaus classes, as is well attested, were steeped in an atmosphere of Oriental and pseudo-Oriental attitudes and mystical teachings drawn from various sources. These, and especially the not entirely respectable doctrines of Mazdaznan—a cult based remotely upon Zoroastrianism, among other things—which found confirmed followers in Itten, Muche, and a number of their students at the Bauhaus, have been the cause for amusement. But they served two important functions, if, perhaps, not both intentional. They served, first of all, to give external form to the intensely idealistic and restless energies of many of the early Bauhaus students, and thereby helped to create and to cement firmly a spirit of solidarity and exclusivity felt especially among the pupils of Itten and Muche.[49] The special diets, the Oriental robes and shaved heads affected by Itten and others—these were outward forms of that "exaggerated romanticism" which Gropius was to criticize, and they came to meet Gropius more than halfway in making the Bauhaus into that "secret conspiracy" he had envisioned in the beginning—though not precisely in the way he had hoped.

But the Orientalism in the Bauhaus had a pedagogical value as well. For Itten, Eastern philosophy was a profound substantiation of that modern ideal of an education by self-discovery and reliance upon intuitive processes which had proven so successful with children. His dictum that "every pupil is burdened with a mass of learned material which he must throw off in order to arrive at experience and his own awareness"[50] has its counterpart in Chuang Tsu's "cherish that which is within you and shut off that

---

sible sources of Itten's knowledge of Chinese painting (Helmut von Erffa, "Bauhaus: First Phase," *Architectural Review* 122 [August 1957]: 105). Von Erffa also cites the importance of Taoist philosophy for Itten and his students (*ibid.*, p. 104, and *idem*, "The Bauhaus Before 1922," *College Art Journal* 3, no. 1 [November 1943]: 16).

[49] Von Erffa, "Bauhaus: First Phase," p. 104. See also the anecdotal reminiscence of Paul Citroen, "Masdasnan am Bauhaus," in *Bauhaus. Idee*, pp. 29–37. Citroen numbers himself among the Bauhaus devotees of Mazdaznan. Some nineteen of Itten's pupils followed him out of Vienna to the Bauhaus, according to information given by Franz Scala in 1963 to the Bauhaus-Archiv. Itten, *Design and Form*, p. 9, gives the number as ca. fourteen.

[50] In the leaflet for the 1922 *Vorkurs* exhibition, in Wingler, *Bauhaus*, p. 64.

which is without, for much knowledge is a curse."[51] Such features
of his course as the preparatory exercises in breathing and bodily
movement, and the preliminary rhythmical stroking with the
brush suggest that Itten may have been following the advice of
Chinese painting treatises that complete rapport between an artist
and his subject requires the tranquil and harmonious preparation
of the mind and body and the absolute willingness of the hand
to obey the impulses of the mind.[52] There was, to be sure, ample
precedence for some of these exercises among Western educators
and artists, including Itten's teacher, Adolf Hoelzel;[53] but we may
assume that his interest in some of Hoelzel's comparable practices
was considerably fortified by his knowledge of Eastern thought,
which gave to such practices a metaphysical import.

The breathing exercises in particular, of course, recall Oriental
meditative practices. In their case, however, inspiration came not
only from direct knowledge of Eastern ways but also from
Mazdaznan. Mazdaznan preaches that the body is "the temple
of the living God," and hence that the individual has the duty and
capability to perfect and bring into harmony all his emotional,
intellectual, and physical powers.[54] It was doubtless this positive

[51] Herbert A. Giles, trans., *Chuang Tzu: Taoist Philosopher and Chinese Mystic*,
2d rev. ed. (London, 1961), p. 111; quoted in Osvald Sirén, *The Chinese on the
Art of Painting: Translations and Comments* (New York, Toronto, and London,
1964), p. 104.

[52] Cf. Sirén, pp. 51, 79, and *passim*.

[53] According to his pupil Carry van Biema, Hoelzel had his pupils begin classwork
with "gymnastischen Übungen" followed by "hundert starken Übungsstrichen, die
etwa dem 'Einspielen' des Geigers entsprechen." She explains, "Es handelt sich
um die Entwicklung der Gesamtkraft aus dem ganzen Körper heraus. . . ." Van
Biema, writing in 1930, gives no date for this class work (*Farben und Formen als
lebendige Kräfte*, Jena, 1930, p. 142); but cf. Adolf Hölzel, "Gedanken über die
Erziehung des künstlerischen Nachwuches," *Der Pelikan*, no. 10 (1920), p. 14,
and Johannes Itten, "Adolf Hölzel und sein Kreis," *Der Pelikan*, no. 65 (April
1963), p. 36, who both mention hand exercises. Warming-up exercises consisting
of broad, sweeping drawing movements were already used in nineteenth-century
drawing classes; e.g., in the classes of the American reform educator Liberty Tadd,
whose *New Methods in Education*, 1899, trans. in 1900 as *Neue Wege zur
künstlerischen Erziehung der Jugend* (Hamburg), had an influence on German edu-
cation theory about the turn of the century (Tadd, Eng., p. 50).

[54] The curious reader may learn about the still active cult and its doctrines from one
of the several books written in English by its German-American founder, Otto
Hanish, who took the name O. Z. A. Ha'nish, or from the magazine, *Mazdaznan*,
begun in 1902 and still published in Los Angeles (see, e.g., issues for the years in

aspect of the otherwise dubious teachings of the cult that chiefly attracted Itten, Muche, and their followers at the Bauhaus; and it is certainly in part behind Itten's schematic way in his later writings of classifying his course work (and the students taking it) according to whether it was emotionally, intellectually, or physically oriented, as well as behind his belief that these supposed tendencies in his students must be brought into balance with each other.[55]

The preparatory exercises of the *Vorkurs* thus sprang from a concept central to all of Itten's teaching: that education in art is as much a process of "release"—of removing intellectual and emotional impediments which prevent the student from calling fully and at will upon his inborn creative powers, whether these are conceived to be divine in origin or not—as it is of formal training and discipline. Hence, these exercises, which had as their chief aim to remove the student from the common atmosphere and attitudes of the everyday and to prepare him psychologically and emotionally for the creative act.

In effect, Itten's intention was to prompt inspiration and to place its workings on something like a regular basis. To this end, Itten brought to bear in his classes a remarkable force of personality and showmanship as a teacher. His emotional outbursts and erratic displays of temperament in class, reported by Klee and Schlemmer among others, seem not the uncontrolled behavior of a highly theatrical and emotional personality, but calculated pedagogical tactics. The incident witnessed by Schlemmer, for example, in which a *Vorkurs* class analysis of a slide of the crying Magdalene of Grünewald was capriciously interrupted by Itten,

---

question, 1918–1923). In the early '20's Mazdaznan had, in the German-speaking parts of Europe, centers in Leipzig, Vienna, and Herrliberg. Itten visited Herrliberg for a time immediately after leaving the Bauhaus. Practically, Mazdaznan placed major importance upon a simple form of breath control, extolled as having wide restorative powers; a stringent vegetarian diet designed to rid the body of its various physical and spiritual ills; and, for the same reason, a drastic and highly dangerous regimen of purgation. The dietary practices were, with the economic difficulties of the postwar period, not altogether a fad at the Bauhaus. It is perhaps worth adding that if anyone at the Bauhaus followed the last recommendation of Mazdaznan, it is unrecorded.

[55] Cf., e.g., Itten, *Design and Form*, p. 177.

who screamed that if the students really had artistic feelings they "would not be able to draw before this most exalted image of the world's sorrow but simply sit here and melt into tears," and who thereupon slammed the door on the class, plainly seems to have had the purpose of intensifying the experience of the painting and keeping the class at an extraordinary pitch of creative excitement.[56] In effect, such scenes aimed at making the moment of creative tension not the exception but the commonplace.

In thus describing what we may call the intuitional side of Itten's classes, however, we must be careful not to exaggerate either its extent or the nature of the intention behind it. It is convenient for the purpose of analysis to distinguish the various parts of the *Vorkurs* according to their dominant functions, as Itten himself did in his descriptive brochure for the 1922 Bauhaus exhibition of *Vorkurs* work.[57] But they were not meant in practice to be separated. Even some of the exercises in abstract, calligraphic rhythms, for example, were as much devised to explore problems of formal relationships and organization as to express emotional states. Similarly, the rapid, expressive tracings of the human figure in motion were in greatest part intended to heighten visual acuity (Figs. 20–21). Conversely, even the "constructive" exercises, as we have just seen in the case of the analysis of Grünewald, and as is constantly underscored by Itten's statements, were not meant to be divorced from the emotions and the intuition.

True enough, the exercises in interpreting emotions or experiences now seem to have been, within the context of a school dedicated to building and *Gestaltung*, little more than outlets for self-expression. But the avowed purpose of such exercises was to school the emotions, to help train for the objectification—for the exact visual equivalent—of a given state of mind. Itten's procedures can be, and in fact at the Bauhaus were, criticized on various grounds; but it is the greatest exaggeration to say, as has been said, that Itten sought to "return incoming students to the noble savagery of childhood."[58] Oriental mysticism was for Itten a confirmation

[56] Schlemmer, *Briefe*, p. 112 (letter of May 16, 1921); quoted in Itten, *Design and Form*, p. 148.
[57] In Wingler, *Bauhaus*, p. 64.
[58] Reyner Banham, *Theory and Design in the First Machine Age* (London, 1960), p. 279.

only; it seems scarcely necessary to observe that at no time did he, as an artist and teacher, espouse the quietism or deliberate return to a state of ignorance preached by Taoism or Zen Buddhism. Not knowledge itself, but the wrong kind of knowledge was under attack at the Bauhaus. We should remember that criticism by artists of the period of the "mass of learned material" which must be discarded usually had behind it the image of the formulistic instruction of the academies and the routinized pattern-work of the schools of applied arts. Artistic and technical knowledge was, in fact, a major objective of Itten's endeavors; but it was intended to be knowledge free of formulas or preconceptions, guided in its final application in a work of art by the requirements of the subject or task as well as, where pertinent, by the "inner necessity" of the artistic emotions.

## Itten's Approach to the "Fundamentals" of Design and His Break with Gropius

The constructive side of Itten's course, which aimed at developing this knowledge, came for the most part from more orthodox artistic sources than the side we have considered up to now. It was based upon the analysis and manipulation of what were regarded as objective principles, forms, or fundamentals of design lying behind all works of art and therefore conceptually—and even historically—prior to any particular stylistic embodiment.

Various tendencies in the modern movement—the search in the 1880's and 1890's for laws of pictorial harmony; Cézanne's and the cubists' emphasis upon geometry; the interest of architects and designers in *Sachlichkeit* and machine form, which was commonly equated with geometry; the development of abstract art— all led in the first two decades of the century to an increasing interest on the part of modern artists and architects in investigating the formal bases of art. And although artists differed to some extent concerning which among the conceivable essentials of design they chose to emphasize, by 1919 this general approach to designing had become a commonplace of modern artistic thought.

One of the most distinctive features of Itten's concept of design, his predominant emphasis upon the element of contrast, was first learned in Stuttgart from Adolf Hoelzel, whose formalist aesthetics, derived in part from the classicistic doctrines of Adolf Hildebrand, called for an art founded upon objective and universally applicable principles. In his teaching Hoelzel placed a strong emphasis upon the all-embracing complementary *Wirkungsprinzipien* of harmony and contrast, the former resulting from the balancing of the latter.[59] In 1904, in his long historical survey of the gradual discovery and use since the Middle Ages of the formal principles of art, he had stated as his conviction, echoing the well-known wish of Goethe: "I believe that just as music has its theory of counterpoint and harmony, a definite theory of artistic contrasts of all kinds and their requisite harmonic balance must be attempted for painting."[60] Of these principles, it was contrast that gave the work of art its compositional and expressive vigor; and much of Hoelzel's historical exposition, consequently, is given over to a description of how the various means of contrast have been used in the past. But for Hoelzel, who had come to maturity in the 1890's, as for most theorists of the nineteenth century, the final end of art was still harmony.[61] Itten, on the contrary, for all that he is indebted to his teacher for much of his theory, is far less concerned with harmonious resolution than he is with expressive visual force.

Itten's writings from his Bauhaus period tell us little about the way he conceived design; most of this was set down by him only from 1930 onward, when the modern practice of teaching a vocabulary of basic abstract forms and procedures had become much

[59] On Hoelzel's theories, see Walter Hess, *Das Problem der Farbe in den Selbstzeugnissen moderner Maler* (Munich, 1953), pp. 91–93 and *passim; idem,* "Zu Hölzels Lehre," *Der Pelikan,* no. 65 (April 1963), pp. 18–34; Hans Hildebrandt, *Adolf Hoelzel* (Stuttgart, 1952); *idem,* "Adolf Hoelzel. Ein Beitrag zu seinem Wirken als Lehrer," *Werk* 40, no. 3 (March 1953): 99–104. Now also Thomas Tritschler, "The Art and Theories of Adolf Hölzel and Their Place in the History of Late Nineteenth and Early Twentieth-Century Painting" (Master's thesis, University of Illinois, 1968).

[60] Adolf Hölzel, "Über künstlerische Ausdrucksmittel und deren Verhältnis zu Natur und Bild," pt. 3, *Die Kunst für Alle* 20, no. 4 (November 15, 1904): 132.

[61] On this see esp. Walter Hess, *Problem der Farbe.*

more firmly established and methods were partly developed. For knowledge of his approach at the Bauhaus we must turn instead to actual examples of class exercises and to the accounts of his students. By them we may judge in part to what extent his later writings describe methods already in use at the Bauhaus.

The *Vorkurs* work confirms Itten's statement in his *Design and Form*, written toward the end of his life, that "the foundation of my basic design teaching was the general theory of contrast. Light and dark, material and texture studies, form and color theory, rhythm and expressive forms were discussed and presented in their contrasting effects.... All ... contrasts had to be worked out singly and in combinations."[62] In fact, contrast effects, whether of value, color, dimension, direction, rhythm, or texture, can be seen to be a clearly calculated part of most, if not all, of the surviving *Vorkurs* exercises that deal with construction or arrangement, including the two-dimensional arrangements of different materials (Figs. 22–29).[63]

Itten's practice of basing his design problems upon polar contrasts betrays its origin in the period of expressionism just before and during World War I. The value Hoelzel gave to contrast as a *Wirkungsprinzip* was essentially confirmed for him, with significantly modified consequences, by modern pictorial theory and the dominant stylistic trends of the time, among them cubism, to which his own work from about 1914 was strongly indebted. The notion of contrast figured prominently in the thinking of modern painters during the first two decades of the century, whether with respect to color contrast, as for instance with Matisse and the fauves, who, drawing upon neoimpressionist color theory, nevertheless used it for strongly personal and expressive ends; or else generalized to include form as well as color, as in the theories of

[62] Itten, *Design and Form*, p. 12, which, however, illustrates his words with exercises of the late twenties from his school in Berlin. Cf. also Itten's *Tagebuch. Beiträge zu einen Kontrapunkt der bildenden Kunst* (Berlin, 1930), p. 3: "Die charakterisierenden Hauptkontraste zu erkennen und in elementarer Weise darzustellen, sollte das erste Ziel einer logisch aufgebauten Anschauungslehre sein."

[63] Cf. Alfred Arndt on the fall-winter 1921 *Vorkurs*: "um die Mitte des Semesters beschäftigten wir uns mit Material-Studien: rau-glatt, spitzig-stumpf, weich-hart usw." (in *Bauhaus. Idee*, p. 43).

Léger and Delaunay.[64] Léger, in fact, had in 1913–1914, in lectures and in print, urged the theory that contrast—both of form and color—should be the basis of all art; that, in his words (and for the same reason as Itten later: as a way of giving life to the work), "contrasting forms are from this time onward the armatures of modern painting." These words were published, among other places, in *Der Sturm* in August 1913 where Itten must certainly have seen them.[65] We may also recall that no French artist had had more influence upon modern German developments before the war than Delaunay, whose theories on light were likewise published in *Der Sturm*, in a translation by Klee, and whose studio Klee, Marc, and Macke had all gone to Paris in 1912 expressly to visit. Delaunay's "contraste simultanée" meant stylistically and conceptually something quite different from Léger's idea of contrast, but like the latter, Delaunay, too, posited in his work strong contrasts of color, abrupt confrontations of form, and sudden changes of direction as the way to achieve vigor of expression. These principles of contrast, although formulated among modern artists most notably by the cubists, were at any rate entirely in accord with the aims of the German painters in the years during and just after the war; and no more so than in the case of Itten, whose works of the war years reflect in their clashing rhythms and forceful oppositions of geometric forms specifically the cataclysmic vision of the late paintings of Franz Marc, and more generally the expressive effects of the futurists and the Right Bank cubists.[66]

[64] On Matisse and the influence of neoimpressionism, see Alfred H. Barr, Jr., *Matisse: His Art and His Public* (New York, 1951), *passim;* on Delaunay's theory of *contraste simultanée*, see Robert Delaunay, *Du cubisme à l'art abstrait: documents inédits publiés par Pierre Francastel et suivis d'un catalogue de l'oeuvre de R. Delaunay par Guy Habasque* (Paris, 1957), esp. pp. 108–126, 158–160.

[65] Fernand Léger, "Les Origines de la peinture contemporaine et sa valeur représentative," *Der Sturm* 4, no. 172–173: 78. His full statement reads "Tout désormais peut concorder vers une intensité de réalisme obtenu par des moyens purement dynamique. Les contrastes picturaux seront employé dans leur acceptation la plus pure. La compréhension de couleur et de lignes les [*sic*] formes contrastées sont désormais les armatures des tableaux modernes." For Léger's theories see also John Golding, *Cubism: A History and an Analysis, 1907–1914* (New York, 1959), pp. 152–154. Léger's article has now been trans. in Edward Fry, *Cubism* (New York and Toronto, 1966), pp. 121–126.

[66] Cf. the theories of August Macke, which were influenced strongly by the French: "Ausschnitte aus alten Bildern zeigen meist ruhige Übergänge. Die Einzel-

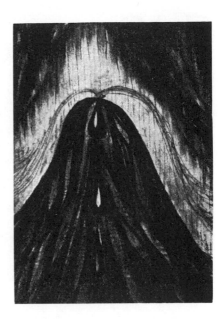

Fig. 18. Student exercises from Franz Cizek's classes, Vienna, ca. 1920–1921. Expressions of specific emotions: sorrow.

Fig. 19. Student exercises from Cizek's classes, Vienna, ca. 1920–1921. Expressions of specific sensations: light versus darkness.

Fig. 20. Werner Graeff. Exercise for Itten's preliminary course, ca. 1921.
Bauhaus-Archiv, Darmstadt.

Fig. 21. Max Peiffer-Watenphul. Exercise for Itten's preliminary course, ca.
1919–1920. Titled on the drawing: "Akte (Bewegungen aus dem Rhyth-
mus)—5." Bauhaus-Archiv, Darmstadt.

Fig. 22. Friedl Dicker. Exercise for Itten's preliminary course, ca. 1919–1920.

Fig. 23. Friedl Dicker. Exercise for Itten's preliminary course, ca. 1919–1920. Bauhaus-Archiv, Darmstadt.

Fig. 24. Max Peiffer-Watenphul. Exercise for Itten's preliminary course, ca. 1919–1920. Bauhaus-Archiv, Darmstadt.

Fig. 25. Franz Singer. Exercise for Itten's preliminary course, ca. 1919–1920. Bauhaus-Archiv, Darmstadt.

Fig. 26. Franz Singer. Exercise for Itten's preliminary course, ca. 1919–1920. Bauhaus-Archiv, Darmstadt.

Fig. 27. Franz Singer. Exercise for Itten's preliminary course, ca. 1919–1920.

Fig. 28. Georg Teltscher. Exercise for Itten's preliminary course, ca. 1921–1922.

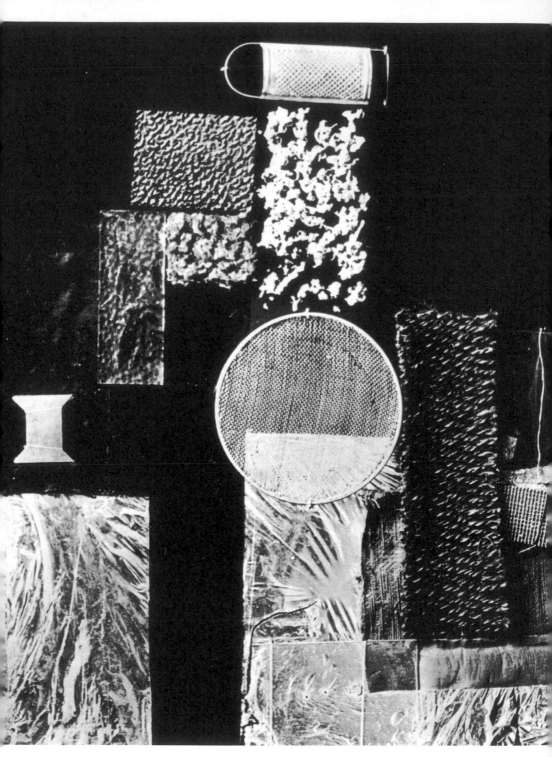

Fig. 29. Unknown student. Materials study for Itten's preliminary course.

But Itten's methods of teaching design not only conformed to the dominant aesthetics of his time, they also established a direct link with an older, nineteenth-century manner of conceiving the elements of art. As Banham, notably, has shown, the very interest itself of early twentieth-century artists in determining the elementary principles of form continued in a general sense a well-established academic way of thinking in both the fine arts and in architecture.[67] In Itten's case, the connection extends to his basic approach.

A characteristic nineteenth-century academic description of the components of design appears in the monumental *Grammaire des arts décoratifs*, written by the librarian of the École des Beaux-Arts, Charles Blanc, and carried through several editions.[68] In his introduction to the "general laws of ornament" in the second edition of his work, Blanc lists and discusses what he calls the "in-

---

spannungen gehen mit der Gesamtspannung meist in ruhigem Kontrast zusammen (es giebt natürlich Ausnahmen z.B. Greco). Das Raumbildende farbiger Kontraste im Gegensatz zum einfachen Helldunkel scheint mir von Delacroix und den Impressionisten zuerst in seiner ganzen Bedeutung für die Lebendigkeit des Bildes erkannt worden zu sein. Seitdem wird immer versucht, dieses Mittel zur einheitlichen Gestaltung des Bildraumes zu verwenden" (from a questionnaire in *Kunst und Künstler*, "Das neue Programm," reprinted in Schmidt, ed., *Manifeste*, pp. 80–83). For ills. of Itten's work of the period, see esp. Hans Curjel, "Johannes Itten," *Werk* 44, no. 10 (October 1957): 359–366.

[67] See esp. his demonstration of the relationships between modern French architectural thought of the period and that of the nineteenth-century École des Beaux-Arts (*Theory and Design*, pp. 15–20). The history of the attempt to discover and explicate the laws of art is a long and complex one, even as it directly pertains to the Bauhaus, and cannot be taken up here. For certain aspects of it in the late nineteenth and early twentieth centuries, see Walter Hess, *Problem der Farbe*, particularly with respect to theories of color harmony. Hoelzel, one of the principal figures in this attempt, himself set down in 1904 a—to be sure, highly selective—history of the artists and theorists who had preceded him in helping to discover the laws of art in his "Über künstlerische Ausdrucksmittel."

[68] Published in Paris, 1882; 2d ed. "augmentée d'une introduction sur les lois générales de l'ornement," also 1882; new editions in 1886 and again in 1897. For a brief discussion of Blanc's formalist approach as helping to prepare for the development of abstract art, see Banham, *Theory and Design*, pp. 15, 18, and *passim*. Banham attributes to Blanc widespread influence, but avoids the question of paths of transmission and parallel tendencies by asserting merely that Blanc's writings "[became] part of the racial sub-conscious, so to speak, of many . . . artists . . . and its ideas can be paralleled (e.g., in Germany) even where they had no direct influence" (p. 15).

evitable elements of all ornament invented by man." All motifs, according to him, can be reduced to the five "principles" of repetition, alteration, symmetry, progression, and confusion, these in turn yielding the "secondary elements" of consonance, contrast, radiation, gradation, and complication.[69]

Now, Itten, who must certainly have been acquainted with Blanc since his student days at the École des Beaux-Arts in Geneva, did not use such an unfruitful and by this time thoroughly ordinary classification, unobjectionable though it might be in itself; but he was nevertheless not altogether free from an orientation to design implicit in Blanc's formulation and nineteenth-century theory as a whole. To emphasize contrast as a primary factor is still, like Blanc, for whom contrast is but a secondary element among the many that must be brought into harmonious balance, to approach design largely through its effective visual forms. It is apparent at once that Blanc's categories, deriving as they did from a conception of design as two-dimensional decorative pattern, do not refer to the actual process of creating a work of art—they do not describe structural principles or ways of conceiving forms—but are, rather, a classification of essentially its visual components. So, too, Itten's approach, insofar as it deals with relatively elementary oppositions of light-dark, large-small, soft-hard, and the like, is essentially affective, placing stress upon dramatic visual presentation. This is distinctly in contrast, for example, with what was later to be Albers's principal emphasis in the *Vorkurs* upon the systematic and rationalistic investigation of the constructive properties of materials and a functional method of forming them, or with the highly original—and even revolutionary—attempt of Klee at the Bauhaus to teach a concept of what is accurately termed symbolic structure, in which structural units or principles gained symbolic as well as formal significance through combination and by interaction with the pictorial ground.[70]

In Klee's teaching, the predominant concern with pictorial

[69] Blanc (1886), pp. ii–xxxviii.

[70] The basic source of information on Klee's Bauhaus teaching is his pedagogical notebooks, collected in Paul Klee, *Das bildnerische Denken*, ed. Jürg Spiller (Basel and Stuttgart, 1956); English trans. Ralph Manheim, *The Thinking Eye: The Notebooks of Paul Klee* (New York and London, 1961).

structure becomes apparent from a mere glance at the topics set down in his pedagogical notebooks for class consideration. In contrast, a coherent theory of structure or pictorial space is absent from Itten's writings, and seems also to have been absent from his teaching if we can judge from the surviving examples of his students' works. There is very little in any of Itten's writings about such matters of composition as the nature of space within a two-dimensional context or the relationship of a figure to its ground. Exercises from Itten's post-Bauhaus classes were to show an increased interest in the problems of spatial composition, as for example, in his assignments to represent solids within a plane;[71] but no theory was ever set down by Itten to explain his own approach to such problems. On the contrary, it is quite clear from everything he wrote—and it is supported by the fluctuations of style and conception in his own paintings—that he adhered to no fixed idea of design and that whatever compositional problems arose in the course of a class were attacked empirically in conformity with the aims of the individual students.

The importance as a tool for the study of composition that Itten gave to the schematic analysis of old masters—which, as is well known, he adopted from Hoelzel and which was not original even with the latter—[72] indicates that at Weimar he tackled the problem of teaching abstract design from a highly general and conservative point of view. For such analyses necessarily remain bound to the naturalistic spatial conceptions of the originals, which at most they can but reduce to two-dimensional patterns. By themselves, therefore, they can offer only a limited understanding of abstract pictorial structure, if by these words, however broadly they are taken, we mean anything of the compositional and spatial complexities that had been created with the development of cubism and abstract art.[73] Their purposes for Itten were, rather,

---

[71] Ill. in Johannes Itten, "Pädagogische Fragmente einer Formlehre," *Form* 5, no. 615 (1930): 160–161, esp. figs. b, d, h; and Itten, *Design and Form*, pp. 121–124.

[72] It was used in the nineteenth century by, among others, Walter Crane, *Bases of Design* (London, 1898; trans. 1901 as *Grundlagen der Zeichnung*), in which there appeared a diagram of the compositional rhythms of the Panathenaic frieze from the Parthenon (p. 8).

[73] All this is not to say that some of the exercises set by Itten in his course were not capable of yielding interesting and unusual abstract compositions, perhaps

as they had been for Hoelzel, preliminary to the actual constructing of designs. They served as training for the sensibilities and the eye, as a way of bringing the student in greater contact with the expressive language of an acknowledged masterpiece while at the same time affording him insight into the means by which the artist had achieved his results. They also served the more important and general function of abstracting through their diagrams of rhythms, colors, values, and the like those universal compositional principles which Itten, following Hoelzel, regarded as underlying all styles of art. Their purpose was thus to lead the student to an abstract way of thinking about forms and color which, in its application to whatever task, would be independent of a particular style —especially a style of the past—subject, expression, or natural form. Within the scope of the *Vorkurs*, which had the purpose of reeducating as well as of introducing the new, such a task necessarily had to precede and perhaps even overshadow any more advanced investigation into the mechanics of abstract composition.

The looseness of Itten's methods was not without its advantages if we compare them to the more strictly conceived approaches of Klee and Kandinsky, who during Itten's time were responsible for the *Formlehre* in its more advanced stage. Itten's stated goal was, as we have seen, to release and develop individual talents and predispositions without forcing them into a mold or single conception of art, no matter how advanced. And in fact, the illustrations collected by him in his *Design and Form*, as well as his descriptions of his classes at Weimar and later, confirm that his methods were general and permissive enough to accommodate a wide variety of styles and expressions. On the whole, it is easy enough to determine the period in which an exercise was done by its relation to the artistic currents of the time. Thus, for example, the exercises of the Vienna period and the first years of the Bauhaus reveal their connections to expressionism in their loose forms and somewhat impressionistic handling of chalk or brush, and in

---

even significant for later abstraction. Most recently, Wingler has proposed a direct relationship between some of the calligraphic exercises done in the Itten course and the post-World War II work of such artists as Hartung (Hans M. Wingler, "Is the Bauhaus Relevant Today?" mimeographed address delivered at the Illinois Institute of Technology, April 20, 1967).

their free, broadly rhythmical compositions (Figs. 22–27).[74] Moreover, the *Vorkurs* was not intended to be an exclusive preparation for fine artists, and Itten's treatment of composition from the visual standpoint of contrast effects had the virtue, whatever its shortcomings, of ready applicability to a variety of problems, including three-dimensional design. This could not easily be accommodated by the narrowly pictorial orientation of Klee and Kandinsky, who in addition brought to their teaching highly developed and pervasive concepts of form, structure, and expression.

Yet it is not, of course, surprising that Itten's methods should eventually prove unsatisfactory to Gropius and others at the Bauhaus. All accounts insist that a personal struggle for authority was to some extent involved in the conflict that developed between Gropius and Itten;[75] but serious differences in their philosophies were the more fundamental cause. Itten's pedagogical ideas had obviously fitted in well with the educative side of Gropius's plans —that side concerned with rearing a generation of creative individuals capable of independent judgment and responsive to viable new artistic and intellectual currents. But unlike Marcks and Feininger, and in company most particularly with Muche, who has boasted that "I promised myself [in accepting charge of the weaving shop] never in my life to weave a thread, tie a knot, or make a textile design with my own hand; I have kept that promise,"[76] Itten had no commitment to the goal of a practical handi-

---

[74] Some of these are dated by Itten and by Wingler, *Bauhaus*, p. 259, as early as 1919–1920, a dating acceptable on stylistic grounds.

[75] E.g., Schlemmer, *Briefe*, p. 120 (letter of Dec. 7, 1921, to Otto Meyer): "Itten hat . . . die wesentlichen Werkstätten in der Hand und will das nicht Geringe . . . : dem Bauhaus seinen Stempel aufdrücken. . . . Heute, meint Gropius (der sich jetzt offen gegen Ittens Monopolstellung wehrt), müsse Itten in seine Schranken gewiesen werden, die Gropius ihm innerhalb des Pädagogischen zieht." Schlemmer's account of the conflict, while possibly oversimplified in its polarization of the issues, agrees with the information available in the documents and is in general more useful than the anecdotal reminiscences of Muche (*Briefe*, pp. 120ff.; cf. Georg Muche, *Blickpunkt. Sturm, Dada, Bauhaus, Gegenwart*, Munich, 1961). Also Feininger letter of Sept. 7, 1922, to Julia Feininger: "Vermutlich wäre er [van Doesburg] . . . nicht fähig, sich innerhalb seiner Grenzen einzuschränken, sondern würde, so wie Itten seinerzeit, bald das Ganze kommandieren wollen" (FP, MS Ger 146 [1445], vol. 2; in Wingler, *Bauhaus*, p. 68).

[76] Muche, *Blickpunkt*, p. 168. Muche has further written that Johannes Molzahn, through whom Gropius first learned of Muche's interest in the Bauhaus, "wusste,

craft training for the artist. Throughout his life he never ceased to insist that all his work in the Bauhaus had been primarily educational in purpose and not intended as a mere *Vorstufe* in the designing of marketable commodities.[77] Itten's cultist leanings, moreover, came to be increasingly at odds with the pragmatic side of the Bauhaus. If at the start Gropius had shared some of the same sentiments as Itten about the East and the necessity of religion for art, they were strictly subordinated to his goal of tangible achievement for the Bauhaus; and this became especially the case beginning in 1921, when the more rationalistic currents from France and Holland (for all that De Stijl theory, as everyone knows, was itself not devoid of a mystical side) began to make themselves strongly felt at the Bauhaus. For Itten, instead, these sentiments—elaborated by him to the point of an actual, if not always coherent doctrine—were at the very center of his teaching. He saw Gropius's desire to bring shopwork into the sphere of practical life as damaging, if not indeed utterly antipathetic to the quietude, reflectiveness, and detachment from the affairs of the marketplace he believed necessary for the full inner development of his students.[78] The conflict between the two points of view was kept within bounds at the beginning by the slow start of the school—by the need to build courses and develop methods, and by the very absence of opportunity to undertake much practical work. When, however, by 1922, along with the growing rationalist sentiment, it became overwhelmingly apparent that the Bauhaus would have to show for political reasons what it was capable of producing if it wanted to keep the grudging good will of the state, an open clash became unavoidable.

The break between Itten and the Bauhaus came already at the end of 1921. The immediate cause was a quarrel with Gropius over commissions given by Itten to the carpentry shop without the

---

dass Handwerkskult nicht meine Sache war. Die Ideen von Ruskin, Morris und die des Deutschen Werkbundes gingen uns nichts an. . . . Ich sollte ein Maler bleiben und mich nicht im Für und Wider eifriger Versuche zur Nutzanwendung der Künste verschwenden" (*ibid.*, p. 163).

[77] E.g., Itten, "Pädagogische Fragmente," p. 141; Itten, "Erziehung durch bildnerisches Tun," in *Handbuch der Kunst- und Werkerziehung*, vol. 1, *Allgemeine Grundlagen der Kunstpädagogik*, 2d ed. (Berlin, 1953), p. 440.

[78] Appendix F, pp. 292; 294, no. 8.

knowledge and approval of the former, who was its titular head. For Itten, Gropius's rejection of his commission—which is to say, from his view, of his artistic policies regarding the shop—was but one more piece of evidence that Gropius lacked understanding of his pedagogical aims and intended to turn the Bauhaus into a mere producing workshop. In anger he declared in a letter to Gropius at the very beginning of 1922 that under the circumstances he had ceased to have "any real interest in the Bauhaus" and that henceforth he would reduce his teaching, like the other masters, to the barest minimum, giving up all his responsibility for the shops and abandoning the obligatory *Vorkurs*. He was persuaded for the sake of the students to retain direction of the stone and wood carving shops and of the *Vorkurs* at least until the end of the semester; but the break was to all intents final, even though he did not leave at once. He stayed for two more semesters. In October he gave his notice, and during Easter 1923, when the semester ended and just as the Bauhaus was preparing for its important summer exhibition, he left.[79]

Certainly much of Itten's teaching seems to have lacked relevance to the developments taking place in the Bauhaus. One may well acknowledge that the *Vorkurs* exercises in expression—the free, rhythmical studies and the depictions of emotions—were valuable in training the students' sensibilities and perceptions, but even at the beginning, if we except the painting and sculpture shops, they had little direct application in the workshops. Certain parts of the analytical, constructive side of the course—the old-master study, for example—were also vulnerable to the criticism of insufficient connection with the shops. This was true even of the materials constructions which culminated the work of the *Vorkurs* and which were intended as direct preparation for entry into the crafts. As with much else in the *Vorkurs*, they had the multiple purpose of helping to free the student from reliance upon narrow or conventional solutions, of developing sensitivity to the qualities of a wide variety of materials and their use, and of teaching com-

[79] On the conflict, see the Itten-Gropius exchange and related correspondence in Appendix F and Gropius's important memorandum of Dec. 9, 1921, to the faculty, pub. in Wingler, *Bauhaus*, p. 61. Itten's formal letter of resignation to Gropius announcing his departure at the end of the winter semester 1922–23 (i.e., at Easter-time 1923) is dated Oct. 4, 1922.

position. But characteristically, the first goal overshadowed and determined the outcome of the other two: the extreme latitude given the students in this exercise—the complete absence of formal limitations and the stipulated use of the widest variety of cast-off materials and detritus—yielded results which in appearance (though not in purpose) were rightly likened at the time to the products of dada whose influence was doubtless in part behind many of them.[80] At best, these exercises could teach little of the formal and technical discipline needed for production in the shops; at worst, they might even hamper its acquisition.

### The Return to Basic Forms in the Early Work of the Shops

Yet all the differences existing between Gropius and Itten must not obscure the fact that on significant aspects of design in the workshops there was general agreement among the faculty. It is possible to demonstrate a consistency of approach in the designing of three-dimensional objects of all types that argues for considerable accord on matters of form among the masters, even in the earliest period. All the masters were committed to a basic rethinking of design in whatever field it might be applied. To this end, when it came particularly to objects of use, all favored, including, it would seem, Itten, that direct explication of function and that strength, simplicity, and clarity of form which could come from the use of simple geometric shapes.

Itten's emphasis in his courses upon strong contrast as the basis of design was entirely in accord with Gropius's own preference in architecture for the "clear contrasts" and visual drama he had urged in print before the war and attempted to demonstrate in his own buildings.[81] One of the evident means by which this contrast could be achieved was geometry. From some of the earliest sur-

---

[80] E.g., the favorable review of the exhibition by Johannes Schlaf in the *Berliner Tageblatt*, which noted the "dadaistische Basteleien" of the materials exercises (clipping file, BD,SG).

[81] Walter Gropius, "Die Entwicklung moderner Industriebaukunst," in *Kunst in Industrie und Handel*, Jahrbuch des Deutschen Werkbundes 1913 (Jena, 1913), pp. 19–20; *idem*, "Der stilbildende Wert industrieller Bauformen," in *Der Verkehr*, Jahrbuch des Deutschen Werkbundes 1914 (Jena, 1914), p. 30.

viving examples of *Vorkurs* exercises, most of them datable without difficulty as 1919–1920 by their expressively free style of drawing and shading, we learn that already at the start Itten assigned compositional problems dealing with the disposition of the elementary geometric forms of the rectangle, circle, and triangle in simple planar oppositions (Figs. 22–29).[82]

Visual contrast, however, was only one reason for emphasizing geometry in his classes; and here Itten showed himself in concurrence with other masters in the Bauhaus. For Itten, as for numerous artists of the period, simple geometric shapes, both solid and planar, were in some sense fundamentals. In this belief he certainly owed something to cubism, from which his own work drew its use of geometric elements; but it is indicative of his approach to design that early *Vorkurs* exercises using geometric forms, as well as the forms of a number of the earliest objects produced under him in the shops, do not show any great geometric precision. We may recall Klee's description in his letter—which he illustrated—of certain *Vorkurs* exercises in which simple spiral, circle, and square motifs were produced like doodles by the action of the hand.[83] Such geometric motifs were valuable for Itten not primarily because they represented mathematically ideal or rational forms, as they tended to do in late cubism—at least there is no evidence for it—but rather because he conceived of them, as we have seen Behne did, as historically and conceptually primary in the creation of art. They represented primary structure before it had been varied and elaborated with sophisticated and complex decoration. Used as decoration, however, the basic geometric figures were "inner" forms in the sense that they were not merely independent of nature or past styles but easily and readily produced out of the working process itself, from the operations of the tool upon the material.

The earliest products of those shops which were under Itten's direction before the latter part of 1922 show what was clearly conceived as a return to formal geometric beginnings. In outcome

[82] These patterns are labeled by Itten in his *Design and Form* as "exercises in the form character of the square [circle, triangle]" (pp. 86, 90, 94).
[83] See above, p. 178.

they are direct extensions within the shops of the two-dimensional problems with geometric forms given by Itten in his *Vorkurs*.[84] This is particularly evident in the objects of use produced under Itten in the wood carving and metal shops (Figs. 30–34). They tend to be conceived as elementary geometric forms, including their decoration, with each part clearly defined and set off as a simple contrast from the next. Characteristically, sculptural ornamentation, such as moldings or flutings which would serve to soften transitions or otherwise moderate the elementary character of each part, is avoided in favor of simple incisions, punches, and other marks of the tool.

Even the artistically more accomplished and elaborate carvings of Joost Schmidt for the Sommerfeld house, which Itten rightly includes in *Design and Form* as having been done under the influence of his teaching, show something of this tendency to express the basics of form and technique. In their elaborate structure of juxtaposed and contrasting planes they are largely cubist in derivation; but a primary consideration in settling on the forms seems to have been their fitness for the wood-cutting tool. The formal intention of making the forms arise out of the basic techniques of wood cutting helps to account for the simple incised edges of the door relief and the mechanically repetitive incised patterns that fill the planes (Fig. 12). The carvings of the staircase are more intricate in concept and technique. They represent the various branches of Sommerfeld's timber industry and, among other things, symbolize them by motifs such as millwheels and gears, and by the use of abstract forms specifically suggestive of joinery and woodworking. But the very choice itself of joinery-like motifs implies the desire to stay expressively as much as possible within the context of a craft dependent directly upon the handling of the tool; and in these reliefs as well, the predominance of incised, rectilinear planes and blocks shows a restriction to forms intrinsic to the basic use of the carving tools (Figs. 13–14). The forms are directly related to the carving on the wooden chest made by Lili Gräf under Itten, which by its stylistic similarity must also be from 1921–22. Both reveal the nature of their conception by their

---

[84] Itten in his *Design and Form*, in fact, describes the forms of these products as conceived with simple, "basic" geometric shapes in mind (pp. 87, 118–119).

kinship with the type of elementary exploration of incised patterns and textures exemplified by Heinrich Busse's exercise of 1921 from the wood carving shop (Fig. 35).[85]

None of the earliest objects from the Bauhaus that survive or have been published take their inspiration from the geometrically exact forms of industrial technology; nor do most of them show any close kinship to, say, the precise and rather elegant geometry produced before the war in the *Wiener Werkstätte* and the Werkbund. The massive, blocky shapes of Lili Gräf's wooden chest and of the other objects illustrated here, the imprecisions of their edges, and their simple, tooled ornamentation connect them stylistically instead with folk craft (Figs. 30–33).

This is true for the early work in all of the shops, not just Itten's. The relationship should be no cause for surprise, considering the early Bauhaus interest in handicraft and the widespread anti-industrial and religious sentiment among German artists at the time.[86] Several factors made folk art relevant for the Bauhaus. It was not merely a source of expressive strength which had not been extensively exploited in the applied arts before then; more importantly, it made pure and direct use of those elementary forms and decorative motifs commonly understood to be prior to all more complex manifestations. It was, consequently, a way of escaping at once from naturalism, the conventional styles of the past, and the arbitrariness of merely individual or subjective inspiration.

Of the relatively small number of objects of use made in the Bauhaus before 1923, those which give the clearest and most convincing demonstration of the renovating use to which folk art was put in the early Bauhaus were not, in fact, produced under Itten. They are the pots of the Dornburg ceramic shop, which, we recall, was opened in October 1920 under Marcks and Max Krehan.

[85] Dated by Itten, *Design and Form*, p. 55 as 1922, and by Wingler, *Bauhaus*, p. 521 as ca. 1922–23, the exercise is probably from 1921, since Busse was already admitted into the shop in June of that year, and it is unlikely that such a basic study would have been done long after his entry there (cf. minutes of *Meisterratssitzung* of June 24, 1921, p. 2, StAW, B'haus, temp. no. 184). Mr. Wingler in a recent correspondence has confirmed the earlier dating on stylistic grounds.

[86] Cf. also the so-called "African" chair by Marcel Breuer of 1921 (ill. Wingler, *Bauhaus*, p. 280).

The ties of the Dornburg ceramics to native folk pottery not only are visible in their style, but have in part been documented. Annegrete Janda, in her fundamental article on the Bauhaus ceramics, has pointed out that the site of Dornburg was chosen partly with the intention of reviving the dying traditional pottery industry of Thuringia, of which Dornburg was a center. The choice of *Handwerkmeister* fell upon Krehan, who owned the last remaining shop in Dornburg for hand-turned pottery and who produced traditional types of inexpensive clay and stoneware. Krehan was a strong early influence upon his pupils. Throughout the Weimar period, with the aid of Bauhaus apprentices, he continued to make his commercial pots, the proceeds from which were a necessary source of income for the school. As a result, the influence of Krehan's simple type of Thuringian pottery can be found even in the independent work of his pupils.[87]

In general, the ceramic work done before about 1923 shows its debt to folk pottery in the squat, potbellied shapes and the rude, strongly protrusive or protruberant forms of spouts and handles, often in multiples, common to much European peasant pottery.[88] Nevertheless, the best students, and most particularly the highly gifted and prolific Otto Lindig and Theo Bogler, did not simply take over and adapt a folk idiom. Their early work is a decided and highly conscious rethinking of the basic forms of traditional pottery, as is revealed by the consistency of the results and the analogies it shows with the early work of the metal and wood carving shops. It is worth spending some time with it, for it does more

[87] Annegrete Janda, "Bauhauskeramik," *Kunstmuseen der Deutschen Demokratischen Republik, Mitteilungen und Berichte* 2 (1959): 85–88. According to her (p. 88), relatively few original student works were produced in the years 1920–21. Cf. Krehan's letter of June 7, 1921, to the Bauhaus in which he notes that there existed as yet scarcely any independently executed works from his pupils (*ibid.*, p. 104).

[88] For the dating of the Bauhaus ceramics, partly on the basis of the potters' marks, partly on the use of the second Bauhaus seal (in use by November 1921), and partly on style, see Janda, "Bauhauskeramik," esp. pp. 88–89, 96 n. 33, and the handlist on pp. 105ff. As a rule, the pre-1923 ceramics can be recognized by the pronounced use of folk elements which all but disappeared with the changeover of the shop in that year to mass-production models. The dating of some of the latter can also be verified by their inclusion in *Neue Arbeiten der Bauhauswerkstätten*, Bauhausbücher 7 (Munich, 1925).

than anything else produced then at the Bauhaus to demonstrate that the lessons of the form masters—of Marcks, whose graphic work and sculpture of the time were also strongly inspired by folk art; but, we can have no doubt, of Itten and his *Vorkurs*, too— had been well learned.

In the great majority of pots by Lindig and Bogler the characteristic high shoulders and strongly flaring necks of the high styles of Greek and later Western vases or of Chinese vases are avoided. Where shoulders are used, they either tend to serve as cushions or supports for the substantially elaborated volumes which surmount them (Fig. 36), or else, more rarely, are topped by comparatively prominent, isolable elements, as in the double-spouted jug by Bogler, for which the spouts are conceived as separate, strongly sculptural forms (Fig. 37). Almost never do their vessels terminate in the formal climax of shoulders capped, as traditionally, with a mere lip or a concave, flaring neck.

It is easy to see why such traditional forms were avoided or else radically altered. In them, typically, feet, necks, and handles tend to be strongly subordinated to, and extensions of, the main volume of the body or else form integral parts of a continuously developing, binding rhythm. The latter case is especially true of much Chinese pottery, in which the interplay of tensely curving convex and concave forms creates an organic unity, bringing each part under a fluid, continuously changing silhouette. Strongly flaring and prolonged concave forms, or parts that rise steeply and curve suddenly back into a high shoulder, lack the self-containment of bulging or cylindrical forms. They tend to be apprehended less as volumes than as mobile contours and hence to read as transitions and subordinate extensions of other forms. In contrast, the parts of Bauhaus vessels show considerable formal independence and charter. The rhythms of the contours are slowed down. The visual weight of each volume and of the vessel as a whole is centralized, thereby making them more self-contained and telling as sculptural forms. As in the containers produced in the metal and woodworking shop, the emphasis in the pottery is on the sharply defined articulation of distinct elements. Parts more often than not are contrasted to each other instead of being harmonized by a flowing contour. Necks, spouts, and lids tend to be treated either as

strongly plastic volumes or as sharply geometric profiles—as in the truncated cones of necks and lids. Feet, when present beyond mere rims, are either pulled into the volume of the body to become a part of the central mass or are likewise treated as strongly contrasting cone or cylinder shapes in balance with necks and lids—highly pronounced but flat, unvolumetric bases of the type of the Greek amphora seem not to have been used at the Bauhaus; we may assume because of their relatively weak character as forms (Figs. 36–42).[89]

After 1922, most of the obvious folk characteristics of Bauhaus pottery were to disappear and their place taken by the geometric precision and severity typical of Theo Bogler's and Otto Lindig's designs for mass production.[90] But the transition from the earlier work, it is apparent, was extremely easy to make and involved no significant change of mind. Although the appearance of the works changed, the basic approach which has been outlined here did not. In the other workshops, the first accomplishments were neither as convincing nor as abundant as they were at Dornburg, perhaps simply because the close dependence of pottery making upon traditional techniques and forms gave it a firmer point of departure. Yet, as we have seen, those few utilitarian objects which survive from other shops, including Itten's, show comparable intentions. The work of the metal shop done after 1922 under Moholy-Nagy underwent a considerably greater change from the earlier work; but here, too, pupils had already become accustomed from Itten to thinking of basic volumes and forms

[89] Cf. Lindig's words which appeared in the *Werkstattbericht des Deutschen Kunstdienstes*, 1942: ". . . die unablässigen zähen Bemühungen um die gute, gesunde, klare Form. Immer war mir diese Arbeit die Wichtigste; das Töpfern ist für mich immer und vor allem eine plastische Angelegenheit" (quoted in Janda, "Bauhauskeramik," p. 92, n. 20). The ceramic work of the Bauhaus can be seen to share that more general tendency, which began ca. 1921 in many fields of modern art, to move away from an emphasis upon overall compositional rhythms toward a greater concern with individual forms and the articulation of more carefully conceived parts. One sees this change at the same time in the work of a number of the Bauhaus masters, most notably Klee, Itten, Schlemmer, and Kandinsky.

[90] It is worth observing that there is no relationship between the forms of French Purism and the later Bauhaus pottery, for all that they both exhibit an interest in a geometric distillation of form. Purist vessels are invariably geometric stereotypes of conventional forms; they could have offered little inspiration to the Bauhaus.

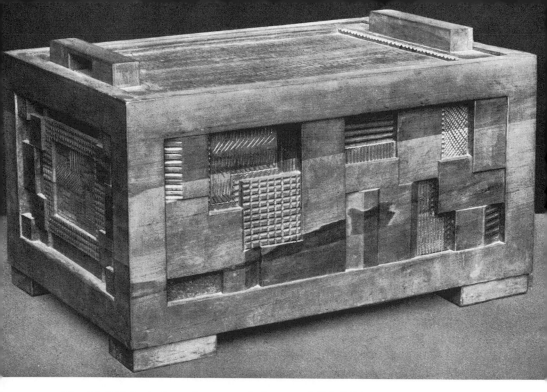

Fig. 30. Lili Gräf. Carved pearwood chest, ca. 1921–1922.

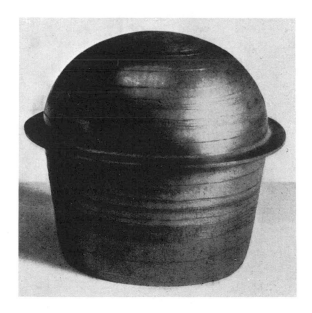

Fig. 31. Karl Auböck. Brass container, ca. 1920–1921.

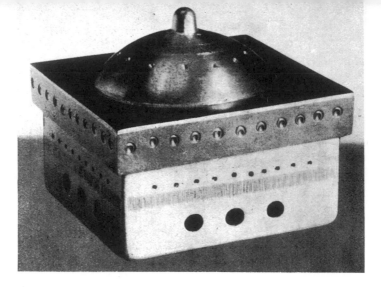

Fig. 32. Lipovec. Brass and copper box, ca. 1920–1921.

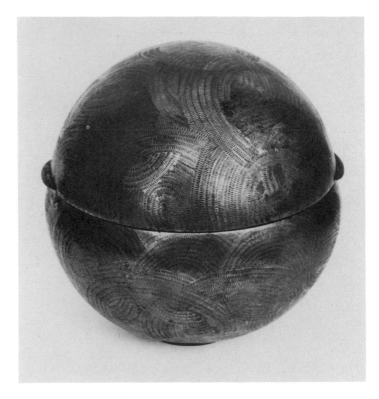

Fig. 33. Naum Slutzky. Copper container, before 1923.

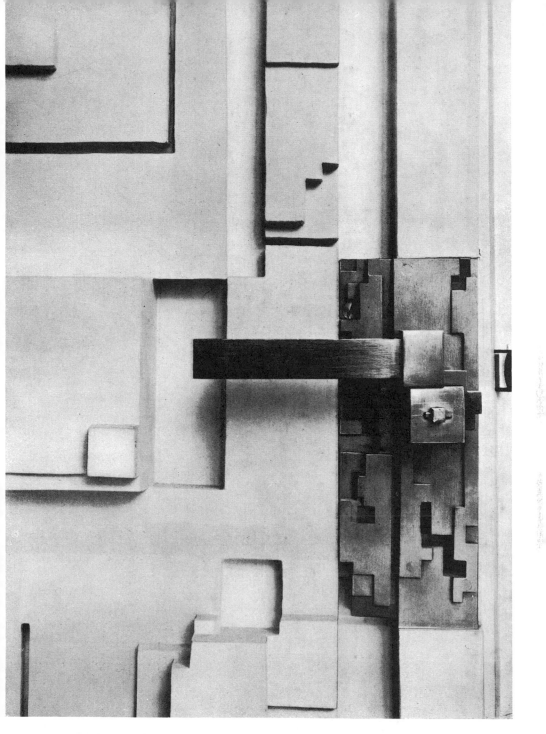

Fig. 34. Naum Slutzky? Wooden door relief with latch of nickel-plated iron, ca. 1921–1922.

Fig. 35. Heinrich Busse. Preliminary exercise for the woodcarving shop, probably 1921.

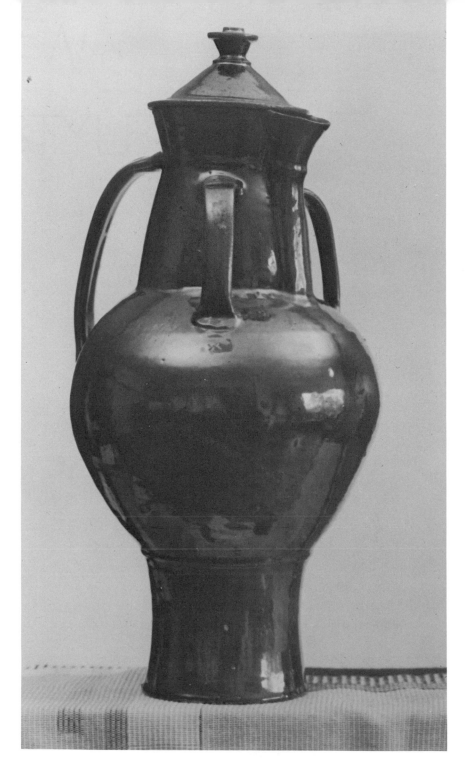

Fig. 36. Otto Lindig. Pitcher with lid, ca. 1921–1922. Staatliche Kunstsammlungen, Weimar.

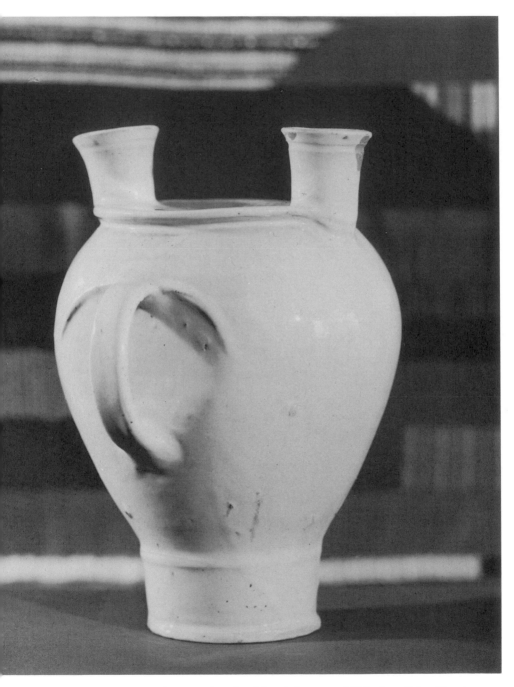

Fig. 37. Theo Bogler. Double pitcher, ca. 1922. Staatliche Kunstsammlungen, Weimar.

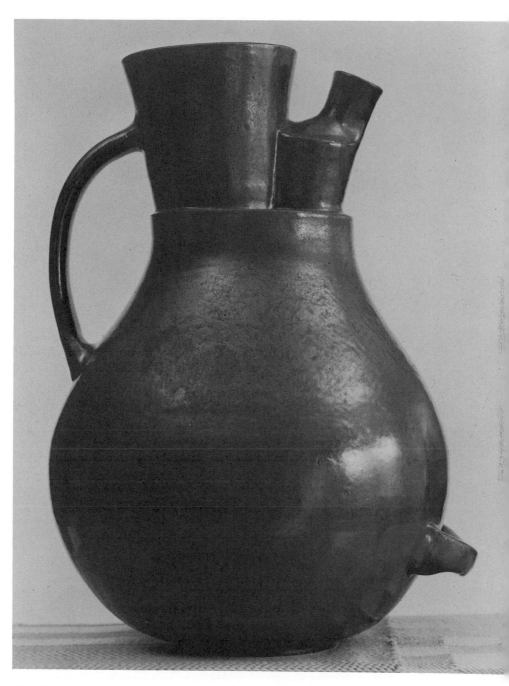

Fig. 38. Otto Lindig. Pitcher, ca. 1921–1922. Staatliche Kunstsammlungen, Weimar.

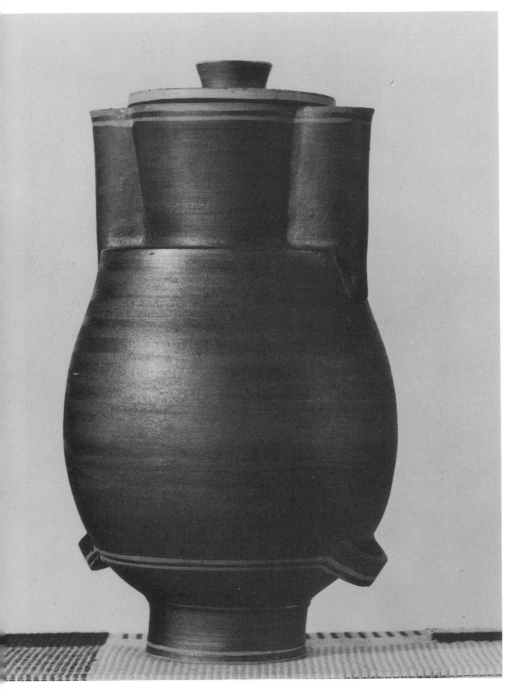

Fig. 39. Otto Lindig. Double pitcher, ca. 1921–1922. Decoration possibly by Gerhard Marcks. Staatliche Kunstsammlungen, Weimar.

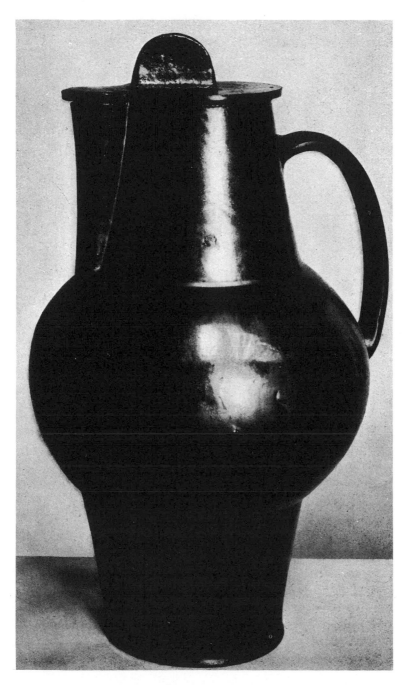

Fig. 40. Otto Lindig. Beer tankard, from a design by Gerhard Marcks, ca. 1921.

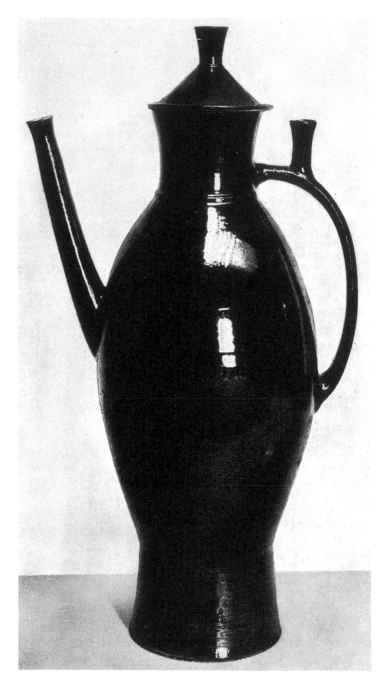

Fig. 41. Otto Lindig. Tankard, ca. first half of 1922.

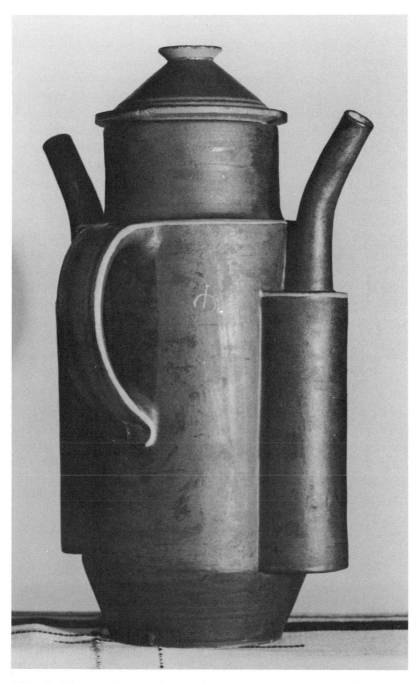

Fig. 42. Theo Bogler. Pitcher with two spouts, decoration by Gerhard
Marcks, late 1921. Staatliche Kunstsammlungen, Weimar.

and clear geometric contrasts, and it was relatively easy to adapt to Moholy-Nagy's greater interest in pure geometry and formal precision.

Gropius has always insisted that the Bauhaus was never interested in handicraft for its own sake, and in one sense this statement can be taken seriously. As we saw at the beginning of this study, by the time of World War I a prominent segment of the Deutsche Werkbund led by Behrens and Muthesius had already departed from the nineteenth-century estimation of the aesthetic values of what was subsumed under the notion of the craftsman's touch. This notion was not so much rejected as put aside in favor of an ideal of simple, well-conceived form that affected crafts products as much as designs intended for machine production. The objects created in the Bauhaus during its early years demonstrate that this ideal continued to dominate the thinking of the artists gathered by Gropius to teach there. We can take it for granted that for all the Bauhaus masters the *sine qua non* of making an object of use was the construction of a vigorous, effective form in close conformity with its purpose and not whatever expressive values might be imparted to it by the actual operations of the hand or by ornamental details at the expense of the basic form.

Much has been written—sometimes in derision—[91] about the penchant of the Bauhaus during its Weimar period for pure geometry. We know that this tendency was especially strong about 1923–24, during the time of Moholy-Nagy, when Dutch and Russian influences were at their height in the Bauhaus. It is customary to see this phase of the Bauhaus's development as the first step in the change toward that relatively impersonal and functionalist style which is still the hallmark of the Bauhaus in the popular conception. From this standpoint, it has been tempting and easy to regard this geometric phase and especially what came afterward as stark contrasts to the supposedly expression-

[91] E.g., by Paul Westheim, in a review of the 1923 Bauhaus exhibition (reprinted in Wingler, *Bauhaus*, p. 82). Cf. Banham, *Theory and Design*, p. 282, who quotes a story told to Nikolaus Pevsner by Wilhelm Wagenfeld that Moholy-Nagy cried betrayal upon seeing Wagenfeld make glass vessels with drop-shaped forms instead of basic geometric shapes (repeated in Pevsner, "Finsterlin," p. 357).

istic excesses of Itten and, at the beginning, of Gropius. To be sure, this change had already begun in 1922, as the early furniture designs of Marcel Breuer dramatically show, but it has usually been attributed to outside influences, and to those few artists on the faculty—most notably Schlemmer, and Gropius after 1921—who were more "tough-minded" in their attitudes toward design. But in fact the situation was far more complex; the documents that have come to light as well as the known examples of student work make it evident that the ideal of sober, geometrically controlled design was ingrained in the Bauhaus from the start and did not develop only in 1921 when Theo van Doesburg came to Weimar to promote his doctrines of pure, rectilinear form. It would be absurd, of course, to claim that van Doesburg's arrival in Weimar was not of great importance for the development of both work and ideas at the Bauhaus; but the Dutch artist found his ground already well prepared. Whatever there was in the early Bauhaus of what can be called expressionist sentiments, ideas, or style which van Doesburg felt bound to combat during his stay there, on some basic assumptions about applied design he found considerable agreement among the masters and even sympathy for his point of view. This much, at least, seems to have been true for Itten no less than for the others.

# CONCLUSION: TOWARD THE
# PERIOD OF CONSOLIDATION

The departure of Johannes Itten in the spring of 1923 marked with finality the end of the first phase of the Bauhaus, even if it was not in itself the cause of that end. Although his resignation was in some measure the result of personal rivalry with Gropius, underlying it were, as we have seen, basic differences over ends and means. There seems little reason to doubt that even without the element of personal antagonism, given the direction of Gropius's thought, Itten would have found himself increasingly on the sidelines—or else forced to give up cherished ideals—if he had decided to stay. Unlike the classes of Klee and Kandinsky which were concerned exclusively with pictorial theory and hence could be accommodated and even welcomed within a curriculum tending perhaps unavoidably to separate practical designing from instruction in the fine arts, Itten's teaching was too central to the work of the shops to fit comfortably within a school moving toward exclusive interest in industrial design and the rationalization of forms and designing procedures.

With the departure of Itten went the major emphasis on empathy—both as a theory and an unspoken assumption—that had been at the heart of his teaching. With it, too, went the relatively great importance given to the projection of feeling and to the preparation of the student for a high and almost reverential

238

calling. During the years 1922–1923, but especially after Itten left, the climate of the Bauhaus—including the attitudes of the students—became appreciably more hardheaded, and the character of the design work more geometric and normative.

In Laszlo Moholy-Nagy, who came to the Bauhaus as Itten's replacement, and Josef Albers, Gropius found two artists to teach basic design who were far more congenial to his way of thinking.

Albers brought to the study of materials an approach based upon their systematic classification and arrangement by qualities and a rigorous methodology in which economy of procedure and ingenuity in exploiting the structural properties of a given material with a minimum of tools were given paramount importance. The famous cut and folded paper exercises that Albers was to devise for his classes were not intended to result in self-sufficient designs—they produced essentially abstract structural units—but were meant, rather, as a way of developing formal inventiveness within system and a strict adherence to structural requirements and the limitations of the problem set.

Moholy-Nagy, in contrast, was far more unsystematic in his portion of the basic design work. But his crusader's zeal for the new impersonal, machine-oriented ideals of the constructivists and elementarists went well with Gropius's new mood. The free play in Itten's *Vorkurs* with "junk" materials, with their rich variety of textures and their unavoidable picturesqueness and nostalgic associations, was replaced in Moholy-Nagy's by the use of clean, hard industrial materials—wire, shining metal, glass, new wood—cut with precise edges and bent and fitted together to create aerial cantilevered structures invariably suggesting the artifacts of a benign scientific technology.

Moholy-Nagy's ebullient artistic personality combined with his gifts as a publicist to put its stamp on the Bauhaus in his time almost as much as Itten's had in his. Yet, if for this reason it is sometimes convenient to speak of the "Itten years" and the "Moholy-Nagy (and Albers) years" of the Weimar Bauhaus as a shorthand for the differences of philosophy in the two periods, we should not make the mistake of dividing them into neatly separated phases. From what we have seen, it is amply apparent

that we cannot easily specify a turning point in the development of the Bauhaus at any time during its Weimar years. It is not merely that the Bauhaus was in continuous process of change, but that from the beginning it was a tangled skein of various and even conflicting motives and tendencies, nowhere more in evidence, as this study has tried to show, than in the person of Gropius himself.

It must also be apparent that the catch-all label, "expressionist," which it has become common to apply to the earliest years of the Bauhaus, is woefully inadequate to characterize them except as the roughest signification of their utopian and relatively more individualistic and subjectively-oriented climate. Nineteen twenty-one, the year marked by the arrival of Oskar Schlemmer and Paul Klee to the faculty, the visit of van Doesburg to Weimar, and the irreconcilable break between Itten and Gropius, saw the beginning of a clarification and simplification of goals and methods. For all that outside forces contributed significantly to this process, most importantly at first van Doesburg and De Stijl, the impulses toward the later Bauhaus were present within it from the start, as we have had occasion to observe in our examination of Gropius's ideas and the common Bauhaus interest in directness and simplicity of design.

To trace the full history of the Bauhaus for even the Itten years is beyond the scope of this study, which has sought, rather, to define as accurately as possible the nature of the ideas that went into its making and its consequent character and general tendency at the start. Nevertheless, it seems appropriate to conclude by at least indicating for that history a few of those personalities and factors within the Bauhaus which, especially from 1921 onward, helped to move the school toward its later, more rationalistic position.

A detailed history would have to take into account, for one, the not inconsiderable influence of Oskar Schlemmer who, trained like Itten in the formalist discipline of Adolf Hoelzel in Stuttgart, brought to the sculpture workshops of the Bauhaus a highly deliberate, constructive style strongly influenced by French Purism and by Léger. From the time of his arrival he saw the lack of an architectural *Versuchsplatz* at the Bauhaus

as a serious failing in its program. Schlemmer's direction of the theater workshop, which replaced Lothar Schreyer's unsuccessful attempt to found there an expressionistic "sacral" theater, certainly had no direct effect on what was produced in the other shops; but his preoccupation with the notion of adapting the performer to the supposed geometric configurations of theatrical space—of turning him into a moving architecture, to use Gropius's description of Schlemmer's dances—through the use of padded, de-personalizing costumes and masks, mechanistic body movements, and rigid spatial configurations, just as surely helped to set the mood of the Bauhaus for geometric order, systematization, and a de-emphasis of self-expression.

A detailed history of the Bauhaus would also have to consider Georg Muche. Despite—or perhaps in part because of—his adherence to Itten, he was to be chosen by the students to design the *Haus am Horn* for the 1923 Bauhaus exhibition and was to go on to design other buildings as well. Muche's active dislike of mixing fine arts with handicraft or industrial design evidently was, or became part of, a more positive interest of his in pure architecture, and it would be worth knowing to what extent his attitude was passed on to his students and helped to form the later, more industrially minded puristic orientation of the Bauhaus.

The roles of the theory classes of Klee and Kandinsky in the evolution of the Bauhaus are more problematic. We tend to think of these artists as being at the opposite pole from Moholy-Nagy and a great distance even from Schlemmer. Neither was in his work or theories an exponent of a normative style or of a supraindividual expression; neither seems to have shown the slightest interest in architecture *per se*. Yet each sought in his teaching to make the assumptions behind his art the bases for an objective, more or less methodical approach to composition, in which, as in the various *Vorkurse*, what was taught were supposedly basic formal and expressive elements capable of being separated from, and utilized independent of, a particular artistic personality.

Kandinsky, especially, seems from the accounts to have brought to his teaching an almost dogmatic insistence on the psycho-

logical objectivity of the pictorial laws he was to publish in his 1926 Bauhaus book, *Punkt und Linie zu Fläche* and elsewhere. This attitude toward theory, along with his way of teaching composition by having the students make schematic analyses of perceived subjects, was well in accord with the pretensions of the other form masters that they were helping to explicate the "exact laws" of art.

The case of Paul Klee is comparable but altogether more interesting. Whether or not it can ever be shown convincingly that Klee's theory courses had an effect on architectural thinking at the Bauhaus, or on modern applied design, it is a demonstrable fact that such thinking affected his teaching as well as his work. From all accounts, Klee's elliptical, metaphoric lectures and presentations were not easy to follow, as might be guessed from a perusal of his pedagogical notebooks. Yet it may well be asked whether those few students who understood what he was driving at did not find confirmation in his classes that even the most elusive musings of the imagination might be put on something like a systematic, constructional basis.

Klee's lessons were conceived in terms closely analogous to those of architecture. In his remarkable pictorial mechanics, justice to which would require an entire separate study, not only was the language of the architect frequently used, but painting itself was understood as a construction built up or put together from repeatable, more or less geometric—in effect modular—units in ways generally comparable to the way architecture is put together; that is, through the figurative balance of tectonic forces.[1] The consequence of this manner of thinking, both in Klee's lessons and his own paintings, was to make the pictorial structure itself symbolic of metaphysical structures capable of being interpreted on several levels at once, from the concrete and commonplace to the abstract and mystical. While such results can hardly be called rationalistic, the means used to produce them can certainly be called rationalized.

We have seen, too, how (despite Feininger's later rejection of

[1] I owe this observation on the analogies between Klee's theories and architecture to Mr. David Hanser, who studied this problem in a seminar on Klee taught by me at the University of Illinois in 1969.

Gropius's renewed zeal to unite art with the machine) Marcks and Feininger from the beginning represented a sobering influence for conscious craft and methodical work in the shops, a position not so much "advanced" as growing out of their personal dedication as artists to sound workmanship. Feininger, indeed, was one of the first at the Bauhaus to turn with great interest and approval to the work of De Stijl as a vital and salutary discipline for modern art, and he played a key role in acquainting the school with the Dutch movement. He was in early contact with De Stijl, first learning of its existence apparently in the late spring of 1919 when he received a copy of the group's peri odical.[2] Shortly thereafter, in the September issue, *De Stijl* published its first reproduction of a Feininger painting along with part of an explanatory letter by Feininger dated July 20, 1919, and an appreciation by van Doesburg calling his work "probably among the most important artistic expressions of modern Germany."[3] Feininger on the whole regarded van Doesburg's influence on the Bauhaus after the latter's arrival in Weimar as an antidote to what he called the "heightened romanticism of many" there; this despite the fact that he recognized the dogmatic and "tyrannic" nature of van Doesburg's teachings and came to be disillusioned by the man himself.[4]

[2] Typed extract by Julia Feininger of Feininger letter to her dated June 1919: "Aus Holland sogar kommt jetzt an mich eine neue, sehr interessante Kunstzeitschrift; wir werden bald wirklich Europäisch werden hier in Weimar" (FP, MS Ger. 146 [1445], vol. 2).

[3] The painting was *Volksroda III*, reproduced p. 132. The role of Feininger in helping to acquaint the Bauhaus with De Stijl was noted already by Alfred Barr when he wrote that "in 1919 through Feininger the influence of the . . . *Stijl* group began to permeate the Bauhaus" (*Cubism and Abstract Art*, New York, 1936, p. 156). Since then both Bruno Zevi (*Poetica dell' architettura neoplastica*, Milan, 1953, p. 13), and H. L. C. Jaffé (*De Stijl 1917–1931: The Dutch Contribution to Modern Art*, Amsterdam, 1956, p. 177), have reasserted the artist's role as an intermediary with Holland.

[4] "Er [van Doesburg] ist wenigstens ganz, und sehr gesund! Von Freund Itten wurde auch erzählt . . ." (extract by Julia Feininger of Feininger letter to her of Nov. 14, 1921, FP, MS Ger. 146 [1445], vol. 2). The excerpt breaks off here, but continues in a loosely translated excerpt at the Busch-Reisinger Museum made by Julia Feininger. It reveals animosity between Feininger and Itten: "He was rather explicit on Monsieur Itten. It seems as if this champion of Theosophy at times does not act up to the role. He is said to have ripped down my work and to have left hardly a shred of my person, which is gratifying." In a letter of Sept. 7, 1922,

But Gropius did not need the painters at the Bauhaus to point the direction, particularly toward De Stijl. De Stijl's ideas and achievements were convincing enough to speak directly to the architect in him. We must recall that in some important respects, both in his thinking and in his designing, he had not strayed very far from his prewar Werkbund days. It is true to say, as Wingler does, that van Doesburg basically reconfirmed some of Gropius's earlier convictions, even while clothing them in a somewhat altered stylistic and theoretical garb. De Stijl's search for a total style was bound to elicit sympathy from the director of a school bent upon the same end, despite differences of means. But besides this, De Stijl could offer by 1921 some substantial achievements in architecture and applied design in the work and projects of van t'Hoff, Wils, Oud, and Rietveld. Gropius was to learn in detail about their work in 1920. In a letter of 1924 to the Bauhaus *Meisterrat*, in which he offered his support to the school in its political troubles, van Doesburg was to remind Gropius of a conversation they had had four years earlier: "I recall what Herr Walter Gropius said about our 'Stijl' work when I showed him photographs for the first time

---

Feininger reported: "Für die meisten [students at the Bauhaus] ist der unsentimentale, wenn auch völlig ungeniale Doesburg, so etwas wie eine Stütze, . . . etwas Bestimmtes, Klares. . . . Weshalb, wieso die freiwillige Unterwerfung unter die *Tyrannei* van Doesburg's, und die vollkommene Widerspenstigkeit gegen alle Massnahmen . . . die vom Bauhaus aus ergehen? . . . Das nun, weil das 'Bauhaus' verpflichtet—van Doesburgerei verpflichtet nicht, man kann dort kommen und gehen. . . . Wenn Doesburg Meister am Bauhaus wäre, wäre er dem Ganzen nicht schädlich, sondern eher nützlich, weil er ein Gegenpol zu mancher verstiegenen Romantik, die bei uns spukt, bedeutet. Vermutlich wäre er aber nicht fähig, sich innerhalb seiner Grenzen einzuschränken, sondern würde, so wie Itten seinerzeit, bald das Ganze kommandieren wollen. Allerdings versagt Doesburg in anderer, menschlicher Hinsicht, er ist ein grosser Hohlkopf, ehrgeizig und eitel . . ." (extract of Feininger letter, FP, MS Ger. 146 [1445], vol. 2). Zevi, presumably on information and documents from the partisan Nelly van Doesburg, has gone so far as to assert that Feininger was in "assidua corrispondenza con van Doesburg. . . . Feininger . . . informava van Doesburg sull'orientamento della scuola, sui corsi che vi tenevano Johannes Itten e Gerhard Marcks, sull'intenzione di invitare come insegnanti Adolf Meyer, Wassily Kandinsky, Laszlo Moholy-Nagy . . ." (*Poetica dell'architettura neoplastica*, p. 13). One may well wonder, however, how "assidua" this correspondence really was, considering his judgment on van Doesburg after he met him. It may be noted that the Feininger correspondence at Harvard contains no letters from van Doesburg.

(1920): 'The artists of the Stijl group are much farther along than we, but we want to promote no dogmas at the Bauhaus. Each shall develop his own creative individuality. . . .' "[5]

Not only Gropius, but other leaders of the Arbeitsrat quickly came to acknowledge De Stijl's achievements. Adolf Behne, who, like Bruno Taut, visited Holland in 1920,[6] returned to write a number of enthusiastic articles on Dutch architecture. These articles, which became the occasions to urge conformity to artistic law and the abandonment of personal arbitrariness, were considerably warmer to De Stijl than they were to the more individualistic Amsterdam school. The architecture that pointed to the future was in the line of Berlage, Lauweriks, and De Stijl; and of the last he admitted, "we must acknowledge that the works of Oud, Wils, and van t'Hoff have given us great pleasure, and that they truly appear to us in special degree to be works of our time."[7]

By 1921 modern architectural thinking almost everywhere was moving from an emphasis upon personal inspiration, the expression of emotion, and in Germany upon utopian projects, toward geometry, "objective laws" of formal construction, and strict accommodation to utilitarian and especially industrial requirements. This process can be traced in Gropius's speeches of 1922 through 1924, the language of which reflects accurately the changing aesthetic assumptions of the period.[8] The marks of

[5] BD,SG; letter of May [?] 1, 1924, addressed: "an Herrn Moholy-Nagy zur Vermittelung. Mit der Bitte diesen Brief in eine *Meisterratsitzung vor zu lesen*": "Ich memoriere was Herr Walter Gropius über unsere 'Stijl' arbeit sagte, wenn ich Ihm am erste Mal (1920) die Photografiën zeigte: 'Die Künstler der Stijlgruppe sind viel weiter wie wir, aber wir wollen keine Dogmen pflegen im Bauhaus. Jeder soll seine eigene schöpferische Individualität entwickeln . . .' " (grammatical and spelling errors his). Gropius's appreciation seems confirmed by a letter from him to Behne ("Ekart") of December 9, 1920: "Die Holländer sind in Bezug auf Architektur mehr geschult wie alle anderen" (GAL, "Briefe, Arbeitsrat für Kunst, 1919/1921" file).
[6] In August and September (letters from "Ekart" to "Mass," GAL, "Briefe, Arbeitsrat für Kunst, 1919/1921" file).
[7] Adolf Behne, "Holländische Baukunst in der Gegenwart," *Wasmuths Monatshefte für Baukunst* 4 (1921–1922): 7 and *passim*. See also Behne, "Europa und die Architektur," *Sozialistische Monatshefte* 27 (January 17, 1921): 28–33.
[8] Newspaper reports of Gropius's speeches, many of which are mere variations on a theme, may be found in the extensive clipping file among Gropius's papers in BD,SG.

transition are still to be found in his best-known essay of the time, "Idee und Aufbau" of 1923, which unmistakably echoes the metaphysical formulation of De Stijl manifestoes in its prefatory statement that the present period has seen the end of the old duality between the individual and the universal, and which also talks of the "boundless space" (*unendlicher Raum*) graspable by our finite brain by virtue of its "belonging to the Cosmos." But already by mid-1922—in his Jena speech of May 24—Gropius was stipulating that the artist learn the objective "counterpoint of the forms of construction" (*Kontrapunkt der Konstruktionsform*) and return to the factory.[9] By 1924, the emphasis in Gropius's speeches, now also echoing among other things Le Corbusier's *Vers une architecture*, was to be overwhelmingly upon precise objective knowledge, measure, and the spirit of mathematics. It was in this year, too, that Gropius began to insist in print that the Bauhaus had never sought to teach handicraft for its own sake,[10] a claim, as we have seen, that is credible only as a way of distinguishing the methods and formal intentions of the Bauhaus from those of the ordinary *Kunstgewerbeschule* of the time. These later years in effect mark the period of consolidation of the Werkbund heritage, which had never ceased to be present in the Bauhaus, and the retreat of those tendencies and ideas which had more essentially come down to Gropius from the fine arts by way of such figures as Bruno Taut.

One may speculate whether the early Bauhaus with its emphasis—particularly in the teaching of Itten—upon individuality and personal inspiration could under more auspicious circumstances have been as successful in the realization of an effective

[9] Summarized in "Das Staatliche Bauhaus und seine Aufgaben," *Das Volk* (Jena), June 2, 1922.

[10] E.g., in a reply to criticism of the Bauhaus by Paul Westheim which had appeared in *Die Glocke* (Gropius typescript dated May 17, 1924, "Die geistige Grundlage des Staatlichen Bauhauses," BD,SG); cf. Westheim, "Architektur-Entwicklung," *Die Glocke*, May 7, 1924, pp. 181–185. In a series of speeches given at the beginning of 1923, Gropius was already stating that handicraft was not an end at the Bauhaus (e.g., in his "Die Mitarbeit des Künstlers in Technik und Wirtschaft," held Feb. 15 in the *Volkshochschule*, Weimar; not in Chemnitz as in Barbara Miller Lane, *Architecture and Politics in Germany, 1918–1945*, Cambridge, Mass., 1968, p. 237, n. 59). It was reported in the *Allgemeine Zeitung für Chemnitz und das Erzgebirge* for Feb. 22, 1923 (BD,SG, clipping file).

applied design as the later, more methodical and more objectively and narrowly oriented school. The fact is that for various reasons it was not. Certainly we must say that all consistently successful work requires discipline and method; more perhaps than was afforded by the Itten *Vorkurs* and by the strongly idealistic and ideological tendencies of the students at the beginning. Certainly, too, the results, had they come before 1921, would have been different and perhaps less significant for the later direction of the applied arts. Yet it will be difficult to deny that the first ideals and creative moment of the school's existence were the indispensable ground of its later fulfillment.

It has been the aim of this study to demonstrate something of the conceptual richness and wealth of inspiration that went into that first moment. Without them, it is safe to say, the Bauhaus would never have attained to the position it holds in the cultural history of this century.

# APPENDIX A

These notes and fragments of speeches or articles by Gropius are among his papers in the Bauhaus-Archiv, Darmstadt. They serve to document the visionary and utopian direction of his thought in the immediate post-World War I period. Although they are undated, and most of them unidentified, their tone and contents—many portions are variants of his published essays and speeches of the time—place them securely within the period from the end of 1918 to about the middle of 1919.

1. Ink manuscript, titled in pencil: "Erste Ansprache im Bauhaus."

> Ebenso *neugierig* auf Sie, wie Sie
> auf mich.
> Hoffentlich keine *Enttäuschung*
> auf beiden Seiten.
> Ich habe es zunächst schwerer
> *150—gegen einen.*
> Und Sie wollen zunächst empfangen,
> ich soll gestalten, geben, *führen.*
> Weiss selbst noch nicht ob ich die
> Hoffnungen, die auf mich gesetzt werden
> erfüllen kann, ob ich der Kerl bin, der
> den unendlichen Wall von Hemmungen besiegen

kann. Wenn mir *Dampf ausgeht,* hoffe ich
auf Anstoss von Ihnen
[in left margin: *Meine Tätigkeit*
                doppelt:
                *Leitende Idee*
                *Weichensteller*]
Jedenfalls bringe ich *einen Willen
und einen Plan* mit
Nicht den Zusammenbruch sehen
sondern, *neue Morgenröte*
Rückkehr aus Krieg—*idiotiert*
Keine Politik *über den Parteien*
Künstler *Anarchist.*
    *Beweglichkeit,* dem Akademischen
werfe ich den *Fehdehandschuh* hin
kein mechanischer *Aufbau,* sondern
*lebendiger, organischer.*
    *Versuchen, probieren,* umwerfen
wieder *versuchen.*
    *Keine Beengung* durch zeitliche
Bindungen. *Programm als
Norm,* aber ohne Zwang
[p. 2]   Kein Unterschied zwischen
schönen [*sic*] und starkem Geschlecht,
absolute *Gleichberechtigung,*
aber auch absolut *gleiche
Pflichten.*
    Keine Rücksicht auf
Damen, *in der Arbeit alle
Handwerker.*
    Die alleinige Beschäftigung
mit *niedlichen Salonbildchen*
als *Zeitvertreib* werde ich scharf
bekämpfen.
    Das schlimmste aber *der
Dünkel,* das Grundübel
unserer Zeit.
    Kunstschriftsteller
          ”   händler
          ”   ausstellungen
          ”   zeitschriften

aber *keine Kunst* INDIEN
Der Künstler berufen die
Grundlage mit zu schaffen,
die *neue Weltanschauung*
*Tiefer Ernst in Heiterkeit*
gekleidet.
    *Einheit, gemeinsame Geistigkeit*
    *Seherische Gabe* des Künstlers
    Überwindung der Trägheit d. m[?] Herzens
*Schwung, Glauben, Wollen*
[p. 3]   Kein kleiner Plan, den ich
    mir vorgenommen.
    *Neues Leben* in Weimar,
nicht am alten zehren,
sondern *selbst aufbauen.*
*Goetheverständnis*
    *Republik der Geister.*
    *Persönlichkeiten*
    *Materielle Möglichkeiten*
gesunken, *geistige* enorm
*gestiegen.*
    Schwer mitzugehen. *Ewiger*
*Wandel.* Dauerndes Umstellen
    Unterstützung *radikal-*
*künstlerischer Absichten.*
[p. 4]   Ein Wort über *Expressionismus*
    *Staatliches Bauhaus*
    Kein *Architektentrick*
verdammter Architekt aus
Berlin - - -
    *Bauen! Gestalten!*
    *Gotik-Indien*
[p. 5]   Allgemeine Reform, Plan
    des A.f.K.
    *Statuten*
    *Geduld* mit mir. Ich will
    mich erst selbst belernen [*sic*].
*Wintersemester.*
    Nicht *Direktor* nennen
[p. 6]   Wer Wünsche hat komme
    zu mir

2. Pencil notes, probably for a speech.

Architektur als Ausdruck der Geistigkeit einer Zeit
   Zwei Pole Orient—Occident (Riegl) ewige Wellenlinie
   Verlust der Kunst. Synthese—Chaos metaphysisches Fundament
jeder allein.

Synthese kann erst kommen, wenn sie innerlich durch geistige Über-
einstimmung, durch gleiches sehnsüchtiges Wollen vorbereitet. Dann
scharen sich verwandte Geister zusammen. Kleine Gemeinschaften an-
stelle der Weltvertrustung. Synthese auch im äusseren Sinne Ars una
species mille. Hüttenwesen, Zusammenarbeit. Architekt, Bildhauer,
Maler *einer* Idee dienen. Gemeinsame Konzeption, kein losgelöstes
Einzelschaffen. Hofkirche in Dresden. Ausdruck der Fläche, architek-
tonische Wirkung d. Raumes unterstreichen. Gegenseitige Unterord-
nung, wie ein gutes Schauspielerensemble. Herabgeminderter Aus-
druck des Einzelkunstwerkes. Bestimmtes Licht, bestimmter Raum.
Dekorat:Kunst im Gegensatz zur Monumentalen.

Neuer Aktivismus. Amerika am weitesten. Giebt am entschlossen-
sten der neuen Welt ein Gepräge, das unbeschwert durch geschicht-
liche Vergangenheit, kühn und wahrhaftig erscheint. Es will nun
scheinen, dass dieser Strom der Welt-Vertrustung [*sic*] sich mehr u
mehr von dem inneren Begriff d. Kunst *entfernt,* dass nur die Sehn-
sucht nach dem Schönen manchen von uns überhaupt in diesen
Erscheinungen den Geist einer [p. 2] Kunst erblicken liess oder wenig-
stens die Vorläufer für eine solche. Mir will es heut so scheinen, als
ob uns dieser Weg an einen äussersten Rand der Entfernung von der
Kunst gebracht hat dass aber gerade in dieser hypertrophischen Verir-
rung der Anlass zur glücklichen Umkehr liegt. Wo die aktivistische
Weltanschauung die klassischen Formen angenommen hat wird der
Wechsel, der sich in allen Dingen mit Naturnotwendigkeit periodisch
vollzieht, auch am frühesten eintreten. Da wo der geistige Vorsprung
in menschlich-sittlicher Beziehung erreicht, wo eine neue Heilswahr-
heit, eine neue Religionsidee geboren wird, muss am ehesten auch der
Umschwung zur Kunst eintreten, denn diese ist nichts anderes als die
Umgestaltung überweltlicher Gedanken in sinnlich Wahrnehmbares,
eine sagen wir kristallisierte Gottessehnsucht; sie ist die notwendige
Prämisse für alle Kunst. Solche Ideen von allgemeingültiger [. . . . . .]
bedeutung [? illeg.] haben lange Zeit gefehlt. Jeder einzelne Mensch
war vor die Aufgabe gestellt sich ein metaphysiches Fundament aus
den eignen beschränkten Geistesmitteln zu erbauen. Der tragende
Gedanke für die [p. 3] Allgemeinheit stellte sich nicht ein. Also konnte

auch der Künstler sich im besten Fall nur zu einer Geistes-Clique wenden, der er sich wesensverwandt fühlte. Ein Künstler des religiösen Mittelalters malte die Madonna und wurde von der Gesamtheit dem *inneren* Sinn seines Vorwurfs nach begriffen, weil das Seelen*erlebnis:* "Madonna" in den Herzen noch lebendige Kraft besass: Erbauer der gotischen Gottesräume.

3. Ink draft for part of a speech or article.

Nach schweren inneren Gemütskrisen Erwachen aus langer Kriegsnarkose. Ein neues Morgenrot leucht [*sic*] in den erdunkelten Hirnen auf. Ein lebendiger Strom neuen geistigen Lebens wird sichtbar, ein hoffnungsfroher Tatendrang, der an eine bessere Zukunft glaubt und sie vorbereiten will. Wir müssen eben nur an sie *glauben*, sie *wollen*, so *muss* sie kommen. Gott sei dank es giebt noch frische himmelstürmende Menschen, die sich gegen die klägliche, laue, herzverstockte Mittelmässigkeit aufbäumen und nicht jammernd das stürzende alte, sondern nur das positiv aufbauende neue Element der Zeit erkennen und daran mitwerkeln. Nur diesen wollen wir angehören. Nehmen wir die Welt physiologisch: was stürzt, war innerlich morsch und krank, das starke Gesunde setzt sich durch und siegt; und wir haben keine Zeit, dem alten nachzutrauern und ihm Grabreden zu halten oder—die Zeit schreitet erbarmungslos über uns hinweg. Gewiss ist es für den einzelnen schwer. Wir sind in einem Chaos der äusseren und inneren Welt. Dinge u. Gedanken schwimmen, wir hängen in der Luft u. kennen noch nicht die neue Ordnung. Wir Lebenden werden sie nicht mehr erleben. Unser Werk kann nur darin bestehen, die kommende Einheit einer späteren, besseren Zeit uns zu bereiten, jeder in seinem vereinsamten Ich eine bessere Lebensform zu erschaffen und die gottverfluchte Unbescheidenheit im Geistigen, das materielle Scheinleben in uns zu zerschlagen zugunsten einer neuen [p. 2] geistigen Menschlichkeit. Nicht mit der Laterne nach den Schuldigen suchen, sondern vor der eigenen Türe fegen. In der Nacht des Chaos Feuer des Glaubens halten, vertrauen auf die junge Generation, ihren inneren Sinn erfassen und lieben. *Mitgehen* um wieder heiter zu werden. Sich nicht so wichtig nehmen. Es kann uns nichts geschehen, wenn wir uns unabhängig von der äusseren Welt machen. Der äussere Unterschied von uns Menschen in Bezug auf Blut, Nation, Besitz, Alter ist *nur* ein gradueller, kein prinzipieller.

  Das Wesentliche: lieben können. Darauf läuft alles hinaus: *unsere Zeit ist nur am Hass erstickt.*

4. Variant ink draft (here slightly abridged) of "Baukunst im freien Volksstaat," published in *Deutscher Revolutions-Almanach für das Jahr 1919*. Portions of this draft were also used in Gropius's reply to question no. 7 of the Arbeitsrat für Kunst's *Ja! Stimmen des Arbeitsrates für Kunst in Berlin*, November 1919. A closer, typed variant of "Baukunst" also exists in BD,SG.

Das Ziel der Bauloge:

Eine grosse allumfassende Baukunst setzt geistige Einheit ihrer Zeit voraus, sie braucht die innigste Verbindung mit der Umwelt, mit dem lebendigen *Menschen*. Erst muss der Mensch wolgestaltet [*sic*] sein, dann erst kann der Künstler ihm ein schönes Kleid gestalten. Die geistige Gesellschaftsschicht, ihr Denken und ihre Lebensformen— soweit sie sich zu erkennbarer Gemeinsamkeit verdichten—bilden also das darzustellende Substrat für den schaffenden Künstler. Sein seherischer Geist sammelt aus der Flucht der geistigen Erscheinungen die häufig Wiederkehrenden auf, um sie nun rhythmisch zu gestalten. Er braucht also ein *Dogma*, das alle verstehen, mit dessen Hilfe er sich *allen* zuwenden kann. Muss er sich das metaphysische Fundament für seine künstlerische Sprachform allein aus seiner isolierten Tat erschaffen, so bleibt er in vereinsamter Abgeschiedenheit und kann sich bestenfalls an eine kleine Gemeinde wenden, in der Gesamtheit findet er kein Echo.

Der heutige Künstler lebt in einer dogmalosen, analytischen Zeit des Chaos. Er steht allein da: die alten Formen sind zerbrochen, die erstarrte Welt ist aufgelockert, der alte Menschengeist ist umgestossen und mitten im Umguss zu neuer Gestalt. Wir werden die grosse Einheit nicht erleben unser Werk kann nur darin bestehen, eine spätere, harmonische Zeit ahnend vorzubereiten. Vielleicht ist der lebende Künstler berufen, ein Kunstwerk zu *leben*, statt zu erschaffen und so durch seine neue *Lebensform* das geistige Fundament zu erbauen, welches die kommende Kunst notwendig braucht. [Crossed out in pencil: Diese Lebensform als eine breite gemeinsame Grundlage für alle schöpferischen Geister der kommenden Zeit, muss unser Geschlecht errichten [?].] *Gemeinsamkeit* im Geistigen tut Not. Die einzelnen Zweige der Kunst dürfen umso mehr beziehungslos nebeneinanderstehen; nur durch inniges Mit- und Ineinanderwirken wird jenes vielstimmige Orchester erzeugt, das allein den Namen "Kunst" verdient. Ars *una*, species mille. Der berufene Dirigent dieses Orchesters aber war von Alters her der Architekt. [Crossed out in pencil: Sein hohes Amt muss wieder zur öffentlichen Geltung gebracht

werden.] Architekt . . . das heisst: Führer der Kunst. Nur er selbst kann sich wieder zu diesem Herrn der Kunst erheben, zu ihrem ersten Diener, übermenschlichem Wächter und dem Ordner ihres ungetrennten Gesamtlebens. Der Architekt von Gestern besitzt nicht mehr das hohe Ansehn im Volke wie sein mittelalterlicher Vorgänger, war nicht mehr der universale Schöpfermensch und mächtige Meister aller künstlerischen Disziplinen. Er hatte den Halt in der Gegenwart verloren. Das Bauen war aus allumfassender Gestaltungskunst zu einem Studium herabgesunken. Der natürliche Zusammenhalt mit seinen Werkbrüdern, namentlich mit den Malern und Bildhauern ging dem Baumeister verloren und also begab er sich seiner vornehmen Würde, Meister vom Stuhl im Haus der Kunst zu sein.

Das Heil liegt allein in neuer fruchtbarer Gemeinschaft. Die führenden Geister unter den Baukünstlern müssen die Einzel"künste" aus ihrer selbstgenügsamen Eigenheit erlösen und wieder zu unlöslichen Bestandteilen der grossen Baukunst machen. Die Probleme der Maler und Bildhauer müssen sie so leidenschaftlich berühren wie die eignen, dann werden sich auch umgekehrt die Werke dieser mit architektonischem Geiste füllen. In engster persönlicher Fühlung, in Arbeits- und Lebensgemeinschaft der Künstler aller Disziplinen untereinander ist allein die ersehnte Einheit wieder zu gewinnen. Eine solche Gemeinschaft lasst uns gründen!

5. Sheet of ink notes concerning a projected Arbeitsrat periodical and some lecture-exhibitions.

> Zeitschrift
> Klare Grundidee:
> Einheit der Künste.
> *Künstler* Herausgeber
> Artikel über Bauhütten
>         ″    ″   falsche Sparsamkeit
>       Protest gegen arme Zeit
> Keine papiernen Kundgebungen
>     sondern Tat.
> Brot u. Ruhe genügen nicht.
>    Keine Schulen
>    Mehr Zerstörung.
> *Arch. Ausstellung*
> Einführung leitende Idee
> Dilettanten.

Sterobilder [*sic*] Modelle
*Vorträge*
1. Heft. Bauen.
Architektur Illustrationen
Feininger etc.

6. Ink notes for a speech or article.

Falsche Sparsamkeit im Bauen. Waffenbrüder in Oestr [Oesterreich] u. lieber gehungert als Ersatzmittel zu fressen. doch kaum zu finden. Ersatzmittel im Krieg. Wir sind arythmisch [*sic*], schönheitsarm geworden, wir sind zwar noch immer reich an Problemen, aber wir haben verlernt sie zu gestalten, sie ans Licht zu bringen. In Oesterreich sagt man der Deutsche ist zu innerlich, er muss sich wenden lassen. Über dem travailler pour le roi de Prusse vergassen wir das schöne Leben und die Folge war, dass wir zwar arbeiteten, weit mehr als die ganze übrige Welt, aber unsere Arbeit war zum grossen Teile auf unwesentliche Ziele gerichtet, auf Geldmachen, auf materielle statt auf geistige Lebensbereicherung. So verlernte der Deutsche das beste in ihm die geistige Vertiefung und wurde der oberflächliche Weltmann, ohne aber das Talent zu diesem Weltmann zu besitzen.

7. Pencil notes on a separate sheet.

Arrogantes Europa-Orient. Zentralisation nach der bisherigen Spezialisierung Humbold [*sic*].—Einheit der Kunst
Das Zerbrechen der Form Krieg, Revolution, Bolschevismus, Expressionismus, Musik [?] Kein Dogma sondern vermehrte Lebendigkeit. Chaos heute keine Form Wir haben das Pferd beim Schwanz aufgezäumt und erst mit Aschbecher u. Waschbecken begonnen, anstatt—

8. Pencil notes on a separate sheet.

Angst vor dem Tode, *nicht* bei Orientalen. Wir schicken Missionäre nach Indien.

# APPENDIX B

Untitled, undated manuscript portion of a Gropius speech held in Weimar in the spring of 1919 before representatives of Weimar crafts and industries (BD,SG). From its content it is presumably identifiable with the speech cited and partly quoted by Gropius in his September 1963 reply in the *Journal of the American Institute of Architects* to Howard Dearstyne, "The Bauhaus Revisited," *Journal of Architectural Education* 17, no. 1 (October 1962):13–16 (published as a supplement to the *JAIA* 38, no. 4). The passage quoted therein is to be found verbatim in the Bauhaus-Archiv draft except for the first mention of "industry," which is omitted from the latter.

M. H. ich begrüsse Sie und danke Ihnen herzlich für Ihr Kommen. Ich habe Sie hierher gebeten, um mit Ihnen gemeinsam zu beraten, welche Wege im allgemeinen und im besonderen hier in Thüringen heute geeignet erscheinen, um die notwendige Brücke zwischen Handwerkern und Künstlern zu schlagen, um *beide gegenseitig zu befruchten.* Die Notwendigkeit zu dieser Bindung ist schon seit mehr als einer Generation erkannt worden. Umfangreiche Gruppen wie der deutsche Werkbund, hervorragende Künstler im einzelnen, wie in Weimar van de Velde haben die Veredelung der handwr. u. industriellen Erzeugnisse auf ihre Fahnen geschrieben. Heute ist nun diese Frage von neuem brennend geworden. [Inserted: Zwar haben

wir in [?] d . . . [*sic*].] Es wird meist nur davon gesprochen, dass wir
Arbeit leisten müssen, um aus dem Elend, in das uns der unglückliche
Krieg geworfen hat herauszukommen. Wir sollten aber überall hinaus-
schreien, dass *gute* Arbeit geleistet werden muss. Gute Arbeit dh.:
jedes Stückchen Rohstoff, das wir im Lande besitzen oder für unsere
letzten Pfennige einführen muss durch *hochqualifizierte Arbeit des
Handwerks oder der Industrie* und vor allem auch durch *unnachahm-
bare Eigenart der Form* an Wert um ein Vielfaches gesteigert werden.
Es [p. 2] muss also versucht werden, den *Rückgang der Rohstoffeinfuhr-
masse*—infolge unserer erlahmten Kaufkraft—durch eine *gesteigerte
Qualität der ausgeführten Fertigware* allmählich wettzumachen. Dahin
weisen verschiedene Wege: Rückgewinnung der Massen ungelernter
Arbeiter für das Handwerk und für industrielle Facharbeit, Durchbil-
dung der gesamten bildenden Künstler im Handwerklichen.

Trotz der ernsthaften erwähnten Bestrebungen in der Vorkriegszeit
war in Deutschland der Umsatz des billigen Artikels ins Unermessliche
gewachsen. Das leichte Verdienen durch Erweiterung der Absatz-
gebiete im Auslande zog uns von der Vertiefung und Veredelung der
Arbeit ab und verlangsamte die Wirkungen einer soliden Minorität.
Heute sind die Verhältnisse von Grund aus verändert. Die Not wird
uns zwingen allenthalben im Handwerk und in der Industrie—soweit
sie am Leben bleibt—die Qualität zu heben. Eine Konkurrenz mit dem
Ausland ist nur denkbar mit einer Ware, die durch beispiellose tech-
nische Güte und geistreiche Formgestaltung eben unnachahmlich
und daher bezahlt sein wird. [p. 3] M. H. solche Entwickelung aus
innerer Einsicht und Not geboren gedeiht, sobald sie gemeinsam
gewollt wird. Dass sie kommen muss steht heute wol [*sic*] überall
ausser Zweifel. Ich kämpfe nun hier für diese Idee und habe mir von
Anfang an vorgenommen, *alles* zu tun, um Missverständnisse und
daraus erwachsende Hemmungen aus dem Wege zu räumen, Sie zu
gemeinsamer Aussprache herzurufen und zu bitten, mitzuarbeiten,
mitzuraten, wie die Fülle [?] an Schwierigkeiten—zumal bei dem
katastrophalen Zustand unserer Wirtschaft—zu gemeinsamen [*sic*]
Nutzen überwunden werden kann. Es muss zweifellos gelingen und
eine ganze Reihe glücklicher Umstände könnte Thüringen an die
Spitze solcher Bewegungen schieben—wenn der Einzelne bereit ist,
anfängliche Misserfolge mit Geduld zu überwinden und hier und da
ein Opfer zu wagen, für das sich der Lohn nicht unmittelbar in Zahlen
ausdrückt.

M. H. wir kommen nur zu einem Ziele wie ich es andeutete, wenn
Kunst und Handwerk sich wieder gegenseitig durchdringen. Heute

stehen sie streng, fast durch Mauern geschieden nebeneinander. Der Handwerker—die Industrie einschliesslich—braucht den [p. 4] lebendigen Zustrom der künstlerischen Gestaltungskraft, die die erstarrte Form aufzulockern und neu zu bilden vermag. Dem Künstler dagegen fehlt die handwerkliche Grundlage, die ihn allein in den sicheren Stand setzen kann, souverän den Stoff, das Material zu gestalten. Zu starken Kulturzeiten verwischten sich die Grenzen zwischen Kunst und Handwerk so stark, dass jeder Handwerker ein Künstler, jeder Künstler ein Handwerker war. Das ganze Volk *baute*, gestaltete, das war seine vornehmste Tätigkeit, das Handel treiben war sekundär. So war es in Deutschland in der besten Zeit der Gotik und so muss es nun bei uns wieder werden. Künstler und Handwerker sind ein und dasselbe sie gehören zusammen. Kunsthandwerk oder Kunstgewerbe als—Architektur.

In dieser Erkenntnis müsste ich auf das Programm des staatlichen Bauhauses als Hauptgrundsatz die *Rückkehr aller künstlerischen Tätigkeit zur Quelle des Handwerks* setzen. Erlauben Sie, m.H., dass ich auf mein Programm jetzt näher eingehe:

Folgt Verlesung des Aufrufs und Besprechung des Programms.

[p. 5] Allmählicher Übergang nur durch die bestimmte veränderte Vorbildung des Nachwuchses. Später regelrechte Lehrwerkstätten. Übergang nur durch Ihre Hülfe [*sic*]. Einrichtung von Kursen, Aufnahme von Lehrlingen, Lehrverträge. Dazu vor allem bitte ich nachher Ihre Stellungnahme, denn es sind die *ersten* Schritte die geschehen müssen. Zuerst müssen wir Künstler bei Ihnen in die Lehre gehn, dann werden Sie auch zu uns kommen und sich bereichern können.

Eigne Absichten laut Programm. Herbst [?] und weitere Zukunft.

Eine Konkurrenzgefahr durch die Lehrwerkstätten, auch wenn sie einige effektive Aufträge ausführen, kann niemals entstehen, denn das Ziel dieser Werkstätten ist ein ganz anderes. Sie wollen der Gesamtheit des Handwerks helfen, nicht es hemmen. Sie wollen einen geeigneten Boden auf dem der Handwerkernachwuchs eine höhere Fachlehre empfängt schaffen. Sie wollen durch Heranziehen von lehrenden Persönlichkeiten durch Schaffung einer Zusammenhängenden Arbeits- und Lehrgemeinschaft eine geistige Atmosphäre schaffen, die über die Stadt und Landgrenzen hinaus wirkt und bekannt wird. Sie wollen vor allem Vorbilder schaffen und durch deren besondere Güte erreichen, dass dem Lande schliesslich auch von *aussen* Aufträge zugeführt werden. Das alles muss auf die Gesamtheit fördernd und nicht hemmend einwirken.

[p. 6] Sie werden nun fragen wie solche Vorbilder aussehen werden.

Diese Frage ist natürlich mit Worten kaum zu beantworten—Ich
werde Sie im Winter einladen[.] Lichtbilder Vorträge. Ich möchte
aber einen Punkt der im Zusammenhang hiermit steht zur prinzipiellen
Klärung bringen. Ein bekannter Meister aus Weimar erzählte mir
neulich, dass verschiedene Handwerkmeister sich zu meinem Pro-
gramm durchaus zustimmend geäussert, aber um das Titelblatt zu
verstehen, reiche ihr Begriffsvermögen nicht aus. Und daraufhin haben
nun manche offenbar sehr bizarre Vorstellungen davon, wie so ein
Wohnhaus von Walter Gropius aussehn mag. M. H. ich bin überzeugt,
Sie werden überrascht sein, wie vernünftig und schlicht ein solches
Haus wie ich es mir vorstelle ist. Und nun komme ich auf das was ich
sagen will. Verquicken wir um Gottes willen nicht die Dinge des
Alltags und des Gebrauchs mit Kunst. Die Kunst ist heilig. Sie ist
selten, ohne Zweck, sie wandert die einsamsten Wege weit voraus, wird
in höchster Ekstase geboren und verstanden. Sehen Sie sich den Turm
einer gotischen Kathedrale an. Ist er nicht völlig zwecklos? Ja er trägt
vielleicht eine Glocke aber um für diese Ständer zu sein braucht es
nicht der abertausend Figuren und Fialen u Sternblumen aus Stein.
Ein solcher Turm [p. 7] war eben der Ausdruck einer seelischen
Bewegung, eines religiösen Sehnsuchtgefühls im ganzen Volke. Wir
kennen dieses gemeinsame starke Empfinden nicht mehr und solange
wird die höchste Kunst nur von wenigen vereinsamten, kaum verstan-
denen Menschen gepflegt und gekannt. Wir täten daher besser, wenn
wir bei alltäglichen Dingen des Gebrauchs, die einfach, zweckmässig
wolgeformt [*sic*] sein sollen, nicht von Kunst spricht [*sic*] sondern nur
dieses Wort heute noch ehe wir eine geistige Einheit wieder haben
für die wenigen Hohenwerke aufspart [*sic*], die zweckgenesen ein vom
Alltag und Geschmack losgelöstes Dasein führen. Vergleichen Sie also
nicht ohne weiteres ein freies, abstraktes und in diesem Sinne zweck-
loses Titelblatt mit einem Wohnhaus oder einem Möbel, denn diese
Dinge werden noch sehr verschieden aussehen, da wir noch keinen
durchgängigen Stil haben und der freie Künstler den Dingen des
täglichen Lebens weit voraus ist. Fangen wir also bei gemeinsamer
Arbeit zunächst an, den handwerkliche[n] oder industriell hergestellten
Gegenstand [inserted: oder Werkteile] schlicht und harmonisch her-
zustellen unter selbstverständlicher Rücksicht auf Überlieferung, wo
solche noch lebendig [p. 8] vorhanden ist. Denn Bereicherung und
Schmuck kann nicht von unten kommen, sondern nur von oben. Ich
muss etwas allgemein werden um das deutlich zu machen. Vor dem
Kriege—.[*sic*] umgekehrt werden. Wir werden warten bis sich wieder

eine grosse geistige Idee verdichtet hat—solchen neuen Welt-
gedankens.

Ich habe bisher nur vom Handwerk gesprochen in der Industrie
liegt das Verhältnis anders.

# APPENDIX C

The following memorandums and correspondence (BD,SG) concern the dispute which broke into the open at the 1914 congress of the Deutsche Werkbund in Cologne, July 2–6, 1914. A full account of the factors involved in the dispute has not yet been published, and they remain somewhat obscure; but unpublished documents among the Gropius papers in Darmstadt shed some light on the play of motives and personalities involved. They show, in particular, that in the eyes of Muthesius's opponents, a crucial issue was the basic, practical one of responsibility for product design. It centered on the old fear that the economic and artistic control of applied design would be taken, or perhaps more accurately remain, largely out of the hands of the trained artist and once again given to the *Musterzeichner*. It must be recognized, as Julius Posener has observed in his comment on the dispute and as was widely acknowledged at the time, that Muthesius's speech at the congress was considerably softer and less provoking on the issue of *Typisierung* than the *Leitsätze* he distributed ahead of time (both in Posener, *Anfänge des Funktionalismus. Von Arts and Crafts zum Deutschen Werkbund*, Berlin, Frankfurt am Main, and Vienna, 1964, pp. 199–205). Nevertheless, Muthesius's opponents, as Endell's memorandum most clearly shows, not without justification understood Muthesius's

262

policies, and those of the state and business interests he spoke for, as inevitably aiming to lessen dependency upon the individual artist. His cherished goal of raising as swiftly as possible the quality of industrial design at the broadest and most popular level would in effect and in intention have meant giving back much of the actual design work of industry to the *Musterzeichner*, though now presumably chastened and guided by the formal types, and perhaps even canons, established by the fine artists.

This issue formed part of a larger and more deep-seated objection concerning the general direction of the Werkbund. Many artists protested against what they believed to be the excessive involvement of the Werkbund, particularly under the guidance of Muthesius, in state policy and work of propaganda and popular education, which they saw as having little relationship to their own artistic goals and ideals.

1. From a letter of Hans Poelzig to Gropius, Breslau, June 30, 1914.

Sehr verehrter Herr Gropius!

Es geht leider doch nicht. Es wird mir wirklich schwer, Ihnen noch abzusagen, da ich ja einsehe, dass etwas geschehen muss. Leider kann ich aber keinesfalls fort. Tauts Antwort auf meinen Brief war so verspätet eingetroffen, dass ich meiner Neigung, nicht zu fahren, nachgegeben hatte und alles so eingerichtet ist, dass ich nun keinesfalls in den nächsten Tagen von Breslau fort kann. . . . Ich schreibe Ihnen das so ausführlich, um Ihnen zu zeigen, dass ich mir die Sache wirklich überlegt habe und nicht ganz leichten Herzens von Köln wegbleibe. Aber ich glaube, Sie können da recht gut ohne mich wirken, vielleicht noch besser.

Nachher stehe ich Ihnen, wenn Sie mich brauchen können, zumal wenn es sich darum handelt, irgend einen anderen Sonderbund zu gründen, ohne weiteres zur Verfügung. Für mich steht es so gut wie fest, dass ich aus dem Werkbund . . . austrete. Es müsste denn ein Wunder geschehen und alle die austreten, die den Werkbund zu einem Monstrum gemacht haben, was er ja eigentlich von vornherein war.


Mit besten Grüssen
Ihr sehr ergebener
Poelzig


2. Ink draft of a letter from Gropius to Karl Ernst Osthaus, July 11, 1914.

Lieber Herr Osthaus

Ich hatte gerade einen Brief an Velde überlegt, in dem ich ihm einige Pressenotizen *für* Muthesius mit warnenden Bemerkungen beilegen wollte, als eben Ihr Brief eintraf. Ich hatte die B.-T. [*Berliner Tageblatt*] Artikel noch nicht gelesen, habe sie mir aber sofort verschafft! Das Vorgehn der "Leitung" empört mich aufs tiefste. Nun ist der Moment gekommen, wo persönliche Rücksichten aufhören müssen, oder unser Prestige ist ein für alle mal im Werkbund begraben. Wir gehören ebenfalls zur "Leitung" und müssen selbstverständlich jetzt öffentlich bekanntgeben, dass wir uns nicht mit jener Notiz identificieren. Die grösste Unverschämtheit darin ist die Erwähnung der "Van de Velde Gruppe," als ob Behrens, Poelzig, Taut und viele andere nicht unabhängig denselben Weg, wie wir gingen!—Wenn wir *jetzt* nicht siegen, können wir es *nie* tun!

Meine Vorschläge sind folgende! Wir müssen *en bloc* fordern, dass *Muthesius seinen Austritt aus dem Vorstand erklärt*, widrigenfalls wir (Velde, Sie und ich, ferner an Mitgliedern Endell, Taut, Poelzig, Obrist u andere) uns aus dem W.Bund zurückziehn. Ferner sofort telegrafisch forden, dass Muth. seinen Artikel beim B. T. nicht erscheinen lässt und drittens im gegebenen Fall vor die Öffentlichkeit bringen, dass M. vor der Aussprache durch seine Frau bei Velde und uns um Gnade flehn ging! Mit geringeren Mitteln ist meiner Ansicht nach jetzt *nichts* zu machen, das lehrt alles Bisherige. Wenn es nicht glückt, *trotzdem glaube ich, dass es glückt*, so brauchen wir nicht zu bedauern uns von einem so wurmstichigen Bund, wie sich der W. B. jetzt zeigt, zurückgezogen zu haben. Allen Mitgliedern, auf die es uns ankommt müssten wir vorher durch ein Rundschreiben unsere Absicht mitteilen und sie zum Austritt auffordern. Ich kann für eine ganze Reihe garantieren.—Was Bruckmann für eine Rolle spielt ist mir dunkel, wer hat die Notiz lanciert?? Wir wollen uns möglichst telegrafisch oder telefonisch verständigen, damit wir einig vorgehn. Ich hoffe, dass diesmal ein wirklich entscheidender Schritt getan wird, der unseren unerschütterlichen eindeutigen Willen in der Frage M. erkennen lässt. Zunächst protestiere ich heute telegrafisch bei Jaeckh. Morgen mittag 12 Uhr werde ich Sie im Folkwang antelefonieren. Darf ich Sie nicht einladen, einige Tage hier am Strande mit mir zu verbringen? Wir könnten alles in Ruhe besprechen, uns mit Velde in Verbindung setzen und dann handeln. Natürlich ist wol [*sic*] grösste

Eile not, sonst ist alles verloren. Ich schreibe heute noch an Velde und sende ihm Copie meines Briefes an Sie.

Ihr

3. Dictated draft, in ink, of a signed letter from Gropius to Osthaus, Timmendorferstrand, July 12, 1914.

Lieber Herr Osthaus mit unseren Gegenvorschlägen kann ich mich noch nicht zufrieden geben. Ich bin mit d. Erwiderung im Tageblatt zwar sehr einverstanden aber ich kann mir nicht verhehlen dass sie allein nicht viel an d. Situation ändern wird. Mit Pressefehden ist d. schlauen Muthesius nicht zu schaden. Jetzt ist d. einzige Augenblick um kühn d. Situation auszunutzen. Auf d. öffentliche Notiz d. ["]Leitung" die Velde Ihnen mir auch Behrens geradezu *contrecoeur* ist gehört sich eigentlich nur *eine* Antwort: Austritt—oder bedingungslose Anerkennung unserer Forderung, d.i. Abdanken d. Muthesius u. Einberufung einer Generalversammlung zur Reorganisation. Warum wollen wir das nicht thuen? Ich bin sicher, ohne diesen Schritt bleiben wir immer im Morast u. Nebel stecken den M. so reichlich um sich verbreitet. Es scheint mir auch deshalb notwendig, weil d. öffentliche Desavouieren u. wieder Desavouieren von Personen die *alle* zur ["]Leitung" gehören einen peinlichen unentschlossenen Eindruck nach aussen hin machen muss. Wir können auf folgende Unterschriften rechnen: (Ich nenne nur die deren ich sicher bin. Velde/ Endell/ Poelzig (?) Abhängigkeitsstellung/ Taut/ Obrist/ Pankok/ [Leopold O.H.] Biermann u. d. Bremer Gruppe/ Heinersdorf [*sic*; of Gottfried Heinersdorff and Co., stained glass, Berlin?]/ R.L.F. Schultz [*sic*; Schulz; head of the Werkstätten für Arbeiten in Bronze, Berlin]/ [Edwin] Redslob [director of the Städtische Museum, Erfurt]/ [Paul] Thiersch/ [Wilhelm] Niemeyer Hamburg/ Capitän [Albert?] Scheibe/ Bildhauer [Gerhard] Marks [*sic*]/ Architect Marks [*sic*; Albert Marx?]/ Maler [Otto] Penner/ Maler [Richard?] Lisker/ Erich Lilienthal [the editor and writer on politics?]/ Julius Klinger/ Lucian Bernhard/ Redacteur [Fritz] Hellwag/ Tiersch [?]/ wahrscheinlich auch Behrens, wenn er alle Namen liest also ca. 25–30 Personen mit grosser Sicherheit da ich deren Meinung durchweg durch persönliche Besprechungen kenne. (Sie werden noch andere mit Sicherheit dazu rechnen.)

Ich denke mir d. Action so dass die Vorgänge der letzten Woche unter Aufführung d. beiden Artikel d. B. T. dargestellt u. privatim an die in Frage kommenden Mitglieder gesandt werden mit d. Aufforde-

rung telegrafisch ihre Einwilligung z. Opposition zu geben. d. Rundschreiben würde wohl am besten von Ihnen Velde mir unterzeichnet. Wenn wir d. obigen Unterschriften haben woran nicht zu zweifeln ist, wird d. Schreiben formell Dr. Jaeckh übergeben. Es würde dann natürlich zum Eklat kommen und M. müsste die Waffen strecken, denn ohne jene Herren wäre der W.B. nichts mehr. Wenn d. Münchener Gruppe M. folgt so wäre das meiner Meinung nach kein Schade nur mit Behrens müssen wir vorsichtig sein. Ich stelle auch z. Erwägung ob es nicht klug wäre Behrens u. Paul (beide sind erklärte Feinde d. M.) die doch ebenfalls im Vorstand sind aufzufordern unsere Entgegnung im Tageblatt mit zu unterschreiben. Sie müssen dann Farbe bekennen u. gleichzeitig fällt d. Omen "d. v. d. Velde Gruppe" wovor man sich gerade nach *jener Notiz sehr hüten muss.*

Ich bin nun gegebenen Falls bereit d. Arbeiten die mit diesen Vorschlägen zusammenhängen in [?] Contact mit Ihnen aufzunehmen. Geben Sie mir bitte gleich Nachricht u. lassen Sie uns stark sein. Es hätte sonst kaum noch Zweck mit zu machen so seicht ist unsere gute Sache geworden. Bitte geben Sie v. d. Velde meine Ansichten weiter.

Gropius

4. From a Gropius carbon copy of a letter from Osthaus to [Behrens?], July 13, 1914. Although without signatures, Osthaus's carbons are identifiable by their typeface and their distinctive format which corresponds to that of letters written on his letterhead stationery.

*Vertraulich.*

Verehrter Freund!

... Sie haben es früher als ich erkannt, dass der Einfluss von Muthesius die Lebenskraft des Werkbundes in jeder Beziehung lähmt und werden daher mit van de Velde, Gropius und mir auch den Wunsch hegen, dass er gebrochen wird. Die Umstände haben es gefügt, dass besonders Gropius und ich in letzter Zeit unter der genügsam bekannten Taktik von Muthesius zu leiden hatten und infolgedessen ins Vordertreffen gerieten. Natürlich aber möchten wir da nicht allein handeln, wo es gemeinsame Interessen gilt, und ich möchte Ihnen daher unsere Abwehrmassregeln zur Kenntnis bringen mit der Bitte, zu erwägen, ob Sie sich unserer Aktion anschliessen wollen. . . . [Explains how on the morning of July 4, Muthesius's wife came to van de Velde to tell him he would withdraw his theses. This was the reason why:] wir uns in der Diskussion die grösste Zurückhaltung auferlegten.

Nachdem durch die Unvorsichtigkeit Tauts und die Bissigkeit Breuers die Situation so verschoben war, dass das ahnungslose Publikum Muthesius mehr zuneigte wie der Opposition, konnte dieser allerdings die Zurücknahme in eine höchst taktlose Form kleiden. . . . Muthesius will nun seinen Vortrag, der ja schliesslich nichts enthält wie banale Gemeinplätze im B.T. erscheinen lassen. . . . Für den Fall, dass die Zeitung sich weigert, habe ich nach Verständigung mit Gropius folgenden Wortlaut einer von uns zu unterzeichnenden Erklärung an van de Velde gesandt. . . .

Ich wäre Ihnen dankbar, wenn Sie van de Velde oder mich telegraphisch wissen lassen, ob Sie dieser Erklärung zustimmen und auch Ihren Namen darunter setzen wollen. Vielleicht sind Sie in der Lage zu beurteilen, ob man auch Paul diese Erklärung vorlegen soll. Es darf vielleicht erwartet werden, dass Muthesius nach dieser Erklärung aus dem Vorstande ausscheidet. Gropius ist der Ansicht, dass dies erzwungen werden muss, wenn es nicht von selbst geschieht und zwar durch eine von den führenden Künstlern zu unterschreibende Erklärung, dass sie dem Werkbund nicht länger angehören werden, wenn Muthesius dem Vorstand länger angehört. Dass sich die meisten unserer näheren Freunde einem solchen Protest anschliessen würden, steht wohl ausser Frage. Mich hält nur noch das Bedenken zurück, dass das äussere Prestige des Werkbundes im Augenblick grösser ist wie zuvor, und dass wir immerhin einen Machtfaktor aus der Hand geben, der so leicht nicht wieder zu schaffen ist. Ich würde mich freuen, hierüber vor allem auch Ihre Meinung zu hören. . . .

5. Carbon copy of a telegram from Behrens, Darmstadt, July 13, 1914.

Erfahre aus Berlin über Konflikt durch Aufsätze in Zeitungen, bin gewiss für unbedingte Freiheit des individuellen Schaffens, halte aber für notwendig, dass Werkbund auf dieser Grundlage erhalten bleibt, rate darum Sezession vorerst zu vermeiden und Klärung durch Aussprache massgebender Personen zu bewirken, würde Spaltung in diesem Falle für abgeschmackt halten und bedauern, glaube als Ihr und der Sache Freund zu raten.

Behrens

6. From a Gropius carbon copy of a letter from [Osthaus] to Ernst Jäckh (general secretary of the Werkbund) in Berlin, July 13, 1914.

Es scheint . . . , dass der Sinn der ganzen Aktion von Muthesius nicht begriffen worden ist. Nicht um Theoretisches handelte es sich in Cöln.

Es sollte vielmehr Muthesius zum Bewusstsein gebracht werden, dass seine seit Jahren geübte Politik im Werkbunde mit den Empfindungen und Auffassungen vieler treibenden Kräfte im schärfsten Widerspruch steht. Nicht seine Auslassungen, sondern seine Handlungen sind es, welche diesen allgemeinen, von der breiten Mehrheit natürlich nicht geahnten Widerspruch entfesselt haben. Dieser ging vor der Tagung so weit, dass eine Anzahl von sehr gewichtigen Mitgliedern ihren Austritt erklären wollten, falls Muthesius seinen Sitz im Vorstande nicht niederlege. . . . Ich bitte Sie, Herrn Professor van de Velde, mit dem Gropius und ich in Verbindung stehen, umgehend zu informieren, ob die Zurücknahme im Berliner Tageblatt von Ihrer Seite erfolgt oder nicht.

7. From a carbon of a Gropius letter addressed "an die Leitung des Deutschen Werkbundes"; Timmendorferstrand (Lübecker Bucht), July 14, 1914.

Die Dinge . . . bringen eine schwere Krise über den Werkbund, viel schwerer als die erste. Ich bedauere das *sehr*, da ich beim Scheiden aus Cöln die Hoffnung mitnahm, die Differenzen seien behoben und freie Bahn für neue Arbeit da. Nun hat aber Muthesius anscheinend die persönliche Rücksichtnahme der Künstler auf ihn und den eigentlichen Sinn der Aktion nicht begriffen oder nicht begreifen wollen. Man hat ihn nach aussen hin mit Sachlichkeit geschützt, in der Erwartung, dass er danach seine Entschliessungen einrichten möge. Es bestand bei der überwiegenden Mehrheit der führenden Künstler die bestimmte Absicht, sich *nicht* unter die Führerschaft seiner Person und . . . seiner Leitsätze bei der Cölner Tagung zu begeben. Ich kann Ihnen mit aller Bestimmtheit sagen, dass eine grosse Zahl von Künstlern, und darunter einige sehr einflussreiche Persönlichkeiten, bereits *vor* der Tagung unter keinen Umständen mehr im Werkbund bleiben wollten. . . . Nun erscheint auf Mahlbergs Artikel im Berliner Tageblatt, der den Sinn der Tagung richtig wiedergibt, die Entgegnung der "Leitung," über deren Zustandekommen ich mir seit Tagen den Kopf zerbreche.

8. From a letter of van de Velde to Gropius, July 15, 1914.

. . . wenn von Seiten des Vorstandes nicht offiziell an alle Mitglieder des Werkbundes mitgeteilt wird, dass der Werkbund nur auf Grundlage unbedingter individueller Freiheit des Schaffens bestehen kann. . . . rate ich zur Secession. Ich freue mich, dass ich mit Persönlichkeiten wie Sie und Osthaus in bestem Einverständnis weiter gehen kann.

9. From a letter of Osthaus to Gropius, July 21, 1914.

Muthesius hat seinen Austritt aus dem Ausschuss des Deutschen Museums erklärt. Wäre er nicht Muthesius, so würde man anzunehmen geneigt sein, dass er diesen Schritt für taktvoll gehalten habe. Wie er nun aber einmal ist, halte ich es mehr für eine Bestrafung meiner Person. Ich wundere mich in diesem Falle eigentlich nur über seine Dummheit.

10. From a Gropius carbon of a letter from [Osthaus] to Muthesius, July 21, 1914.

Sie haben es jedoch für richtig gehalten, . . . es zugelassen, dass das Berliner Tageblatt Ihrem Aufsatz eine Bemerkung vorausschickte, die eine den Tatsachen nicht entsprechende Scheidelinie zwischen Behrens, Paul und Riemerschmid auf der einen Seite und van de Velde auf der anderen Seite legte. Dass Behrens sich gegen diese Bemerkung in der Vorstandssitzung verwahrte, charakterisiert ihren sachlichen Wert.

Nun spricht das Tageblatt aufs neue die Auffassung aus, dass nichts anderes geschehen sei, als dass Sie vor einer Ueberspannung des Persönlichen gewarnt hätten [article in *Berliner Tageblatt*, Saturday, July 7, 1914: "Schliesslich war ja nichts anderes geschehen, als dass Muthesius vor einer Ueberspannung des Persönlichen gewarnt hatte, und das haben andere schon schärfer getan."], also wiederum eine Herabsetzung derer, die sich in ihrer Auffassung von Kunst von Ihnen unterscheiden.

11. From a letter of August Endell to Gropius, Berlin, July 25, 1914.

Herrn Architekt W. Gropius, z. Zt. Timmendorfer Strand

  Lieber Herr Gropius

  Besten Dank für Ihren Brief vom 23. d. Ich habe mich Dank des Wetterumschlages so weit erholt, dass ich etwas ruhiger über unsere Niederlage denke. Ihr Urteil über van de Velde und Osthaus halte ich für zu hart, wenn auch sicher der Kernpunkt darin liegt, dass niemand sich traut, den Vorsitz selber zu übernehmen, weil man die Arbeitslast scheut. Jetzt noch etwas zu unternehmen, halte ich für zwecklos, die Stosskraft ist nun einmal dahin, und nachdem der Vorstand sich die skandalösen Vorgänge hat gefallen lassen, ohne jeden energischen Einspruch, hat es gar keinen Zweck, das Feuer von neuem zu entflammen. Wir können garnichts besseres tun, als uns zunächst ruhig zu verhalten, und die weitere Entwicklung abzuwarten. So wie ich

Muthesius kenne, gibt es in zwei drei Jahren eine neue Auflage skandalöser Vorfälle, und vielleicht ist es dann möglich, mehr zu erreichen. Schreiben werde ich über die Sache, aber rein sachlich, in der Neuen Rundschau, wo ich die Kämpfe hinter den Kulissen nur ganz flüchtig andeuten werde. [Presumably his article, "Deutsche Tracht," *Neue Rundschau*, September, 1914, pp. 1458–1462.] Ausserdem hatte ich den beiliegenden Artikel schon vor der Vorstandssitzung geschrieben, ich wollte ihn durch eine Korrespondenz verbreiten lassen, bin mir aber nicht klar, ob das jetzt noch einen Sinn hat. Im Grossen und Ganzen bin ich die Sache ziemlich leid und bedaure, so viel Kräfte darauf verwandt zu haben. . . . Ein Austritt aus dem Werkbund würde jetzt nur ein Hohngelächter der Gegenpartei hervorrufen, und hätte gar keinen Zweck. . . .

12. "Nachwort zur Werkbundtagung" (abridged). Unsigned, undated memorandum on the Werkbund debate. Identifiable as Endell's by a comparison of the typeface with that of Endell's letters. Cf. its content to that of Endell's speech in the debate (in Posener, pp. 208–209). This is presumably the "beiliegende Artikel" mentioned in Endell's letter of July 25, 1914.

Leider sind die Berichte über die Werkbundtagung so kurz gewesen, dass der Aussenstehende nur einen sehr verworrenen Eindruck davon bekommen konnte, dass auf dieser Tagung die Geister ziemlich heftig aufeinanderplatzten. Eine genauere Darstellung ist daher wohl erwünscht, natürlich nicht der Tagung, mit allen ihren Einzelheiten, sondern der Gegensätze und treibenden Kräfte, die dort zum Ausdruck kamen. Auf der Tagung sollte es zu einer Aussprache über den heutigen Stand des Kunstgewerbes kommen. Herr Geheimrat Muthesius hatte den Hauptvortrag übernommen, und gab acht Tage vor der Tagung Leitsätze als Disposition seines Vortrages heraus, die der Diskussion als Unterlage dienen sollten. Diese Leitsätze waren weder sehr klar, noch eindeutig und stimmten auch mit den im Vortrag gegebenen Ausführungen nur sehr ungefähr überein. Ihr Grundgedanke war ungefähr folgender:
Das Deutsche Kunstgewerbe braucht einen grösseren Export. Um diesen zu ermöglichen, sei es notwendig, eine geschmackvolle Allgemeinhöhe zu erreichen, und diese sei nur . . . zu erzielen, durch eine Typisierung der im modernen Kunstgewerbe gebildeten Formen. All das war in nicht sehr deutlichen Sätzen gesagt, fast jeder Satz liess verschiedenartige Auslegungen zu. Immerhin war der Eindruck allgemein, dass diese Leitsätze gegen die künstlerische Mitarbeit sich

richteten, und die Folge eine leidenschaftliche Erbitterung der Künstler, die zunächst in Gegenleitsätzen [p. 2] von van de Velde zum Ausdruck kam, in denen in klarer und unantastbarer Form die Stellung der Künstler im Kunstgewerbe deutlich umschrieben wurde. Die Erbitterung trat weiter zu Tage, in den zum Teil sehr heftigen Diskussionsreden, die schliesslich dazu führten, dass Herr Muthesius seine Leitsätze zurückzog, natürlich mit den in solchen Fällen üblichen Verklausulierungen....

... diese Leitsätze sind zurückgezogen, und die Gefahr, dass sie dem Werkbundprogramm eingefügt werden könnten, ist glücklicherweise vorüber. Für die Allgemeinheit aber ist wichtig zu wissen, was eigentlich diese grosse Erbitterung hervorgerufen hat. Und da ist es zunächst dieser unselige Ausdruck Typisierung gewesen, der den heftigsten Widerstand heraufbeschwor, denn dieses schauerliche Wort—griechischer Stamm und französisch-deutsche Endung—gibt in der Tat keinen klaren Sinn, wie man es auch drehen und wenden möge. [Crossed out: Wohl kann man nach einem Typus, einem Muster, Einzelstücke machen, wie man aber umgekehrt Einzelstücke zu einem Typus machen könne, ist nicht einzusehen. Und]

[Inserted page: Natürlich liegt der alte Irrtum zu Grunde, die Architektur und das Kunstgewerbe vergangener Zeiten seien einheitlich gewesen, hätten Typen gebildet. Aber das ist nur ein Irrtum ungenügender Betrachtung. Je genauer wir die vergangenen Zeiten kennen lernen, um so deutlicher wird es, dass auch die Kunstwerke der Architektur zu allen Zeiten individuell waren, typisch aber nur bei ungenauer Betrachtung erschienen. Nur in den klassizistischen Perioden, die sich auf die antiken Säulenordnungen in bestimmten Proportionen festlegten, kann von einer Einheitlichkeit die Rede sein, und auch da nur in sehr beschränktem Masse. Wie man es aber anfangen soll solchen Typus künstlich zu erzeugen, ist ganz und gar nicht einzusehen, um so weniger, als die moderne Bewegung in erster Linie an die mittelalterlich gotische Kunst anknüpft, nicht an die klassizistische. Jeder Künstler sucht seine Formen zu vervollkommnen, und bildet auf diese Weise einen eigenen, für ihn charakteristischen Formenkreis. Auch findet unter den Künstlern eine gegenseitige Beeinflussung statt, Formen finden Anklang, werden von andern aufgenommen und weitergebildet. Auf diese Weise mögen hier und da typische Formen entstehen, sie aber bewusst bilden zu wollen, ist ein hoffnungsloses Unternehmen, und es erscheint töricht, durch Vereinsbeschlüsse in dieser Richtung die allgemeine Arbeit beeinflussen zu wollen. Im übrigen ist auch bisher—die Werkbundausstellung beweist

es—von einer beginnenden Vereinheitlichung nichts zu merken, es sei denn im reinen Negativ, in der ängstlichen, ja pedantischen Dürftigkeit der Formen, die bewusst allem Lebendigen aus dem Wege geht.]

[p. 2] Wir haben gerade im Werkbund allen Grund, uns vor dunklen Worten ängstlich zu hüten, denn der Werkbund hat ohnehin in sein Programm das Wort Qualitätsarbeit aufgenommen, was zu unzähligen Missverständnissen geführt hat. . . . [p. 3] Qualität machen heisst ja weiter nichts als gutmachen, und dass bedeutet eigentlich herzlich wenig, da wohl jeder in jedem Gebiete der Meinung ist, seine Arbeit gut machen zu wollen. Dieses unselige Wort hat aber dazu geführt, dass man das Wesentliche im Kunstgewerbe, die geistige Qualität, die Schönheit, beiseite liess, und mit der materiellen technischen Qualität schon Wunder welche Taten zu verrichten glaubte. Lichtechtheit, haltbares Papier sind gewiss sehr wünschenswerte Eigenschaften einer Tapete, aber künstlerisch schlechte Tapeten haben nur eine Entschuldigung für ihre Existenz, nämlich die, dass sie auf dem schlechtesten Papier und mit den vergänglichsten Farben gedruckt sind. . . .

Es ist begreiflich, dass nach den bedenklichen Erfahrungen mit dem Unglückswort Qualität das Wort Typisierung direkt einen panischen Schrecken unter allen Beteiligten hervorrief. Man fürchtete neue Missverständnisse, und das um so mehr, als der eigentliche Sinn des Wortes sich nur erraten liess. Dass es auf alle Fälle auf ein Schema oder eine Schablone hinauslaufen muss, ist ja ohne weiteres klar, und dass ein Schema gerade in die moderne Kunst hineingetragen werden soll, die im Gegensatz zur akademischen klassizistischen Kunst sich gebildet hatte, musste [p. 4] recht stutzig machen. Noch schlimmer aber musste der Sinn der Typisierung erscheinen, wenn im 9. Leitsatz gesagt war "Für einen etwaigen Export ist das Vorhandensein leistungsfähiger und geschmacklich sicherer Grossgeschäfte die Vorbedingung. Mit dem vom Künstler für den Einzelfall entworfenen Gegenstand würde nicht einmal der einheimische Bedarf gedeckt werden können." Das heisst, der Künstler soll ersetzt werden durch den geschmacklich sicheren Fabricanten oder den Kaufmann. Dass ein solcher Satz als eine Herausforderung empfunden wurde, als eine unmittelbare Ableugnung aller unserer Bestrebungen im Kunstgewerbe, und in der Architektur, als eine Vernichtung der mühevollen Arbeit vieler Jahre, kann niemand wundernehmen. Denn gerade dagegen hat sich die moderne Bewegung von Anfang an mit aller Stärke gerichtet, dass der Fabrikant neben seiner technischen und kaufmännischen Tätigkeit auch noch künstlerisch dilettiert, und durch seinen persönlichen

Geschmack den Künstler ersetzen will. Es lag von jeher nahe, dass der Fabrikant, gewohnt seinen Willen im Kaufmännischen und Technischen durchzusetzen, sich auch in künstlerischen Dingen als letzte Instanz ansah. Die Fabrikanten hatten immer erklärt, mit Künstlern könne man nicht arbeiten, sie verständen nichts vom Geschäft, ihre Entwürfe seien technisch und wirtschaftlich unbrauchbar, Ware nach Künstlerentwürfen sei immer unverkäuflich, wobei nur eben vergessen wurde, dass man schliesslich nur verkaufen kann, was man für gut hält, nicht aber das, was man selbst mit unverhohlenem Misstrauen betrachtet. Und das künstlerische Können, das unsichtbar in der Seele lebt, wurde als ungreifbar gering geschätzt, und man hielt es allgemein für leicht, für einen verständigen [p. 5] Menschen, so nebenbei auch noch die geschmackliche und künstlerische Leitung zu besorgen. Dabei sah man natürlich bald ein, dass eine Verfeinerung der Form auf diesem Wege nicht möglich ist, sondern im günstigsten Fall eine geschmackvolle Vergröberung der Form, was ja denn wohl auch den wirklichen Sinn jener rätselhaften Typisierung ausmacht. Gegen diese Auffassung des Kunstgewerbes richtete sich von Anfang an die ganze künstlerische Bewegung, und es gelang, wenn auch nicht überall so doch in vielen Fällen, ein wirklich aufrichtiges gleichberechtigtes Zusammenarbeiten zwischen Fabrikanten und Künstler zu erreichen. Und es sind dabei recht gute Sachen zustanden gekommen, wie man leicht sehen kann, wenn man sich die Mühe macht, die unsinnig grosse Werkbundausstellung im einzelnen zu durchsuchen. So haben Riemerschmid und Erismann in Breisach in verständnisvollem Zusammenarbeiten eine Tapete geschaffen, die von überraschender Schönheit ist, and zu dem Besten gehört, was ich überhaupt auf der Ausstellung gesehen habe. Und ich selber habe verschiedentlich von Industriellen eine grosse und weitherzige Förderung erfahren. Es wäre die eigentlichste Aufgabe des Werkbundes, diese Beziehungen zwischen Künstler und Fabrikanten, die nun so glücklich angebahnt sind, immer weiter und fruchtbarer auszubilden. An Künstlern fehlt es wirklich nicht, und die gegenteilige Behauptung nimmt sich seltsam genug aus in dem Munde eines Mannes, der Dezernent für Kunstgewerbeschulen Preussens ist, und für ihre Vergrösserung Erhebliches . . . [last 2 words illegible].

[p. 6] Man begreift jetzt, wie sehr sich durch die Leitsätze die Künstler betroffen fühlen mussten, nicht nur in ihrer Existenz, sondern auch in den wichtigsten Zielen ihrer Arbeit . . . und es war durchaus verständlich, dass in der Diskussion mit Leidenschaft als einziges Ziel Schönheit und schöpferische Arbeit gesetzt wurde, und dass laut und

deutlich gesagt wurde, dass ein kunstgewerblicher Export eine nationale Bedeutung nur haben könne, wenn das Kunstgewerbe sich Schönheit als ausschliessliches Ziel setze. Nur Schönheit kann mit Anstand und Ehre fremde Zollschranken übersteigen, nicht aber ein kunstgewerblicher Export, der sich feige fremden Geschmacksrichtungen anpasst, oder womöglich sich internationalisiert.

Der Werkbund stand vor der wichtigen Entscheidung, soll Qualität und Typisierung, oder Schönheit und ernsthafte gleichberechtigte Mitarbeit des Künstlers in der Industrie als unser Ziel gelten. Nur wenn man sich für das Letzte offen und ehrlich entscheidet, hat der Werkbund eine Daseinsberechtigung und eine Zukunft. Tut man das nicht, bleibt man bei den konfusen und vieldeutigen Worten Qualität und Typisierung, so ist der Werkbund der Gefahr ausgesetzt, zu einem Organ für die heute so beliebte ethisch kulturelle Reklame herabzusinken, auf die auch jene Fabrikanten nicht verzichten mögen, die aus Geschäftsprinzip die Mitarbeit der Künstler verachten, und sie im Werkbund nur geduldet sehen wollen, weil sie für jene Reklame immerhin ganz nützlich sind.

# APPENDIX D

Since there has been some confusion over the chronology of the founding of the Arbeitsrat für Kunst and Gropius's position in it, it may be well to review the pertinent facts as far as they are generally available and to add to them some hitherto unpublished bits of clarifying information. At its inception in late November 1918 immediately in the wake of the November Revolution, the Arbeitsrat was organized provisionally into a number of committees or sections, one for each of the arts, with an "Architekten-Ausschuss" at the head directed by Bruno Taut. (Aside from its mention in the Gropius letters excerpted here, this *Ausschuss*, with Taut so listed, is referred to in an introductory footnote to his article, "Die Erde eine gute Wohnung," *Die Volkswohnung* 1, no. 4 [February 24, 1919]: 45–48.)

The first Arbeitsrat announcement of purpose, or program, was published as early as December 26, 1918, in at least *Die Bauwelt*, above a list of signatures arranged in simple alphabetical order without titles of office, and repeated in January 1919 in *Der Cicerone*, this time without signatures ("Ein neues künstlerisches Programm," *Die Bauwelt*, p. 5). Sometime in February, Gropius was elected chairman of the organization, as he announced in a form letter sent out to Arbeitsrat supporters as early as February 23, 1919 (e.g., to Franz von Mendelssohn on that date: "Der

Arbeitsrat hat mich zu seinem Vorsitzenden gewählt . . . [GAL, "Briefe, Arbeitsrat für Kunst, 1919/1921" file]). His plan to re-organize it by bringing the three arts together in an *Arbeits-ausschuss* (also called a *Geschäftsausschuss* in Arbeitsrat an-nouncements) comprising painters, sculptors, and architects was adopted in two meetings of March 1 and 22, 1919. In their wake, a second statement of purpose mentioning the dates of reorganiza-tion was drawn up and published in the April *Cicerone* (p. 230). This time a list of the new officers was included among the mem-bers of the *Arbeitsausschuss*, with Gropius as *Vorsitzender*, César Klein as *Stellvertretender Vorsitzender*, and Adolf Behne as *Geschäftsführer*. At about the same time, the first and second announcements were also put together and printed as a separate pamphlet. Its date is clear from the mention in it of the dates of reorganization and from its listing of the new chain of command (with, however, Gropius, Klein, and Behne simply listed as *Leitung* within what is here called the *Geschäftsausschuss*).

The correct chronology of the Arbeitsrat's founding was given by Lindahl, who incidentally cited an early notice on the Arbeitsrat program with "the original signers" in the *Mitteilungen des Deutschen Werkbundes*, no. 4, 1918, p. 16 (Göran Lindahl, "Von der Zukunftskathedrale bis zur Wohnmaschine. Deutsche Archi-tektur und Architekturdebatte nach dem ersten Weltkriege," in *Idea and Form*, Figura: Uppsala Studies in the History of Art, N.S., vol. 1, 1959, pp. 234–236; this *Mitteilungen* issue was un-available to me). Lindahl, however, creates a difficulty by his statement that "ein kurzes und recht allgemeines Programm des Arbeitsrates kam schon im November 1918 als Flugblatt heraus" (p. 233). Is this another pamphlet, as his description seems to indicate, or a misdating of the March-April one? He does not further discuss it, and only cites—and quotes—the first program as it appeared in the January 1919 *Cicerone*, p. 26. More recently, Pevsner published the March-April pamphlet; but unaccountably overlooking the reorganization dates stated therein, he called the whole work a publication of November 1918 and thereby mis-takenly put Gropius, Klein, and Behne in the directorate from the start (Nikolaus Pevsner, "Finsterlin and Some Others," *Archi-*

*tectural Review* 132, no. 789 [November 1962]:353). The German edition of Conrads and Sperlich, *The Architecture of Fantasy*, excerpts and correctly dates the March-April flyer but does not mention the earlier appearance in print of part of its content, thus permitting the inference that the Arbeitsrat program as a whole was formulated only in the spring of 1919. The English edition corrects this by adding a note that "this [program] was reported almost verbatim in *Der Cicerone* . . . January and April of 1919," but by so doing inadvertently opens the way for the equally mistaken assumption that Gropius was already chairman at the inception of the Arbeitsrat. Both editions further confuse matters by contradictorily and incorrectly observing elsewhere that the "Arbeitsrat für Kunst . . . was, until its merger with the November Group in November 1919 [actually not until December 17, according to an A.f.K. business report, StAW, B'haus 399; I am indebted to Allan Greenberg for the reference] composed exclusively of a committee on architecture under the chairmanship of Bruno Taut" (Ulrich Conrads and Hans G. Sperlich, *Phantastische Architektur*, Stuttgart, 1960; English ed., *The Architecture of Fantasy: Utopian Building and Planning in Modern Times*, trans., ed., and expanded C. C. Collins and G. R. Collins, New York and Washington, 1962; both eds. pp. 136–137, 182 n175, and 23). Conrads in his anthology of architectural programs and manifestoes also discusses and correctly dates the pamphlet as March 1919; but he publishes only the first—November-December 1918—portion of it without indicating that it is only an excerpt from the pamphlet and without referring to its earlier appearances in the press (Ulrich Conrads, ed., *Programme und Manifeste zur Architektur des 20. Jahrhunderts*, Berlin, Frankfurt am Main, and Vienna, 1964, pp. 41–42). Conrads observes merely that "der Arbeitsrat wird jetzt [i.e., in the spring of 1919] geleitet von Walter Gropius, César Klein und Adolf Behne" without mentioning that it had first been headed by Taut.

1. From a carbon copy of a letter from Gropius to Wilhelm Valentiner, February 18, 1919 (GAL, "Briefe, Arbeitsrat für Kunst, 1919/1921" file).

Taut will im A.f.K. nicht mehr mittun. . . . Es muss unbedingt sofort etwas geschehen, sonst fällt die ganze, so schön eingefädelte Unternehmung ins Wasser.

2. From a carbon of a Gropius letter to Professor [Paul?] Weiss, April 9, 1919, explaining the reorganization of the A.f.K. (GAL, Arbeitsrat file).

Es stellte sich immer mehr heraus, dass etwas Fruchtbares nur entstehen könnte in einem geschlossenen Kreis von Künstlern, die sich an ganz positive Arbeiten begeben. Deshalb machte ich den Vorschlag, zunächst endlich einmal Ernst damit zu machen, die drei Gruppen Architekten, Maler, Bildhauer unter einen Hut zu bringen. Das geschah, und in der Vollversammlung . . . wurde der Arbeitsausschuss gewählt, der die Aufgabe haben sollte, die organisatorische Arbeit für den Arbeitsrat für Kunst zu übernehmen.

3. From a carbon of a Gropius letter to Hans Poelzig, April 23, 1919, trying to keep him from resigning from the A.f.K. over a dispute with Taut (GAL, Arbeitsrat file).

Taut ist nicht Obmann im A.f.K. Er hat zu Beginn die Führung im Architektenausschuss gehabt. Seit einigen Monaten aber habe ich die gesamte Führung des Arbeitsrats übernommen, und Taut spielt keine andere Rolle darin wie die übrigen Mitglieder.

4. Excerpt from a single-page, typed fragment of a Gropius speech before the Arbeitsrat (BD,SG). Its content shows he had just taken office as chairman and hence must date from February or the beginning of March, 1919.

In der letzten Sitzung habe ich etwas schweren Herzens das Tautsche Erbe angetreten, weil ich mir nicht darüber klar war, ob ich Ihr Vertrauen in mich auch würde rechtfertigen können. Wir waren auf einem toten Punkt angelangt. Tauts Bedenken musste ich in der Hauptsache teilen, hatte aber doch das Gefühl, wir sollten trotz aller Widrigkeiten der äusseren Politik unsere Fäden in aller Stille weiterspinnen.

Es ist in der letzten Sitzung etwas m.E. einscheidend Wichtiges beschlossen worden: der Verzicht auf Sonderausschüsse der Architekten, Maler und Bildhauer, der Entschluss, gemeinsam zu handeln. Meine Herren, ich glaube, wir sind die erste Gruppe, die zur Tat übergegangen ist, die trennenden Grenzen zwischen den verschiedenen

Gattungen von Künstlern zu verwischen und damit den ersten Schritt zu tun, die verschiedenen künstlerischen Disziplinen aus ihrer Isoliertheit herauszureissen, eben mit der Sehnsucht nach dem Ziel: Zusammenschluss der Künste unter den Flügeln einer grossen Baukunst.

Ich möchte nun heute meinen Vorsitz damit beginnen, ein paar grundlegende Worte vorauszusagen, mit denen ich hoffe, die Unklarheiten endgültig aus der Welt zu schaffen, die sich in der bisherigen Zusammensetzung des Arbeitsrats und in der Frage, wie er sein Programm durchsetzen will, herausgeschält haben.

5. Two-page, typed fragment of a Gropius Arbeitsrat speech, with handwritten emendations (BD,SG). Its content likewise indicates it as a speech given upon Gropius's taking office. Perhaps part of the same speech as fragment 4.

Wir mussten uns erst langsam durchringen zur Klarheit dessen, was wir wollen. Die Kluft zwischen den beiden grundverschiedenen Absichten, die von Anfang an verhängnisvoll miteinander verquickt wurden, ob wir Kunst p o l i t i k auf breiter Basis treiben oder aber durch Zusammenschluss einer kleinen Minorität einem radikalen künstlerischen Bekenntnisse zum Siege verhelfen wollen, hat sich erst nach und nach zu Gunsten der letzteren Auffassung überbrücken lassen. Nun haben wir eigentlich erst das klare Fundament, auf dem wir aufbauen können, und ich glaube, wir können dankbar sein, dass uns unsere Portemonnaieklammheit verhindert hat, breit hervorzutreten. Wir haben heut den Vorteil davon, dass noch ein geheimnisvolles Mysterium über dem Arbeitsrat ausgebreitet liegt und die Oeffentlichkeit alles oder nichts von uns erwartet.

Ich betrachte unsern Bund als eine Verschwörung; wir sind eine kleine Minorität. Wenn wir etwas Starkes erreichen wollen, so müssen wir unser Programm in jeder Beziehung hochhalten und keine Kompromisse dulden, vor allem nicht unter uns selbst. Wir wollen lieber zunächst praktisch n i c h t s erreichen, denn jedes Lavieren ist Anfang vom Ende. Wir müssen uns die Kraft zutrauen, auszuharren, bis der Tag kommt, an dem wir—und dann mit Vehemenz—vollkommen v o r b e r e i t e t an die Oeffentlichkeit treten. Wir dürfen uns nicht mit einigen Zugeständnissen von der andern Seite begnügen, die man sich dort gnädig abringen lässt; sondern wir brauchen den andern G e i s t, aus dem heraus uns dann von selbst, wenn er erst e r s c h a f - f e n ist, Erfüllung wird. Haben wir den Mut, zu warten, bis eine bessere opinio communis da ist. Es geht vielleicht schneller, als wir

erwarten. Ich meine damit nicht etwa, dass wir untätig sein sollen, ganz im Gegenteil, denn wir heissen ja Arbeitsrat, aber schliessen wir uns erst einmal selbst zusammen und sammeln wir Stoff. Den Zusammenschluss unter uns selbst [p. 2] halte ich überhaupt für das Wichtigste und Wertvollste unserer Vereinigung, viel wichtiger als alle Propaganda nach aussen. Wir laufen noch alle, jeder in seiner Arbeit für sich isoliert, neben einander her und brauchen zuerst einmal die enge persönliche Berührung, um uns über unsere künstlerischen Absichten gegenseitig auszusprechen und diese in einen gewissen praktischen Einklang zu bringen. Wir ahnen alle erst das Ziel, auf das wir hinwollen. Wir haben zwar ein schönes Programm, das eindeutig radikale Ziele aufstellt, die aber, wie es im Text heisst, nur a n g e d e u t e t sind, und über diese Andeutungen sind wir ja in den meisten Punkten noch nicht hinaus. Ausser dem Hauptstück unserer bisherigen Arbeit, Tauts prächtigem Architekturprogramm, für das auch ich, wie ich betonen möchte, in vollem Umfange einstehe, und dem noch in der Schwebe befindlichen Lehrprogramm Bartnings sind ja noch zahllose andere Fragen zu bearbeiten.

Ich möchte nun darauf hinaus, dass wir uns zuerst alle untereinander in unserer Gemeinschaft i n a l l e r S t i l l e konsolidieren und, ehe wir an die Oeffentlichkeit treten, gründlich Material fertigstellen und aufhäufen: Vorträge, Ausstellungen vorbereiten, Flugblätter fertig gedruckt hinlegen und dann, wenn der Tag dazu reif ist, plötzlich mit unserm gesamten Material aufspringen und laut erklären: Hier sind wir. Das wird unendlich stärker wirken als kleine Feuilletons in der Tagespresse. Wir erreichen dann in einem Tage mehr als in Jahren. Also statt tropfenweiser Verausgabung schlage ich vor: Ansammlung und plötzlichen Stoss. Ich lege nachher ein positives Arbeitsprogramm vor als Vorschlag für die Verteilung der Arbeit unter uns so, wie es schon Taut neulich in der Sitzung angeregt hat. Ehe ich aber zur positiven Tagesordnung übergehe, richte ich die Frage an Sie: Stimmen Sie mit der Wirkungsweise des Arbeitsrats so, wie ich sie eben skizziert habe, überein, oder bestehen prinzipielle Bedenken gegen meinen Plan?

# APPENDIX E

Gropius memorandum for the Arbeitsrat für Kunst. Typescript draft with handwritten emendations (BD,SG), titled "Gesichtspunkte für Kunstausstellungen" (slightly abridged).

Der Arbeitsrat für Kunst hat als wichtigstes Ziel auf sein Programm geschrieben: Zusammenschluss der Künste unter den Flügeln einer grossen Baukunst. Die Kunst soll nicht mehr Genuss weniger, sondern Glück und Leben der Masse sein.

Die Baukunst ist Sache des ganzen Volkes. Das Interesse für sie ist in unserer Zeit fast völlig eingeschlummert. Die Erkenntnis, dass die Bauwerke einer Zeit die kulturelle Formung seines geistigen Inhalts bedeuten, ist den wenigsten gegenwärtig. Sie muss mit allen Mitteln erweckt werden. . . .

Künstlerisch starke Zeiten brauchten keine äusseren Hülfsmittel [sic], um die Kunst ins Volk zu tragen. Die Kunst hatte es nicht nötig, sich anzubieten, und Kunstausstellungen waren deshalb unbekannt. Die Kunstausstellung ist eine Missgeburt des armen, kulturlosen [inserted as replacement: kunstverarmten Epochen] Europas. Da die Kunst im wirklichen Leben der . . . Völker keinen Raum mehr fand, musste sie sich in groteske Schauhäuser flüchten und dort prostituieren. Wir werden trotz dieser Erkenntnis nicht mit einem Schlage die alten Kunstausstellungen aus der Welt schaffen, aber wir sollten versuchen, neue Wege zu finden, um die Ideen und Werke der Künstlerschaft dem Volke in einer Form zu zeigen, die dem lebendigen Leben

näherkommt [p. 2] als die bisherigen Ansammlungen von Werken der Salonkunst. Die alten Salonkunstausstellungen zeigten fern von der Einheit des ganzen Baues mit Bildern gespickte Wände und liessen den ursprünglichen Sinn der bildenden Künste, im Bau zu wirken, unbeachtet. Die Werke der Maler und Bildhauer gehören aber in den Rahmen architektonischer Glieder. In bisherigen Ausstellungen war fast nirgends das Werk des Architekten zu finden. Während der Maler und Bildhauer seine Werke—gerahmte Bilder und freistehende Plastiken—im Original in den Kunstausstellungen zeigte, ist es dem Architekten nicht möglich, seine Werke in Originalen auszustellen, da sie untransportabel sind. Abbildungen, ja auch Modelle von Bauten geben aber nur einen schwachen Begriff der Wirklichkeit und wirken nicht reizvoll genug auf das Auge des Beschauers. Die Unmittelbarkeit des künstlerischen Eindrucks geht in diesen Darstellungen verloren. Wir müssen neue, bessere Mittel suchen, um die Architekten den Augen des Volkes näher zu bringen.

Staat und Kommunen müssen der Künstlerschaft ständige Probiergelände zur Verfügung stellen, auf denen sie in gemeinsamer Arbeit untereinander und mit den Industrien zusammen, die an der Entwicklung der Materialien und Techniken im Bau interessiert sind, neue künstlerische Wirkungen und technische Möglichkeiten ausprobieren und dem Volke mit allen Mitteln der Darstellung ununterbrochen nahebringen. In grossen Hallen sowie auf Freiflächen sollen Teilausschnitte lebensgrosser Architekturen—räumliche und körperliche Wirkungen—sei es in echten Materialien [p. 3] oder in geeigneter Imitation—vor Augen geführt werden. Malereien und Plastiken sind Wänden und Architekturteilen als bauliche Glieder eingefügt, also nicht mehr isoliert und ohne Beziehung zum Bau. Die Modelle bleiben dauernd stehen, um Künstlern und Technikern die Möglichkeit zu geben, in fortgesetzter Weiterentwicklung künstlerische und technische Einzelheiten experimentell auszuprobieren.

Neben diesen mehr fachlichen ernsten Versuchen leichte Ausstellungsbauten in heiteren Formen und Bemalungen, die dem Vergnügen des Publikums dienen.

Der grosse Bau der Zukunft soll immer wiederkehrend, in grossen Idealprojekten der Künstler vorgeführt werden, z.B. weit gespannte Pläne für Volkshäuser, an denen Generationen zu bauen haben, sollen in grossen Modellen, die der ständigen Verbesserung der Künstler unterliegen, vor Augen geführt werden. Auch hierfür Versuche von Details des Bauwerks in natürlicher Grösse. Versuche, bis zu welchen Grenzen kühner Formungsmöglichkeiten Materialien wie Beton, Glas,

Eisen sich gipfeln lassen und ferner Versuche über Inkrustationen dieser Materialien (Wirkung und Wetterbeständigkeit).

Die modellmässigen Darstellungen von Architekturen in kleinem und grossem Massstab sollen ferner ergänzt werden erst durch kinematographische Stereo-Aufnahmen, die gute Architekturen alter und neuer Zeit an dem Auge des Beschauers vorbeilaufen lassen. Drastische Auswahl in Verbindung mit entsprechenden Vorträgen. Nur die allerbesten Bauwerke der Jetztzeit aller Länder, dazwischen Alt-Indien, China, Gotik u.s.w., aber auch abschreckende Beispiele.

2) Dieselben Aufnahmen in Form von Mutoskopen, die in Schaukästen ausstellungsmässig neben einander angeordnet und [p. 4] durch Kurbeldrehung des Beschauers in Bewegung gesetzt werden.

3) Feststehende Stereo-Aufnahmen von Architekturen und Architekturteilen, die in gleicher Weise wie die Mutoskope angeordnet, durch vergrössernde Stereoskopgläser betrachtet werden.

Solche Aufnahmen sichern bis zu einem gewissen Grade die unentbehrliche plastische Wirkung der Bauwerke und geben auch dem Laien einen verständlicheren Eindruck als die einfache Photographie oder gar Zeichnung. Farbige Stereoaufnahmen werden den Eindruck noch mehr erhöhen.

Solche Probierstätten der Künstler, die der unablässigen Entwicklung des lebendigen Gestaltens dienen sollen, werden mit der Zeit die schon heute in der Idee überlebten Salonkunstausstellungen unnötig machen und das Schwergewicht der künstlerischen Wirkungen wieder in das Volksleben tragen. Es ist klar, dass eine solche Einrichtung gegenüber den bisherigen Kunstausstellungen, die blosse Stapelplätze waren, grössere Mittel verlangen [sic] als diese. Da sie aber zu der unerlässlichen Vereinheitlichung der einzelnen Kunstdisziplinen beitragen und bildenden [sic] Künstler und Architekten wieder in selbstverständliche Berührung bringen wird, so hat der Staat unmittelbares Interesse, Mittel dafür an andern Stellen freizumachen, die bisher für die Kunst fruchtlos ausgegeben wurden. Ausserdem haben die zahllosen Industrien die Möglichkeit, Versuche innerhalb ihrer eigenen Betriebe auf den Probierplätzen zu erweitern und werden Mittel und Materialien zur Verfügung stellen, zumal die ständige Teilnahme an diesen Versuchen eine Ehre und zugleich die würdigste Reklame in sich schliesst.

Es wird der Antrag gestellt, dass das Kultusministerium zunächst für den Bezirk Gross-Berlin ein geeignetes, von der Stadtbevölkerung leicht zu erreichendes Gelände als architektonischen Probierplatz ständig zur Verfügung stellt und unter [p. 5] Bereitstellung einer

entsprechenden Summe zunächst einige namhafte, fortschrittlich gesinnte Architekten mit der Einrichtung des Unternehmens betraut. Gleichzeitig sollte vom Ministerium ein Rundschreiben an alle in Frage kommenden Industrien mit der Aufforderung zur Teilnahme an dem Unternehmen ergehen.

# APPENDIX F

Gropius-Itten exchange and related correspondence concerning the disputed role of the workshops in the Bauhaus (BD,SG).

1. Undated memorandum from Lyonel Feininger. Probably from December 1921 in reply to Gropius's memorandum of December 9 (excerpted in Wingler, *Bauhaus*, p. 61). The question whether to keep the *Vorkurs* obligatory had been debated throughout the autumn without decision.

Ich kann, wenn ich offen sein und so sprechen soll, wie ich fühle, nicht viel zu sagen finden. Das wenige, aber, erscheint mir wichtig und alles übrige in sich zu schliessen.

Mir scheint, dass, vor allem andern, die Erlernung der technischen Grundlage des handwerklichen Schaffens, wie sie heute besteht, die Grundbedingung sei, für alles Weitere, was folgen soll.

Ehe wir an neue Methoden herangehen, müssen wir dafür sorgen, dass die allgemein gültigen Grundlagen zum technischen Handwerk dem Studierenden übermittelt werden.

Es fragt sich für mich, ob wir nicht das, was wir erklärtermaassen [*sic*] am strengsten meiden wollten, nämlich das Grossziehen künstlerischer Prätension, durch unsere bisherigen [*sic*] Anforderung an das Schöpferische bei noch völligen Anfängern, ehe sie irgendwie durch handwerkliche Disciplinierung irgendeinen Rückhalt gefunden haben, nicht doch förderten. Tatsache ist, dass wir der Improvisation

einen sehr weiten Platz einräumen, und dies bei noch ganz wenig technisch erfahrenen Studierenden. Es kann zweifelhaft erscheinen, ob wir hierzu berechtigt sind. Die Verantwortung, die daraus entsteht, ist jedenfalls gross. Die theoretische Erziehung kann, meines Erachtens, unter Umständen zu früh einsetzen. Sie sollte möglichst in Begleitung des Praktischen gefördert werden. Mit dem Vorschlag eines technischen und theoretischen Versuchs-Platzes bin ich einverstanden. Das wird in mehr als nur äusserlicher Hinsicht ein Versuchsplatz sein. Auch dem "Spieltrieb" sollte, an geeigneter Stelle, Rechnung getragen werden.

Ich spreche mich für Beendigung des Obligatoriums, beim Formunterricht, aus, sobald der Studierende endgültig aufgenommen ist. Die Verbindung mit dem Formgebenden Meister kann auf Antrag des Lehrlings weiter aufrechterhalten bleiben.

In unsern Werkstätten soll das Handwerk nach streng praktischen Grundsätzen zunächst gelehrt werden. Auch in Punkto *Ordnung*, während der Arbeitsstunden sollte darauf streng gesehen werden, das ist klar.

Durch die Zusammenstellung unserer formgebenden Körperschaft ist das Bauhaus zweifellos in der Lage, allen Ausnahmefällen im weitesten Geiste gerecht zu werden. Eine Dosis Utopie steckt in jedem von uns. Ein irgendwie schöpferischer Geist geht wegen der Erlernung praktischen Handwerks nicht flöten. Für uns ist die erste Aufgabe und Verantwortung, das *Handwerk* in den verschiedensten Fächern, den Studierenden *gründlichst* beizubringen. Zu Künstlern müssen sie sich selber durchringen.

Lyonel Feininger

## 2. Letter from Gerhard Marcks to Gropius, Dornburg, December 3, 1921.

Lieber Walter!

Ich habe mir eine Nierenerkältung geholt und weiss noch nicht ob mich der Arzt am Montag zu der wichtigen Besprechung fahren lässt. Deshalb möchte ich für alle Fälle mich schriftlich zum Thema äussern: Für mich ist das Bauhaus mehr Werkstatt als Schule, vor allem aber ein Organismus, den man nicht vorzeitig verkalken lassen soll.

Bilden sich in dieser unsrer Arbeitsgemeinschaft, was doch zu wünschen und zu hoffen, Leute heraus, die die Sache einmal besser verstehn, so ist es Zeit für uns Formenmeister, wie für die Werkmeister, abzutreten. Das heutige Bauhaus ist eine Art Mutterpilz, er streut seinen Samen und zieht es vor zu vergehn statt zu vegetieren. Also

nach 7 Jahren (oder 7 x 7 Jahren) ist ein andres Bild. Wir wollen doch uns hinaufentwickeln!

Was die Schüler anbetrifft, so müsste man unbedingt die besten halten, als Mitglieder, eben als Gesellen. Und sind sie wanderlustig oder wird die Bude zu eng, so sollten Tochterkolonien gegründet werden, d.h. man versucht vom Bauhaus aus das Geld zu bekommen (Geldleute zu interessieren etc) um neue Werkstätten kleineren Stils, die in mehr oder weniger festem Zusammenhang mit dem Bauhause arbeiten[x]), zu gründen. Denn unsern Betrieb können wir wohl nicht ohne Schaden vergrössern.

Der Staat wird, da man ihm ja auch die Leistungen der Kolonien unter die Nase halten kann, mit diesem Weg nicht uneinverstanden sein. Es ist aber besser ganz Deutschland hat etwas von unsrer Arbeit als dass wir in isolierter "Berühmtheit" bleiben.

Mit einer schönen Empfehlung an den Meisterrat

herzlich

Gerhard Marcks

[x]) d.h. die Betriebe sind aber selbständig.

3. Memorandum from Georg Muche: "Äusserung zur Meisterratssitzung vom 8. Dezember 1921."

Zunächst halte ich den Versuch die Situation durch programmatische schriftliche Erklärungen zu fördern nicht für aussichtsvoll, weil es sich hier um überaus lebendige Dinge und nicht um starre Begriffe handelt. Bevor ich mich also äussere möchte ich hoffen, dass trotz dieser Formulierungen das Lebensvolle nicht schmerzhaft getroffen wird. Wenn die Verhältnisse gegenwärtig auch sehr unklar sind, so ist es doch besser sie im Fluss zu lassen, als sie durch dogmatische Denkweise zu regulieren.

Die vorige Besprechung hat gezeigt, dass im Meisterrat kein einheitliches Denken, kein einheitliches Ziel und auch kein einheitliches *Wollen* besteht. Dieser Tatsache muss fernerhin Rechnung getragen werden, wenn es sich am Bauhaus nicht blos [sic] um die Verwirklichung eines schematischen Begriffs, sondern um die in schöpferischer Ungebundenheit begonnene künstlerische Verwirklichung einer anderen Weltanschauung handeln soll. Da also die Einheitlichkeit tatsächlich schon im Meisterrat nicht vorhanden ist, so kann sie auch nicht die Voraussetzung für die Arbeit am Bauhaus überhaupt sein.

Ich persönlich glaubte bisher, dass diese Einheit im Meisterrat wenigstens in der Idee vorhanden wäre und richtete danach meine ganze Einstellung und versuchte meine Tätigkeit mit der des Bau-

hauses zu identifizieren, nicht aus Pflichtbewusstsein, sondern aus der Überzeugung, dass die schöpferischen Ideen der Gegenwart eine breite Basis verlangen, damit sie sich nicht mehr blos [*sic*] im Bild, sondern im Leben selbst realisieren können.

Da also nun eine kollektive Wirksamkeit nicht möglich ist, so scheint mir noch folgender Weg gangbar: Jeder Meister sucht seine Beziehungen zu den Studierenden auf *seine* Art. Unterrichtet auf *seine* Art und lehrt in den Werkstätten auf *seine* Art. Die Gefahr ist dann die Akademie. Aber es ist ja möglich, dass die Akademie, wenn sie auch sicherlich nicht das einzig notwendige ist, so doch das einzig mögliche bleibt. Aber dann kann das *geistige* Interesse nicht mehr vorhanden sein, und ich persönlich stände vor einer ganz anderen, neuen Situation.

Was den allgemeinen Formunterricht betrifft, so halte ich es für notwendig, dass der Meister, der den tonangebenden Einfluss auf die Werkstätten hat, auch den Form- und Vorunterricht leitet. Es will mir nicht zweckmässig und sinnvoll erscheinen, wenn der Unterricht, der ja die Vorbereitung und Ergänzung für die Arbeit in den Werkstätten sein soll, in den Werkstätten selbst nicht zur Durchführung gelangt. Ein Monopol für diese Arbeit gibt es unter den Meistern selbstverständlich nicht, aber es kann auch nicht etwa eine nach äusseren Gesichtspunkten vorgenommene gleichmässige Verteilung der Arbeitsgebiete das richtige sein, sondern nur eine solche die je nach Neigung und Vermögen der einzelnen Meister auf natürliche Art entsteht.

Georg Muche

## 4. Memorandum from Oskar Schlemmer.

### Meisterrat am 9 Dez. 21

Der Konflikt wurde heraufbeschworen durch die Tatsache der *Aufträge*, die einen Zusammenstoss der Meinungen über Schule u. Werkstatt zur Folge hatten. Die Aufträge, wenn sie wachsen werden, können zur Folge haben, dass eine Werkstatt auf grössere Zeiträume fern vom Bhs sein muss. (Beispiel Wandmalerei.) Die Werkstatt steht leer, die Schüler gehen des wertvollen Unterrichts verlustig und den ansässigen Werkstätten ist die Möglichkeit einer Zusammenarbeit genommen.

Vielleicht ist eine Lösung möglich mit einer Teilung in *Schul- und Versuchswerkstatt* einerseits und *Produktion- oder Bauwerkstatt* anderseits.—In der Schul- u. Versuchswerkstatt wäre das *Hand*werk Bildungs- u. Erziehungsmittel mit romantischem Einschlag (das

Basteln). Die Produktion- oder Bauwerkstatt leiste rationelle Arbeit möglicherweise bis zum maschinellen Grossbetrieb. Dort würde *erdacht*, was hier mit allen Mitteln der Technik *gemacht* würde.

Von jeher und heute noch vermisse ich am Bhs eine starke dominierende Architektur-Abteilung; die bis jetzt nur im Programm in ihrer Bedeutung umschrieben ist. Sie müsste dem Bhs das Gesicht geben. Auch in den Statuten tritt sie zu sehr in Hintergrund gegenüber den Werkstätten, die sich in ihrer Formulierung von denen der alten Kunstgewerbeschulen wenig unterscheiden. Ich bedaure dies hinsichtlich der Stosskraft der B'hsidee weil dadurch Bauschule u. Akademie, die wir miteinschliessen wollten, wieder an Daseinsrecht gewinnen.—Ich habe eine sehr hohe Meinung von der Architektur-Abteilung, weil ich glaube dass die neue Baukunst aus der Malerei herauswächst; diese stand und steht noch im Brennpunkt der modernen Kunst. Sie hat die Plastik erobert und ist im Begriff sich der Baukunst zu bemächtigen. Der Standpunkt des Architekten ist falsch, der die angewandten Künste und Künstler seinem Bau "schmückend" dienstbar macht; sie müssen ihn durchdringen.

Der Leiter und einzige Architekt des Bhs's müsste hier sein eigenstes und würdigstes Arbeitsgebiet haben.

Das *obligatorische* Probehalbjahr als Vorunterricht für die Neueingetretenen erscheint mir notwendig. (Vielleicht sind Ausnahmen in Einzelfällen von genügender Vorbildung u. ausgesprochener Klarheit über die zu erwählende Werkstatt zu erwägen.) Fraglicher erscheint die Weiterführung des *Obligatorismus* als *Form* Kurs, eine Massnahme die vielleicht berechtigt war bei dem früheren Zustand des Bhs, aber einer Revision bedürftig ist, seitdem der Meisterrat vollzählig ist. Das Obligatorische dieses Unterrichts misst diesem eine principielle [*sic*] Bedeutung bei, die die Schüler veranlassen kann darin ein Werturteil gegenüber den Kursen der andern Meister zu erblicken.

Ich halte es für notwendig dass das Bhs solange es staatl. Institut ist eine Neutralität in religiösen Dingen bewahrt, wenn nicht überhaupt eine Verpflichtung erwächst als staatl. Institut dem herrschenden Staatsgedanken zu dienen.

Oskar Schlemmer

5. Letter from Lothar Schreyer to Gropius, Weimar, December 9, 1921.

Lieber Herr Gropius:

Ich habe lang darüber nachgedacht und sehe nur einen Weg, die Krise

aus der Welt zu schaffen. Und fürchte fast, dass es hierzu schon zu spät ist.

Ich fürchte, dass es zwischen Ihnen und Herrn Itten zum offenen Kampf kommt, wenn die Gefühle der Montagsitzung nicht beseitigt werden können. Der Kampf aber wird Zerstörung bringen. Und er wird das Wesentliche am Bauhaus zerstören. Der Kampf wird die Machtfrage aufrollen. Es liegt in Ihrer Macht, Herrn Itten zum Niederlegen der Arbeit zu bringen. Und es liegt in Herrn Ittens Macht, Ihnen die Arbeit sehr zu erschweren. Das Bauhaus kann nicht einen dieser Fälle aushalten. Jeder dieser Fälle zerstört die gemeinsame Arbeit und teilt den Meisterrat in 2 Lager. Die Folgen eines Zwiespaltes zwischen uns sind für Unterricht und Werkstatt vernichtend. Ich bitte daher Sie und Herrn Itten, es nicht zum offenen Kampf kommen zu lassen und die Gefühle des geheimen Kampfes auszulöschen. Das ist wohl nur möglich, wenn Sie versuchen, auf alle gegenseitigen Forderungen zu verzichten und bei Anerkennung der persönlichen Verschiedenheiten anerkennen, dass das Bauhaus ein *gemeinsames* Werk ist und bleiben muss, an dem jeder nach besten Kräften gewirkt hat und wirken wird. Alle sachlichen Änderungen in Unterrichts- u Werkstatturteilung oder Organisationsfragen halte ich nur für Ausflüchte, so lange der Zwiespalt nicht grundsächlich beigelegt ist.

Verzeihen Sie dass ich so unumwunden meine Meinung ausspreche. Vielleicht können Sie mir recht geben und vielleicht finde ich Unterstützung im Meisterrat, dem ich Sie bitte diese Zeilen mitzuteilen.

Mit herzlichem Gruss

Lothar Schreyer

6. Gropius memorandum to the *Meisterrat*, Weimar, January 10, 1922.

Ich bitte den Meisterrat von in Abschrift mitfolgender Korrespondenz zwischen Meister Itten und mir Kenntnis zu nehmen.

Am 21. Dezember erfuhr ich durch Zufall von Herrn Zachmann [*Handwerkmeister* in the carpentry shop], dass er mit Meister Itten am kommenden Tage nach Leipzig fahren wolle, um Holzeinkäufe für umfangreiche Aufträge, die Meister Itten an die Tischlerei gegeben habe, zu machen. Weder bei mir persönlich noch im Sekretariat waren diese Aufträge angemeldet worden. Wenige Tage vorher waren auf Grund unserer letzten gemeinsamen Sitzung auf Wunsch des Meister Itten und aus Rücksicht auf die von ihm vorgebrachten Einwendungen die von mir bereits vermittelten Tischler-Aufträge für das Theater in Jena zurückgezogen worden. Da in der Sitzung verein-

bart worden war, dass zu Ende des Semesters die endgültige Klärung der aufgeworfenen Fragen herbeigeführt werden sollte, musste es mich befremden, dass er die Tischlereiwerkstatt, ohne sich darüber mit mir in Verbindung zu setzen, mit Aufträgen versorgt, die sie weit über diesen Zeitpunkt hinaus beschäftigen würde. Ich bat ihn deshalb in einem kurzen Schreiben in gleichem Masse wie ich es getan hätte von den von ihm persönlich erteilten Aufträgen Abstand zu nehmen. Die weiter sich an dieses kurze Schreiben, von dem ich keine Abschrift besitze, anknüpfende Korrespondenz mit Meister Itten, lege ich in Abschrift zur Kenntnisnahme bei.

In seinem Brief vom 10. Januar gibt Meister Itten Entschlüsse zur Kenntnis, die den Meisterrat in die Notwendigkeit versetzen der bis zum Semester-Ende vertagten Neuordnung der Arbeitsverteilung unter den Meistern nun sofort näher zu treten.

Ich bitte die Meister um schriftliche Stellungnahme zu der gesamten Angelegenheit unter gleichzeitiger Beifügung von praktischen Vorschlägen für evtl. Neuverteilung der Werkstätten bis zum Freitag, den 13. d.M. Ich werde dann anschliessend eine Meistersitzung zusammen bitten.

Gropius

7. Copies of the following six letters were included with the above Gropius memorandum to the *Meisterrat*. Itten's originals are also in the Bauhaus-Archiv.

a) Undated letter from Itten to Gropius. "22/12gr[opius]" (date received) added in pencil in upper right.

Meister Gropius/

Leider verreise ich in 2 Stdn. doch in Eile soviel. In der Sitzung wurde doch mit aller Deutlichkeit gesagt dass bis zum Semesterschluss die Werkstättenverteilung so bleibt wie bisher. Da ist doch Klarheit genug und ich handle darnach.

Gruss Itten

b) Gropius reply, December 22, 1921.

Meister Itten,

An der Werkstattverteilung ist von mir nichts geändert worden; ich bitte nur nochmals, da ich auf *Ihren* Wunsch von schon laufenden Aufträgen Abstand nahm, auch Ihrerseits davon Abstand zu nehmen, neue Aufträge an die Werkstatt zu geben. Ausserdem liegt die Ent-

scheidung über die Aufträge in meiner Hand, es sind mir aber keine Unterlagen vorgelegt worden, erst durch Meister Zachmann erfahre ich, dass Sie Aufträge vorbereiten, die die Werkstatt für mehr als ein halbes Jahr beschäftigen würden. Ich bitte Sie davon Abstand zu nehmen.

Gruss Gropius

c) Itten reply, January 4, 1922. "5/gr" (date received) in pencil in upper right.

Meister Gropius

Auf Ihr Schreiben vom 22. XII. 21 möchte ich Ihnen folgendes antworten.

In der Schreinerei habe ich seit ¾ Jahren Arbeiten vorbereitet auf deren Durchführung ich seit 2½ Jahren warte. Ich muss diese Aufträge nun zurücknehmen obschon ich der Überzeugung bin dass sie in jeder Beziehung/sowohl für Bauhaus wie Schüler von grösstem Vorteil wären. Statt dieser Aufträge müssen Ihre Bauaufträge ausgeführt werden die ich als in jeder Beziehung schädlich ablehne. Da Sie durch Ihr Vorgehen meine Arbeit in der Tischlerei in dem Augenblick sabotieren in welchem meine Vorbereitungen für intensive Arbeit zu Ende gediehen sind und die Arbeit beginnen soll so lehne ich hiemit jede Verantwortung für die Tischlerei ab.—

Ferner habe ich seit ½ Jahr öfters Sie gebeten für die Metallwerkstatt einen Meister zu suchen und anzustellen. Ich erkläre hiemit dass ich die Metallwerkstatt nicht mehr betrete und jede Verantwortung dafür ablehne.

In der Stein und Holzbildhauerei muss ich ebenfalls jede Verantwortung ablehnen da dort eine Arbeit ausgeführt werden muss die ich prinzipiel [sic] ablehne und die 3-4 Monate die freie Tätigkeit der Lehrlinge hemmen wird.

Also als Gesamtbild ergibt sich dass ich jede Verantwortung für oben genannte drei Werkstätten ablehnen muss. Meine Arbeit in den Werkstätten also aufgehört hat.

Ich behalte mir nun vor meinen Unterricht so einzuschränken dass ich etwa die Stundenzahl wie die andern Meister für Unterricht zur Verfügung stelle; *also meinen gesamten obligatorischen Unterricht aufgebe.*

Ihnen persönlich teile ich mit dass ich jedes tiefere Interesse am Bauhaus verloren habe und dass ich mich in Zukunft durchaus passiv / d.h. die vertraglichen Grenzen einhaltend verhalten werde.

Johannes Itten

d) Gropius reply, January 5, 1922.

Meister Itten,

Ich habe Ihren Brief vom 4. d. Mts. erhalten. Es wird mir schwer Ihre Einstellung zu verstehen. Es geschah nichts, als dass ich Sie um das gleiche bat, was ich selbst zuvor getan hatte und was mir der Takt aus der Lage der Dinge heraus gebot: Die Aufträge von der Tischlerei zurückzuhalten bis im Frühjahr die aufgetauchten Fragen zur Klärung gebracht waren. Es musste mich eigenartig berühren, als ich zufällig erfuhr, Sie hätten *nach* unserer neulichen Sitzung umfangreiche Arbeiten an die Werkstatt gegeben, *ohne* dass Sie mir, der ich als Leiter davon unterrichtet sein *muss*, das Geringste mitgeteilt hatten.

Auf meine einfache Bitte hin, Sie möchten von den geplanten Aufträgen vorläufig Abstand nehmen, erwidern Sie nun heute ich hätte Ihre Arbeit sabotiert und werfen mir alles vor die Füsse. Ich vermag nicht darauf zu antworten, ebensowenig wie auf die anderen Bemerkungen Ihres Briefes, denn ich sehe jetzt, dass die Gründe zu unserer Spannung weniger in der Sache als viel mehr in persönlichem liegen. Seit einiger Zeit hegen Sie einen förmlichen Hass gegen meine Person; warum konnte ich bis heute nicht ergründen. Solange nun Ihre völlig negative Einstellung zu meiner Person und meiner Arbeit bestehen bleibt, fürchte ich, dass trotz all meiner Bemühungen um Sie, keine gedeihliche Atmosphäre entstehen kann—. Ich bedaure das tief, da es die *Gemeinsamkeit* unseres Werkes paralysiert.

Wenn Sie es nicht auf sich nehmen wollen, wie wir neulich übereinkamen Ihre Arbeit weiter zu führen, so werde ich die Meister sogleich um ihre Entscheidung angehen. In diesem Falle darf ich Ihre Nachricht erwarten. Für jeden Fall bitte ich Sie bis zur Klärung der Lage Ihren ganzen Unterricht weiterzuführen, damit die Schüler nicht leiden müssen.

Gropius

e) Itten reply, January 10, 1922. "10/gr" added in pencil.

Meister Gropius

Ihr Schreiben vom 5.1.22 beantwortend möchte ich Ihnen folgendes mitteilen. Damit die Schüler keinen allzugrossen Schaden haben werde ich den Unterricht bis Ende des Semesters weiter führen. Ich erkläre aber dass ich zukünftig weder Vorkurs noch Form Unterricht erteilen und leiten werde. Deshalb bitte ich den Meisterrat von meiner Erklärung zu unterrichten.

In Bezug auf die Werkstätten bitte ich sowohl Tischlerei wie Metall-

werkstatt einem andern Meister zu übertragen. Ich werde die Stein und Holzbildhauerei behalten mit dem Vorbehalt dass ich keine Verantwortung übernehme für die gesamte Werkstattarbeit, sondern NUR für die Arbeiten die von mir veranlasst und angenommen sind.— 

Im Übrigen überlasse ich es durchaus Ihnen selbst den Gegensatz zwischen Ihnen und mir auszulegen wie es Ihnen angenehm ist. Ich *bitte* aber die Besprechungen der letzten zwei Sitzungen in denen über prinzipielle Dinge gesprochen wurde, dem wesentlichen Inhalte nach zu *protokollieren,* und zwar hielte ich es für notwendig dies möglichst bald zu tun.

In der Hoffnung dass ich mich nun so weit zurückgezogen habe dass Sie Ihre Absichten und Pläne frei entwickeln können ohne dass ich im Wege stehe mit meinen Einsichten und dass nun alle Diskussion ein Ende nimmt / will ich diese letzte Auseinandersetzung schliessen.

Johannes Itten

f) Gropius reply, January 10, 1922.

Meister Itten.

Ich habe mit aufrichtigem Bedauern Ihren Brief vom 10. gelesen. Ich muss nun für Klärung der ganzen Angelegenheit die Meister um ihre Entscheidung bitten. Wenn Sie mir bis morgen mittag nicht andere Vorschläge machen, nehme ich Ihr Einverständnis an, dass ich der Einfachheit halber den Meistern unsere Korrespondenz der letzten Tage als Unterlage zugängig mache.

Walter Gropius

8. Undated letter from Itten to Gropius. From its content, undoubtedly a reply to Gropius's memorandum of February 3, 1922 (excerpted in Wingler, *Bauhaus*, pp. 62–63).

Meister Gropius /

Durch meine Arbeit in den verflossenen 2½ Jahren die ich hier am Bauhaus geleistet habe glaube ich genügend klar gezeigt zu haben welches meine Ansicht ist in Bezug auf Erziehung/Unterricht und Leben / sodass ich es für durchaus überflüssig erachte mich dazu noch einmal zu äussern.

Im Übrigen kann ich mir kein klares Bild von den Absichten und Plänen die Sie uns mitteilen machen; weshalb ich auf meiner romantischen Insel in Stille verharre.

Johannes Itten

9. Muche memorandum to the *Meisterrat*, February 8, 1922, in reply
to Gropius's memorandum of February 3.

Ich schreibe folgende Zeilen mit der Absicht, die im Meisterrat
bestehenden Gegensätze möglichst deutlich zu machen, damit viel-
leicht auf diese Art zum Nutzen unserer gemeinsamen Arbeit eine
baldige Klarheit entsteht.

Ich bin der Meinung, dass Kunst sich heute noch ebenso Selbst-
zweck ist wie zu jeder Zeit, und dass sie für den eindeutig künstlerisch
begabten Menschen immer Selbstzweck bleiben wird, auch dort wo sie
angewandt erscheint. Ich befürchte, dass man die Freiheit der schöp-
ferischen Individualität zu eng begrenzen würde, wenn man die Nega-
tion einer Formel ("l'art pour l'art") zum Grundsatz erhebe würde.
Das zwecklose Bild ist in ebensolchem Masse ursprünglich schöp-
ferisch wie die zweckvolle Maschine des Technikers.

Kunst, Technik und Wissenschaft existieren in der Erscheinungs-
welt vollkommen ebenbürtig neben- und ineinander. Sie alle 3 sind
Äusserungen *des* Lebens, das in *der Form* sein natürliches Ende findet.
Sie alle 3 sind deshalb in geistiger Hinsicht sekundär. Ausserdem
könnte man die Kunst nicht dadurch auf eine höhere Stufe stellen, dass
man sie der Architektur oder Technik unter- oder überordnete. Sie
würde eher ihre eigentümliche Bedeutung verlieren. Im Gegensatz
z. B. zum Mittelalter wo das: "ut in omnibus glorificetur Deus" alle
sekundären Lebensformen einer primären unterordnete.

Was nun die wirtschaftliche Aussenwelt betrifft, so halte ich es für
verkehrt, sich ausser vielleicht im bürgerlichen Leben nach den
bestehenden Verhältnissen auf diesem Gebiet zu richten. Für wichtig
halte ich es aber, auf diese Aussenwelt den grösstmöglichen Einfluss
auszuüben, denn die gegenwärtig dort herrschenden Verhältnisse und
Lebensformen sind überaus verwirrt. Für gefährlich halte ich es, mit
dieser verwirrten, sinnverlorenen Formenwelt in kompromittierende
Verbindung zu treten, soweit es schöpferische und lebendige Dinge
betrifft. Die stetige, kompromisslose Weiterentwicklung des Bauhauses
könnte die Möglichkeit eines wirksamen Einflusses auf die allgemeinen
Zustände bieten.

Ich denke mir, dass zu dem Zeitpunkt, an dem die Angehörigen des
Bauhauses ihre Absichten in handwerklicher Hinsicht vollkommen
erfüllen können (aber nur von diesem Zeitpunkt ab) Werkstätten auf
breiterer Basis und mit maschineller Einrichtung errichtet werden
müssen, denn schon die Weitergabe unserer Werkstättenerzeugnisse
an Industriefirmen zur wirtschaftlichen Ausnutzung scheint mir ein

unerlaubtes Kompromiss zu sein, weil wir gerade dadurch auf eine allseitige Lösung künstlerisch-wirtschaftlicher Probleme zu früh verzichten würden. Wir könnten auch erst dann in materiell-finanzieller und allgemein wirtschaftlicher Hinsicht in zeitgemässe Bahnen kommen und zugleich die erhöhten Möglichkeiten technischer Maschinen für die Entfaltung künstlerischer Ideen ausnutzen. In dieser Richtung scheinen mir die aussichtsreichen Ziele des Bauhauses nach aussen zu liegen, während das innere Ziel in einer allseitigeren menschlichen Entwicklung liegt.

Kein Verhältnis habe ich zu dem was "zwecklose Maschine" genannt ist. Eine Maschine scheint mir gut zu sein, wenn sie ihre Aufgabe gut erfüllt. Eine Maschine, die diesen ihren Zweck nicht erfüllt scheint mir sinnlos zu sein, auch wenn sie die schönsten künstlerischen Formen hat. Sie ist dann ausserdem auch unkünstlerisch. Das Künstlervölkchen sollte nicht hinter den Technikern herlaufen, um ihnen ihre Maschinen nach einer modernen Ästhetik anzustreichen. Es wäre eine allzu lächerliche Rolle, zumal ihnen viel Techniker in schöpferischer Hinsicht weit überlegen sind, weil sie unsentimental und sachlich sein können.

Die Lehrfreiheit fasse ich nicht im akademischen, aber im freiesten Sinn auf.

Georg Muche

10. Marcks's reply to the Gropius memorandum, February 16, 1922. Marcks's memorandum was circulated and note taken thereof on an attached sheet dated February 21, 1922 by Feininger (who added "Stimme Marcks vollkommen bei!"), Itten, Klee, Muche, Schlemmer, and Schreyer.

Über das Rundschreiben vom 3.II.1922

Aus dem für und wider die mechanische Ästhetik kann man keine Weltanschauung ableiten. Die Maschine ist nicht *wegzuläugnen* [sic], und auch nicht zu überschätzen. Gebt ihr was das ihre ist. Heutigentags wird man selbstverständlich Eisenbahn fahren, und Schreibmaschinen gebrauchen, kaum aber wird man einen Liebesbrief oder an den Weihnachtsmann jemals mit der Maschine schreiben.

Wenn man also die mechanische Ästhetik nicht ablehnt, sondern sich zu ihr bekennt, dann gehe man unvoreingenommen an die Arbeit.

Die Maschinenform ist längst gefunden, und zwar von Ingenieuren, die vielleicht auch Künstler waren; denn Künstler ist keine Berufsfrage.

Es ist ebenso falsch dem Bau oder der Maschine fremde Elemente als stilbildend aufzuzwingen (jonische Säule oder Quadrat), wie es

leerer Ästhetizismus ist, maschinenähnliche Unmaschinen zu bilden.
Ein Koupé 3 Kl. kann durch Ästhetizismen, von aussen hereingetragen,
nur um seine Schönheit gebracht werden. Wer also den Ingenieuren
Schmiden [*sic*] Töpfern Tischlern etc helfen will der werde selbst einer,
d.h. er vertiefe sich in den Gegenstand und nicht in die Theorie.

Sonst gehts wie folgt:

Ein Maler wollte sich nach eigener Farbenkomposition ein Beet im
Garten machen lassen: und er hatte nicht nur die Farben im Kopf, er
wusste auch die Blumen die diese Farben hatten. Er berief also den
Gärtner: "Hier ist meine Idee, pflanzen Sie!" Der Gärtner aber
schüttelt den Kopf: "Mein Herr, Sie haben hier einen Kaktus neben
die Sumpflilie gesetzt, und das eine braucht Dürre, das andre Wasser.—
Hier sollen Kaiserkronen stehn, die im April blühn, und hier Sonnen-
blumen die im Oktober blühn, und darunter Kresse, die aber im
Schatten garnicht blüht,—ich kann das Beet nicht so machen."—"So!
dann sind Sie aber kein Gärtner!"—

Résumé: die mechanische Ästhetik betreffend, ist das Bauhaus
entstanden aus unsres Nichts durchbohrendem Gefühle, die Lehrlinge
sollen das werden, was leider keiner von uns ist: Formmeister und
Werkmeister in einer Person.



Gerhard Marcks
Dornburg 16.II.22



11. Itten's formal handwritten letter of resignation from the Bauhaus,
Weimar, October 4, 1922.

Herrn Direktor Walter Gropius/
  z. Händen des Thürig. Kultusministeriums



*Weimar*



Sehr geehrter Herr Gropius/

Da sich meine Auffassung von der Lösung der Aufgabe des staatl.
Bauhauses in den Hauptpunkten wesentlich unterscheidet von der
Art und Weise wie Sie als Leiter der Anstalt die Lösung versuchen, so
sehe ich mich ausserstande, mit die Verantwortung für das Gelingen
der Lösung tragen zu helfen. Dies veranlasst mich Sie zu bitten, mich
auf Ende des Wintersemesters 1922/23 aus dem Lehrkörper des staatl.
Bauhauses zu entlassen.

Meine Meinung über die Aufgaben des Bauhauses und deren
Lösung ist Ihnen bekannt, sodass ich auf eine nähere Begründung
meines Entschlusses verzichten kann.



Hochachtungsvollst zeichnet!
Johannes Itten



# BIBLIOGRAPHY

### Collections in Archives

For this study I have drawn chiefly upon three major sources of archival material: the Bauhaus-Archiv in Darmstadt, the Staatsarchiv in Weimar, and the Gropius archives in Lincoln, Massachusetts, the first two being the principal repositories for documents concerning Gropius and the Bauhaus. The nucleus of the Bauhaus-Archiv was formed from papers donated by Gropius. Apart from such Bauhaus documents as copies of statutes, memorandums and letters by faculty and students, and a number of minutes of faculty meetings, it contains letters to and from Gropius and fragments of his articles and speeches invaluable for the study of his career and ideas in Germany. From the Staatsarchiv, Weimar, I have made use of microfilms of the extant minutes of the Bauhaus faculty meetings. Each archive possesses copies of minutes not to be found in the other. Although much of the material from Gropius's own collection in Lincoln is now in Darmstadt, as of 1969 it still contained extensive correspondence and clipping files covering Gropius's entire career, and manuscripts of his published essays and books. Particularly valuable for this study was the file case labeled "Briefe, Arbeitsrat für Kunst, 1919/1921." The clipping files also exist in microfilm copy in the Lamont Library, Harvard University.

In addition to these sources, I have used the collected papers of
Lyonel Feininger in the Houghton Library, Harvard. Approximately half of his letters have been restricted until the death of
Mrs. Feininger, but copies of some of them exist in Mrs. Feininger's translations in the Busch-Reisinger Museum at Harvard,
and I have relied upon these when necessary. The Busch-Reisinger
Museum also possesses, it should be noted, a small number of
documents pertinent to the Bauhaus, principally in photocopies.
These primarily concern the later years of the school, and most of
them are also to be found in the other archives.

**Books and Articles**

This list is limited to works bearing directly upon the themes
treated in this study. I have by no means attempted to survey the
entire literature on the art and architecture of the periods in
question. For a comprehensive bibliography of the Bauhaus itself,
the reader is referred to Hans M. Wingler's book on the school.
Not every work cited in the notes has been included; on the other
hand, a number of works have been added which, while not specifically cited, were nevertheless useful either for background information or as further documentation for interpretations and
arguments.

Adams, George. "Memories of a Bauhaus Student." *Architectural Review* 144, no. 859 (September 1968): 192–194.

Adler, Bruno. "The Bauhaus 1919–33." *The Listener* 41, no. 1052 (March 24, 1949): 485–486.

———. "Damals in Weimar. . . ." *Das Kunstwerk* 17, no. 9 (March 1964): 29.

———. *Das Weimarer Bauhaus*. Vorträge zur Ideengeschichte des Bauhauses. Bauhaus-Archiv, Darmstadt [1963].

*Adolf Hoelzel (1853 bis 1934). Katalog der Gedächtnis-Ausstellung zum hundertsten Geburtstag von Adolf Hoelzel*. Kunstverein, Freiburg i. Br., July 1953.

*Adolf Hoelzel. Gedächtnisausstellung* (catalogue). Kestner-Gesellschaft, Hanover, January 20–February 24, 1935.

*Die Aktion*, 1911–1914. Edited by Franz Pfemfert. Introduction and commentary by Paul Raabe. 4 vols. Stuttgart, 1961.

Albers, Josef. "Werkstatt-Arbeiten des Staatlichen Bauhauses zu Weimar." *Neue Frauenkleidung und Frauenkultur*, no. 1 (January 1925), pp. 1–5.

*Arbeiten aus der graphischen Druckerei des Staatlichen Bauhauses in Weimar 1919–1925* (catalogue). Bauhaus-Archiv, Darmstadt, March 30–May 26, 1963.

"Arbeitsrat für Kunst." *Der Cicerone* 11, no. 1–2 (January 1919): 26.

"Der Arbeitsrat für Kunst in Berlin." *Der Cicerone* 11, no. 8 (April 1919): 230.

*Architecture 1918–1928: From the Novembergruppe to the C.I.A.M. (Functionalism and Expressionism). Proceedings of the Modern Architecture Symposium, May 4 and 5, 1962.* Columbia University, 1963.

Argan, Giulio Carlo. *Walter Gropius e la Bauhaus.* [Turin], 1951.

*Ausstellung für unbekannte Architekten veranstaltet vom Arbeitsrat für Kunst im Graphischen Kabinett J. B. Neumann, Kurfürstendamm 232, April 1919* (pamphlet).

Aust, Günter. *Otto Freundlich 1878–1943.* Cologne, 1960.

*Der Austausch. Veröffentlichungen der Studierenden am Staatlichen Bauhaus zu Weimar,* May, June, July, 1919.

Ball, Hugo. *Briefe 1911–1927.* Einsiedeln, Zurich, and Cologne, 1957.

———. *Die Flucht aus der Zeit.* Lucerne, 1946.

Banham, Reyner. "The Glass Paradise." *Architectural Review* 125, no. 745 (February 1959): 87–89.

———. *Theory and Design in the First Machine Age.* London, 1960.

Bartning, Otto. "Bau-Kunst, -Verwaltung und -Unterricht." *Vorwärts. Berliner Volksblatt. Zentralorgan der sozialdemokratischen Partei Deutschlands.* October 5, 1919.

———. "Vorschläge zu einem Lehrplan für Handwerker, Architekten und bildende Künstler." *Mitteilungen des Deutschen Werkbundes.* September 1, 1919, pp. 42–47.

*Bauhaus. Idee—Form—Zweck—Zeit* (catalogue). Göppinger Galerie, Frankfurt am Main, February 1–March 14, 1964.

*Bauhaus: Weimar, Dessau* (catalogue). Harvard Society for Contemporary Art, Cambridge, Massachusetts, 1930–1931.

Bayer, Herbert; Gropius, Walter; and Gropius, Ise, eds. *Bauhaus 1919–1928.* Boston, 1959.

Behne, Adolf. "Der Arbeitsrat für Kunst in Berlin." *Der Cicerone* 11, no. 9 (April 1919): 264.

———. "Bauhausresumee." *Sozialistische Monatshefte* 29 (September 18, 1923): 542–545.

————. "Berlin: Bauten." *Sozialistische Monatshefte* 27 (February 14, 1921): 165–166.

————. "Biologie und Kubismus." *Die Tat. Monatsschrift für die Zukunft deutscher Kultur* 9, no. 8 (November 1917): 694–705.

————. "Bruno Taut." *Der Sturm* 4, no. 198–199 (February 1914): 182–183.

————. "Deutsche Expressionisten." *Der Sturm* 5, no. 17–18 (December 1914): 114–115.

————. "Entwürfe und Bauten von Walter Gropius." *Zentralblatt der Bauverwaltung* 42, no. 104 (December 27, 1922): 637–640.

————. "Europa und die Architektur." *Sozialistische Monatshefte* 27 (January 17, 1921): 28–33.

————. "Expressionistische Architektur." *Der Sturm* 5, no. 19–20 (January 1915): 135.

————. "Holländische Baukunst in der Gegenwart." *Wasmuths Monatshefte für Baukunst* 4 (1921–1922): 1–32.

————. "Die internationale Architektur-Ausstellung im Bauhaus zu Weimar." *Die Bauwelt*, no. 37 (September 13, 1923), p. 533.

————. "Junge französische Architektur." *Sozialistische Monatshefte* 28 (June 8, 1922): 512–519.

————. "Die Kölner Werkbundausstellung." *Die Gegenwart*, no. 32 (1914), pp. 501–506.

————. "Kunst und Schule." *Sozialistische Monatshefte* 27, no. 14 (July 11, 1921): 607–611.

————. "Kunstwende?" *Sozialistische Monatshefte* 24 (October 15, 1918): 946–952.

————. "Kurze Chronik." *Sozialistische Monatshefte* 25, no. 2–3 (February 10, 1919): 136.

————. "Die neue Aufgabe der Kunst." *Sozialistische Monatshefte* 27, no. 18–19 (September 19, 1921): 813–815.

————. "Poelzig." *Sozialistische Monatshefte* 25, no. 2–3 (February 10, 1919): 131–134.

————. "Die russische Ästhetik." *Sozialistische Monatshefte* 24 (September 24, 1918): 894–896.

————. "Die Überwindung des Tektonischen in der russischen Baukunst." *Sozialistische Monatshefte* 24 (September 3, 1918): 833–837.

————. "Unbekannte Architekten." *Sozialistische Monatshefte* 25, no. 10 (April 28, 1919): 422–423.

————. "Vorschlag einer brüderlichen Zusammenkunft der Künstler

aller Länder." *Sozialistische Monatshefte* 25, no. 4–5 (March 3, 1919): 155–157.

———. "Wem gehört die Gothik?" *Sozialistische Monatshefte* 23, no. 22 (October 31, 1917): 1126–1129.

———. "Werkbund." *Sozialistische Monatshefte* 26 (January 26, 1920): 68–69.

———. *Die Wiederkehr der Kunst*. Leipzig, 1919.

———. "Die Zukunft unserer Architektur." *Sozialistische Monatshefte* 27 (January 31, 1921): 90–94.

Behrens, Peter. "Die Dombauhütte. Aus der Eröffnungsrede von Peter Behrens." *Deutsche Kunst und Dekoration* 51 (26. Jhrg., January 1923): 221–229.

———. "Einfluss von Zeit- und Raumausnutzung auf moderne Formentwicklung." In *Der Verkehr*. Jahrbuch des Deutschen Werkbundes 1914. Jena, 1914, pp. 7–10.

———. "Kunst und Technik." *Elektrotechnische Zeitschrift* 31, no. 22 (June 2, 1910): 552–555.

Benevolo, Leonardo. *Storia dell'architettura moderna*. 2 vols. Bari, 1960.

Berlage, H. P. "Foundations and Development of Architecture," pts. 1 and 2. *The Western Architect* 18, nos. 9, 10 (September and October 1912): 96–99, 104–108.

———. "Frank Lloyd Wright." *Wendingen* 4, no. 11 (1921): 3–8.

———. *Grundlagen und Entwicklung der Architektur. Vier Vorträge gehalten im Kunstgewerbemuseum zu Zürich*. Berlin, 1908.

———. "Modern Architecture." *The Western Architect* 18, no. 3 (March 1912): 29–36.

Biema, Carry van. *Farben und Formen als lebendige Kräfte*. Jena, 1930.

Bill, Max. "Bauhaus heute." *Form*, no. 22 (1963), pp. 3–5.

———. "The Bauhaus Idea." In *Architects' Year Book*, no. 5 (London, 1953), pp. 29–32.

Blake, Peter. *Marcel Breuer: Architect and Designer* (catalogue). Museum of Modern Art, New York, 1949.

Blanc, Charles. *Grammaire des arts décoratifs: décoration intérieure de la maison*. New ed. Paris, [1886].

*Der Blaue Reiter. Herausgegeben von Wassily Kandinsky und Franz Marc*. Edited and documented by Klaus Lankheit. Munich, 1965.

Blümner, Rudolf. *Der Geist des Kubismus und die Kunst*. Berlin, 1921.

Board, H. "Die Kunstgewerbeschule zu Düsseldorf." *Dekorative Kunst* 12 (7. Jhrg.), no. 11 (August 1904): 409–432.

Bode, Wilhelm von. "Aufgaben der Kunsterziehung nach dem Krieg." *Die Woche* 18, no. 14 (April 1, 1916): 469–471.

B[ogler], Th[eodor]. "Arbeiten des Staatl. Bauhauses Weimar. Keramische Werkstatt Dornburg-Saale." *Keramos* (August 3, 1924), pp. 287–289.

Bogler, Theodor. *Ein Mönch erzählt*. Honnef/Rhein, 1959.

Borsi, F., and König, G. K. *Architettura dell'espressionismo*. Genoa and Paris, 1967.

Bosselt, Rudolf. "Der Unterricht im Zeichnen auf den Schulen." In *Die Durchgeistigung der deutschen Arbeit. Wege und Ziele in Zusammenhang von Industrie, Handwerk und Kunst*. Jahrbuch des Deutschen Werkbundes 1912. Jena, 1912, pp. 71–75.

Bracher, Karl Dietrich. *Die Auflösung der Weimarer Republik*. 3d enlarged ed. Villingen/Schwarzwald, 1960.

Breuer, Marcel. "Aspects of the Art of Paul Klee." *Museum of Modern Art Bulletin* 17, no. 4 (Summer 1950): 3–5.

Breuer, Robert. "Die Cölner Werkbund-Ausstellung, Mai-Oktober 1914." *Deutsche Kunst und Dekoration* 34 (17. Jhrg.), no. 12 (September 1914): 417–436.

———. "Typus und Individualität. Zur Tagung des deutschen Werkbundes, Köln, 2.–4. Juli 1914." *Deutsche Kunst und Dekoration* 34 (17. Jhrg.), no. 11 (August 1914): 378–387.

Brown, Theodore M. *The Work of G. Rietveld Architect*. Utrecht, 1958.

Coellen, Ludwig. *Die neue Malerei*. Munich, 1912.

Collins, George R. *Antonio Gaudí*. New York, 1960.

Collins, Peter. *Changing Ideals in Modern Architecture 1750–1950*. London, 1965.

Conrads, Ulrich, ed. *Programme und Manifeste zur Architektur des 20. Jahrhunderts*. Berlin, Frankfurt am Main, and Vienna, 1964.

———, and Sperlich, Hans G. *The Architecture of Fantasy: Utopian Building and Planning in Modern Times*. Translated, edited, and expanded by C. C. Collins and G. R. Collins. New York and Washington, 1962.

Cornelius, Hans. *Elementargesetze der bildenden Kunst*. 3d enlarged ed. Leipzig and Berlin, 1921.

Cox, Anthony. "The Bauhaus: A Summing-up." *Architectural Review* 86, no. 515 (October 1939): 172–173.

Crane, Walter. *The Bases of Design*. London, 1898.

Creighton, Thomas H. "Walter Gropius and the Arts." In *Four Great*

*Makers of Modern Architecture, Gropius, Le Corbusier, Mies van der Rohe, Wright: A verbatim record of a symposium held at the [Columbia University] School of Architecture from March to May 1961.* New York, 1963, pp. 247–258.

Curjel, Hans. "Johannes Itten." *Werk* 44, no. 10 (October 1957): 359–366.

Dearstyne, Howard. "The Bauhaus Revisited." *Journal of Architectural Education* 17, no. 1 (October 1962): 13–16 (supplement to *Journal of the American Institute of Architects* 38, no. 4); Gropius letter, *JAIA* 39, no. 6 (June 1963): 120–121, with Dearstyne reply; Gropius letter, *JAIA* 40, no. 3 (September 1963): 105–106, with Dearstyne reply.

Debschitz, Wilhelm von. "Eine Methode des Kunstunterrichts." *Dekorative Kunst* 12 (7. Jhrg.), no. 6 (March 1904): 209–227.

Delaunay, Robert. *Du cubisme à l'art abstrait: documents inédits publiés par Pierre Francastel et suivis d'un catalogue de l'oeuvre de R. Delaunay par Guy Habasque.* Paris, 1957.

*Deutsche Form im Kriegsjahr. Die Ausstellung Köln 1914.* Jahrbuch des Deutschen Werkbundes 1915. Munich, 1915.

*Deutsche Kunsterziehung* [Essays commissioned by the *Deutsche Landesausschuss* for the 3d International Congress for the Advancement of Drawing and Art Teaching, London, 1908]. Leipzig and Berlin, 1908.

*Das deutsche Kunstgewerbe 1906. III Deutsche Kunstgewerbe-Ausstellung Dresden 1906* (catalogue). Munich, 1906.

Doesburg, Theo van. "'Der Wille zum Stil' (Neugestaltung von Leben, Kunst und Technik)." *De Stijl* 5, nos. 2, 3 (February and March 1922): 23–32, 33–41.

Dorner, Alexander. *The Way Beyond "Art"—the Work of Herbert Bayer.* New York, 1947.

Dressler, Willy Oskar, ed. *Dresslers Kunsthandbuch. Das Buch der lebenden deutschen Künstler, Altertumsforscher, Kunstgelehrten und Kunstschriftsteller.* Berlin, 1930.

*Die Durchgeistigung der deutschen Arbeit. Wege und Ziele in Zusammenhang von Industrie, Handwerk und Kunst.* Jahrbuch des Deutschen Werkbundes 1912. Jena, 1912.

Eckardt, Wolf von. "The Bauhaus." *Horizon* 4, no. 2 (November 1961): 58–75.

———. "The Bauhaus in Weimar." In *Four Great Makers of Modern Architecture, Gropius, Le Corbusier, Mies van der Rohe, Wright: A verbatim record of a symposium held at the [Columbia Uni-*

*versity*] *School of Architecture from March to May 1961.* New York, 1963.

Eckardt, Wolfgang. *Otto Dorfner.* Stuttgart, 1960.

Eckstein, Hans. "Das Bauhaus und seine Maler." *Zeitschrift für Kunst* 4, no. 4 (1950): 300–305.

Endell, August. "Deutsche Tracht." *Die neue Rundschau* 25 (September 1914): 1458–1462.

———. "Erneuerung der Akademien." *Das Kunstblatt* 3, no. 3 (March 1919): 93–94.

———. "Kunst und Maschine." *Dekorative Kunst* 27 (22. Jhrg.), no. 11 (August 1919): 327–329.

Endow, Eckart von. *Die deutsche expressionistische Kultur und Malerei.* Berlin, 1920.

Erffa, Helmut von. "The Bauhaus Before 1922." *College Art Journal* 3, no. 1 (November 1943): 14–20.

———. "Bauhaus: First Phase." *Architectural Review* 122 (August 1957): 103–105.

———. "Das frühe Bauhaus. Jahre der Entwicklung 1919–23." *Wallraf-Richartz-Jahrbuch* 24 (1962): 413–414.

*Erste russische Kunstausstellung Berlin 1922* (catalogue). Galerie van Diemen and Co., Berlin, 1922.

Ettel, J. "40 Jahre Wiener Jugendkunstklasse von Franz Cizek." *Die Österreichische Schule*, no. 8, (1937), pp. 567–576.

*Expressionismus. Literatur und Kunst 1910–1923* (catalogue). Eine Ausstellung des deutschen Literaturarchivs im Schiller-Nationalmuseum, Marbach a. N., May 8–October 1960.

Feininger, T. Lux. "The Bauhaus: Evolution of an Idea." *Criticism* 2, no. 3 (Summer 1960): 260–277.

Fiedler, Konrad. *Schriften über Kunst.* Vol. 2, *Nachlass.* Munich, 1914.

*50 Years Bauhaus: German Exhibition Sponsored by the Federal Republic of Germany, Organized by the Württembergischer Kunstverein, Prepared in Connection with the Bauhaus-Archiv, Darmstadt.* Illinois Institute of Technology, August 25-September 26, 1969.

Fischel, Hartwig. "Die Frühjahrausstellung österreichischer Kunstgewerbe und der k. k. Kunstgewerbeschule im Österreichischen Museum." *Kunst und Kunsthandwerk* 15 (1912): 329–363.

Fischer, Theodor. *Für die deutsche Baukunst.* Flugschriften des Münchener Bundes, no. 2. Munich, October 1917.

———. "Fur die Zukunft der deutschen Baukunst." *Deutsche Bauhütte* 22, no. 15–16 (April 12, 1918): 73–78.

————. "Was ich bauen möchte." *Der Kunstwart* 20, pt. 1, no. 1 (October 1906): 5–9.

*Die Form ohne Ornament. Werkbundausstellung 1924.* Introduction by Wolfgang Pleiderer and foreword by Walter Riezler. Stuttgart, Berlin, and Leipzig, 1924.

*50 Jahre Deutscher Werkbund.* Edited with introduction by Hans Eckstein. Frankfurt am Main and Berlin, 1958.

Gay, Peter. *Weimar Culture: The Outsider as Insider.* New York, 1968.

Gehlen, Arnold. *Zeit-Bilder. Zur Soziologie und Ästhetik der modernen Malerei.* Frankfurt am Main and Bonn, 1960.

Gerstenberg, Kurt. "Revolution in der Architektur." *Der Cicerone* 11, no. 9 (May 1919): 255–257.

Giedion, S[igfried]. "Das Bauhaus und seine Zeit." In *Die Zeit ohne Eigenschaften. Eine Bilanz der zwanziger Jahre.* Stuttgart, 1961, pp. 15–31. With discussion by Georg Muche, Lucia Moholy, Walther Kiaulehn, Hans Mersmann, Joseph Albers, Gustav Hassenpflug, Karl Pawek, pp. 139–157.

————. *Space, Time, and Architecture.* 4th enlarged ed. Cambridge, Mass., 1962.

————. "Walter Gropius." *L'Architecture d'aujourd'hui* no. 28 (February 1950), pp. 6–8.

————. *Walter Gropius, Work and Teamwork.* New York, 1954.

*Die gläserne Kette. Visionäre Architekturen aus dem Kreis um Bruno Taut 1919–1920* (catalogue). Museum Leverkusen, Schloss Morsbroich, and in der Akademie der Künste Berlin, [1963].

Gleizes, Albert. *Du cubisme et des moyens de le comprendre.* Paris, 1920.

————. "Tradition und Freiheit." *Das Kunstblatt* 6, no. 1 (January 1922): 26–32.

Goldwater, Robert. *Primitivism in Modern Art.* Revised ed. New York, 1966.

Goll, Ivan. "Der Purismus." *Der Ararat* 2 (November 1921): 280–282.

————. "Über Kubismus." *Das Kunstblatt* 4, no. 7 (July 1920): 215–222.

Gordon, Donald E. "On the Origin of the Word 'Expressionism'." *Journal of the Warburg and Courtauld Institutes* 29 (1966): 368–385.

Graeff, Werner. "Bemerkungen eines Bauhäuslers." In *Werner Graeff-Essen* (catalogue). Städtische Kunstgalerie, Bochum, March 3–31, 1963.

————. "Mit der Avantgarde." In *Werner Graeff* (catalogue). Kunst-

verein für die Rheinlande und Westfalen, Kunsthalle, Düsseldorf, November 9–December 9, 1962.

Greenberg, Allan. "Artists and the Weimar Republic: Dada and the Bauhaus, 1917–1925." Ph.D. dissertation, University of Illinois, 1967.

Grohmann, Will. "Zehn Jahre Novembergruppe." *Kunst der Zeit. Zeitschrift für Kunst und Literatur* 3, no. 1–3 (special no.: Zehn Jahre Novembergruppe), 1928.

Gropius, Walter. Illustrations of Gropius's architecture in *Wasmuths Monatshefte* 7 (1922–23): 323–354.

——. "Der Baugeist der neuen Volksgemeinde." *Die Glocke* 10 (June 5, 1924): 311–315.

——. "Baugeist oder Krämertum?" *Die Schuhwelt* (Pirmasens), no. 37 (October 15, 1919), pp. 819–821; no. 38 (October 22, 1919), pp. 858–860; no. 39 (October 29, 1919), pp. 894–895.

——. "Baukunst im freien Volksstaat." In *Deutscher Revolutions-Almanach für das Jahr 1919.* Hamburg and Berlin, 1919, pp. 134–136.

——. "Die Entwicklung moderner Industriebaukunst." in *Die Kunst in Industrie und Handel.* Jahrbuch des Deutschen Werkbundes 1913. Jena, 1913, pp. 17–22.

——. *The New Architecture and the Bauhaus.* Translated by P. Morton Shand. Cambridge, Mass., 1965.

——. *Scope of Total Architecture.* New York, 1962.

——. "Der stilbildende Wert industrieller Bauformen." In *Der Verkehr.* Jahrbuch des Deutschen Werkbundes 1914. Jena, 1914, pp. 29–32.

——. "Tradition and Continuity in Architecture," pt. 1. *Architectural Record* 135, no. 5 (May 1964): 131–136.

"Gropius at Twenty-six." *Architectural Review* 130 (July 1961): 49–51.

Gross, Karl. "Das Ornament." In *Die Durchgeistigung der deutschen Arbeit. Wege und Ziele in Zusammenhang von Industrie, Handwerk und Kunst.* Jahrbuch des Deutschen Werkbundes 1912. Jena, 1912, pp. 60–64.

Grunow, Gertrud. "Der Aufbau der lebendigen Farbe, Form, Ton." In *Staatliches Bauhaus Weimar, 1919–23.* Weimar and Munich, 1923, pp. 20–23.

Gurlitt, Cornelius. *Die deutsche Kunst des neunzehnten Jahrhunderts. Ihre Ziele und Taten.* 3d ed. Berlin, 1907.

H. G. "Eine staatliche Schule für Expressionismus in Wien." *Der Cicerone* 13, no. 15–16 (August 1921): 452.

Hagstotz, Hilda Boettcher. *The Educational Theories of John Ruskin.* Lincoln, Neb., 1942.

Hartlaub, G[ustav] F. *Kunst und Religion. Ein Versuch über die Möglichkeit neuer religiöser Kunst.* Leipzig, 1919.

Hartwig, Josef. *Leben und Meinungen des Bildhauers Josef Hartwig.* Frankfurt am Main, 1955.

Hausenstein, Wilhelm. *Die bildende Kunst der Gegenwart: Malerei, Plastik, Zeichnung.* Stuttgart and Berlin, 1914.

Hausmann, R.; Arp, Hans; Puni, Iwan; and Moholy-Nagy, [Laszlo]. "Aufruf zur elementaren Kunst." *De Stijl* 4, no. 10 (October 1921): 156.

Hentzen, Alfred. *Werner Gilles.* Cologne, 1960.

Herbert, Gilbert. *The Synthetic Vision of Walter Gropius.* Johannesburg, 1959.

Herbert, Robert L., ed. *The Art Criticism of John Ruskin.* Garden City, 1964.

Hess, Hans. *Lyonel Feininger.* New York, 1961.

Hess, Walter. "Adolf Hoelzel zum 100. Geburtstag." *Die Kunst und das schöne Heim* 51, no. 11 (August 1953): 414–415.

———. *Das Problem der Farbe in den Selbstzeugnissen moderner Maler.* Munich, 1953.

———. "Zu Hölzels Lehre." *Der Pelikan. Zeitschrift der Pelikan-Werke Günther Wagner Hannover,* no. 65 (April 1963), pp. 18–34.

Heuss, Theodor. *Hans Poelzig. Lebensbild.* Tübingen, 1939.

———. "Phantasie und Baukunst." *Der Kunstwart* 32, pt. 4, no. 19 (July 1919): 17–20.

Hilberseimer, L[udwig]. "Paul Scheerbart und die Architekten." *Das Kunstblatt* 3, no. 9 (September 1919): 271–274.

Hildebrand, Adolf. *The Problem of Form in Painting and Sculpture.* Translated by Max Meyer and Robert Morris Ogden. New York, 1907.

Hildebrandt, Hans. *Adolf Hoelzel.* Stuttgart, 1952.

———. "Adolf Hoelzel. Ein Beitrag zu seinem Wirken als Lehrer." *Werk* 40, no. 3 (March 1953): 99–104.

———. "Die Zukunft der Monumentalmalerei." *Mitteilungen des Deutschen Werkbundes.* 1918, no. 2, pp. 25–29.

Hirschfeld-Mack, L. *The Bauhaus: An Introductory Survey.* With a

foreword by Walter Gropius, an introduction by Joseph Burke, and an epilogue by Sir Herbert Read. Victoria, 1963.

Hitchcock, Henry-Russell. *Architecture: Nineteenth and Twentieth Centuries.* Baltimore, 1958.

Hoeber, Fritz. "Die Aufgabe der Baukunst in der Kultur unserer Zeit." *Dekorative Kunst* 26 (21. Jhrg.), no. 8 (May 1918): 238–242.

———. "Das neue Bauhaus in Weimar." *Der Architekt* 22 (1919): 22.

———. *Peter Behrens.* Munich, 1913.

———. "Revolutionierung des Kunstunterrichts." *Die neue Rundschau* 30, no. 4 (April 1919): 487–497.

Hölzel, Adolf. "Gedanken über die Erziehung des künstlerischen Nachwuches." *Der Pelikan,* no. 10 (1920), pp. 7–16.

Hoelzel, Adolf. *Gedanken und Lehren.* Collected by Maria Lemmé. Stuttgart, 1953.

Hölzel, Adolf. "Über künstlerische Ausdrucksmittel und deren Verhältnis zu Natur und Bild." *Die Kunst für Alle* 20, no. 4 (November 15, 1904): 81–88; no. 5 (December 1, 1904): 106–113; no. 6 (December 15, 1904): 121–142.

*Hölzel und sein Kreis. Der Beitrag Stuttgarts zur Malerei des 20. Jahrhunderts* (catalogue). Kunstverein, Stuttgart, September 8-November 5, 1961.

Hoffmann, Hubert. "Das historische Bauhaus. Eine Darstellung seiner Idee und Geschichte 1919–1933." *Baukunst und Werkform,* no. 10–11 (October-November 1953), pp. 564–570.

Hübner, Herbert. *Die soziale Utopie des Bauhauses. Ein Beitrag zur Wissenssoziologie in der bildenden Kunst.* Ph.D. dissertation, Westfälische Wilhelms-Universität zu Münster. Darmstadt, 1963.

Huszar, Vilmos. "Das staatliche Bauhaus in Weimar." *De Stijl* 5, no. 9 (September 1922): 135–138.

Itten, Johannes. "Adolf Hölzel und sein Kreis." *Der Pelikan. Zeitschrift der Pelikan-Werke Günther Wagner Hannover,* no. 65 (April 1963), pp. 34–40.

———. *Analysen alter Meister.* Utopia: Dokumente der Wirklichkeit. Weimar, 1921.

———. *Design and Form: The Basic Course at the Bauhaus.* Translated by John Maass. New York, 1964.

———. "Erziehung durch bildnerisches Tun." In *Handbuch der Kunst- und Werkerziehung.* Vol. 1, *Allgemeine Grundlagen der Kunstpädagogik.* 2d ed. Berlin, 1953, pp. 440–442.

———. "The Foundation Course at the Bauhaus." In *Education of Vision.* Edited by Gyorgy Kepes. New York, 1965, pp. 104–121.

————. "Meine Bauhaus-Jahre." *Werk* 51, no. 1 (January 1964): 27–28.

————. "Pädagogische Fragmente einer Formlehre." *Form* 5, no. 615 (1930): 141–161.

————. *Tagebuch. Beiträge zu einen Kontrapunkt der bildenden Kunst.* Berlin, 1930.

————. "Der Vorkurs." *Form*, no. 6 (1959), pp. 12–17.

*In Memoriam Laszlo Moholy-Nagy* (catalogue). Museum of Non-Objective Art, New York, May 15–July 10, 1947.

J. Gr. "Keramische Ausbildung im 'Staatlichen Bauhaus.' " *Keramische Rundschau* 30, no. 7 (February 16, 1922): 72.

*Ja! Stimmen des Arbeitsrates für Kunst in Berlin.* Berlin, November 1919.

Jäckh, Ernst. *Der Goldene Pflug. Lebensernte eines Weltbürgers.* Stuttgart, 1954.

Jaffé, H. L. C. *De Stijl 1917–1931: The Dutch Contribution to Modern Art.* Amsterdam, 1956.

Janda, Annegrete. "Bauhauskeramik." *Kunstmuseen der Deutschen Demokratischen Republik. Mitteilungen und Berichte* 2 (1959): 83–114.

Jessen, Peter. "Der Werkbund und die Grossmächte der deutschen Arbeit." In *Die Durchgeistigung der deutschen Arbeit. Wege und Ziele in Zusammenhang von Industrie, Handwerk und Kunst.* Jahrbuch des Deutschen Werkbundes 1912. Jena, 1912, pp. 2–10.

*Johannes Itten gesehen von Freunden und Schülern* [no publishing information].

*Junge Menschen. Monatshefte für Politik, Kunst, Literatur und Leben aus dem Geiste der jungen Generation* 5, no. 8 (Bauhaus special issue, November 1924).

[Kahnweiler], Daniel Henry. "André Derain." *Das Kunstblatt* 3, no. 10 (October 1919): 289–304.

————. *Der Weg zum Kubismus.* Munich, 1920.

Kampffmeyer, Hans. *Friedenstadt. Ein Vorschlag für ein deutsches Kriegsdenkmal.* 2d ed. Jena, 1918.

Kandinsky, Wassily. *Essays über Kunst und Künstler.* Edited by Max Bill. Bern, 1955.

————. *Punkt und Linie zu Fläche. Beitrag zur Analyse der malerischen Elemente.* 2d ed. Munich, 1928.

————. *Schematic Plan of Studies and Work of the Institute of Art Culture, Proposed by Wassily Kandinsky.* In *In Memory of*

*Wassily Kandinsky* (catalogue). Museum of Non-Objective Art, New York, 1945, pp. 75–86.

———. *Über das Geistige in der Kunst, insbesondere in der Malerei.* 2d ed. Munich, 1912.

Kémeny, [Alfred], and Moholy-Nagy, [Laszlo]. "Dynamisch-konstruktives Kraftsystem." *Der Sturm* 13, no. 12 (December 1922): 186.

Kerschensteiner, Georg. *Begriff der Arbeitsschule.* Leipzig and Berlin, 1912.

———. "Die Entwicklung der zeichnerischen Begabung." In *Deutsche Kunsterziehung.* Leipzig and Berlin, 1908, pp. 13–26.

Klee, Paul. *The Thinking Eye: The Notebooks of Paul Klee.* Edited by Jürg Spiller. New York and London, 1961. Translated by Ralph Manheim from *Das bildnerische Denken.* Basel and Stuttgart, 1956.

Klopfer, Paul. "Das Bauhaus aus der Nähe gesehen." *Baukunst und Werkform,* no. 2–3 (February-March 1953), pp. 80–83.

Kluge, Kurt. *Die Neugestaltung der Künstlererziehung gelegentlich der Eingabe der Leipziger Künstlerschaft an das Kultusministerium* (pamphlet). Leipzig, December 17, 1918.

Knoblauch, Adolf. "Die Kirche (für Lyonel Feininger)." *Der Sturm* 7, no. 12 (March 1917): 143.

Kropotkin, Peter. *Fields, Factories and Workshops.* London, 1898. German eds., *Landwirtschaft, Industrie und Handwerk.* 1904, 1910, 1921 (enlarged ed.).

Kühn, Herbert. "Expressionismus und Sozialismus." *1919. Neue Blätter für Kunst und Dichtung* 2 (May 1919): 28–30.

Küppers, Paul Erich. *Der Kubismus. Ein künstlerisches Formproblem unserer Zeit.* Leipzig, 1920.

Kultermann, Udo. "Paul Scheerbart und die Architektur im 20. Jahrhundert." In *Handbuch des Bauwesens 1963.* Stuttgart, 1962, pp. 46–63.

———. *Der Schlüssel zur Architektur von heute.* Vienna and Düsseldorf, 1963.

———. *Wassili und Hans Luckhardt, Bauten und Entwürfe.* Tübingen, 1958.

*Die Kunst in Industrie und Handel.* Jahrbuch des Deutschen Werkbundes 1913. Jena, 1913.

*Kunsterziehung. Ergebnisse und Anregungen des Kunsterziehungstages in Dresden am 28. und 29. September 1901.* Leipzig, 1902.

*Kunstgewerbe. Ein Bericht über Entwicklung und Tätigkeit der Hand-*

*werker- u. Kunstgewerbeschulen in Preussen.* Published by the Bund der Kunstgewerbeschulmänner. Berlin, 1922.

"Das Kunstprogramm des Kommissariats für Volksaufklärung in Russland." *Das Kunstblatt* 3, no. 3 (March 1919): 91–93.

*Kunst- und Kulturrat. Weltanschauung, Dichtung, Graphik. Monatsblätter für die Persönlichkeit,* no. 8 (February 1920). Edited by Joseph Aug. Lux, in collaboration with, *inter alia*, Peter Behrens, Karl Hagemann, Ernst Osthaus, Paul Schultze-Naumburg, Karl Schmidt, and the Oesterreichische Werkbund.

"Kunstschulen." *Kunst und Künstler* 5, no. 5 (February 1907): 206–210.

Lane, Barbara Miller. *Architecture and Politics in Germany, 1918–1945.* Cambridge, Mass., 1968.

Lang, Lothar. *Das Bauhaus 1919–1933. Idee und Wirklichkeit.* Studienreihe angewandte Kunst, Neuzeit 2. Berlin, 1965.

Lankheit, Klaus. "Die Frühromantik und die Grundlagen der 'gegenstandslosen Malerei.'" *Neue Heidelberger Jahrbücher,* new series, 1951, pp. 55–90.

Lauterbach, Heinrich, and Joedicke, Jürgen. *Hugo Häring. Schriften, Entwürfe, Bauten.* Dokumente der modernen Architektur. Beiträge zur Interpretation und Dokumentation der Baukunst, vol. 4. Stuttgart, 1965.

Le Corbusier. *Vers une architecture.* Paris, 1923.

Léger, Fernand. "Les Origines de la peinture contemporaine et sa valeur représentative." *Der Sturm* 4, no. 172–173 (August 1913): 76–79.

Lehmann-Haupt, Hellmut. *Art under a Dictatorship.* New York, 1954.

Lethaby, W. R. *Form in Civilization.* London, 1922.

Lichtwark, Alfred. *Eine Auswahl seiner Schriften.* 2 vols. Berlin, 1917.

Lindahl, Göran. "Von der Zukunftskathedrale bis zur Wohnmaschine. Deutsche Architektur und Architekturdebatte nach dem ersten Weltkriege." In *Idea and Form.* Figura: Uppsala Studies in the History of Art, N.S., vol. 1, 1959, pp. 226–282.

Lipps, Theodor. *Ästhetik. Psychologie des Schönen und der Kunst.* Vol. 1, *Grundlegung der Ästhetik.* Vol. 2, *Die ästhetische Betrachtung und die bildende Kunst.* Hamburg, 1903, 1906.

———. *Raumästhetik und geometrisch-optische Täuschungen.* Leipzig, 1897.

Logan, Frederick. "Kindergarten and Bauhaus." *College Art Journal* 10, no. 1 (Fall 1950): 36–43.

Loos, Adolf. "Richtlinien für ein Kunstamt." *Der Friede*, no. 62 (1919).

———. *Sämtliche Schriften*, vol. 1. Edited by Franz Glück. Vienna and Munich, 1962.

———. "Über Architektur." *Der Sturm* 1, no. 42 (December 15, 1910): 334.

Lux, Joseph August. *Das neue Kunstgewerbe in Deutschland*. Leipzig, 1908.

Macke, August, and Marc, Franz. *Briefwechsel*. Cologne, 1964.

Maldonado, Tomás. "Ist das Bauhaus aktuell?" *Ulm. Zeitschrift der Hochscule für Gestaltung*, no. 8–9 (September 1963), pp. 5–13.

———. "New Developments in Industry and the Training of the Designer." *Ulm*, no. 2 (October 1958), pp. 25–40.

*Die Maler am Bauhaus* (catalogue). Introduction by Ludwig Grote. Haus der Kunst, Munich, May-June 1950.

"Manifest 1 of 'The Style', 1918." *De Stijl* 2, no. 1 (November 1918): 4.

Marc, Franz. *Briefe, Aufzeichnungen und Aphorismen*. 2 vols. Berlin, 1920.

Marquina, E. "La Sagrada Familia." *L'Art et les artistes* 6, no. 11 (February 1908): 516–522.

Mayer, Hans. "Rückblick auf den Expressionismus." *Neue deutsche Hefte* 13, no. 4 (1966): 32–51.

Mendelsohn, Erich. *Briefe eines Architekten*. Edited by Oskar Beyer. Munich, 1961.

———. *Das Gesamtschaffen des Architekten*. Berlin, 1930.

Miesel, Victor H. "The Term Expressionism in the Visual Arts (1911–1920)." In *The Uses of History*. Edited by Hayden V. White. Detroit, 1968, pp. 135–151.

Moholy-Nagy, Laszlo. *The New Vision* and *Abstract of an Artist*. New York, 1947.

———. "Produktion-Reproduktion." *De Stijl* 5, no. 7 (July 1922): 98–100.

———. *Vision in Motion*. Chicago, 1947.

Moholy-Nagy, Sibyl. *Moholy-Nagy; Experiment in Totality*. Introduction by Walter Gropius. New York, 1950.

Mosse, George L. *The Crisis of German Ideology: Intellectual Origins of the Third Reich*. New York, 1964.

Muche, Georg. *Blickpunkt. Sturm, Dada, Bauhaus, Gegenwart*. Munich, 1961.

*München 1869–1958. Aufbruch zur modernen Kunst* (catalogue). Haus der Kunst, Munich, June 21–October 5, 1958.

Muthesius, Hermann. "Die Bedeutung des Kunstgewerbes. Eröffnungsrede zu den Vorlesungen über modernes Kunstgewerbe an der Handelshochschule in Berlin." *Dekorative Kunst* 15 (10. Jhrg.), no. 5 (February 1907): 177–192.

————. *Die Einheit der Architektur. Betrachtungen über Baukunst, Ingenieurbau und Kunstgewerbe.* Berlin, 1908.

————. *Die englische Baukunst der Gegenwart.* 2 vols. Leipzig and Berlin, 1900.

————. *Das englische Haus.* 3 vols. Berlin, 1904–5.

————. "Das Formproblem im Ingenieurbau." In *Die Kunst in Industrie und Handel.* Jahrbuch des Deutschen Werkbundes 1913. Jena, 1913, pp. 23–32.

————. *Kultur und Kunst.* 2d ed. Jena, 1909.

————. *Kunstgewerbe und Architektur.* Jena, 1907.

————. "Kunst und Maschine." *Dekorative Kunst* 9 (5. Jhrg.), no. 4 (January 1902): 141–147.

————. "Die neuere Entwicklung und der heutige Stand des kunstgewerblichen Schulwesens in Preussen." In *Das deutsche Kunstgewerbe 1906. III. deutsche Kunstgewerbeausstellung Dresden 1906.* Munich, 1906, pp. 41–51.

————. "Die Verpflichtung zur Form (Aus einem Vortrage)." *Dekorative Kunst* 26 (21. Jhrg.), no. 11 (August 1918): 305–316.

————. "Die Werkbund-Arbeit der Zukunft, und Aussprache darüber von Ferdinand Avenarius, Peter Behrens, Rudolf Bosselt, Robert Breuer, Peter Bruckmann, August Endell, von Engelhardt, Karl Gross, Hermann Obrist, Karl Ernst Osthaus, Wilhelm Ostwald, Erich Pistor, E. A. Reichel, Richard Riemerschmid, Walter Riezler, Karl Schäfer, Bruno Taut, Jòszef Vàgò, van de Velde." In [Transactions of the] 7. *Jahresversammlung des Deutschen Werkbundes vom 2. bis 6. Juli 1914 in Köln.* Jena, 1914.

————. "Wo stehen wir? Vortrag, gehalten auf der Jahresversammlung des Deutschen Werkbundes in Dresden 1911." In *Die Durchgeistigung der deutschen Arbeit. Wege und Ziele in Zusammenhang von Industrie, Handwerk und Kunst.* Jahrbuch des Deutschen Werkbundes 1912. Jena, 1912, pp. 11–26.

Naumann, Friedrich. "Kunst und Industrie." In *Das deutsche Kunstgewerbe 1906. III. deutsche Kunstgewerbeausstellung, Dresden 1906.* Munich, 1906, pp. 32–35.

Naylor, Gillian. *The Bauhaus.* New York and London, 1968. ∨

*Neue Arbeiten der Bauhauswerkstätten.* Bauhausbücher, no. 7. Munich, 1925.

Niemeyer, W. "Peter Behrens und die Raumaesthetik seiner Kunst." *Dekorative Kunst* 15 (10. Jhrg.), no. 4 (January 1907): 137–165.

Obrist, Hermann. "Der 'Fall Muthesius' und die Künstler." *Dekorative Kunst* 16 (11. Jhrg.), no. 1 (October 1907): 42–44.

————. "Die Lehr- und Versuch-Ateliers für angewandte und freie Kunst." *Dekorative Kunst* 12 (7. Jhrg.), no. 6 (March 1904): 228–232.

————. "Luxuskunst oder Volkskunst?" *Dekorative Kunst* 9 (5. Jhrg.), no. 3 (December 1901): 81–99.

————. "Neue Möglichkeiten in der bildenden Kunst." *Der Kunstwart* 16, pt. 2 (April 1903): 18–26, 66–74.

————. *Neue Möglichkeiten in der bildenden Kunst. Essays.* Leipzig, 1903.

*Offizieller Katalog der Deutschen Werkbund-Austellung, Cöln 1914, Mai bis Oktober.* Cologne and Berlin, 1914.

Osthaus, Karl Ernst. "Die Folkwang-Schule, ein Entwurf von Bruno Taut." *Genius* 2 (1920): 199–205.

————. *Henry van de Velde. Leben und Schaffen des Künstlers.* Die neue Baukunst. Monographienreihe, vol. 1. Hagen i. W., 1920.

Ostwald, Wilhelm. "Normen." In *Der Verkehr.* Jahrbuch des Deutschen Werkbundes 1914. Jena, 1914, pp. 77–86.

Oud, J. J. P. "Kunst en machine." *De Stijl* 1, no. 4 [*sic*—3] (January 1918): 25–26.

————. "Orientatie." *De Stijl* 3, no. 2 (December 1919): 13–15.

Paepcke, Alice Antonia. "The Evolution of Bauhaus Typography 1919–1928." B.A. Honors thesis. Radcliffe College, Cambridge, Mass., March 1957.

Pallat, Ludwig. "Zeichenunterricht." In *Deutsche Kunsterziehung.* Leipzig and Berlin, 1908.

Parnitzke, Erich. "Zur Geschichte des Zeichen- und Kunstunterrichts." In *Handbuch der Kunst- und Werkerziehung.* Vol. 1, *Allgemeine Grundlagen der Kunstpädagogik.* Berlin, 1953, pp. 98–106.

Paul, Bruno. *Erziehung der Künstler an staatlichen Schulen* (pamphlet). n.d.

————. "Erziehung der Künstler an staatlichen Schulen." *Deutsche Kunst und Dekoration* 45 (23. Jhrg.), no. 7 (December 1919): 193–196.

*Paul Klee, Alexej Jawlensky* (catalogue). Städtisches Museum Gemäldegalerie, Wiesbaden, 1962.

Pazitnov, L. *Das schöpferische Erbe des Bauhauses, 1919–1933.* Berlin, 1963.

Pehnt, Wolfgang. "Gewissheit des Wunders. Der Expressionismus in der Architektur." *Das Kunstwerk* 17, no. 9 (March 1964): 2–11.

Peters, Heinz. *Die Bauhaus-Mappen. "Neue europäische Graphik"* 1921–23. Cologne, 1957.

Pevsner, Nikolaus. *Academies of Art Past and Present.* Cambridge, 1940.

————. "The Fantastical Twenties." *Architectural Review* 135, no. 806 (April 1964): 241.

————. "Finsterlin and Some Others." *Architectural Review* 132, no. 789 (November 1962): 353–357.

————. "Gropius and van de Velde." *Architectural Review* 133, no. 793 (March 1963): 165–168. With a reply by Gropius, July 1963, p. 6.

————. *Pioneers of Modern Design: From William Morris to Walter Gropius.* Rev. ed. Harmondsworth, Middlesex, 1960.

————. "Post-War Tendencies in German Art Schools." *Journal of the Royal Society of Arts* 84 (1936): 248–261.

Pfeiffer-Belli, Erich. "Die Maler am Bauhaus." *Frankfurter Hefte* 5, no. 7 (1950): 789ff.

Pfister, Rudolf. *Theodor Fischer. Leben und Wirken eines deutschen Baumeisters.* Munich, 1968.

Poelzig, Hans. "Architekturfragen." *Das Kunstblatt* 1 (1917): 129–136.

————. "Festspielhaus in Salzburg. Ein Vorprojekt und eine Ansprache von Hans Poelzig." *Das Kunstblatt* 5, no. 4 (1921): 77–88.

————. "Der neuzeitliche Fabrikbau." *Der Industriebau* 2, no. 5 (May 15, 1911): 100–105.

————. "Rede zur Werkbund-Tagung." *Das Kunstblatt* 3, no. 10 (October 1919): 307–316.

*Poelzig, Endell, Moll und die Breslauer Kunstakademie 1911–1932* (catalogue). Akademie der Künste and the Städtische Museum Mülheim an der Ruhr, 1965.

Pörtner, Paul, ed. *Literaturrevolution 1910–1925.* 2 vols. Darmstadt, 1960, 1961.

Ponten, Josef. *Architektur die nicht gebaut wurde.* 2 vols. Stuttgart, Berlin, and Leipzig, 1925.

Posener, Julius. *Anfänge des Funktionalismus. Von Arts and Crafts*

*zum Deutschen Werkbund.* Berlin, Frankfurt am Main, and Vienna, 1964.

Prinzhorn, Hans. *Gottfried Sempers aesthetische Grundanschauungen.* Stuttgart, 1909.

"Purismus und Totalismus." *Der Ararat* 2 (June 1921): 166–167.

Raabe, Paul. *Die Zeitschriften und Sammlungen des literarischen Expressionismus 1910–1921.* Stuttgart, 1964.

Raleigh, Henry P. "Johannes Itten and the Background of Modern Art Education." *Art Journal* 27, no. 3 (Spring 1968): 284–287, 302.

Raphael, Max. *Von Monet zu Picasso. Grundzüge einer Ästhetik und Entwicklung der modernen Malerei.* 3d unchanged ed. Munich, 1919.

Richter, Horst. *Georg Muche.* Recklinghausen, 1960.

Riemerschmid, Richard. *Künstlerische Erziehungsfragen,* pts. 1 and 2. Flugschriften des Münchner Bundes, nos. 1 and 5. Munich 1917, 1919.

Ringbom, Sixten. "Art in 'the Epoch of the Great Spiritual': Occult Elements in the Early Theory of Abstract Painting." *Journal of the Warburg and Courtauld Institutes* 29 (1966): 386–418.

Rochowanski, L. W. *Der Formwille der Zeit in der angewandten Kunst.* Vienna, 1922.

Roller, Alfred. "Fünfzig Jahre Wiener Kunstgewerbeschule." *Kunst und Kunsthandwerk* 21, no. 8–10 (1918): 336–349.

Roters, Eberhard. *Painters of the Bauhaus.* Translated by Anna Rose Cooper. New York and Washington, 1969.

Rühl, Konrad. "Erinnerungen an Bruno Taut." *Baukunst und Werkform* 12, no. 9 (September 1959): 485–494.

*Ruf zum Bauen. Zweite Buchpublikation des Arbeiterrats* [sic] *für Kunst.* Berlin, 1920.

*Russische Kunst* (catalogue). Galerie von Garvens, Hanover, March 1921.

Scheerbart, Paul. *Dichterische Hauptwerke.* Stuttgart, 1962.

———. *Glasarchitektur.* Berlin, 1914.

———. *Paul Scheerbart. Eine Einführung in sein Werk und eine Auswahl.* Edited with an introduction by Carl Mumm. Wiesbaden, 1955.

Scheffauer, Herman George. "Bruno Taut: A Visionary in Practice." *Architectural Review* 52, no. 313 (December 1922): 155–159.

———. "Hans Poelzig." *Architectural Review* 54, no. 323 (October 1923): 122–127.

————. *The New Vision in the German Arts*. New York, 1924.

Scheffler, Karl. *Moderne Baukunst*. Leipzig, 1908.

Scheidig, Walther. *Crafts of the Weimar Bauhaus 1919–1924: An Early Experiment in Industrial Design*. Translated by Ruth Michaelis-Jena with the collaboration of Patrick Murray, F.S.A. (Scot). New York, 1967.

————. *Die Weimarer Malerschule*. Erfurt, 1950.

Scheyer, Ernst. "Molzahn, Muche and the Weimar Bauhaus." *Art Journal* 28, no. 3 (Spring 1969) : 269–277.

Schlemmer, Oskar. *Briefe und Tagebücher*. Edited by Tut Schlemmer. Munich, 1958.

————. "Paul Klee und die Stuttgarter Akademie." *Das Kunstblatt* 4, no. 4 (April 1920) : 123–124.

————; Moholy-Nagy, Laszlo; and Molnar, Farkas. *The Theatre of the Bauhaus*. Edited and with an introduction by Walter Gropius. Translated by Arthur S. Wensinger. Middletown, Conn., 1961.

Schmidkunz, Hans. *Die Ausbildung des Künstlers*. Führer zur Kunst, vol. 7. Esslingen, 1907.

Schmidt, Diether. *Bauhaus. Weimar 1919 bis 1925, Dessau 1925 bis 1932, Berlin 1932 bis 1933*. Dresden, 1966.

————, ed. *Manifeste Manifeste 1905–1933. Schriften deutscher Künstler des zwanzigsten Jahrhunderts*, vol. 1. Dresden, [1964].

Schmidt, Paul F. "Werkbund-Krisis." *Der Cicerone* 11, no. 21 (1919) : 704–705.

Schmied, Wieland, ed. *Wegbereiter zur modernen Kunst. 50 Jahre Kestner-Gesellschaft*. Hanover, 1966.

Schoenberg, Arnold. *Briefe*. Selected and edited by Erwin Stein. Mainz, [1958].

Schreyer, Lothar. *Erinnerungen an Sturm und Bauhaus*. Munich, 1956.

————. "Das Gegenständliche in der Malerei." In *Expressionismus. Die Kunstwende*. Berlin, 1918, pp. 22–28.

————. "Die neue Kunst." *Der Sturm* 10, no. 5 (August 1919) : 66–70; no. 6 (September 1919) : 83–90; no. 7 (October 1919) : 103–106; no. 8 (November 1919) : 118–125.

Schumacher, Fritz. *Die Reform der kunsttechnischen Erziehung*. Deutscher Ausschuss für Erziehung und Unterricht, no. 3. Leipzig, 1918.

Selz, Peter. *German Expressionist Painting*. Berkeley and Los Angeles, 1957.

Semper, Gottfried. *Der Stil in den technischen und tektonischen Künsten, oder praktische Aesthetik. Ein Handbuch für Techniker,*

*Künstler und Kunstfreunde.* 2 vols. Frankfurt am Main, 1860, Munich, 1863.

Seuphor, Michel. *Piet Mondrian, Life and Work.* New York, [1956].

Severini, Gino. *Du cubisme au classicisme.* Esthétique du compas et du nombre. Paris, 1921.

Sharp, Dennis. *Modern Architecture and Expressionism.* New York, 1966.

Soergel, Albert. *Dichtung und Dichter der Zeit. Eine Schilderung der deutschen Literatur der letzten Jahrzehnte.* Leipzig, 1911.

————. *Dichtung und Dichter der Zeit. Eine Schilderung der deutschen Literatur der letzten Jahrzehnte. Neue Folge: Im Banne des Expressionismus.* Leipzig, 1926.

Sörgel, Hermann. *Theorie der Baukunst.* Vol. 1, *Architektur-Ästhetik.* 3d enlarged ed. Munich, 1921.

Sokel, Walter H. *The Writer in Extremis: Expressionism in Twentieth-Century German Literature.* New York, Toronto, and London, 1964.

"Das Staatliche Bauhaus und seine Aufgaben." *Das Volk* (Jena), June 2, 1922.

*Staatliche Bauhochschule Weimar.* Weimar, 1929.

*Staatliches Bauhaus Weimar 1919–1923.* Weimar and Munich, [1923].

"Stellungnahme der Gruppe 'Ma' in Wien zum ersten Kongress der fortschrittlichen Künstler in Düsseldorf." *De Stijl* 5, no. 8 (August 1922): 125–128.

Stern, Fritz. *The Politics of Cultural Despair.* Garden City, 1965.

Stern, Lisabeth. "Kurze Chronik." *Sozialistische Monatshefte* 25, no. 6–7 (March 24, 1919): 297.

————. "Kurze Chronik." *Sozialistische Monatshefte* 25, no. 13–14 (June 10, 1919): 587.

————. "Sozialismus und Kunst." *Sozialistische Monatshefte* 25, no. 15–16 (July 7, 1919): 675–676.

[Stölzl] Sharon-Stölzl, Gunta. "Die Entwicklung der Bauhausweberei." *Bauhaus. Zeitschrift für Gestaltung,* no. 2 (July 1931) [unpaged].

[Stölzl] Stadler-Stölzl, Gunta. "In der Textilwerkstatt des Bauhauses 1919 bis 1931." *Werk* 55, no. 11 (November 1968): 744–748.

Stölzl, Gunta. "Weberei am Bauhaus." *Offset- Buch- und Werbekunst,* no. 7 (Bauhaus no., 1926), pp. 405–406.

Sydow, Eckart von. "Das religiöse Bewusstsein des Expressionismus." *1919. Neue Blätter für Kunst und Dichtung* 1 (January 1919): 193–199.

Tadd, J. Liberty. *New Methods in Education: Art, Real Manual Training, Nature Study.* New York and London, 1899.

Taut, Bruno. *Alpine Architektur. Hagen i. W.,* 1919.

————. *Ein Architektur-Programm.* Flugschriften des Arbeitsrates für Kunst, no. 1. 2d ed. Berlin, Spring 1919.

————. *Die Auflösung der Städte oder Die Erde eine gute Wohnung oder auch: Der Weg zur alpinen Architektur in 30 Zeichnungen.* Hagen i. W., 1920.

————. "Die Erde eine gute Wohnung." *Die Volkswohnung. Zeitschrift für Wohnungsbau und Siedlungswesen* 1, no. 4 (February 24, 1919): 45–48.

————. *Frühlicht 1920–22. Eine Folge für die Verwirklichung des neuen Baugedankens.* Edited by Ulrich Conrads. Berlin, Frankfurt am Main, and Vienna, 1963.

————. "Für die neue Baukunst!" *Das Kunstblatt* 3, no. 1 (January 1919): 16–24.

————. "Ein Ledigenheim in Schöneberg." *Stadtbaukunst alter und neuer Zeit,* no. 9 (1920), pp. 136–138.

————. "Eine Notwendigkeit." *Der Sturm* 4, no. 196–197 (February 1914): 174–175.

————. "Der Sozialismus des Künstlers." *Sozialistische Monatshefte* 25, no. 6–7 (March 24, 1919): 259–262.

————. *Die Stadtkrone.* With contributions by Paul Scheerbart, Erich Baron, and Adolf Behne. Jena, 1919.

————. *Der Weltbaumeister. Architektur-Schauspiel für symphonische Musik.* Hagen i. W., 1920.

————. "Zu den Arbeiten der Architekten Bruno Taut und Hoffmann." *Moderne Bauformen* 12, no. 3 (March 1913): 121–141.

Tessenow, Heinrich. *Handwerk und Kleinstadt.* Berlin, 1919.

Thwaites, John Anthony. "The Bauhaus Painters and the New Style-Epoch." *Art Quarterly* 14, no. 1 (Spring 1951): 19–32.

————. "The Bauhaus Painters in Munich." *Burlington Magazine* 92, no. 569 (August 1950): 237.

Tritschler, Thomas. "The Art and Theories of Adolf Hölzel and Their Place in the History of Late Nineteenth and Early Twentieth-Century Painting." Master's thesis, University of Illinois, 1968.

Trümper, Herbert. "Theoretische Grundlagen der Kunstpädagogik." In *Handbuch der Kunst- und Werkerziehung.* Vol. 1, *Allgemeine Grundlagen der Kunstpädagogik.* Berlin, 1953, pp. 20–72.

Umanskij, Konstantin. *Neue Kunst in Russland 1914–1919.* Potsdam and Munich, 1920.

————. "Neue Kunstrichtung in Russland." Part 1, "Der Tatlinismus oder die Maschinenkunst." *Der Ararat*, no. 4 (January 1920), pp. 12–14.

Vantongerloo, Georges. "Réflections." Part 2, "La Création, le visible, la substance." *De Stijl* 2, no. 2 (December 1918): 21–22.

Velde, Henry van de. *Geschichte meines Lebens*. Munich, 1962.

————. *Die Renaissance im modernen Kunstgewerbe*. Berlin, 1901.

————. *Zum neuen Stil*. Edited by Hans Curjel. Munich, 1955.

Venzmer, Wolfgang. "Adolf Hölzel, Leben und Werk." *Der Pelikan. Zeitschrift der Pelikan-Werke Günther Wagner Hannover*, no. 65 (April 1963), pp. 4–14.

*Die Veredelung der gewerblichen Arbeit im Zusammenwirken von Kunst, Industrie und Handwerk. Verhandlung des Deutschen Werkbundes zu München am 11. und 12. Juli 1908*. Leipzig, n.d.

*Der Verkehr*. Jahrbuch des Deutschen Werkbundes 1914. Jena, 1914.

*Ein Versuchshaus des Bauhauses in Weimar*. Bauhausbücher, no. 3. Munich, 1925.

Viola, Wilhelm. *Child Art*. 2d ed. Peoria, n.d.

————. *Child Art and Franz Cizek*. Vienna and New York, 1936.

Waentig, Heinrich. *Wirtschaft und Kunst*. Jena, 1909.

Wagenfeld, Wilhelm. "Das Staatliche Bauhaus—die Jahre in Weimar." *Form. Zeitschrift für Gestaltung*, no. 37 (March 1967), pp. 17–19.

Wagner, Martin. "La Socialisation des entreprises de bâtiment." *Les Annales de la régie directe* 14 (November 1921-June 1922): 12–63. Translated by H. Buriot-Darsiles.

Wagner, Otto. *Modern Architecture: A Guide for His Pupils in This Domain of Art*. Translated by N. Clifford Ricker from the 2d German ed. Boston, 1902.

————. *Moderne Architektur*. 3d ed. Vienna, 1902.

Weber, Helmut. *Walter Gropius und das Faguswerk*. Munich, 1961.

Weininger, Andor. "Bauhaus und Stijl." *Form*, no. 6 (1959), pp. 7–8.

Werfel, Alma Mahler. *And the Bridge Is Love*. New York, 1958.

Westheim, Paul. "Architektur in Frankreich: Le Corbusier-Saugnier." *Wasmuths Monatshefte für Baukunst* 7, no. 3–4 (1922–23): 69–82.

————. "Künstlerisches Handwerk." *Sozialistische Monatshefte* 24 (November 26, 1918): 1111.

Whittick, Arnold. *Erich Mendelsohn*. 2d ed. London, 1956.

————. *European Architecture in the Twentieth Century*. 2 vols. London, 1950.

Wingler, Hans M. *Das Bauhaus, 1919–1933. Weimar, Dessau, Berlin.* Bramsche, 1962. English ed., *The Bauhaus: Weimar, Dessau, Berlin, Chicago.* Translated by Wolfgang Jabs and Basil Gilbert. Cambridge, Mass., 1968.

————. "Is the Bauhaus Relevant Today?" Mimeographed address delivered at the Illinois Institute of Technology, Chicago, April 20, 1967.

*Wohnung und Hausrat. Beispiele neuzeitlicher Wohnräume und ihrer Ausstattung.* Munich, 1908.

Wolf, Georg Jacob. "Der Deutsche Werkbund und die Deutsche Werkbund-Ausstellung in Köln." *Dekorative Kunst* 22 (17. Jhrg.), no. 12 (September 1914): 529–550.

Zevi, Bruno. "L'insegnamento critico di Thèo van Doesburg." *Metron,* no. 44 (1952), pp. 21–37.

————. "Ist das Bauhaus aktuell?" *L'architettura: cronache e storia* 10, no. 3 (July 1964): 147.

————. *Poetica dell'architettura neoplastica.* Milan, 1953.

# INDEX

*Numbers in italics indicate appendices.*